Fitz H. Lane

Fitz H. Lane

An Artist's Voyage through Nineteenth-Century America

James A. Craig

Charleston London

History
PRESS

Published by The History Press
Charleston, SC 29403
www.historypress.net

Cover image: Fitz Henry Lane, *Bark "Eastern Star" of Boston*, 1853, oil on canvas, 23 x 39 in. *Private collection.*

First published 2006

Manufactured in the United Kingdom

ISBN 1.59629.090.0

Library of Congress Cataloging-in-Publication Data

Craig, James A.
 Fitz H. Lane : an artist's voyage through nineteenth-century America /
James A. Craig.
 p. cm.
 Includes bibliographical references and index.
 ISBN 1-59629-090-0 (alk. paper)
 1. Lane, Fitz Hugh, 1804-1865. 2. Landscape painters--United
States--Biography. 3. Luminism (Art)--United States. I. Title: Artist's
voyage through nineteenth-century America. II. Lane, Fitz Hugh, 1804-1865.
III. Title.
 ND237.L27C73 2006
 759.13--dc22
 2006006792

To *Mitak' oyas'in*.

Contents

Preface

From bold canvases depicting storm-tossed seas to tranquil images of harbors bathed in the roseate hues of sunset, from studies of bustling wharves teeming with activity to sketches of regal sail ships lying quietly at anchor, the artwork of Luminist painter Fitz H. Lane was a triumph, succeeding in capturing the atmosphere, character and moods of mid-nineteenth-century coastal New England.

Today the works of this great Gloucester artist, celebrated as "one of America's preeminent marine painters,"[1] continue to hold the fascination and captivate the eye of people the world over. His work is shown in twenty-seven museums across the country, including the White House, and was the subject of a major exhibition at the National Gallery of Art in 1988. Lane's work has also begun to reach European audiences, for his art is now exhibited within the permanent collection of the Museo Thyssen-Bornemisza in Madrid, and was featured in a show titled *The American Scene, 1860–1910* at the Musée d'Art Américain in Giverny, France, in 2005. It was for the prestige of owning one of this man's paintings that the record figure of $5,506,000 was recently paid, one of the hundred all-time greatest sums ever spent at auction for a work of art.[2]

Meanwhile the general public continues to seek out images of Lane's handiwork in books, prints and on the Internet in ever-increasing numbers. To date, 156 titles attempting to explain the works of Fitz H. Lane have been published,[3] offering intimate insights into this man's career. His brush strokes, his color palate, the changes in his style and subject matter—these and more are discussed at great length, but as of yet no attempt has been made to truly explain the *man* who made these timeless images. So much focus has been put upon his creations that Lane himself has become but an incidental detail, a pale ghost shoved to the back, eclipsed by his own artwork.

The year 2004 marked the 200th anniversary of the birth of Fitz H. Lane, and it is inevitable that a milestone anniversary such as this should invite a host of questions: "Why are Lane's paintings so valued?" "What is it about his work that makes it so quintessentially American?" "What is the significance of his art, and what relevance does it bear for people today, dwelling in the twenty-first century?" In an attempt to answer these questions, the Cape Ann Historical Association, possessor of the world's largest collection of Fitz H.

Lane paintings and sketches, hosted a three-part lecture series focusing upon Lane in July 2004. Crafted with a diverse audience in mind, these lectures sought to capture the interest of the layman and the scholar alike. By exploring not only his art but also what it depicted, the time in American history during which it was being created and the few bits of personal history scholars have been able to uncover, the three addresses not only served to acquaint the public with Lane, but also offered a more intimate and complete understanding of this great painter than perhaps has ever been afforded before.

This book was born of those three lectures, inspired by the suggestions and feedback of those who attended and the encouragement of friends and colleagues. It is hoped that, indeed, a more thorough understanding of Lane shall be gained within these pages.

The story of Fitz H. Lane is one of native-born genius, of a man documenting the progress and change that unfolded during one of humanity's most dramatic and confusing historical epochs. It is also one of overcoming obstacles, celebrating ideals, honoring the inventions of man and the serene, eternal grace of the natural world. And yet it is also a tale shrouded in mystery. Lane left us few clues as to his everyday comings and goings. Only a handful of personal correspondences and contemporary newspaper articles have survived, and to our knowledge Lane never kept a journal or diary. To reconstruct his life scholars are forced to employ the techniques of the detective, pasting together a small, fragmented collection of exhibition records, legal documents, contemporary newspaper clippings and Lane's most telling of documents—his artwork—all in the endeavor to "flesh out" this extraordinary man.

Acknowledgements

In the telling of this tale I have many persons to thank. First and foremost, to Mr. Erik A.R. Ronnberg Jr.—a man of unequaled and boundless genius who has devoted years of research and study to Lane and the maritime world in general, I lift my voice in the heartiest of salutations. Your questions and guidance moved me to look in places I would never have thought to, and helped shape this book into something far greater than it otherwise would have been. Mr. Ronnberg, may you receive the just honors you so richly deserve.

As well I must thank the great laureate historian of Gloucester, author Joseph Garland, for encouraging me to pursue the idea of a Lane book and then being so kind as to put in a good word for me with his (and now my) publisher, Ms. Kirsty Sutton, to whom I also offer heartfelt words of praise and thanksgiving. I also acknowledge my sincere indebtedness to artist and fellow curator Susan Erony, for suggesting the creation of the lectures that led to this book in the first place. Words of gratitude must be extended to archivist Stephanie Buck and her husband Fred—Stephanie, for bringing to my attention Judith Millett, Annette Babson and a host of other primary sources, and for her wise counsel; Fred, for selflessly volunteering his time to scan many of the images that are to be found within this tome. To Marcia Steele and Moyna Stanton of the Cleveland Museum of Art, and Henry Travers Newton, I wish to voice my praises for their pioneering work on the methods, tools and techniques of Fitz H. Lane, and for letting me be privy to their investigations. I must also thank Karen Quinn and company from the Museum of Fine Arts, Boston, for letting me be privy to *their* investigations. Ms. Quinn also deserves special words of thanks for her help in the viewing of the MFA's collection of Salmon, Doughty and Fisher works,

her assistance in tracking down various Lane paintings and for her input concerning the effects of tourism on nineteenth-century painters and their craft.

I bow my head in humble appreciation to Ms. Catharina Slautterback of the Boston Athenaeum, without whose help chapter 5 simply could not have happened, given her immeasurable knowledge of and assistance concerning nineteenth-century American lithography; and to Mary Warnement, also of the Boston Athenaeum, for her facilitating my access to the Athenaeum's collection. For his extreme generosity, Mr. Peter Nicholas must also be remembered, and Mr. Ronald Bourgeault of Northeast Auctions and Carey Vose of Vose Galleries deserve special mention for their help in tracking down exquisite and rare Lane paintings within private collections. The staff at The Finer Image of Danvers, Massachusetts, and Gino and Company from Northlight Photo deserve recognition for their expert scanning/ photography of those images Fred Buck didn't copy, and deserving acknowledgement as well are Mary McCarl, Ellen and Paul Nelson, and Elizabeth Waugh, gentle souls whom I feel should be recognized for all their assistance, ideas and encouragements, as well as for their warm friendship.

And last but never least, to my wife Katie. Your patience and firm conviction in me have made this and so much more a blessed reality. Thank you. For everything.

Part I: From Birth to 1832

Our home is on the ocean; our wealth we draw from the deep; and by dangers and sufferings; which from repetition we have become familiar; we support ourselves, our wives, and our children.
—Unknown citizen of Gloucester, Massachusetts, ca. 1812

Chapter 1
Gloucester
Family History and a Childhood
Spent by the Sea

The story of marine painter Fitz H. Lane, like that of his native Gloucester, Massachusetts, is one of an intimate relationship with the sea. Indeed, to fully comprehend this man and his art, we must turn to the sea, for it was from a maritime culture that he emerged, and it was a maritime culture which he forever memorialized upon the painted canvas.

To begin, we focus our attention upon that one city within whose precincts Fitz H. Lane would spend the vast majority of his years: Gloucester, Massachusetts. [See figure 1.] Ever since its founding in 1623, Gloucester has thrown its lot in with the ocean. Source of sustenance, provider of income and the avenue by which Gloucester's citizenry has conversed with the larger world, the high seas have come to dominate the lives of those who call Gloucester home, molding and shaping their society for almost four hundred years. Upon her fickle tides fortunes have risen and fallen; some have known nothing but plenty and gain while riding her capricious winds—others, loss and ruin.

This relationship with the sea—dangerous, unpredictable and seldom rewarding as it is—was inevitable, being determined not so much by the will and designs of humankind, but rather by the awesome forces of geology and geography. Glaciers of the latter Pleistocene epoch, plowing and ripping the earth's crust before them, had formed a land both promising and forbidding.[4] Bordered by the Atlantic Ocean on three sides, replete with snug coves and harbors, yet sporting an interior that was but a boulder-strewn waste of thin soil and dark forest, it was only natural for humans residing here to turn to the sea for their livelihood.

American Indians were the first to inhabit this granite promontory. For roughly eleven thousand years they dwelled here, generation after generation making use of the peninsula's rich marine life during the summer months and retreating inland before the icy winds of winter.[5] Arrowheads and butchering sites have been discovered throughout Cape Ann, as well as evidence of simple horticulture. Early European visitors described in great detail the "corn, beans, melons, pumpkins, tobacco, and grapes" they found the native inhabitants cultivating, as well as the techniques they employed in this endeavor.[6] But the overwhelming prevalence of stone fishing weights, harpoon heads, shell middens

and trash heaps filled with fish bones inform us that fishing and the harvesting of shellfish were the primary preoccupations for those seasonal residents so long ago.

Gloucester's first recorded contact with the Old World occurred in the year 1606, when the French explorer Samuel de Champlain, at the behest of a Huguenot fur trader and colonizer named Pierre Du Gua de Monts, sailed southward from the coast of Maine in the quest to find a habitable site for settlement.[7] The broad, well-protected harbor he found (modern-day Gloucester Harbor) offered sanctuary from storms, while ample springs held the promise of supporting a colony. Yet despite its promise, the area was not settled. That honor would ultimately fall to England.

British interest in the area was first stirred by the adventurer Captain John Smith, who in 1614 sailed along the coast of Cape Ann, his intent being "to take whales, and make trials of a mine of gold and copper."[8] Nine years after Smith's fleeting reconnaissance of the region, its first English colonists arrived. A scant fourteen in number, they were to last no more than three years. The English would not be so easily discouraged, though. Pioneers hailing from the British Isles continued to trickle into the area, some staying for only a few seasons, others stubbornly persisting year after toilsome year. In 1634 the village finally had a name: Gloucester, in homage to the township back in England from whence many of the settlers had originated. (The cape itself had received its present appellation back in 1624, when King Charles I of England named the peninsula in honor of his mother.)[9] By the year 1650 eighty-two hardy souls were calling Gloucester home,[10] and, like those before them, it was to the sea they turned to secure their existence.

Codfish would prove to be their cash crop. High in protein, low in fatty oils, it was both abundant and easy to process. Once caught, gutted and salted, the fish would take but a few days to dry, and once packed in barrels it would keep as many as five years—though some claimed it could last even longer. It was a commodity that defied spoilage in the rank, humid hulls of seventeenth-century cargo ships, and as well it commanded high prices in the Catholic countries, where piety demanded the faithful abstain from meat on Fridays. Salted Cod found itself being exchanged for goods that simply could not be found in the New World yet. Figs, chick peas, and fine Madeira wine from Iberia, iron and linen from home, sugar from plantations in the West Indies—these were but a few of the items that the humble livelihood of fishing helped secure for the growing village. This course of wresting a living from the ocean would ultimately prove unstoppable—growing, adapting and changing with the demands of the larger world over the centuries and into our present day.

By the time he was born, Fitz H. Lane's family had already been calling the town of Gloucester home for five generations. The first Lane to arrive upon the granite shores of Cape Ann was John Lane who, as historian John J. Babson states in his *History of the Town of Gloucester, Cape Ann*, "was born about 1653; and, with his wife and children, came to Gloucester, about the close of the seventeenth century, from Falmouth, ME; driven thence, probably, on the second destruction of that place by Indians."[11] Samuel Lane, supposed

brother of John and a direct ancestor of Fitz H. Lane, would, in 1708, be granted land in a small yet inviting corner of Gloucester lying along the Cape's northern edge, commonly known at the time as Flatstone Cove.[12]

Given the hamlet's size and its prime source of revenue, it is almost certain that both John and Samuel Lane's livelihoods were linked with the growing fisheries in one manner or another. It is known that Samuel practiced the trade of the blacksmith.[13] In such a capacity, he would have been providing his patrons with everything from nails, door hinges and cooking utensils to fishhooks and the fittings needed aboard those vessels that operated out of the cove. Flatstone Cove soon came to be known as Lane's Cove, and the tiny hamlet that emerged around it, Lanesville, both titles alluding to the family's seeming ownership of the inlet and their mounting privilege.[14]

Subsequent generations certainly partook of the seafaring lifestyle, to either their profit or detriment. John Lane Jr. chose to invest in ships, becoming part owner of a coasting vessel and a fishing craft, and in time accumulated an estate worth nearly five hundred pounds in 1724. Meanwhile Stephen Lane, Fitz H. Lane's grandfather, who sailed with a Captain Jonathan Dennison, also of Gloucester, was tragically lost in a shipwreck off Scituate, Massachusetts, on December 28, 1774.[15]

Details concerning Fitz H. Lane and his early days in Gloucester have for many years proven hard to come by, yet over time scholars have cobbled together stray bits of information that afford tantalizing glimpses of the artist's formative years. The future artist was born in Gloucester on December 19, 1804,[16] and christened at the First Parish Church on March 17, 1805, as Nathaniel Rogers Lane.[17]

By 1804 the branch of the Lane family into which Fitz was born was no longer calling the northern coast of the Cape their home, living instead upon the periphery of Gloucester Harbor's working waterfront, by then the undisputed center of commerce on Cape Ann. His father, Jonathan Dennison Lane, was a sailmaker by trade, and quite possibly was the owner and proprietor of a sail loft, earning a prosperous, affluent living, as evidenced by his ownership of "the second house on Middle street,"[18] a fashionable neighborhood that was at the time home to Gloucester's elite merchants and sea captains. Typical for the times, his mother Sarah was a homemaker. Concerning siblings, there are three whose existence we are certain of: Edward, an older brother born on November 5, 1802, and two younger sisters, both named Sarah Ann (the first of which died at the tender age of two).[19] Clues alluding to the presence of a possible fourth sibling, Steven, have recently come to light.[20] If indeed Steven Lane was a brother to Fitz H. Lane, he would have been an older brother as well, in fact the oldest in the family.

If there was one aspect of Lane's childhood that would prove life-defining—one single, solitary event from which a chain reaction would ensue, catapulting him along the path of ultimately becoming an artist—it was his now-legendary loss of mobility. Babson, in his *History of Gloucester*, relates: "At the age of eighteen months, while playing in the yard or garden, [Lane] ate some of the seeds of the apple-peru; and was so unfortunate as to lose the use of his lower limbs in consequence, owing to late and unskilful [sic] medical

treatment."[21] Lane's nephew, Edward Lane, would later claim in an article titled "Early Recollections of Artist Fitz H. Lane" (published after the artist's passing) that his uncle ate not the seeds of the "Apple Peru," but rather "some of its leaves."[22] While the apple of Peru is nothing more than the common tomato, the similarly named Peru-apple is in fact *Datura stramonium*, an annual weed in the nightshade family, of which all parts are, in fact, quite poisonous. Also known as Jimsonweed,[23] this relative of the tomato "is extremely toxic and in large doses can not only cause severe neurological disturbances, but may even be fatal."[24] Had Lane in fact ingested Jimsonweed, any number of symptoms could have manifested in his nervous system, including paralysis.

Past scholars have speculated that infantile polio was in fact the culprit of Lane's condition.[25] With the passage of time, this theory has gained a level of credence with the general public so great that it has come to be accepted as fact. Yet upon scrutiny, inconsistencies emerge. If polio had afflicted Lane, then he was virtually its sole victim in Gloucester in 1806, for the public records are strangely quiet concerning an outbreak of children struck by the sickness. The state of Massachusetts did not begin officially counting and recording polio cases until 1909,[26] but contemporary periodicals, diaries and personal letters are unlikely to have failed in noticing its presence among the community, regardless of whether or not it was an identified malady. It should also be noted that the first polio epidemic reported in the United States occurred fairly late in the nineteenth century, unfolding in Vermont in 1894, and consisted of 132 cases (including adults).[27] Polio was generally an unknown in Lane's time, not due to the ignorance of contemporary medical science but rather due to its overall infrequency. History has proven polio to ultimately be a disease of the twentieth century rather than the nineteenth, with massive outbreaks such as that of 1952 (fifty-eight thousand cases of polio in the United States alone[28]) being unheard of in the time of Lane's youth. Edmund Sass, in his work *Polio's Legacy*, has suggested that "before the advent of modern sewage treatment plants and other improvements in public sanitation, virtually all individuals were exposed to the polio virus early in their lives…Thus, they developed mild, non-paralytic infections, probably during infancy, which provided them with lifelong immunity."[29] Lane was living during a time when most everyone was being exposed to the virus and suffering few to no ill effects, so it seems quite unlikely that he could have been infected. Finally, when one considers that, unlike the common polio victim, Lane's legs did not atrophy ("although he grew to the ordinary stature of a man his [Lane's] legs were useless"[30]), the polio theory loses credibility.

Whatever the cause for his illness, there is no dispute concerning its aftermath: Fitz H. Lane would never regain the use of his legs, remaining unto his dying day paralyzed from the waist down, forced to employ crutches for his mobility. Yet rather than being defined by his handicap, Lane would instead triumph over it. Denied the usual outlets for exploration and self-realization, and unable to partake in the games and rituals of healthy children his own age, the young Lane turned to another means by which he could investigate his environs: drawing.

Mr. Lane in early youth exhibited uncommon proof of capacity, by drawings of wonderful vigor and truthfulness.[31]

We can easily imagine the young Lane whiling away the hours, sketching the captivating subject matter that abounded in the busy port just then, the same subject matter upon which his artistic career would center as an adult. From the testimony of Gloucester native John Trask,[32] a personal acquaintance who apparently supplied Lane with painting materials during his adult years, we know that Lane's father first exposed the future artist to Gloucester's maritime world, providing intimate access to its characters and activities. Lane's paintings throughout the 1840s, and stretching well into the 1850s, would focus heavily upon busy harbor scenes, his foregrounds replete with common laborers and toilers of the quay.

In regard to his education, our investigation hits an abrupt void. Contrary to the claim that "Lane attended the Gloucester Common School,"[33] there are no records within the vaults of the Gloucester City Archives to corroborate this assertion that Lane was educated within the city's school system. Yet it is obvious that Lane received an education somewhere in his formative years. Personal letters readily attest to his being literate, and the technical demands his future career as a lithographer and artist would require speak of a man well versed in mathematics. As an adult Lane would prominently participate in more than a few intellectual and social reform movements, circulating within highly educated, diverse social circles the likes of which no rough-hewn bumpkin would ever have been admitted to. His close friend Joseph L. Stevens Jr. testifies that Lane was a rather literate fellow, stating, "Lane's art books and magazines were always at my service…notably the London Art Journal to which he long subscribed."[34] Clearly Lane was educated, and well educated at that. If in fact he was not the recipient of a public education, it stands to reason that he probably received instruction within a private school. And of the private learning institutions then found in Gloucester, the most likely candidate for having taught Lane is a Miss Judith Millett, described by a former student as being "a tall elderly and brightminded woman who was endowed with the frame of a grenadier and with a distendness of conception and a clearness of statement." Miss Millett's teaching was "highly valued in all the countryside,"[35] and we find that her school would have been the most convenient and readily accessible of private schools available to Lane, given its central location, first along Middle Street, then Hancock Street (both within close proximity of Lane's house), as well as its having been open to both girls and boys. As to the quality of instruction a student could receive in her classroom, we turn to the following description:

Judy's school was run with strict discipline. It is said that she wore a thimble at all times and snapped the children with it. She also had a bundle of whalebone umbrella ribs on the table just in case she needed them. At one time she punished one of the Dale boys by making him learn by heart one hundred verses of a Psalm…Judy also made a visitor in a white dress sit on a spit stove. The little child wiggled so much the cover tipped and she got very dirty. She also pinched children's ears.[36]

Another interesting aspect of Lane's childhood of which few details are known is the matter of his name. Christened Nathaniel Rogers Lane, it has long been believed that the artist changed his name during his childhood. As to why the future artist chose to change his name, it has been maintained that "the child was christened Nathaniel Rogers on 17 March, 1805, but disliking his name, he had it changed to Fitz Hugh as soon as he was able."[37] As with the legend of the apple-peru and polio, there the matter has rested for many years, with scholars making nothing more of it. Thus it comes as a great surprise to find out that Fitz Hugh Lane was not, in fact, the name the artist chose to be known by.

Within the "List of Persons Whose Names Have Been Changed in Massachusetts, 1780–1892," it is stated "that Nathaniel Rogers Lane, of Gloucester, may take the name of Fitz *Henry* Lane" (emphasis added).[38]

It also seems that Lane was not a young boy when he petitioned to change his name. In a letter dated December 26, 1831, located within the Massachusetts State Archives, Lane makes his formal request:

> *To the Honorable Senate and House of representatives of the Commonwealth of Massachusetts in General Court assembled. –the subscriber Inhabitant of the town of Gloucester beg leave to petition your Honorable Body, that he may take the name of Fitz Henry Lane, instead of Nathaniel, Rogers, Lane. Gloucester, December 26th-1831*
>
> *Nathaniel R. Lane*[39]

The name change was granted on March 13, 1832, when Lane was twenty-seven years old.[40]

In personal correspondences both to and from friends and family, in legal documents and in his personal signature, both upon sketches and painted canvases, Lane is roundly identified by one of the following monikers: F.H.L., F.H. Lane or Fitz H. Lane. Two known Lane paintings (*Clipper Ship "Sweepstakes,"* 1853, in the collection of the Museum of the City of New York, and *The Golden State Entering New York Harbor*, 1854, in the collection of the Metropolitan Museum of Art, New York) bear the full signature "Fitz Henry Lane." At no point, either by sources contemporary to the artist or by the artist himself, is the letter *H* ever identified as representing the middle name Hugh.

As to why Lane chose to change his name, we have only the words of John Trask to offer us any idea. "His original name was Nathaniel Rogers Lane but he said, 'Damned if he wouldn't change that name' and so by legislature it was changed."[41]

Paralysis, a penchant for drawing and a sailmaker for a father—any one of these factors by themselves could have played a deciding role in determining numerous directions the future artist's life would take. Yet when combined, the course toward a career as a marine painter was virtually assured. Had he not lost the use of his legs, Fitz Henry Lane would have enjoyed a life that offered more opportunities and possibilities. Perhaps, like his older

brother(s), he would have received instruction from Master Moore, a private teacher and experienced mariner who specialized in tutoring the young men of Gloucester in the navigational arts,[42] and in time would have embarked upon a career as a mariner instead of taking brush in hand and developing his artistic skills. Had he grown up within an inland farming community, it is more likely he would have developed a far greater interest in pastoral scenes and country vistas rather than nautical subjects. And without his father to introduce him to the inner workings of the Gloucester waterfront, his paintings would have been second-rate depictions at best. Yet aside from this scattered collection of facts and suppositions, Lane's early years in Gloucester remain a foggy haze. Thus, to understand Fitz Henry Lane, the significance of his art and what it depicts, we must first turn to the environment from which he came.

Chapter 2
Federalist-era Gloucester

The Gloucester into which Lane was born was a bold participant in the expansion and development of the young American nation. As part of the bedrock upon which Massachusetts was founded, so was Gloucester part of the thriving thirteen colonies, and thus, part of the new nation that emerged from the fires of the American Revolution.

The Revolution was still a fresh, recent memory in Lane's Gloucester. Veterans of that conflict were numerous, often to be heard recounting their wartime exploits. The city's scars of that conflict were quite numerous as well. Cape Ann's three-sided exposure to the sea—a blessing in peacetime—proved a curse in time of war. British frigates had prowled the neighboring waters, attacking colonial vessels and stealing into harbors, seeking to capture livestock or burn a schooner down to the waterline. Cannonballs hurled at Gloucester by the British could still be seen in Lane's day, fixed into the sides of people's homes and lodged within the steeple of his First Parish church.[43] Fortifications erected as a means by which to protect the town were still standing, hulking sentinels that ringed the harbor, surveying it with a grim determination. Perhaps the deepest scars to be found, though, were those in the eyes of Gloucester's people. For they had witnessed engagements such as that between the privateer *Yankee Hero* and the British frigate *Milford* unfold right off the Cape Ann coast, in plain sight of land. It was the common citizen who had repelled the HMS *Falcon*, preventing its sailors from seizing their schooners and burning down their very homes. The scars of war were also to be found in the eyes of Gloucester's mothers, wives and children, for 357 of the men who marched or sailed off to defy King George never returned home, leaving loved ones to resume the rhythms of life without them.[44]

Fitz Henry Lane was also living in the predawn of another revolution: the Industrial Revolution. Inventions that would dramatically increase the pace of life, challenge cherished beliefs and erase centuries-old ways of living were to make their appearance during his lifetime. When Lane was born, the hum of the mill could already be heard along the streams and rivers of New England. By the 1830s that hum would become a roar, with over 130 water-powered factories in Massachusetts alone churning out a glut of mass-produced goods meant for everyday ease and convenience.[45] Steamboats would begin to appear in

New England waters in earnest by the 1820s, permitting people and commodities to move faster and farther in a single day than ever before in human history.[46] A decade later railroads would arrive upon the scene, bringing with them the same effect. No facet of everyday life would remain untouched; leaving the world Lane was born into a drastically transformed, almost unrecognizable place by the time of his passing in the 1860s.

America at this time was still a new country, eager to both prove itself and distance itself from the old attitudes and institutions of Europe. As the world's first modern-day democracy, America's government was considered to be an experiment. Institutions that are often taken for granted today, such as the empowerment of the common citizen through the right to vote, the right to own private property and the notion of equality between the classes, were new, unproven and even radical ideas in Lane's America.

The early years of the fledgling Republic were generally marked with boundless optimism—Americans had defied the most powerful empire on earth to win for themselves not only a nation of their own, but also the awesome responsibility of determining their collective future. The notion of Manifest Destiny was alive and well at this time, embodying a belief then common to most Americans that they were a chosen people, preordained by a higher authority to tame the wild continent and prosper accordingly. Armed with this conviction, settlers wasted no time in crossing into what was then the Northwest Territory or pouring westward through the Cumberland Gap.

And yet the American nation's focus lay not just toward the west. While settlers plodded into Kentucky and Ohio and Lewis and Clark explored the wilds beyond the Mississippi, the merchants and mariners of America's coastal cities were increasingly turning their attention east—to the Far East.

Previous to the American Revolution, a mariner sailing out of a port anywhere within the Thirteen Colonies found himself heavily regulated by the British Crown. As a result, colonial merchants were generally relegated to trading only with England, her possessions in the West Indies, and other colonies along the Eastern seaboard.[47] Yet with the conclusion of the Revolution and British maritime laws no longer being applicable, New England mariners suddenly found themselves free to trade wherever and with whomever they pleased. Fueled by economic necessity, the mariners of the young republic now eagerly sought out new, untried markets in exotic corners of the world. Ventures into the Mediterranean and Baltic regions were first. Then, in 1785 the nation thrilled to the news of the New York–based ship *Empress of China*'s pioneering voyage to Canton. The Orient was now within their reach, and its people were willing to trade. Soon the race was on, with Java, Sumatra, India, Arabia, East Africa and the South Pacific all, like China, receiving regular visits from Yankee traders.[48]

In the scramble to trade with the Far East, complete with its unpredictable market fluctuations and intense competition, each American port involved sought to carve out its own particular niche. Nearby Boston would send her vessels on voyages round South America, collecting pelts and furs in the Pacific Northwest to trade in Canton for spectacular profits while Salem, Massachusetts, chose to focus upon the Sumatran pepper trade and

the Indian subcontinent. Gloucester's merchant households would set sail for Marseille, Malaga, Antwerp, Rotterdam, Amsterdam, Riga, Kronstadt and Saint Petersburg, looking for that ideal market in which their small town could stake *her* claim.[49] By 1789 there was enough foreign trade going on in Gloucester Harbor to attract the attention of the Federal government, which promptly installed a customs house in the township, expressly for the levying and collecting of duties on ships' cargoes.[50]

Smaller than Boston, New York and Salem, and lacking the expansive waterfronts and deeper waters her competitors had been so blessed with, Gloucester never had a chance at becoming a premier Federalist-era port. Despite her mariners' brashness and daring, and despite the successes she was reaping, Gloucester would always prove a distant second when compared to her rivals. Again and again, Gloucester found herself lacking the capital to properly break into and monopolize foreign markets. A loss at sea or a failed venture proved harder for her merchants to recover from. It took them longer to accumulate a cargo that would sell abroad. And no matter how much a successful voyage had gained, her profits were but the scraps neglected by her stronger neighbors who were constantly crowding her out.

That was, until 1790. For in that year the industrious visionary Colonel David Pearce would send a vessel to the port of Paramaribo (or, as it was then popularly known, Surinam), capital of the colony of Dutch Guiana, located along the northeast coast of South America.[51] Here Gloucester found her monopoly, exchanging salt hake (along with beef, pork, lard and flour) for coffee, cocoa, tropical fruits, sugar and, most importantly, molasses, which Gloucester would then turn into rum and re-sell in America and Europe at great profit.[52] Ultimately it was no different from the trade Gloucester had enjoyed with Britain's Caribbean plantations before the war. And as before, Gloucester reaped huge dividends. One Gloucesterman remembered:

> *Much Dutch plate* [silver]*, mostly old, and a great deal of specie went from Holland to Paramaribo in trade, and our Gloucester goods sent to Paramaribo were often paid for in part with this plate and silver, though sometimes with gold plate and even jewelry. I remember seeing…men pushing wheelbarrows of specie or lugging a sailor bag of plate up Short Street.*[53]

Fishing from late spring to autumn, Gloucester's sailors would, with the mounting chill of winter settling in around them, load brigs and ships with the salted fruit of their summer labors and set sail southward, arriving after a voyage of fifty some-odd days in Paramaribo.[54] There, amidst the color and show of that exotic tropic, with sultry airs and the babble of many strange tongues swirling about them, they would sell their cargoes dockside, engaging in barter either privately or in public auction.[55] Tamarinds, plantains, oranges—foods the likes of which they had never tasted, flavored with aromatic spices, were theirs to enjoy, while even the lowliest cabin boy could take home some delftware as a souvenir, or perhaps a monkey or parrot for a pet. Leading this double existence, Gloucester's humble men of the sea would secure a quality of life for their families and neighbors better than anything they had ever known before.

As well, they would be exposed to the wonders of a larger world, eroding their New England provincialism with every successful trip. Many prospered. More than a few became truly rich. And even for those who did not ride the wave, the blessings this trade bestowed upon the town would trickle down to them, enriching the daily living of one and all.

One class that apparently prospered indirectly from this trade was that of the artisans. The merchants and sea captains of Cape Ann were not above ostentatious displays of their newfound largess. In fact they readily sought to memorialize themselves and their achievements, sparing no expense while (as they had done before the Revolution) turning to the greatest American artists of their time. "No town of equal size gave Copley more commissions than Gloucester, the wealthy people of the place patronizing Stuart as well."[56] In his diary, the celebrated Reverend William Bentley of Salem, Massachusetts, detailed his trips to the nearby Cape, and so left for us an eyewitness account of how prosperity was supporting many an artisan there. In a passage dated April 5, 1792, Bentley records a visit with, among others, Colonel David Pearce:

> *Breakfasted with Col. Pearce, & after breakfast went with him to see his Spermaceti works, his distillery, and the numerous artisans whom he employs…We then went to Mr. Beach's…In the mansion, which I have repeatedly visited, we have in the great entry & chambers elegantly in frames & glass all the representations and cuts of Cooke's Voyages, besides a full portrait of Capt. Beach upon an eminence, with a painting of the death of Hector. At the Father's we have an Italian view taken from a painting in the Pamphili palace at Rome, richly coloured.* [57]

As to what effect growing up amidst the frenetic activity and aesthetic glories of a global trade port had on Fitz Henry Lane, it would seem a safe bet to say much. Lane was growing up at a time when everyone, in one way or another, went "down to the sea in ships." His own family was tied in with the town's mercantile pursuits. His father was a sailmaker, and his brother(s) were taught the navigational arts. To the young Lane, the Gloucester waterfront was a scene filled with excitement and engaging vistas—brigs, barks and schooners raising sail and weighing anchor, stevedores piling goods upon the crowded wharves while customs inspectors weighed, measured and assessed them, the groan of pulleys hoisting casks of rum, the rumble of cart and dray piled high with produce. That the youth of Gloucester were fascinated by and gravitated toward this wharfside spectacle is no secret, as the late Alfred Mansfield Brooks plainly attested to in his memoirs:

> *Another excitement for small boys and boys not so small was to go to the old Fort and watch the Surinamers take out their first unloading onto barges in the stream.*[58]

Lane was surely no exception. With sporadic schooling being the norm for his time, and a handicap that excluded him from not only play but also from many of the manual chores a child would be expected to perform, Lane was left no other choice than to bear witness to the pageantry of the harbor. His youthful mind, as precocious, inquisitive and imaginative as

any other child his age, would have sought stimulation, eagerly seeking to probe and explore his environs. And where his legs failed him, his eyes and hands took up the slack. His paralysis undoubtedly forced him to turn to more sedentary pursuits (such as drawing) and afforded him the opportunity to witness all the romance and beauty of his town for however long he pleased.

Gloucester Harbor was his first classroom, and the testimonies of his contemporaries and many scholars confirm his skill. "His vessels and other marine objects were perfect portraits."[59] "Lane was a stickler for detail and he literally knew his ropes. No one has found a spar or rigging mistake in his paintings."[60] "His pictures delighted sailors by their perfect truth. Lane knows the name and place of every rope on a vessel; he knows the construction, the anatomy, the expression—and for a seaman everything that sails has expression and individuality—he knows how she will stand under this rig, before this wind; how she looks stern foremost, bows foremost, to windward, to leeward, in all changes and guises."[61]

Statements such as these acknowledge the tremendous realism and detail Fitz Henry Lane would exhibit in his compositions as an adult. Marine artists abounded in the port cities of the world during the mid-nineteenth century, providing ship portraits aplenty to sea captains and merchant princes. Lane stands above them in his attention to detail, surpassing all but the best of his contemporaries (of whom he stands among as equals).

It appears that Lane's first artistic endeavors unfolded in his father's sail loft. John Trask remembers, "When a child [Lane] was taken into his father's —? —shop and having red and white chalk he drew upon the floor vessels etc."[62] It is possible that Lane received instruction, to one degree or another, in the trade of the sailmaker, which would explain his incredible skill in accurate portrayals of sails and their rigging. Lane's parents, by seeking formal instruction in the nautical arts for their son Edward (and the possible other son, Steven) demonstrated a desire to give their sons a specific marketable trade with which to build a career upon. The absence of Lane's name in the ledger of Master Moore is no surprise, given how his handicap would have prevented him from pursuing a seagoing vocation, but the choice of the sailmaker's trade would have been a logical one for Lane, as it is sedentary by nature, involving long hours of sewing and stitching while seated upon a workbench. As well, work within a sail loft was roundly considered to be the most prestigious of the waterfront trades. For his parents, it would have been a good choice in an otherwise bleak situation. That Lane's older brother Edward followed in their father's footsteps and became a sailmaker himself establishes a precedent within the family, one that Fitz Henry could easily have partaken of as well.[63] In addition, previous to his career as a lithographer and artist, Fitz Henry Lane toiled as a shoemaker, another job that involved sewing and stitching while seated atop a workbench.[64] In fact, the skills needed for sailmaking readily lend themselves to shoemaking.

As an adult Lane would undeniably have access to sail plans via his older brother Edward. And through personally cultivated connections along the waterfronts of Gloucester and Boston, Fitz Henry could easily have gained entrance to mold lofts and the blueprints of shipwrights. Many of his surviving sketches, given their deft handling of hull forms—even beneath the waterline—support this notion. [See figure 2.] His handling of the subject matter runs parallel to the thumbnail sketches of contemporary naval architects,[65] and the

many seafaring patrons who in later years commissioned Lane to portray their watercraft on canvas would have granted him up-close access to their vessels.

Within a leather-bound book of sail plans amassed by a William Fuller Davis, dated 1845 and found in the archives of the Cape Ann Historical Association, we find a sketch most extraordinary.[66] Page after page in the drafting book sports nothing more than flat, two-dimensional, technical schematics for the construction of sails—little more than geometric forms used to calculate the required square footage of canvas for a client's vessel. But one page stands out among all others. Where other diagrams terminate in blank page, this plan finds itself with a crisp depiction in pencil of a "sharpshooter" fishing schooner. [See figure 3.] While its creator failed to sign or initial the work, its smooth lines and graceful curves—all executed freehand—readily reveal the artist to have been thoroughly trained in draftsmanship (as Fitz H. Lane was known to be) and more than familiar with naval architecture. Not a technical illustration by any stretch, the piece strives for a realism of the sort that denotes an artist's eye. Even its precise shadowing and the manner with which the vessel sits amid rippling water are skillfully captured. A nearly identical schooner appears in Lane's *Gloucester Inner Harbor*, ca. 1850 [plate 5]. In addition, the wife of the owner of the sail plan book was a known patron of Lane's, lending even further assurance to the identity of the sail plan sketch's author. If indeed Lane was responsible for this sketch, it is a direct testimony to his association among sailmakers, being granted access to their plans and permitted to study and learn from their labors. As well, the accuracy with which the schooner's hull is depicted, even down to its trailboards and billet head, [see figures 4 and 5] attests to Lane's being privy to the designs and techniques of naval architects.

While Lane made good use of sail plans, mold lofts and close-up access to vessels, there is something more afoot here. To depict a vessel faithfully enough so as to pass muster with the discriminating eye of a shipowner is one thing, but to accurately portray with such a high degree of exactitude how they move through the water, the particular way wind fills their sails, the manner with which waves rise and fall and how light plays off them, and the cloud forms passing over on high requires an early, meticulous and thorough exposure to the ocean itself. Lane's *Three Master in Rough Seas*, early 1850s [plate 31], may be the perfect example of this and stands as a tour de force of the artist's abilities to accurately depict a ship's sails, rigging and movement, the water through which it moves and the atmospheric effects of a storm at sea. Lane's sure hand betrays that his knowledge of the sea, its many moods and those vessels that sailed across it, was ultimately of an instinctual nature, gained only by countless hours of observation and recording, each sketch gently and consistently training his hand and honing his skill through his developmental years.

Additional evidence of this early and comprehensive association with the water's edge is to be found in the foreground activity of Lane's compositions. Never do we find the figures in the foreground to be merely taking up space. Rather, as found in works such as his *Gloucester Harbor*, 1847 [plate 4]; *The Fort and Ten Pound Island, Gloucester*, 1848; and *Gloucester Harbor*, 1852 [plate 7], each individual is engaged in a task pertinent to the waterfront. For an artist unskilled in the comings and goings of a seafaring community, inconsistencies would readily emerge between

what the figures were doing and where they were situated. Simply put, such an artist would not understand nor be knowledgeable in the functions of a port, and thus would inaccurately depict a fisherman or a shipwright at work, if they even chose to include them at all. Tools would be improperly wielded, the wrong gear would lie beside a boat and vessels would be offloading commodities they were never meant to transport. Not so with Lane.

In his *Gloucester Inner Harbor*, ca.1850 [plate 5], we see in the foreground, front and center, a boat called by nautical historians a "New England Boat," and colloquially known as a "double ender," her gear offloaded and the ritual of processing her catch having begun. In this painting Lane freely exhibits his sure knowledge of the fisherman's profession, for everything is *exactly* as it should be. To begin, it would seem the artist is familiar with some of the fisherman's "tricks of the trade," in this case, how a fisherman dries his nets by hanging them in the boat's rigging. The net itself is not generic by any means. Close inspection reveals it to be a gill net, a particular type employed close to shore, in shallow coves and bays. It is a rather opportunistic way to catch fish, the floats along its top suspending the net like a curtain in the water, catching any fish small and unfortunate enough as to get its gills stuck within the mesh. (See plate 7 *Gloucester Harbor*, 1852, for an example of a gill net in use.) The pile of tackle to the left beside the boat is not generic either. Instead we find among the coils of rope and anchor two longlines, a particular technology already over two hundred years old by the time Lane made this painting, used specifically to ensnare cod. Cod by their nature are bottom feeders, and in 1850 were still to be found plentifully along the New England coastline, fairly close to shore. The gill net and longlines relate perfectly to the double ender. This particular type of vessel was designed specifically to fish banks and ledges close to shore. Fast, light, maneuverable and easily handled, it was never meant to venture beyond the inshore fishing grounds. The tools being exhibited are those of coastal fishermen seeking groundfish, and a glance toward the man hunched over the washtub immediately right of the boat reveals that this is exactly what they have caught. The fish he is presently gutting and washing are indeed cod, as evidenced by the fish heads strewn about nearby, and a flounder's tail can be seen sticking up out of the bucket to the right of the tub. Thus boat, gear and fish all agree with one another completely, executed in a manner so casual and carefree as to convince the viewer that Lane had known scenes like this since his earliest days. An artist unfamiliar with this subject matter, even if he was painting it as he saw it right before him (which Lane was not, given what we know of his painting habits and his preliminary sketch for this work, *View in Gloucester Harbor*, 1850s [figure 6]), would have failed at one point or another in the creation of such a piece. Key details would have either been glossed over or neglected outright. A hull form incongruous to the activities, gear and accoutrement might have been chosen instead. Perhaps the boat would have been portrayed tied up to a spacious wharf, most unlikely for a vessel of this type, rather than sitting ingloriously in the muck of low tide. Instead, we find the work of a man who thoroughly understands what he is depicting, and executes his portrayal flawlessly.

In the search for the roots of Lane's artistic career we need look no further than the wharves of Gloucester. For it was here that a little boy with an eager mind and a proclivity for drawing found the subject matter that would become his life's work.

Chapter 3
First-known Works
and First-known Employment

In the three decades since the Revolution's conclusion, Gloucester, that hard-bitten community of fishermen wedged between granite ledges and an unforgiving sea, had truly prospered. Where simple cottages had once stood, fine houses of the merchant elite now reigned. Wharves that had only known the stink of fish now breathed with the aromatic scents of exotic spices and produce. A harbor that had sheltered only humble ketches, sloops and schooners before, now opened wide its arms to grand brigs and ships aplenty. Her provincial streets now hummed with a more urbane tune as artisans and the treasures of many a foreign land lent a taste of the modern and the sophisticated, elevating her people to a state of refinement undreamt of a generation before.

Unfortunately, this affluence was not to last. Events unfolding on the other side of the Atlantic in the 1790s were soon to involve the young American nation, and no port would prove immune. Europe was afire. France, writhing in the painful throes of its own revolution, had threatened to engulf the world with its rabid Jacobinism, and with the joint decision of Prussia, Austria, Holland and England to crush the French revolutionaries, that which was most feared had indeed happened.[67] Full-out war erupted on the Continent, and for American mariners, their country's flag would offer scant protection.

The United States saw itself as being above the fray, a neutral carrier free to trade with both of the prime antagonists of the Napoleonic Wars. Great Britain and France did not agree, however. A shipment to an enemy was an act of aid, no matter its point of origin or the flag under which it sailed, and consequently American ships were deemed fair game, suffering illegal seizures and unprovoked attacks aplenty. Events would come to a head on June 18, 1812, with the United States Congress formally declaring war on Great Britain. For Cape Ann, conflict with the world's reigning maritime power could only bring misery, as attested to by Gloucester's Gorham Parsons Low:

The war with England (1812–1815) caused great distress and poverty in the town and when I should have been at school I was watching the enemy's men-of-war which were constantly in sight from our shores and we were frequently alarmed by them. In June 1814, I followed a crowd of militia men to Wheeler's Point to drive off a barge, sent from an

English frigate in Ipswich Bay to destroy a sloop. When we arrived the crew of the barge had set the sloop on fire and were on their way back to the frigate and all we had to do was to look on and see the vessel burn.[68]

As her merchants had feared, the War of 1812 proved to be a disaster for Gloucester, disrupting the fisheries, nearly eradicating her foreign commerce and plummeting the township into an economic depression that would last for decades.[69] The affluent, bold, exciting Gloucester of F.H. Lane's early childhood had fallen into the lassitude of economic depression and stagnation, a languor that would keep the town held fast in its iron grip until the 1840s. Given his father's profession, it is obvious that the Lane family's situation was anything but comfortable during these tense years. Fitz would have been growing up in a household intimately familiar with want. As well, it would be a household intimately familiar with war. Lane had surely heard neighbors and veterans spin tales of valor from the last struggle against England. Now, as a child of nine, he would hear such tales spill forth from the lips of his own family members. Jonathan Dennison Lane would briefly serve as a private within Captain J.S. Sayward's company of artillery for six days between September 19 and October 29, 1814. Raised and stationed in Gloucester, this unit would see combat, participating in the repulse of a large British raiding party in Sandy Bay.[70] We find the name of Fitz's (probable) oldest brother Steven appearing within the militia rolls (listed as Stephen Lane) as a private within Captain B. Haskell's detached company, serving at Gloucester from June 21 to September 18, 1814, and again from September 21 to November of that same year.[71] As well, it is most probable that the young future artist was privy to more than just the accounts of others. Like Gorham Parsons Low we can easily imagine Lane "watching the enemy's men-of-war," perhaps from atop the old fort, the site where so many local youths observed the comings and goings of the harbor in peacetime.

The post-war years would not be kind to the Lane family. On April 28, 1815, (probable) oldest son Steven was laid to eternal rest.[72] Little more than a year later, Lane's father would follow, passing away on November 19, 1816, after a bout with fever,[73] leaving wife Sarah to raise and provide for their three remaining children alone. As to how she would support herself and her children in the face of such daunting circumstances, we know that she sought to reduce the family's expenses by being declared exempt from taxation, as by 1820 the town of Gloucester would elect to not tax Mrs. Sarah Haskell Lane, citing that she "supports a lame child / ought not to be taxed."[74] The family also moved out of their prosperous Middle Street house and took up quarters in the humbler "old Whittemore house"[75] along plebian Washington Street. Yet contrary to the claim "the family sold the house on Middle Street,"[76] after Lane's father died, we know the family to have still been in ownership of their Middle Street property until the year 1830, when older brother Edward bought out his brother's and sister's claims to the property for the sum of $400.[77] Herein is how Sarah Haskell Lane probably derived an income. By retaining their Middle Street house, Sarah would most certainly have rented out the property, and

with the rent she would have gained from this property, located in what was still the most fashionable neighborhood in Gloucester, she could have afforded to pay the rent for living in the Whittemore house while still having some left over to support her family. Such an arrangement would have by no means been lucrative, proving instead to be one of mere basic subsistence.

Living in hardship probably did not shed any social stigma upon the young Nathaniel Rogers Lane, considering the widespread destitution to be found on Cape Ann just then. Financial troubles would have been a problem familiar to many a neighbor. And given his young age, the family's sudden fall from affluence was probably not nearly as distressing as it would have been had he been an adult. On the other hand, having lost his father and oldest brother in such rapid succession surely had an effect upon the now eleven-year-old boy.

For a young man paralyzed from the waist down, coming of age at a time of economic depression, Gloucester offered scant promise of a prosperous future. To gain an understanding as to just how great the depths of this depression were for Cape Ann, we turn to the following extract from a letter penned by Amanda Stanwood of Gloucester, written to her brother Captain Richard Stanwood:

May 20, 1833

Our town is in a truly deplorable condition. No business whatever doing. All the storekeepers are entirely discouraged; they do not sell a cents worth sometimes from Monday morn till Saturday night. They say the place never was known to be so dull before and if something does not take place soon for their advantage, they must move away. W.E.P.R. has been down to Bangor, and has given such a lively description of the place and the immense business carried on that several [are] *interested* [in] *going there. He will move there himself the middle of June and will issue his first paper the first of July…Solomon is completely discouraged; he says he must go somewhere, he cannot think of staying here.*[78]

As to how Lane faced such bleak prospects while engaging in a search for his place in the world, John Trask remembers that "at about fifteen [Lane] was apprenticed to one Haskell to learn a shoreworkers trade."[79] Lane's nephew Edward also describes Lane's early apprenticeship: "Before he became an artist he worked for a short time making shoes, but after a while, seeing that he could draw pictures better than he could make shoes he went to Boston and took lessons in drawing and painting and became a marine artist."[80]

The occupation of a shoemaker was not by any stretch an odd pursuit in Lane's time. By the 1820s, Massachusetts was well underway in making its transition from commerce to industry, and included in that shift was the manufacture of shoes. Shoemaking took root naturally enough in the destitute fishing ports along the coast, providing employment for the legions of fishermen, net menders and sailmakers who found themselves generally without work, especially in the wintertime.[81] This, combined with the particular demands

of their chosen professions (nimble fingers, strong hands and tough-as-ox-hide calluses), made these men ideally suited for such toil.

While working as a shoemaker, Lane continued to work at his art, developing and honing his natural-born, self-taught talent. Evidence for this may be found in his earliest known work, *The Burning of the Packet Ship "Boston,"* 1830 [plate 2], a watercolor portrayal derived from a sketch drawn by Elias Davis Knight, citizen of Gloucester and first officer of the *Boston.* Bound for Liverpool, England, with a hold full of cotton, the *Boston* had the rather dramatic misfortune of being struck by lightning at around eleven o'clock on the evening of May 26, 1830, the ensuing conflagration as depicted by Lane consuming the ship in its entirety. Quite reminiscent of what one finds in Japanese woodblock prints, the piece offers the viewer a decidedly Oriental feel, especially in its portrayal of ocean waves. That this painting can be dated to the year 1830, and that it is the product of a self-taught artisan, untutored in the techniques of the painter's trade, is established by a personal correspondence between first officer Knight and a Mr. Joseph L. Stevens Jr., close personal friend of Lane's in later years, written thirty-nine years after the incident:

> *Agreeable to your request that I would write something to attach to the picture in your possession of the Burning of the Packet Ship Boston in 1830, your object I suppose is to establish the fact that it is really one of the early productions of our fellow townsman and afterward most distinguished Artist Fitz H. Lane.*
>
> *The picture was drawn the same year by Mr. Lane from a sketch I made soon after the disaster aided by one of the passengers S.S. Osgood, Esq. afterward a distinguished portrait painter. Mr. Lane had made no pretention [sic] of course at this time as an artist and probably had received no instruction.*[82]

Thus *The Burning of the Packet Ship "Boston"* serves as an invaluable window into the raw, unrefined skill Lane had developed by his own hand. While possessing the overall texture of an amateur endeavor, the piece is remarkable in its sense of depth, light, proportion and attention to detail, making it a surprisingly competent composition indicative of the promise Lane held at twenty-six years of age.

Its stylistically Asian waves reveal that the artist was more than likely exposed to Japanese woodblock prints. This is not the impossibility some authors have claimed in previous tomes dedicated to Lane, sporting statements such as "Lane, of course, did not have such images in his mind when he undertook this watercolor."[83] American vessels, chartered by the Dutch East India Company, visited Japan briefly between the years 1799 and 1801. Though sailing for the Dutch, private trading adventures were permitted for the American officers onboard, and so the first trickle of Japanese goods made their way to America.[84] Given that ships from nearby Boston and Salem did the majority of these chartered cruises, it is possible that Japanese articles made their way up to Gloucester via coastal and overland trade. Even more likely, though, is that Japanese woodblock prints found their way to Gloucester via Surinam. The Dutch were the sole nation permitted

to trade with Japan for almost two centuries. It is well documented that many old Dutch wares made their way to Paramaribo in trade, and from thence traveled to Gloucester as part of payment for goods.[85] In the global trade the Dutch practiced, it is quite likely that Japanese art and artifacts traveled first to Surinam, then Gloucester, where they could have served to inspire and instruct the eager Lane in Asian artistic aesthetics.

As well, Lane's earliest recorded watercolor informs us that he was already enjoying close associations with mariners of station and means, circulating among those types of individuals who in later years would be his patrons. It was no mere happenstance that Lane came upon Knight's sketch of the incident. Rather, his being privy to the sketch, as well as First Officer Knight's being familiar enough with Lane's career at the time of the watercolor's genesis so as to comment upon it, reveals to us that Lane was an associate of the local maritime social circle and taken into its confidence.

And yet, in viewing *The Burning of the Packet Ship "Boston,"* questions remain. Many have wondered if indeed Lane *had* received previous instruction, at least in the rudimentary basics of drawing. The possibility that he was taught the fundamentals of artistic composition as a child in school seems rather remote, given that it would not be until the last third of the nineteenth century that America's public schools would begin to offer art instruction, with Massachusetts consenting to such in 1870 (yet only in municipalities of more than ten thousand inhabitants).[86]

Another possibility that has been put forward is that Lane instructed himself with the aid of drawing books. Offering rudimentary lessons in the techniques needed to sketch competently, these mass-produced volumes were instrumental in educating novice Americans in symmetry, balance, shadowing and perspective. That everyone from school children to folk artists to ladies of refinement employed these tools of self-learning is well testified to, and Lane may have done the same.

If indeed Lane used drawing books, the extent to which he did cannot be ascertained. It has been noted how the elevated perspective employed in his *View of the Town of Gloucester, Massachusetts*, 1836, mirrors principles that British drawing books of the late eighteenth century advocated.[87] However, drawing books did not begin to come into vogue in America until the 1840s, when Lane was already an accomplished artist. Even the immensely popular *Lucas' Progressive Drawing Book* did not make its debut until 1827, fairly late in Lane's preliminary artistic development. As well, these texts were so generalized in their lessons that Lane would have gathered little useful instruction beyond the basics of drawing, with none of the "hard" lessons needed to take his skills beyond those of the amateur and into the realm of the serious marine painter.

What seems far more plausible, given both his early familial connections with the Gloucester waterfront and his ultimate career as a marine artist, is that rather than turning to conventional drawing books, Lane instead consulted with late eighteenth- and early nineteenth-century literature on ship design, such as *Short and Plain Principles of Linear Perspective*, by A. Cobin; *Architectura Navalis Mercatoria*, by Fredrik Henrik Chapman; *The Elements and Practice of Naval Architecture*, edited by David Steel; *Sixty Five Plates of Shipping*

and Craft, by Edward William Cooke; and various lithographed "picture books" by Samuel Prout and W.M. Grundy (possibly a pseudonym used by Prout).[88] Such publications would have been plentiful and easily accessible along the Gloucester waterfront, offering Lane compositional tips key to producing the masterful renderings of naval craft he would one day be noted for. Within their pages numerous plates illustrating the perspective drawing of hull forms, including how a ship moves through water, were found [figures 7 and 8]. Some of these publications even went so far as to include artists in their intended audiences, as we see in the publisher's preface to the fourth edition of A. Cobin's *Short and Plain Principles of Linear Perspective*, where the publisher describes the book as being "a study equally necessary both to the general painter and the naval artist."[89]

We know that other marine painters contemporary to Lane, such as William Bradford, trained themselves in the basics of the craft by employing texts such as these,[90] and furthermore, we find Edward William Cooke, author of *Sixty Five Plates of Shipping and Craft*, to have been an artist himself.[91] His instructional work, rather than featuring guidance in the traditional maritime themes of "naval engagements, sweeping port vistas, and formal vessel portraits,"[92] focused instead on the everyday comings and goings of the working waterfront—themes that Lane would celebrate again and again.

The Burning of the Packet Ship "Boston" remains to date the earliest known confirmed painting by Fitz H. Lane. Yet recently, celebrated maritime historian and expert on the work of F.H. Lane, Erik A.R. Ronnberg Jr., has brought to light the existence of another watercolor possibly executed by Lane while still an untrained, untutored painter. [See plate 1.] Possessing neither a title nor an artist's signature, the piece has spent many a year hanging in anonymity upon the walls of the Cape Ann Historical Association of Gloucester, Massachusetts, eliciting the interest of passersby, yet offering no clues as to its creator. The watercolor itself is an unfinished skyline view of Gloucester as it appeared between the years 1830 and 1831.[93] The case for this work being an early creation of Lane's falls upon a comparison between certain features within the watercolor and Lane's known sketches. Though this comparison is between one of the artist's (possible) early amateur compositions and his later, more mature work, we see that while not exact, several stylistic similarities are present. First, there is the similar layout between this piece and known Lane works from later on in his life. From his early lithograph *View of the Town of Gloucester, Mass.*, 1836 [figure 9], to paintings executed during his last years, such as *Sawyer Homestead*, 1860 [plate 21], and *Norman's Woe, Gloucester*, 1862 [plate 30], we find present the characteristic hyper-accentuated vegetation and boulders, and the compositional layout of building up the bottom left corner with flora and rock, with the vista unfolding on a gentle downward slope toward the bottom right corner. Concerning those boulders, in his later years Lane would sketch them with an approach most akin to those depicted in the painting in question [figure 10], focusing his attention upon the cracks and fissures that scar these monoliths. And as in his paintings *Sawyer Homestead*, 1860; *Riverdale*, 1863 [plate 22]; *Babson and Ellery Houses, Gloucester*, 1863 [plate 23], and again the lithograph *View of the Town of Gloucester, Mass.*, 1836, we find the walls in this watercolor executed in the same

manner, the artist striving to articulate each and every stone. These factors, combined with a similarity between the sky present in the watercolor and that not obscured by billowing smoke in *The Burning of the Packet Ship "Boston"* (upper right corner), the characteristic minute attention paid to architectural details, the fact that the watercolor in question is pieced together in the same way Lane in later years joined the pages of his sketchpad so as to make large panoramic views and finally the absence of artists residing in Gloucester at that time possessing comparable skill, enhance if not confirm the case for this unnamed piece of art being another early Lane painting.

In the quest to determine when Lane's career as an artist formally began, it has long been maintained that in the early 1830s Lane gained his first meaningful employment in Gloucester as a practitioner of the then-new printing process known as lithography at a print shop named Clegg and Dodge, owned by a W.E.P. Rogers. It has also been claimed that it was through the intervention of W.E.P. Rogers that the Boston lithographer William S. Pendleton opted to offer Lane a job at the Boston-based lithography firm he owned.[94] Unfortunately, a deeper look into this claim informs us otherwise. Only one source contemporary to Lane testifies to his having ever worked at an establishment named "Clegg and Dodge," that being John Trask:

> *Later he worked for "Clegg and Dodge," Sea Street, now Hancock Street. and* [sic] *at that time Mr. W.E.P. Rogers who became interested showed Mr. Pendleton of Pendleton's Lithographic Establishment a drawing which Mr. Lane made of the Universalist Church and Yard.*[95]

From Trask's account it becomes apparent that "Clegg and Dodge" was not the actual title of the business, but rather a colloquial term used by locals familiar with the operation. Nowhere does Trask make the claim that "Clegg and Dodge" was a lithography shop; in fact, he never states what services the business rendered. In addition, Trask never identifies W.E.P. Rogers as having any connection to "Clegg and Dodge," let alone owning the business.

The Museum of Fine Arts, Boston, the Metropolitan Museum of Art, New York, the Library of Congress, the American Antiquarian Society and the Boston Athenaeum— institutions that have comprehensive, in-depth collections of nineteenth-century American prints—are all in agreement as to there being no known lithographs in their respective collections published by a Clegg and Dodge of Gloucester, Massachusetts, or by any lithography shop located in Gloucester in the 1820s and '30s. That Gloucester did not play host to such a business is not a surprise; lithography was an art form then in its infancy in America. Having arisen in Germany in the late 1790s, by the mid-1820s only two American cities, New York and Boston, possessed viable lithographic workshops.[96] While in a few years Baltimore and Philadelphia would have effective workshops in operation as well, it would not be until mid-century that the art form was to be found widespread across the nation.[97] That Gloucester, a fishing village then in the midst of an economic decline, with her citizens moving away in search of job opportunities, should have played

host to an experimental form of mass media is simply implausible. The investment would have proven beyond the means of her economy, and even if funding did exist, the risks inherent with investing in an unproven technology with no local market would have been too perilous for her citizenry to seriously contemplate.

And lastly, while a Mr. W.E.P. Rogers of Gloucester did exist, we know from Amanda Stanwood's letter quoted above that he was a newspaper printer, *not* a lithographer. ("W.E.P.R. has been down to Bangor...He will move there himself the middle of June and will issue his first paper the first of July."[98]) Since newspaper printing employed a set of skills incompatible with lithography, employment within Mr. Rogers's print shop (though no proof exists claiming Lane ever worked for him in *any* capacity) would not have benefited Lane in regard to his future career as a lithographer. Most likely, "Clegg and Dodge" was the name of the shop where Lane briefly plied the shoemaker's trade, as we find a John B. Dodge of Gloucester's Magnolia Village listed in 1873 as being, of all things, a shoemaker.[99]

In the search for when and where the future marine painter received both his first meaningful employment as an artist and his first formal training, the historical record informs us that, rather than unfolding within the confines of a lithography shop that never was in a dead-end port called Gloucester, Lane would arise from anonymity as an apprentice inside the nation's most prestigious lithography shop, thirty miles to the south, in another port town just then beginning to be known the world over as "the Hub."

Part II: Days in Boston

*Boston commands special attention as the town which was appointed by
the destiny of nations to lead the civilization of North America.*
—Ralph Waldo Emerson

Chapter 4
America's Athens

The artistic career of Fitz H. Lane can be divided into three separate and distinct epochs. The first of these stretches from the inception of his training as a lithographer in 1832 to the departure of the British marine painter Robert Salmon from Boston in 1842. The second involves Lane's emergence as a painter of port scenes and master of ship portraiture, falling within the years 1842–50. And the third and final period, his time as a port and seascape artist and master of a style modern scholars have chosen to label "Luminism," unfolded starting in the year 1850 and continued until his passing in 1865. Yet without the city of Boston, Massachusetts, none of this could have happened. For ultimately the events, philosophies, tutelage and personalities responsible for shaping and honing both Lane's artistic skill and his artistic vision all have their roots within that one city.

In comparison to Gloucester at the time, no greater collection of opposites could be imagined. National center of industry and commerce, home to America's most celebrated authors, architects and inventors, the port city of Boston was at that moment experiencing the excitement and wonderment of a true renaissance, no less powerful and far reaching than that which had flowered in Italy four centuries earlier. Advancements in medicine, engineering, religion and philosophy were flourishing within Boston's precincts, nourished and encouraged by a revived network of global trade and a longstanding tradition of intellectual curiosity.

Not unlike Gloucester, Boston's merchant-mariners had suffered in the aftermath of the War of 1812. Trade missions ceased abruptly and commerce stagnated within her mighty harbor no differently than in any other port. Yet unlike Gloucester, Boston would not linger in the malaise of another post-war depression. Rather, she would emerge even stronger than before, achieving gains undreamt of at any time previous in her history.[100] The key to jumpstarting Boston's economy had been the recognition of where new business opportunities lay and investing accordingly. And for Massachusetts, those new opportunities lay within industrialization.

The Industrial Revolution, that rapid and sudden advancement in the realms of manufacture, transportation and agriculture, had originated within England during the latter half of the eighteenth century.[101] By the early 1800s the inevitable spread of such

innovation had already reached New England, where a population with their own long history of mechanical inventiveness eagerly adopted the latest labor-saving concepts coming out of Britain and established America's first manufactories. The War of 1812 had actually proven to be a boon to the fledgling manufactories of Massachusetts. The call to supply the necessities of the nation's military (as well as her citizenry, denied access to the goods normally provided by merchant vessels) had thrown desperately needed funds into her industrial ventures at the exact moment when investment was most essential. And with the war drawing to a close, visionary Bostonians "prepared against peace" by investing capital gained both from pre-war trade and wartime production into the nation's first complete cotton factories.[102] Overnight, military manufacturing was successfully converted to the production of items for the civilian market.

Inevitably, this move toward domestic manufacture would have a far-reaching impact upon the state's maritime communities, forcing an increasing shift "from wharf to waterfall."[103] Before 1812, the nation's merchant fleet had set sail for distant ports in the quest to obtain merchandise not found in America. From fine silks, Madeira wine, Chinese teas, coffee and exotic spices, to such basics as nails, cheese, hemp rope, cotton, soap and tin wares, America's merchant-mariners were the means by which the country at large obtained the necessities for living. Industry had merely existed to serve the needs of shipping in the guise of sailmaking, lumbering, distilling and shipbuilding. Now, as Massachusetts led the nation forward in self-sufficiency via industrialization, shipping would increasingly serve the needs of industry, with watercraft being reassigned to bringing New England's manufactured goods to the rest of the country, and the world.

Wealth flowed into nineteenth-century Boston at a rate unprecedented in her history. From the textile mills of the Merrimack River to the factories along her South Bay, she provided the nation and the world with the fruits of an industrial revolution that had been born right in her own backyard. Daring mariners equipped with the best offerings shipwrights of the time could provide carried her wares to the farthest corners of the earth. By mid-century Boston was the richest city her size in the world—"a metropolis of wealth and refinement."[104]

But such largess was not just for spectacle and show. Rather than being squandered on idle opulence, the patrician fathers of Boston would choose instead to invest this prosperity into their community, and in so doing nourished and fostered an intellectual revolution that has since come to be known as "The New England Renaissance."

Perhaps no better example of this phenomenon can be found than within Boston's Colonel Thomas Handasyd Perkins. Having begun his career as a lowly apprentice clerk in a retail establishment, Perkins would in time build a fortune greater than one million dollars by partaking in the China and Baltic trades and investing in mines, quarries, theatres and hotels, as well as finding the time to serve eight terms in the United States Senate. Not above the smuggling of slaves and opium, this ambitious, complex man would prove as generous as he was shrewd, financing charities and cultural institutions aplenty. The Bunker Hill Monument (upon completion the tallest edifice in North America and

herald of a brave new age of technology and growth),[105] the initial drive to fill in the Back Bay (the single largest engineering feat in the world until the building of the Panama Canal), Massachusetts General Hospital (site of numerous medical innovations, including the modern world's first use of anesthesia during surgery), the Perkins Institute for the Blind (alma mater of Helen Keller and the nation's first school dedicated to providing blind children with a comprehensive education) and Boston's Museum of Fine Arts were just some of the projects he funded—projects that would establish Boston as a world leader in the arts, engineering, medicine and social reform.[106]

Perkins was not the sole philanthropist Boston sported, being in fact just one of a large assortment of affluent, altruistic businessmen. It is clear, then, how that city's material prosperity directly translated into a renaissance of science, technology and thought. Yankee mariners were naturally curious about the greater world beyond their shores that global trade had opened up to them. Profits gleaned from this trade gave rise to a leisure class with the time and the means to concentrate upon topics beyond the everyday. The hospitals, museums and colleges they founded and funded attracted many of the brightest minds of the time. And perhaps most significantly, by being a crossroads of waterborne trade among so many nations, Boston was opened to a host of foreign perspectives and attitudes much in the same manner as ancient Athens and Renaissance Venice. In the words of Bostonian Ezra S. Gannett:

> *Every packet ship…brings…the thought and feeling which prevail there, to be added to our stock of ideas and sentiments. We welcome each new contribution. We read and reprint foreign literature, we copy foreign manners, we adopt the…rules of judgment which obtain abroad. This is natural. It is foolish to complain about it.* [107]

Consequently, antebellum Boston (with collaboration from nearby Salem) became the birthplace of both a new faith (Unitarianism) and the American nation's first true philosophical movement (transcendentalism), as well as witnessing the emergence of a host of causes spawned by these two powerful new forces. Abolition, temperance, education reform, prison reform, child labor laws and the issue of treatment and care for the mentally ill were but a few of the movements that crowned the hour. The streets of Boston were rife with poets, reformers and idealists: Ralph Waldo Emerson, celebrating the values of nature and self-reliance and calling upon humanity to experience the divine as they—not church dogma—saw fit; Dorothea Dix, legislating for the humane treatment of the mentally ill and the rehabilitation of the criminal; Henry Wadsworth Longfellow, writing immortal poems of assurance and comfort amid changing times; Amos Bronson Alcott, rankling the feathers of many a conservative with his controversial Temple School and educational theories; Margaret Fuller, penning feminist treatises; William Lloyd Garrison, calling for the end of America's greatest evil, slavery; Richard Henry Dana, advocate for the rights of merchant seamen; Nathaniel Hawthorne, exploring the very depths of the human soul and finding it to be a chilled land populated by loneliness and Gothic nightmare; Henry

David Thoreau, returning to the wild amid the woods of Walden; Harriet Beecher Stowe; John Greenleaf Whittier; Elizabeth Palmer Peabody; William Dean Howell; William Hinckling Prescott; James Russell Lowell—a veritable galaxy of literary luminaries, their words, letters and lectures firing the minds of a young nation and constructing its national character. Little wonder is it then that Oliver Wendell Holmes would so casually confess, "All I claim for Boston is that it is the thinking center of the continent, and therefore, of the planet."[108]

Such was the seething cauldron of thought, philosophy, affluence and invention into which Fitz Henry Lane entered in 1832. Within that great city, forces and personalities that would come to define him patiently awaited his arrival; with Lane himself unsure as to just how dramatically and thoroughly the Hub would transform him.

Chapter 5
Pendleton's Lithographic Shop

Given the absence of data in support of the claims that "Clegg and Dodge" was involved with the manufacture of lithographs, that Fitz Henry Lane received lithographic training in Gloucester and that he was recruited from this business to work in Pendleton's lithography shop, the question remains, Where did Lane receive his first meaningful employment as an artist, and his first formal training?

Lane's friend, and Gloucester historian, John J. Babson informs us that Lane "showed in boyhood a talent for drawing and painting; but received no instruction in the rules till he went to Boston, at the age of twenty-eight, to work in Pendleton's lithographic establishment."[109]

Indeed, Babson's words ring true. Fitz Henry Lane did in fact enter into apprenticeship at the lithography firm of William and John Pendleton of Boston. But it is less certain exactly how and why Lane came to gain employment within this institution. In the search for answers to these pressing questions, two possibilities emerge. The first, as attested to in a published eulogy to Lane after his passing in 1865, written by someone who chose to identify themselves only as "W." (most likely the *New York Tribune* dramatic critic and Gloucester native William Winter), maintains that indeed Fitz Henry was recruited by Pendleton's:

> *Mr. Lane in his early youth exhibited uncommon proofs of capacity, by drawings of wonderful vigor and truthfulness. These were so admirable, under all the circumstances, that they attracted the notice of the best judges, and among others of Mr. Pendleton, the pioneer of the art of Lithography, who took a generous interest in the young artist, and invited him to Boston, where greater opportunities could be afforded him for study and improvement.*[110]

It would appear that the words of John Trask only support this claim, as "Mr. W.E.P. Rogers...showed Mr. Pendleton of Pendleton's Lithographic Establishment a drawing which Mr. Lane made of the Universalist Church and Yard."[111]

The second possibility is that Lane, rather than being the chance recipient of a windfall through little or no effort of his own, instead methodically and intentionally planned upon

becoming an apprentice at the Pendleton lithography firm, and took the appropriate steps needed to attain that goal.

In order to determine which of these two possibilities holds the answer to our questions, we must first look at the opportunities for artistic instruction Lane would have been afforded in Massachusetts in 1832. Gloucester, still floundering within a post-war depression, simply could not offer him "greater opportunity…for study and improvement" just then. Lean times called for practical, pragmatic skills, and the visual arts were plainly of no use at a moment like this to the people of Cape Ann. Boston, on the other hand, booming with wealth and sophistication, would serve as the perfect place within which to gain a working knowledge of the artist's craft, though not as one would readily expect. For despite the many cultural pursuits of her populace, no formal academy of art would be found within Boston until the last third of the nineteenth century. Thus, to gain training in the visual arts, Lane would have had to turn to another institution: the lithography firm.

Lithography was a new artistic medium to 1820s America, the process having been invented by Alois Senefelder of Germany only a little over two decades before, in 1798. As opposed to intaglio and relief processes, in which the design is cut into the printing block via either a tool or acid, lithography employs the chemical repellence of oil upon water to create an image. The process has four distinct parts: first, the artist draws an image in reverse upon limestone with grease crayons. (One can also paint the image by using a greasy ink.) The stone is then moistened with water, which the limestone absorbs in areas not covered by the grease. Next the artist applies an oily ink with a roller onto the face of the stone. Naturally repelled by the wet parts of the stone, the ink only adheres to the drawn image. The final step is to transfer the image onto paper, which is done simply by pressing paper against the inked drawing. Since the printing and non-printing areas of the plate are both at the same level, the problems inherent with engraving and etching (namely, the dulling of the image lines over time with repeated usage) are avoided. This, combined with the relative ease and inexpensive nature of the process, helped to make it a profitable alternative ideally suited for mass production.

The arrival of this new, low-cost mass media came at a time of dramatic growth for America. As her population centers increased in size and her people poured west into uncharted, virgin lands, Americans were predictably growing curious about their new homeland. From natural wonders such as Niagara Falls and Jefferson's Rock to its busy harbors, emergent cities and towering monuments, the American landscape was now a source of fascination and pride for its inhabitants. The great cities, cathedrals and markets of the Old World, its historic personages and momentous events, so recently introduced to Americans via global trade, called out to their sensibilities as well. Those who could afford to traveled to these sites and witnessed them firsthand, freely partaking of the latest steamboats, coach lines, packet ships and railroads to aid in their pilgrimages.

But tourism was still in its infancy. While surprisingly mobile for their time, the majority of Americans living in the first half of the nineteenth century were nevertheless a provincial

people tied directly to their livelihoods. Whether it was a twelve-hour workday at a mill or the tedium of tending to the family farm, most Americans would never be afforded the chance to leave their home county or state and behold the splendors of their age. This was still a subsistence economy for most.

And yet that burning interest in what lay beyond still needed to be quenched. To satiate their avid desire for knowledge of the outside world, Americans would turn to a host of sources, many of which were carried from town to town by itinerant showmen. Cosmoramas, shadowboxes, dioramas depicting "views of cities and edifices in Europe, and ruins, -and of Napoleon's battles and Nelson's sea fights,"[112] and folk artists specializing in landscapes were but a few of the many ways by which, for a modest fee, one could catch a glimpse of that larger world that teased their curiosity so. Yet lithographs, given their ease of production, consistent quality, inexpensive cost to craft and subsequent low purchase prices and general availability, would become the primary form of visual communication in nineteenth-century America. From scenic vistas to bustling urban climes to architectural marvels and beyond, this art form would become by and large dedicated to documenting the landscape *as is*, capturing every nuance and detail of a subject like a photograph, freezing a moment in time for the edification and enjoyment of the viewer.

The demands of this new process called for competent draftsmen adept at fluent tonal work and freehand drawing, skills that were sorely lacking in the United States just then. Several practitioners of the centuries-old art of engraving were present in America, and would have seemed a ready source for talent if not for the fact that their medium stressed controlled, precise cutting skills rather than freehand abilities, while also having no need for tonality whatsoever. Engravers would ultimately prove unable to apply their training toward lithography. Thus, with an almost non-existent labor pool to draw from, lithography firms would be forced to train their own draftsmen. Such schooling would not fall along the conventional, centuries-old master-apprentice model, since the process was so new to America that no true master of the medium was yet to be found within the country. Litho shop owners themselves could not be called upon to fulfill the master role for, being businessmen rather than artists, they generally possessed scant artistic skill.[113] Rather, instruction would have to take place on the job, with apprentices informally learning drawing skills from their fellow colleagues as they worked beside them.

Little contemporary testimony as to the inner workings of lithography shops has survived into our modern day, but an apprentice's schooling presumably began with the graining of stones, the making of lithographic crayons and the copying of the designs and pictures of others onto limestone. As his talents developed, the apprentice would find himself gradually taking on more challenging tasks, from drafting and composing images (the role of the designer) to ultimately being permitted to draw his own original compositions upon limestone (that most prestigious of ranks within a litho shop, the lithographic artist).[114] Since the compositional techniques employed in lithography differed little from those taught in European academic drawing, and the tonal work so necessary for the process to succeed was akin to that found in painting (indeed, when his studio began in 1825 John

Pendleton specifically sought out painters for employment in his establishment due to their habits of thinking in tonal terms[115]), an apprenticeship within a lithographic workshop like Pendleton's in Boston was roughly equivalent to that offered by fine art academies for beginning students. It even featured the added bonus of being paid while learning precious skills, something that was completely contrary to the experiences of academy students. (Lithographic artists on average made between fifteen to eighteen dollars per week, a substantial income for the times.[116])

Of the few testimonials known to exist detailing an apprentice's experience, that of lithographer Charles Hart, employed at the Endicott shop of New York City, indeed confirms that many of those who entered into apprenticeship had often done so not with a lithography career in mind, but rather as a means of starting an artistic vocation: "There was about the Endicott's establishment an artistic atmosphere…There one could associate with those who, like himself, had aspirations far above commercial lithography."[117]

Hart even goes on to confess how his fellow draftsmen feared they may "relinquish all…high artistic aspirations and settle down to the position of a lithographer, pure and simple, for the rest of [one's] life, and grind out commercial lithographs."[118] Obviously such fears reveal the true motives of these men for seeking employment at Endicott's. Lithography was but a means to an end, a temporary yet necessary step in the pursuit of a formal artistic career.

American lithographic workshops had inadvertently come to serve as impromptu art academies for young men desiring to follow the calling of the artist, yet unable to travel to Europe or afford the tuition at New York's National Academy of Design or Philadelphia's Pennsylvania Academy of the Fine Arts. Consequently, litho shops would prove instrumental in launching the careers of more than one great American painter, nurturing the talents of Alfred Jacob Miller, William Rimmer, George Loring Brown and Winslow Homer, among many others.

Exactly how Fitz Henry Lane was introduced to this profession is yet unknown. In regard to the claims of "W.," while it is not beyond the realm of possibilities that Lane was invited to go to Boston, this testimony is questionable. Given its abrupt, non-specific nature, much of the eulogy when taken as a whole seems to be the cobbling together of the words and remembrances of others, rather than a firsthand reminiscence by the author himself. In addition, by the time Lane came to Boston, Pendleton's reputation was secure, and aspiring artists were actively beseeching the Pendleton brothers to hire them, not the other way around. David Tatham, in his article "The Pendleton-Moore Shop," notes that "by the early 1830s the shop's [Pendleton's] prestige was high enough to attract young men who aspired to careers in painting but who lacked the necessary means or the precocity to study with either American or European masters."[119] If Lane had gone to Boston in 1825, when the shop had just opened and the need for draftsman was so acute that John Pendleton was going about enlisting painters to work there, then the claim that he was solicited to work in the shop would be of little surprise. Yet by 1832 everything had changed. Pendleton's

reputation was now secure, and aspiring artists were actively beseeching the Pendleton brothers to hire them, something which we readily find in the example of Lane's fellow Pendleton apprentice Benjamin Champney. Having, like Lane, been employed in the shoe trade (as a cobbler's apprentice) as well as being a self-taught artist, Champney would in 1833 seek out a position at Pendleton's with the explicit hope of one day becoming a painter. Of further interest, it should be noted that Champney was initially refused employment at Pendleton's, and only obtained a position there through the intervention of chief draftsman Robert Cooke. If Pendleton's was, as "W." claimed, willing to actively seek out and recruit someone like Fitz H. Lane, then why would they reject someone with similar qualifications and background just one year later?

More likely than his being a victim of pleasant circumstance, it would seem Lane was a man of ambition, taking calculated risks and following the scent of opportunity in an endeavor to attain for himself a better, more fulfilling life's pursuit. It was the promise of an art education equivalent to that found within an academy that drew Lane to Pendleton's, not a convenient quirk of fate. It was this that moved him to actively campaign for a spot in the Pendleton workshop, to hone and perfect his skills so as to become good enough to be hired. The statement by John Trask where he speaks of W.E.P. Rogers showing a drawing by Lane to Pendleton when seen in this light offers a completely different impression: Rather than being a work of charity or benevolence on the part of Rogers, it instead could well have been done at Lane's insistence. Herein could lie the reasoning behind such early works as *The Burning of the Packet Ship "Boston"* and his recently rediscovered *Gloucester from Governor's Hill*, 1830–31. Lane may very well have been compiling a portfolio, a means by which to demonstrate his existing talents and sell himself to the Pendleton brothers through Rogers, who appears to have enjoyed a connection with the two.[120]

That his journey to the Hub was one driven by intent and planning is further corroborated by Lane's petition to the State of Massachusetts for a change of name on December 26, 1831, the eve of his departure for Boston. While the ultimate reasoning behind his decision to adopt the moniker Fitz Henry Lane will probably never be known, it is obvious that the timing of this request was no mere coincidence. Instead it would seem to be part of a larger plan by the Gloucester native to cultivate a professional, perhaps romantic persona, in anticipation for the career awaiting him thirty miles to the south. Ultimately, rather than being a man who just happened to have the dumb luck of being recruited by the nation's most prominent lithography firm, it is far more probable that Lane, like so many other young, aspiring artists of his time, went to Pendleton's on a mission.

"A lithographic artist was expected to do anything and everything," Charles Hart informs us,[121] and we have no reason to believe Lane would have been held to any less a standard. Established in 1825 by the brothers William and John Pendleton, Pendleton's would become the first successful lithography firm founded in Boston, (and, arguably, within the United States).[122] As well, it would become for that time in history the nation's most prestigious firm, and consequently it did not suffer from a lack of commissions. By this time, Boston had become a major publishing center, so thus it is of little surprise that

a horde of artistic prints, labels, billheads, broadsides, certificates, music sheet covers, town plans, maps, surveys and reports for the earliest New England railroad companies would be produced within Pendleton's, offering its apprentices ample toil and many a learning opportunity.[123] Remembering that apprentices received their on-the-job education from fellow draftsmen (and at times even fellow trainees), Lane's co-workers would prove instrumental in the development of his artistic proficiency, gently nurturing and guiding his creative capacity as he worked beside them. That Lane would be exposed to a wide range of artistic skills and styles during his training is confirmed by a quick look at his co-workers and the successful careers they would pursue after Pendleton's: Seth Cheney, Robert Cooke and Benjamin F. Nutting would become portrait painters, while Benjamin Champney, John W.A. Scott and George Loring Brown developed into landscape painters. David Claypoole Johnston, regarded as one of the most original artists in the shop, evolved as a satirical caricaturist, William Rimmer became both a sculptor and portraitist and Nathaniel Currier would one day come to head the most famous American lithography firm ever. Lane was also apparently quite close with another artist during his Pendleton days, a marine painter by the name of Moody, of whom we know nothing of aside from the words of John Trask: "He practiced lithography with a marine artist, [S.L.?] Moody with whom he was intimate."[124]

Through observation and duplication of these and other draftsmen's creations Lane would learn the nuances of symmetry, depth, balance, tonality, proportion and perspective. The fact that as a group these gentlemen were adept at teaching the fundamentals of art is no secret, for several would publish their own instructional drawing texts, such as Benjamin F. Nutting's *Initiatory Drawing Cards*, a series of eighteen tutorial drawing cards with accompanying four pages of text, meant for children. As well, the testimonial of fellow apprentice Benjamin Champney, who would begin his training two years after Lane's arrival in Boston, confirms that it was common practice within Pendleton's for the less experienced to be trained by the shop's veterans. Champney clearly tells of his having been instructed by chief draftsman Robert Cooke, as well as by fellow draftsmen William Rimmer and Fitz Henry Lane. As Champney received lessons from the more experienced artisans within the shop, so unquestionably had Lane when he first took up the lithographer's trade.

Benjamin Champney's experiences at Pendleton's offer us many clues as to what Lane's time with that firm may have been like. From attending exhibitions at the Boston Athenaeum and Harding Gallery and seeking out criticism from Boston's top painter Washington Allston, to renting a studio with fellow employee Robert Cooke and saving his money in the hope of embarking upon a tour of Europe for further artistic study, Champney presents an image of an apprentice engaged in an eager search for instruction and ideas within the greater art community beyond that of the litho shop, building toward the day when he would move on from his apprenticeship and begin an earnest career within the fine arts. Lane's experience in Boston would, in several ways, remarkably mirror that of Champney's.

It is from a Pendleton co-worker that we receive our first glimpse of Fitz Henry Lane the man himself [figure 11], via the hand of chief draftsman and future portraitist Robert Cooke. Executed in 1835, the drawing shows the Gloucester artist at the age of thirty-one, a handsome and somewhat romantic character, appropriately enough with the sea at his back, sharply dressed and with folio in hand. Cooke's depiction of Lane conforms to contemporary descriptions of the artist, specifically in his being an impeccable dresser (as Trask would note, Lane "dressed neatly and in good taste"[125]) and, if the rocks are any indication as to scale, his being of rather small stature. John Trask of Gloucester would describe Lane as follows:

> He was about five feet, four inches tall and weighed one hundred and fifteen to one hundred and twenty pounds. He was of light complexion with fresh color and light brown beard. He had keen gray eyes and a full broad forehead. He was quick, nervous, and dyspeptic.[126]

Helen Mansfield, also of Gloucester, would corroborate Trask's words, saying Lane was a "small, thin man, of the Daniel Webster type of countenance."[127] It would seem Cooke's sketch successfully captured both the features (beard excluded) and the essence of his friend from Gloucester.

As to just what Lane was working on during his tenure at Pendleton's, Champney again proves helpful in permitting us a brief yet priceless firsthand account:

> F. H. Lane, afterwards well known as a marine painter, did most of the views, hotels, etc. He was very accurate in his drawings, understood perspective and naval architecture perfectly, as well as the handling of vessels, and was a good all-around draughtsman.[128]

Roughly within the first year of his apprenticeship, Fitz Henry would produce his first lithograph, a point-blank testimony as to both the talents he had cultivated in the years preceding his venture to Boston and the earnestness with which he now devoted himself to mastering the lithographic medium. Titled *Sicilian Vespers* [figure 12], the piece served as the cover illustration to a music sheet. Sheet music covers were low-end work that demanded little technical competence and were the "bread & butter" of the lithography industry, whose production was generally the domain of the lowly apprentice. The scene drips with exotic imagery. From the Eastern dress of the woman and the Moor-inspired architecture of the chapel along the cliff to the lateen sail rig of the fishing boats, the image Lane has crafted accurately reflects both the Moslem world's influence upon Sicilian culture and the West's growing enchantment and idealistic romanticizing of Eastern subject matter, something which we see in the contemporary works of English engraver and topographical illustrator Thomas Hosmer Shepherd, English landscape painter John Martin and Scottish landscape painter David Roberts, among many others.

The Gloucester artist's initials are found in the lower left corner, inserted in the water, albeit faintly. (This unobtrusive initialing is a characteristic practice of Lane's, one that

would endure throughout his career.) Lane's involvement in the creation of this piece should not be exaggerated, though. While fittingly enough a depiction of the fishing trade, it would seem unlikely that Lane was acquainted with Eastern dress, architecture and sail rig, let alone the intricacies of creating an original lithographic composition and placing it upon limestone at this time in his career. Instead it is likely that this idyllic portrayal of simple toil as pursued by a robust, earthy people was merely copied by Lane from a British music sheet cover, the practice of pirating foreign-produced images (especially English) being quite common at that time in America.

Objections as to 1832–33 being the year in which Lane fashioned *Sicilian Vespers* are put to rest by investigating the publisher of this piece of sheet music. Pendleton's had been contracted to make the cover illustration for the publisher C. Bradlee of Boston, which is identified in the cover's text as being located at 162 Washington Street. *Stimpson's Boston Directory* reveals that C. Bradlee was located at 164 Washington Street between the years 1831 and 1833, after which it was relocated to new quarters at Sweetser Court.[129] (C. Bradlee was not in business before the year 1830.)

It is almost a certainty that Lane, by one degree or another, was involved in the production of many more sheet music covers in the years following *Sicilian Vespers*. Unfortunately though, we find at present no hard proof of this, largely due to the fact that the average Pendleton's apprentice "signed or initialed on stone when the mood moved him."[130] Unsigned, undated sheet music covers such as *The Corsair's Bride*, *The Midshipman's Farewell* and *The Ship is Ready* [figures 13, 14 and 15] could very well have been crafted by Lane, as they bear the unmistakable touches that denote his handiwork. In fact, *The Ship is Ready* holds a direct parallel to the known Lane painting *View of Boston with Constitution Wharf*, 1841–42.

It is a full three years later that we encounter another lithograph solidly identified as having been executed by Fitz H. Lane. "Drawn by F.H. Lane"[131] in 1835, his *View of the Old Building at the Corner of Ann Street* [figure 16] exhibits without restraint the fruits of three years of intensive apprenticeship. Champney's claim that Lane understood perspective is verified within this piece, given its convincing sense of depth and three-dimensionality. The composition itself is interesting not only in that it testifies to Lane's increasing skill and successful schooling at Pendleton's, but also in the matter of what it depicts. The three buildings sharing the stage in this lithograph are more than merely scenic structures. The sagging, multi-gabled structure off to the left was already a rare artifact from an ancient time when Lane drew it, being one of a precious handful of Boston's seventeenth-century Puritan edifices then still standing. Personified as "a petrified old gentleman," and christened with such colorful titles as "the Old Feather Store" and "Old Cocked Hat,"[132] this novel, picturesque structure was generally cherished by the city's populace, and looked upon with both affection and respect. For the average Bostonian the building served as a means of connecting with their early Puritan history—a history that Nathaniel Hawthorne would state in 1851 was "a bygone time…that is flitting away from us."[133] The brick structure seated off to the right is Boston's immortal Faneuil Hall, "Cradle

of Liberty," site of many a fiery oration calling for American independence in the days preceding the American Revolution. Designed by Scottish portrait painter John Smibert in 1742 and enlarged by Charles Bulfinch in 1805, Faneuil Hall came to commemorate not only Boston's proud role in serving as the seminal birthplace of the American nation, but also that city's transition from eighteenth-century colonial possession to early nineteenth-century independent metropolis. Finally, the third building, lying immediately within the middle of the piece, is none other than Quincy Market, having been completed just ten years previous. With its cutting edge Greek Revival motif, solid granite construction and central role as a point of exchange for goods hailing from around the world, it served as an embodiment of all that was new, modern and progressive in Boston.

In this one lithograph Lane has done nothing less than represent three centuries of Boston history, as incarnated within three of her most easily recognized edifices. Long has it been assumed that "this first lithograph was probably an ad."[134] While two businesses are identified by placards affixed to the sides of buildings within the image (John K. Simpson Jr.'s upholstery goods store and William H. Milton's clothing warehouse), no one particular business is specified as being the central topic of the piece, either within the image or its title. As well, no one structure is the star; the three present in fact sharing the spotlight. Lane has specifically elected to employ a point of view that encompasses the breadth of Dock Square, rather than tightening the composition and directing the viewer's attention to focus on one particular building.

All this runs contrary to what we see in other Lane advertisement lithographs, such as *George W. Simmons' Popular Tailoring Establishment, "Oak Hall," Boston* [figure 17] and *Horticultural Hall* [figure 18], where in both the title and the work itself there is no mistaking the subject being advertised. As well, we find complementary text included with these images. The *Oak Hall* lithograph is the frontispiece to a foldout pamphlet complete with a prologue, epilogue and poem in four parts celebrating the clothier in question, while the full title of *Horticultural Hall* rambles on to include "School St. Boston. All kinds of fruits and ornamental trees, shrubs, plants, fruit, etc., also agricultural and horticultural seeds, for sale by Samuel Walker. A large assortment of tools, books, and other horticultural articles. Trees and plants imported to order. Catalogues may be had gratis on application."[135] *View of the Old Building at the Corner of Ann Street* has no such complementary text. Rather than being an advertisement, it would seem that it was a scenic street scene meant to be sold by subscription, seeking to generate sales by appealing to the average Bostonian's sense of history and the pride inherent with their accomplishments across a span of two hundred years.

Employing an almost identical point of view, as well as featuring signage upon the building in question, we know the remarkably similar *Old Wharehouse—Dock Square, Boston: Built 1680. Taken Down 1860*, ca. 1860, by Alfred K. Kipps [figure 19] to have not been an advertisement but rather a celebration of this distinctive Boston landmark. Despite *View of the Old Building at the Corner of Ann Street* being somewhat small for a subscription piece, the message conveyed within its composition—a message most akin to that found in Alfred K. Kipps's illustration—conveys that this piece was not intended as an advertisement.

Beginning in 1835, Lane would also commence two harbor scenes, these being in fact his earliest known depictions of a harbor. The first, *View of the City of Bangor, Maine*, 1835 [figure 20], while not bearing his signature, has been authoritatively attributed to him. Taken "from a drawing by A.H. Wallace,"[136] it possesses many of the characteristics that have come to define a Lane composition (subject matter, hyper-accentuated foliage in the foreground, immense attention to detail and cloud forms, for example), and yet within this piece problems of proportionality are quite evident, namely within the river running across the foreground. Simply put, the river bears a subtle yet unmistakable curve, giving it more the form of an arching rainbow than a body of water. A glance toward the horizon reveals a similar arc. For Lane, an artist who would come to be known for his flawless depictions of topography, to have represented the river so unconvincingly stands contrary to his other works, where landforms are approached with competence and accuracy. Such flaws allude to this being the work of an ambitious draftsman, one not yet versed in the finer points of the trade and having some trouble composing and translating an image this large and complex onto limestone.

Lane would soon master these problems, as revealed by *View of the Town of Gloucester, Mass.*, 1836 [figure 9]. Begun in the summer of 1835 and crafted with the intention of being sold by subscription, this panoramic lithograph would be deemed newsworthy by the local Gloucester newspapers, which reported on the progress of the piece from time to time with zealous enthusiasm, their columns ultimately appearing to be more akin to thinly veiled advertisements than objective journalism:

> *It will be recollected that we stated some time since, that it was the intention of Mr. Fitz H. Lane, an artist belonging to this place, to lithograph a view of Gloucester, provided a sufficient number of copies were subscribed for to warrant the undertaking. The progress of the subscription has been slow, but we are happy to learn it is now large enough to cover the necessary expenses of publication, and that it will be completed and furnished to subscribers as soon as possible. Mr. Lane has been in town during the past week, and has completed his sketch…Taking it all in all, the mirror-like surface and graceful bends of the harbor, studded here and there with the most exquisitely drawn vessels; the lofty hills which nearly encompass the town, and last, our handsomely situated, and really handsome village, forms the most beautiful picture of the kind we ever saw. We trust our citizens, and those who have gone from among us to other places, will duly appreciate the labors of Mr. Lane, and render his sketch not only a source of pleasure, but of profit to him. We would not be without a copy of it, when finished, for five times the amount of the subscription price.*[137]

Lane would not finish the piece until March of the following year, an event that the local papers did not fail to notice.

> *We have received a copy of a lithographic sketch of the town of Gloucester, executed by Mr. Fitz H. Lane of this town. The sketch itself is, we think, most admirably executed; and so far*

as we are acquainted with the art, there is a softness and beauty in the design, which we do not always find in the works of older and more distinguished artists…We venture to predict that he will one day become distinguished in his art. Subscribers and others may obtain the print at the store of Isaac A. Smith.[138]

Within *View of the Town of Gloucester, Mass.*, we find certain traits that would become the classic hallmarks of this man's artwork—constant, unchanging devices and arrangements present in canvas after canvas from the first days of his career to the last. Of course, there is the presence of nautical subject matter, the very soul of Lane's art. From the pinkey grounded out alongside a cob wharf at right and the schooners under sail across the harbor, to the square-rigged ship looming toward the background at center, Lane, in what would become his characteristic fashion, has depicted a host of naval craft in accurate, convincing detail. The distinctive expanse of sky, the interplay of light and dark, and the presence of hyper-accentuated vegetation within the immediate foreground[139]—all of which would recur in canvas after canvas over the years—are also to be found here. Lane also utilized the elevated "insider point of view" perspective in several other lithographs, such as *View of the City of Bangor, Maine*, 1835, and his 1838 lithograph *View of the City of Washington*, as well as in some of his paintings, like *View of Baltimore from Federal Hill*, 1850, and *View of Norwich, Connecticut*, 1847 (both having been originally derived from Lane lithographs), and his *Castine, Maine* [figure 21] and *Castine from Fort George*, executed respectively in 1850 and 1856.

Yet perhaps most characteristic of Lane's art is the overwhelming amount of detail within this lithograph. Since early to mid-nineteenth-century lithography was generally committed to recording the landscape precisely as it was, Lane would find himself the recipient of a specialized training that stressed an uncommon attention to detail. For proof of this we need only look over *View of the Town of Gloucester, Mass.*, with magnifying glass in hand. No detail has been overlooked: individual leaves of shrubbery; boulders cast upon the shore; lines of rigging on the vessels; a rug hung out on the garden fence of the house in the foreground; the panes of glass within the windows of the structures along the right; each individual stone composing the wall in the bottom right portion of the piece; even the whip cracking through the air in mid stroke, as brandished by the teamster driving his cart before the bow of the pinkey upon the beach—throughout the lithograph rich details abound. This legacy of Lane's training at Pendleton's would become the bedrock foundation of his art, the seminal point of origin from which all future creations sprang. Topography, buildings, ships and other details would all come to be portrayed upon the Gloucester artist's canvases with the utmost realism, leaving us today with not only a host of beautiful pictures, but also priceless historical documents attesting to the most minute details of coastal New England in the nineteenth century.

Fitz H. Lane would produce lithographs at Pendleton's despite successive changes in the company's ownership, first in 1836, when William S. Pendleton sold the business to his bookkeeper, Thomas Moore, and again, when Moore sold the business in 1840 to Benjamin

W. Thayer (who would in four years' passing sell the firm to John H. Bufford). After Moore assumed ownership of the firm, Lane began to take on a far more visible role, producing on stone a host of complex, accomplished works for a number of uses. Business-related advertisements like *Oak Hall* and *Horticultural Hall* proved common fare for his talents. Subscription work like *View of the Town of Gloucester* did as well, though we find most of Lane's panoramas of cities and historic events being derived not from his having witnessed them firsthand but rather from the sketches of others. His *View of the City of Washington*, 1838, was based upon a drawing by a certain P. Anderson; his *View of the Great Conflagration, St. John, New Brunswick*, 1838, was copied from a drawing of the incident by a William H. Wentworth, which itself was taken from an original sketch by a Thomas H. Wentworth who was an eyewitness to the event; and of course there is the 1835 *View of the City of Bangor, Maine*, from A.H. Wallace's drawing.

Predictably though, sheet music covers continued to make up the majority of his work, with several, like *The Salem Mechanick Light Infantry Quickstep*, 1836, and *A Yankee Ship and a Yankee Crew*, 1837 [figure 22], featuring martial themes. Some, in a reflection of the era's taste for the sentimental and the melodramatic, would bear the heavy stamp of pathos and loss—*The Maniac*, *The Mad Girl's Song* and *The Old Arm Chair* [figure 23], all ca. 1840—while others were merely popular tunes, as in *The Pesky Sarpent: A Pathetic Ballad*, also ca. 1840. Much about the status of Lane's lithographic career around 1840 is revealed within these music sheet cover commissions, for they stand apart from *Sicilian Vespers* in many substantial ways. One fundamental difference is that they are original compositions crafted by Lane himself, rather than being pirated copies of foreign publications. After eight well-spent years at Pendleton's he had risen to become a master lithographic artist. A second bit of distinction these pieces may claim is that, rather than being typical ballads, they were some of the most commercially successful pieces of sheet music in America at that time. Three of the four abovementioned melodies (*The Maniac*, *The Mad Girl's Song* and *The Old Arm Chair*) were arranged by Henry Russell, an English-born composer who had come to the United States in the 1830s and found an American audience eager and enthusiastic for his work. With his songs being performed both upon the stages of theatres and music halls and within the home around the family piano, Henry Russell became a popular household name, being perhaps the most popular songwriter in mid-century America. And as his name was spread far and wide, so, to a lesser degree, was Lane's, since it was Lane's handiwork that crowned the cover of several Russell compositions. *The Old Arm Chair* alone would go through a phenomenal twenty-three successive editions (admittedly, not all of these editions featured Lane's cover design), becoming beyond dispute the best-loved American song of the 1840s.[140]

Lane's sheet music covers often demonstrate radically divergent styles, alluding to his having designed them with the tastes of their specific audiences in mind. Though both were created in the year 1840, the figure in *The Maniac* [figure 24] differs greatly from those found upon the cover of *The Pesky Sarpent* [figure 25]. Cloaked in classical drapery and crowned with curly locks, *The Maniac* possesses all the beauty and grace of a Greco-Roman statue, conveying unto the viewer a sense of true loss and tragedy. *The Maniac* is

a noble, elevated soul brought low by his mental frailty, an ultimately pathetic character who should be receiving attentive care rather than incarceration. Lane has intentionally crafted a figure meant to garner sympathy and empathy from the audience, which is only accentuated by the contrast between his virtuous bearing and the dank, wretched dungeon he finds himself in. Meanwhile, the husband and wife featured in *The Pesky Sarpent* are portrayed in a comical manner, with disheveled clothing, exaggerated body language and the humble, unsophisticated surroundings of their rural home. The two figures are farcical caricatures, meant to elicit laughter, not sympathy. The fact that these two covers are so different, despite their being crafted by the same artist in the same year and for the same purpose, demonstrates Lane's taking into account the natures of and intended audiences of these two songs. Lane's cover illustration for Henry Russell's *The Maniac* had to agree with lyrics that bore high drama, while simultaneously underlining the miserable living conditions of the mentally ill:

> *He quits the grate, he turns the key,*
> *He quits the grate, I knelt in vain,*
> *His glim'ring lamp, still still I see,*
> *And all, and all is gloom again;*
> *Cold, bitter cold, no life, no light;*
> *Life all thy comforts once I had,*
> *But here I'm chained this freezing night;*
> *No by heaven no by heav'n I am not mad;*
> *Oh! Release me, oh! Release me,*
> *no by heaven no by heav'n I am not mad.* [141]

Meanwhile, *The Pesky Sarpent* enjoys far different roots. Having originated as a folk ballad in the days before the American Revolution, it is most likely the first original American folk ballad to have ever been recorded. The song recounts the true story of Timothy Merrick, who was bitten by a rattlesnake while mowing hay barefoot on August 7, 1761, and died within three hours.[142] Originally sung as a sincere lament for the deceased, it grew in popularity as a folk song until, around the 1840s, the song made its way to the vaudeville stage, where it would be parodied with "highly exaggerated and melodramatic details,"[143] which is exactly what we see Lane doing on the cover illustration he designed.

It is probably due to the widespread circulation of Lane's artwork via sheet music covers that we find him taking on work from beyond Pendleton's—and beyond Boston for that matter—as early as 1839. While pieces such as *The Pesky Sarpent* were created outside the Pendleton firm yet still within the precincts of Boston (this piece was commissioned by Sharp & Michelin & Company of Boston), his *View of Norwich from the West Side of the River*, 1839, was "Lith. And Printed in Colors by Sarony & Major, 117 Fulton St., New York,"[144] a clear indication that Lane's reputation as a lithographer was beginning to come to the attention of those beyond his immediate environs.

Given the vibrant, diverse talent, informal instruction and intimate working conditions such as those found inside Pendleton's during Lane's tenure there, it may be difficult to determine how much of his art was the product of his own personal vision, and how much was influenced and derived from working beside his fellow lithographers. An answer to this question may reside within one very particular Lane lithograph, believed to have been executed in 1837. Titled *View in Boston Harbour* [figure 26], it stands out as being radically different from anything he had produced before. Unprecedented in its point of perspective, its shifting strips of sunlight and shade falling upon the water, the scalloped surface of the water, the way vessels are abruptly severed along the piece's borders and, most tellingly, the intense verve that resonates throughout the piece, conveying to the viewer an immediate sense of throbbing bustle and energy, this work reveals the unmistakable imprint of another artist, one whom Lane would come to know quite well during his time at Pendleton's—Robert Salmon.

Chapter 6
Robert Salmon, First Exhibitions and First Clients

In July of 1841, nine years after his arrival in the Massachusetts state capital, Fitz Henry Lane was listed in Stimpson's Boston Almanac as a marine painter, residing at 7 Summer Street.[145] This listing stands not only as his first known Boston residential address (he had never been listed previously in Stimpson's) but also as his first public declaration of being a marine artist, so marking a bold new chapter in his career. No longer a mere apprentice to lithographers, he was now ready to assert himself professionally, confident in his abilities and determined to build a clientele.

Working as a lithographer had given Lane a thorough grounding in the fundamentals of art. The secrets of depth, balance, symmetry, tonality, proportion and perspective had all been imparted upon him by his co-workers, helping to make him one of the best lithographic artists in Boston, if not the nation. Many of his co-workers would pursue successful careers in the fine arts after their tenure at Pendleton's, and it is easy to surmise that Lane gained the skills of painting in oils from informal instruction, as offered by his peers. Yet to learn the intricacies of oil painting, more than a few stray bits of advice would be needed. To master this medium, to learn how to mix a color palette, wield a brush, apply varnishes, stretch a canvas or know the different types and differing qualities of brushes, canvases and commercial paints would require an in-depth formal training, and an examination of Lane's lithographs and early canvases readily reveals the most likely source for this instruction.

Marine artist Robert Salomon was described as "a small man, most unmistakably Scotch in his appearance and conversation...of very quick temper, and one who generally called a spade a spade."[146] Son of Francis Salomon, a jeweler, Robert Salomon was born along the English border with Scotland in Whitehaven, Cumberland, England, in October or November of 1775. Little else is known concerning his early years, including what drew him toward the profession of the marine artist or from where he derived his training, though it is clear from viewing his works that he was familiar with the works of Dutch marine painters of the seventeenth century, the art of the Italian painter Giovanni Antonio Canal (Canaletto) and the British marine tradition. By 1806, after a brief residency in London, the thirty-one-year-old Salomon was living in Liverpool, where the aspiring artist

produced some of his earliest marine paintings, such as *A Packet off Liverpool*, 1809, and *The East Indiaman "Warley,"* 1804 [plate 35]. It was also at this time that he, in an act oddly reminiscent of what Fitz Henry Lane would someday do, decided to change his name, in this case dropping the first *o* in Salomon, and so became Robert Salmon. Given Liverpool's longstanding place as a center of commerce and shipbuilding, it has been hypothesized that Salmon augmented his income either by working in a shipyard or by gaining employment as a deckhand upon one vessel or another.[147] In fact, he is known to have introduced himself as being "a sea-faring man."[148] Regardless of whether or not he had worked with vessels firsthand, it is undeniable that his detailed depictions of naval craft were created with an intimate, even instinctual knowledge of ships, their rigging and their profile when moving through the ocean.

Starting in 1811, Salmon would find himself living in a succession of cities, scraping a living by painting theatrical scenery and panoramas as well as marine portraits. This pattern would persist until the year 1828, when the restless artist would begin a bold new chapter in his life by immigrating to America, specifically to the port of Boston.[149] The decision to emigrate was a lucrative one for Salmon. Back in his native England, he was but one of many skillful marine artists. Yet in Boston, he would practically be the only one. Boston, being at this time a giant in commerce, featured many shipowners, investors and sea captains eager to have their vessels celebrated upon the canvas. As much a matter of pride as it was a matter of aesthetics, these men sought the most accomplished painters to portray their craft (often relying on artists in foreign ports, like Antoine Roux of Marseilles, the painters of the Liverpool School or so many Chinese artisans, their names forever lost to posterity, to do such work). For Salmon, the environment was rich with opportunity: Boston merchants had the money and the desire; he had the talents they required. And so began a fruitful fourteen-year-long relationship between the two parties, with Salmon working for some of the richest merchants in Boston.

It is within Salmon's *Boston Harbor from Constitution Wharf*, 1833 [plate 10], that we find so many of the traits that made his work accomplished and distinctive, as well as sought after by Boston's maritime elite. First to catch our eye would be the peculiar wave pattern upon the surface of the water. Being the most easily recognized and identifiable feature of a Salmon painting, the scalloped wave pattern stands as Salmon's signature trait, something that no other painter in Boston was practicing at the time. Vessels severed abruptly along the canvas edge, like we see along the left-hand side of this composition, is a contrivance Salmon would often employ within his works as well. (Both of these techniques would seem to have been incorporated by Salmon directly from the example of Giovanni Antonio Canal (Canaletto), the Italian-born painter of maritime subject matter who plied his trade in England from 1746 to late 1755. [See plate 36.] Salmon would also include in his pictures several subtle compositional devices by which to direct the viewer's eye across the canvas. From the spars gathered together in the immediate bottom-center of the piece and the cannon and anchor upon the wharf, to the gesture of the man in the rowboat in the bottom-right corner—and even the placement of the very vessels themselves—

Salmon ingeniously guides the viewer's eye about the canvas, pointing them toward the various focal points of the composition. The color red (another technique borrowed from Canaletto), as found within the American flags on the left and right sides of the painting and the shirt of one of the men on the dock in the foreground, serves the same purpose here, this loud color standing out and apart from its surroundings and thus assuring that the viewer's eye will be drawn to those corners of the canvas.

Yet it was the exact detail Salmon used in a ship's rigging, the convincing interplay of shadow and light on the ship's sails, and the manner with which the wind filled (or in this case, *didn't*) a sail, that set him apart from any other painter in Boston at that time. For these realistic touches were the particular kind of details a shipowner or sea captain would readily appreciate if not demand, and it was through such accurate depictions of the technical aspects of naval architecture that Salmon's patron base was assured.

Robert Salmon's compositions are executed with a flair for unusual (and thus quite engaging) points of perspective. The subject matter he pursues, as dictated by both his personal history and the interests of the clientele from which he earned his income, invariably involves the sea and the maritime culture that existed within Boston at that time. And throughout his work runs perhaps that most signature of Salmon-esque traits: a sense of activity. A Salmon depiction of a harbor is one of crowded bustle, where a multitude of ships makes their way to and fro across the canvas, each off on its own self-important task. A sense of motion and urgency generally permeates his creations.

These are the traits that we find in Fitz Henry Lane's *View in Boston Harbour*, the publication of which in 1837 marked a most radical transformation of Lane's artwork. It is within this work that a host of new traits never before seen within his lithographic *oeuvre* appear; traits unmistakably identical to those featured within Robert Salmon's compositions. [See figure 26.] Scalloped waves, the shifting horizontal strips of sunlight and shade falling across the water, vessels abruptly severed along the composition's edge, unerringly accurate rigging and hull forms—this lithograph almost hums with the essence of a Salmon creation, and it is just the first of many other pieces by Lane to feature the presence of the Englishman's influence.

Sometimes the similarities between their creations are small, as in the way Lane employed the three figures in the foreground of his lithograph *View of Gloucester from Rocky Neck*, 1846 [figure 27], to direct the audience's eye in a fashion almost identical to Salmon's figures in *Plimouth Sound*, 1837 [figure 28], or how Lane constructs his figures and depicts water dripping off the oar of a rowboat in the bottom left of his *Yacht "Northern Light" in Boston Harbor*, 1845 [plate 12], in a manner identical to Salmon's rowboat and figures in *Rainsford's Island* [figure 29]. Other times, the similarities are so numerous as to be found throughout the canvas, permeating every corner of its construction, as we find in comparing Lane's *Gloucester Harbor at Sunrise*, ca. 1851 [plate 11], to Salmon's *Boston Harbor from Constitution Wharf*, 1833 [plate 10]. Lane's work is essentially a replication of Salmon's, the main differences being that Lane has chosen to depict the waterfront in the sleepy repose of early morning rather than the vibrant activity of day's end, and has simply reversed the

orientation of the painting, placing the primary ship subject off on the left as opposed to the right, positioning the cluster of watercraft on the right instead of the left, and having the wharf face at an angle toward the left side of the painting, rather than toward the right. Indeed, we even find the same compositional devices inhabiting the foreground: a spar to the right of the wharf and a man in a red shirt, an anchor and a cannon atop said wharf, all fulfilling the same function as they do in Salmon's masterpiece, all while the light effects and cloud patterns within each painting are virtually identical.

Most of these similarities appear for only a few years, in the early stages of Lane's career as a professional marine artist before his artistic vision had fully matured. Salmon's characteristic scalloped waves emerge within more than a few Lane paintings from the late 1840s and early 1850s, such as *The Britannia Entering Boston Harbor*, 1848 [plate 13], and *Clipper Ship "Southern Cross" Leaving Boston Harbor*, 1851 [plate 14]. Vessels sharply cropped along the edge of a composition can also be found manifesting during this time as well, as in *Yacht "Northern Light" in Boston Harbor*, 1845 [plate 12]; *Gloucester Harbor*, 1847 [plate 4]; and *Gloucester Inner Harbor*, ca. 1850 [plate 5]. Bands of shadow and light falling across the water, on the other hand, are discovered not only in early works like *The Britannia Entering Boston Harbor* and *Clipper Ship "Southern Cross" Leaving Boston Harbor*, but even in paintings Lane crafted within the twilight of his career, as in *Approaching Storm, Owl's Head*, 1860. Some Salmon-inspired features would persist throughout the full spectrum of Lane's career: men in the foreground wearing a red article of clothing (most often a shirt), driftwood, ships and other articles directing the viewer's eye across the canvas; toilers of the waterfront plying their trades; meticulously accurate ships and rigging; realistic depictions of vessels moving through the water and the way light, shadow and wind appear within their sails—all these are to be found in canvas after canvas, forming the very bedrock of Lane's painting style.

As Lane's fellow Pendleton's apprentice Benjamin Champney recalled, "At this time there were few artists in Boston. Alvan Fischer and Thomas Doughty were painting landscapes; Salmon, marines."[150] In the small community of artists then to be found in Boston, the name of Robert Salmon would have been readily recognized, especially since he stood out as a success story in a city that was just beginning to fully embrace the fine arts. As Champney informs us, aspiring artists in their individual quests to become successful painters were wont to seek instruction from Washington Allston, romantic poet and classically trained painter, who at the time was "the great master" of the Boston art scene, and the only man in Boston aside from Salmon who had spent many years committed to painting.[151] Allston was a natural choice for these men (and some women), as he was what so many of them aspired to be: an accomplished, acclaimed landscape painter. If Fitz Henry Lane had not already intended it from the beginning, he surely realized soon after having started at Pendleton's that his greatest (and most marketable) of strengths was his ability to competently render realistic likenesses of naval craft. With this realization in hand, Lane would surely have done what Champney and so many others did, and actively

sought out criticism from an acknowledged, established master. Only rather than turning to Allston, Lane would have logically enough turned to Boston's top marine painter, Robert Salmon.

Lane would not have had to go very far in seeking out an audience with the great English artist. Only two years after Lane's arrival in Boston, *Stimpson's Boston Almanac* lists Robert Salmon, artist, as residing at the "rear of Pendleton's, Washington [Street]."[152] As well, it has been claimed that between the years 1830 and 1833 Salmon submitted several drawings to Pendleton's for purposes of being copied onto stone, thus affording Lane the opportunity to not only meet him but to view his works as well.[153] For Lane to not have taken advantage of this superb resource, so close at hand, is virtually unthinkable.

We know that Lane most certainly did have a professional relationship with Robert Salmon, given the inscription found on the back of his *Yacht "Northern Light" in Boston Harbor*, 1845, "From a sketch by Robert Salmon."[154] Yet even if Lane had somehow inexplicably failed to take advantage of Salmon's presence within the close, informal work environment of Pendleton's, he surely would have heard of Salmon's reputation and viewed his paintings at the annual art exhibitions held at the Boston Athenaeum. Open to the general public for the fee of 12½ cents (until 1846, when the price was doubled[155]), these immensely popular exhibitions featured numerous paintings and sculptures that were either loaned out temporarily for purposes of display by library "proprietors" (members), or were being actively offered for sale by the artists themselves. Forty-four paintings by Salmon would be featured in the Athenaeum's art exhibitions during his fourteen-year sojourn in the Hub, the pieces being provided both by himself and by proprietors. As it is well documented that Boston's aspiring young artists naturally enough frequented these shows, studying intently the methods and techniques of everyone from their more successful peers to the old Dutch masters and Italian Renaissance painters, it is a safe assumption that Lane went to the Athenaeum exhibitions as well, quite likely in the company of his fellow apprentices, and in so doing would have viewed many Salmon paintings.[156]

Unfortunately, to date no correspondences or accounts contemporary to Lane have surfaced confirming the notion that Fitz Henry Lane was instructed firsthand by Robert Salmon in the ways of oil painting. John Trask, rather than validating our suspicions, informs us Lane "never had a master and never went abroad."[157] As to whether Robert Salmon was Fitz Henry Lane's mentor, despite the wealth of circumstantial evidence, for the moment we can only offer educated guesses. The similarities found within the art of these two men reach far beyond simple coincidence and banal mimicry. Lane did not just borrow a few stylistic traits from Salmon, nor was he merely indulging an interest in the same subject matter. Rather, he constructed compositions strictly faithful to the fashion of Salmon, and employed the exact same devices in order to do so. Even in matters of brush stroke and the employment of fine, thin glazes, we see technical parallels too precise to be written off as merely being the product of coincidence. Indeed, we find them to have been wielded in a competent and unified manner, revealing Lane's paintings to have been infused with both an understanding of how and why these devices work

together, as well as confidence in applying them. A comparison between the artwork of these two men ultimately demonstrates that Lane possessed a clear comprehension of the particular mechanics employed by Salmon in the creation of his canvases, a knowledge that he would have been hard-pressed to gain except via an intense study of Salmon's artwork, witnessing the evolution of numerous canvases from inception to completion, or by personal instruction from Robert Salmon himself.

The similarities between these two men are not only confined to the technical aspects of their art. The very fact that Lane, like Salmon, chose to portray the common laborers of the waterfront engaged in even the most menial trades, reveals an influence far greater than compositional tools and brush stroke techniques. By intentionally depicting these tradesmen at work, Lane was sharing in the same ideology as expressed by Salmon in his works: the celebrating of the democratic ideals of industry, labor and the common workingman. And even in matters of lodging these two men would share similarities that are more than circumstantial. Salmon is listed in the 1840 *Stimpson's Boston Almanac* as living at "16 Marine Railway."[158] A marine railway, much like a dry dock, served as a means to accomplish routine repairs and maintenance on the hulls of craft too large to be careened on a beach. Running down an iron track and into the water, a cradle moved along the partially submerged railway. The vessel to be worked upon would be carefully maneuvered atop the submerged cradle and, once positioned over it, would then be hauled up the ramp and out of the water by a stationary steam engine upon land. For Robert Salmon, the advantages to living beside such a facility are obvious: to accurately portray a vessel and how it moved through the water called for an intimate knowledge of naval architecture, as the geometry of a vessel's hull bottom dictates the subtleties of form in the topsides. This understanding is vital if the artist is to convincingly depict a hull displacing water, rather than merely sitting on the surface as if no part of the hull was immersed. By living at a marine railway, Salmon was granted up-close, uninterrupted access to a host of vessels out of the water most any time of the day, permitting him to sketch and study numerous different hull forms at his leisure, and even to confer with shipwrights, shipowners and ship designers about technical matters when needed.

When Lane eventually left Boston and returned to Gloucester in the late 1840s, he, like Salmon, would seek out quarters immediately beside the busy wharves and quays of his hometown. Lane would go to considerable lengths, both in matters of expense and in the negotiation of easements with neighbors, to obtain property upon a particular spot of the Gloucester waterfront known as Duncan's Point. In what simply cannot be attributed to coincidence, we discover the reason Lane went to such trouble: less than a few hundred feet from where he would build his house stood the Gloucester Marine Railway, built in 1849–50.[159] (See *Three Master on the Gloucester Railway*, 1857 [plate 9].) Lane would construct his home at exactly the same time as the railway, and in so doing faithfully followed the example of Salmon, reaping the same rewards for the sake of his art as the Englishman did, while giving us yet another compelling reason to conclude that these two men enjoyed strong professional associations.

Perhaps the greatest clue supporting the theory that Salmon mentored Lane is to be found within their patronage. Salmon produced oil paintings for Boston's seafaring elite—Colonel Thomas Handasyd Perkins, the great merchant-philanthropist; John Perkins Cushing, nephew to Colonel Perkins and "the most wealthy and highly respected foreign merchant in China"[160]; Josiah Putnam Bradlee, head of the shipping firm Josiah Bradlee and Sons; Charles Francis Adams, minister to Great Britain. Yet of the many merchants and mariners Salmon worked for in Boston, perhaps no one gave him as much business as Robert Bennett Forbes [figure 30]. Another nephew of Colonel Perkins, Forbes would be celebrated as having "the most original brain, and the most attractive personality of any Boston merchant of his generation."[161] Ambitious and intelligent, Forbes would prove himself to be the consummate Yankee mariner. He was a ship's master by age twenty, ship's captain by twenty-six, and in the span of ten years spent trading with China he would tarry as little as six months upon dry land. Entering into the firm of Russell & Co., Canton, in 1832, the clever and gifted Forbes would in eight years' time rise to become head of the firm.

Returning to Boston in 1840, Forbes chose to invest his considerable fortune into the pursuits of the merchant-shipowner. Here, his genius manifested itself not only in matters of shrewd investing, but also in humanitarian ventures, the introducing of the sport of yachting to the United States and innovations within the field of naval architecture. When famine struck Ireland in 1846, the people of Yankee New England would gather provisions and cash totaling over $150,000 and load it upon the sloop of war *Jamestown*, loaned by the United States Navy expressly for the purpose of delivering supplies to the starving Irish populace. Loaded to a hair's breadth of sinking, the *Jamestown* would depart Boston on March 28, 1847, crewed by civilian volunteers and with Robert Bennett Forbes in command (the only civilian to ever command a commissioned U.S. warship). Through torturous storms and gales Forbes would sail the perilously overloaded *Jamestown* without mercy, reaching Cork Harbor in fifteen days and three hours out from Boston, one of the best Atlantic crossings by sail ever recorded. Not to rest on his laurels, he would sail back home to America immediately, only so as to return to Ireland with no less than four more merchant ships and two steamers, all loaded with life-saving foodstuffs.

Yet for Commodore Forbes, his greatest contributions to the nautical world would lie in his visionary designs for oceangoing craft. At a time when his fellow Boston merchants still fretted over steam propulsion, he emerged as a staunch advocate for the new technology, as well as for iron hull construction, writing numerous articles that called for these and other improved ship designs to be implemented. First to introduce auxiliary steamers to Chinese waters and first to build an oceangoing twin-screw iron tugboat, Forbes would also be the first to have his vessels sport such revolutionary shipboard innovations as the double topsail rig (a device that permitted the top half of a vessel's square topsails to be set or furled, sparing the crew the toil and hazards of reefing the huge square topsails) and swiveling propeller hoisting arrangements. His vessels were the first to sport these technologies because he himself had invented them.[162]

For a man like Robert Bennett Forbes, no typical ship portrait painter would do. Technical accuracy was a must. Rigs would have to be exact, hull forms most faithful and an aesthetic quality that took the viewer beyond the mundane, everyday ship portrait was most certainly a requirement. Forbes would find all these qualities in the works of Robert Salmon, and owned at least five of his compositions (all, of course, being marines).[163] Yet when Salmon returned to Europe in 1842, Forbes (and other patrons) suddenly found himself deprived of his painter's talents. It is at this crucial moment that we find Fitz H. Lane, an artist who, until that moment, had enjoyed marked commercial success as a lithographer but was yet generally unknown as a marine painter, acting in the role of the heir apparent, assuming the position of Boston's most accomplished marine artist by filling the void for Salmon's patrons, Forbes included.

The relationship between Forbes and Lane was one of close cooperation stretching over many years. It would appear that Lane was Forbes's "go to" man not only for paintings, but also whenever he found himself in need of a technically accurate, accomplished illustration of one of his vessels for matters of publication. In the year 1845 Lane produced two separate lithographs of Forbes's auxiliary steam bark *Massachusetts*, the first American steamship to successfully traverse the Atlantic since the historic voyage of the SS *Savannah* in 1819, and the first commercially successful American steamship to have crossed that ocean.[164] Of particular notice is Lane's *Auxiliary steam packet ship Massachusetts*, 1845 [figure 31], where Lane has portrayed the *Massachusetts* in a way contrary to the prevailing trends of the time. Due to the public's general mistrust for steam propulsion (which by 1845 was still quite prone to accidents and breakdowns), it was common practice to depict a steam-propelled vessel merrily sailing under its own power, with auxiliary sails tightly furled, so as to assuage the public's fears and misgivings (as we see Lane doing in his portraits of the *Britannia*). In this lithograph though, Lane has elected to do the opposite. No smoke arises from the smokestack, and the sails are fully deployed, carrying the *Massachusetts* forward by sail power alone. To show a steam packet under sail rather than with engines engaged would appear as a vote of no confidence for the steam engine to Americans of the nineteenth century, the last thing a shipowner would have wanted. Did Lane make a critical mistake when he created this piece? A closer look tells us otherwise, for the masts of the *Massachusetts* are no ordinary masts, but rather Forbes's unique double topsail rig. In addition, given the general inefficiency of steam power at that time, as well as the large amount of cargo space that would be lost in order to accommodate the coal needed to fuel the engines, Forbes chose to employ steam power onboard his ships merely as a backup to their main form of propulsion, wind power. Thus, *Auxiliary steam packet ship Massachusetts* can be seen as an endorsement for Forbes's use of auxiliary steam power and the double topsail rig design, and reveals that Lane was actively conferring with Forbes before creating a commissioned work for him, taking into consideration and including the various technical aspects Forbes wished to have accentuated in these works.

Two years later, Lane would provide both a painting and another lithograph for his patron involving his humanitarian mission to Ireland. Entitled *Departure of the Jamestown for*

Cork, Ireland: R.B. Forbes commander. Boston March 28th, 1847 [figure 32], Lane's lithograph was specifically created as a frontispiece to Forbes's personal account of his humanitarian mission to the Emerald Isle. This work as well testifies to Lane working closely with his client, as the overloaded *Jamestown* sits abnormally low in the water, a historic detail so important to the telling of the tale. Even in 1855, a full decade since the beginning of their professional relationship and even after the artist had returned to Gloucester, Lane was still producing paintings, with derivative lithographs, for Forbes, thus revealing that their mutually beneficial collaboration was still active. With *Steam Demi Bark Antelope*, 615 tons, 1855 [figure 33], Lane had again faithfully represented one of Forbes's novel ship designs, though with a rather noticeable difference: this time, unlike what he had done with the *Massachusetts*, the vessel in question proudly goes forward under steam power. Forbes had designed the *Antelope* with a very specific mission in mind—trade between American merchants located in China and the recently opened ports of Japan. As these waters were notoriously pirate-ridden (giving reason for her to bear "three large caliber deck guns on swivel mounts"[165]), Forbes would turn to auxiliary steam propulsion to assure that this vessel would be able to make way in light airs and, more importantly, have extra speed when evading the pirates of those Far Eastern waters. Yet this was but the first of several applications of innovative steam technology aboard the *Antelope*—applications so ingenious as to make that vessel a tour de force of Forbes's talents and inventive imagination.

> *Antelope was equipped with an impressive array of steam-driven pumps that could pump the bilges, take out sand ballast, flood the powder magazines, fight fires, and even throw jets of scalding water on any pirates who might attempt to board her!* [166]

For a vessel such as this, the accentuating of steam propulsion in its portrait was an obvious necessity.

After Salmon's departure in 1842, Lane's artistic talents would be increasingly called upon by the merchant-mariners of Boston. That he was well known among the wealthy seafarers of the Northeast, and that his works were highly respected, is revealed by the *Boston Daily Evening Transcript*:

> *It was this faithfulness in the delineation of vessels, that procured* [Lane] *orders from the largest ship owners of New York and Boston, who did not consider their counting rooms (and even their parlors sometimes) furnished, without one of Lane's paintings of some favorite clipper.* [167]

Beginning with his *Cunard Liner Britannia*, 1842 [figure 34], the earliest known ship portrait he created (which, by all appearances, was not a commissioned work but rather an attempt to capitalize on the monumental fame and importance of the Cunard Line among Bostonians, using a highly visible subject to attract the attention of potential clients[168]), Lane

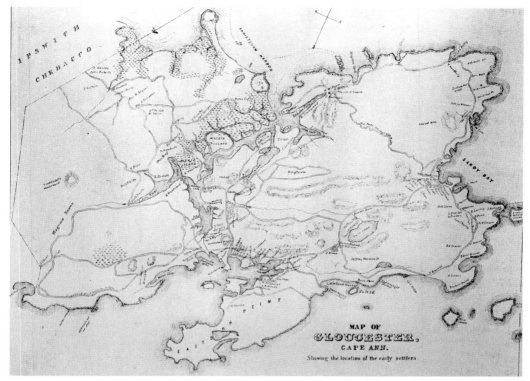

Figure 1. *Map of Gloucester Harbour Village, 1851. Cape Ann Historical Association, Gloucester, Massachusetts.*

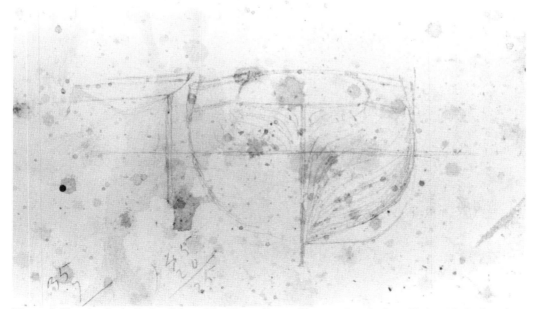

Figure 2. Sketch of a hull; detail from Fitz Henry Lane, *Gloucester from the Outer Harbor*, 1852. *Cape Ann Historical Association, Gloucester, Massachusetts.*

Figure 3. Attributed to Fitz Henry Lane, *Sail Plan of an Unidentified Fishing Schooner* (from the sail plan book of William F. Davis, Gloucester), pencil on paper, 1845. [Page 20 x 14 in.; image 9½ in.; scale ⅛ in. = 1 ft.] *Cape Ann Historical Association, Gloucester, Massachusetts.*

Figure 4.
Trailboards; detail
from (attributed
to) Fitz Henry
Lane, *Sail Plan of an
Unidentified Fishing
Schooner*, (from the
sail plan book of
William F. Davis,
Gloucester), pencil
on paper, 1845.
*Cape Ann Historical
Association, Gloucester,
Massachusetts.*

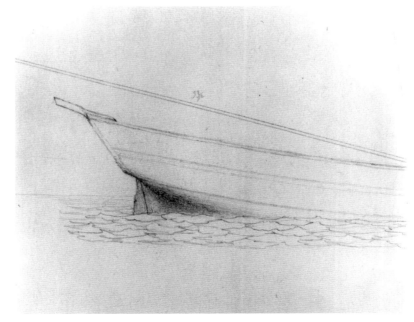

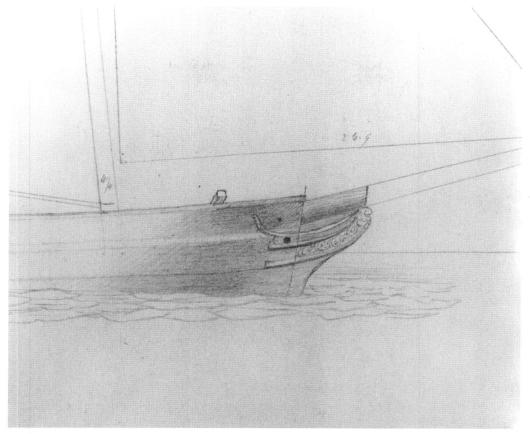

Figure 5. Billethead; detail from (attributed to) Fitz Henry Lane, *Sail Plan of an Unidentified Fishing Schooner*, (from the sail plan book of William F. Davis, Gloucester), pencil on paper, 1845. *Cape Ann Historical Association, Gloucester, Massachusetts.*

Figure 6. Fitz Henry Lane, *View in Gloucester Harbor*, pencil on paper, 1850. [9¹⁄₂ x 34³⁄₄ in.] *Cape Ann Historical Association, Gloucester, Massachusetts.*

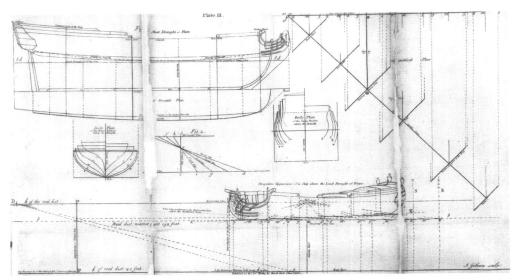

Figure 7. A. Cobin, *Short and Plain Principles of Linear Perspective, Adapted to Naval Architecture*, 4th ed. (London, 1794). Plate III. The five folding plates within this text illustrate the perspective drawing of ship and boat hulls, beginning with simple geometric shapes, then going on to progressively complex hull forms and difficult angles of view. *Private collection.*

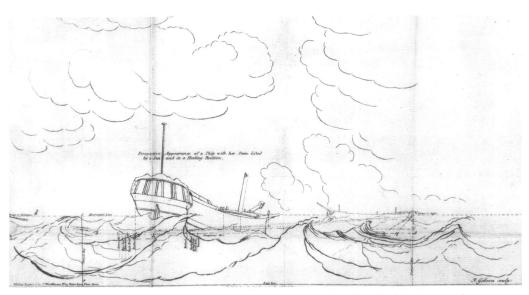

Figure 8. A. Cobin, *Short and Plain Principles of Linear Perspective, Adapted to Naval Architecture*, 4th ed. (London, 1794). Plate V. Of particular note are the similarities between how the waves in this plate have been constructed and those found within many Lane paintings (see *A Smart Blow*, 1856, figure 43, for a perfect example), and how more than three quarters of the image is sky, a near constant in Lane's compositions throughout his career. *Private collection.*

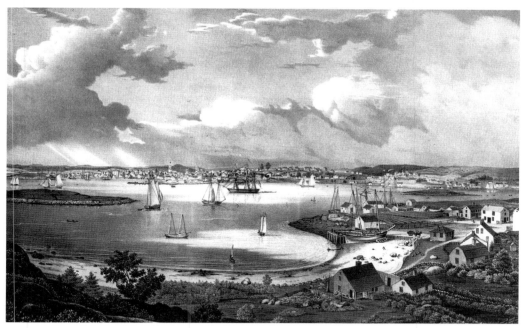

Figure 9. Fitz Henry Lane, *View of the Town of Gloucester, Mass.*, lithograph, 1836. [13 x 19¾ in.] *Cape Ann Historical Association, Gloucester, Massachusetts.*

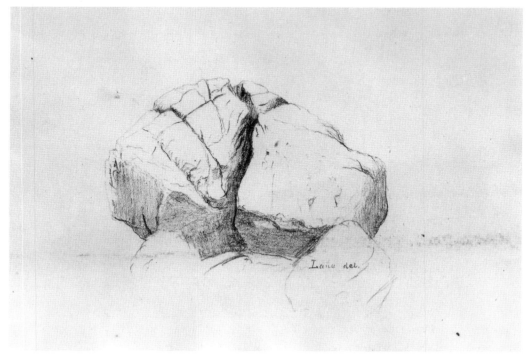

Figure 10. Fitz Henry Lane, *Rocks*, pencil on paper, 1850s. [7¼ x 9½ in.] *Cape Ann Historical Association, Gloucester, Massachusetts.*

Figure 11. Robert Cook, *Lane at Age 31*, drawing, 1835. *American Antiquarian Society, Worcester, Massachusetts.*

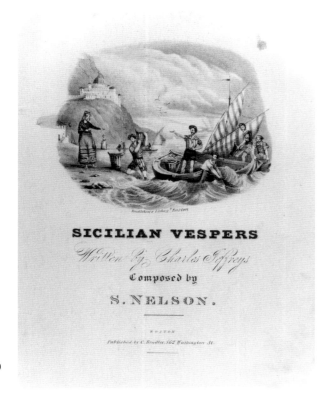

Figure 12. Fitz Henry Lane, *Sicilian Vespers*, lithographed sheet music cover, 1832. [Sheet 33.5 x 25 cm.; image 13.9 x 17.5 cm.] *Boston Athenaeum.*

Figure 13. Attributed to Fitz Henry Lane, *The Corsair's Bride*, lithographed sheet music cover. *Private collection.*

Figure 14. Attributed to Fitz Henry Lane, *The Midshipman's Farewell*, lithographed sheet music cover. *Private collection.*

Figure 15. Attributed to Fitz Henry Lane, *The Ship is Ready*, lithographed sheet music cover. *Private collection*.

Figure 16. Fitz Henry Lane, *View of the Old Building at the Corner of Ann Street*, lithograph, 1835. [10½ x 13 in.] *Boston Athenaeum.*

Figure 17. Fitz Henry Lane, *George W. Simmons'*
Popular Tailoring Establishment, Oak Hall, Boston,
lithographed pamphlet frontispiece, 1844.
[20¼ x 13¾ in.] *Boston Athenaeum.*

Figure 18. Fitz Henry Lane, *Horticultural Hall*, lithograph, ca. 1845. [15 x 10 in.] *Boston Athenaeum*.

Figure 19. Alfred K. Kipps, *Old Warehouse–Dock Square, Boston: Built 1680. Taken Down 1860*, lithograph, ca. 1861. [Sheet 34.8 x 43.8 cm.; image 26.9 x 37.5 cm.] *Boston Athenaeum.*

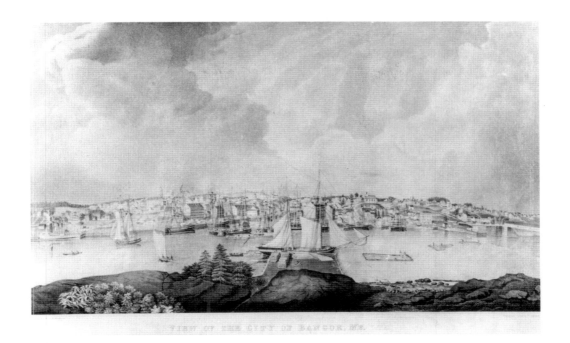

Figure 20. Attributed to Fitz Henry Lane, *View of the City of Bangor, Maine*, lithograph, 1835. [Sheet 52 x 76.1 cm.; image 40.5 x 68.3 cm.] *Boston Athenaeum.*

Figure 21. Fitz Henry Lane, *Castine, Maine*, oil on canvas, 1850. [21⅛ x 33½ in.] *Museum of Fine Arts, Boston, Bequest of Maxim Karolik.*

Figure 22. Fitz Henry Lane, *A Yankee Ship and a Yankee Crew*, lithographed sheet music cover. *Private collection.*

Figure 23. Fitz Henry Lane, *The Old Arm Chair*, lithographed sheet music cover, 1840. [Sheet 34.4 x 26 cm.; image 28 x 20.6 cm.] *Boston Athenaeum.*

Figure 24. Fitz Henry Lane, *The Maniac*, lithographed sheet music cover, 1840. [11¾ x 9 in.]
Boston Athenaeum.

Figure 25. Fitz Henry Lane, *The Pesky Sarpent: A Pathetic Ballad*, lithographed sheet music cover, 1840. [Sheet 34.5 x 24.9 cm.; image 25.1 x 18.9 cm.] *Boston Athenaeum.*

Figure 26. Fitz Henry Lane, *View in Boston Harbour*, lithograph, ca. 1837. [12 x 18 11/16 in.] *Museum of Fine Arts, Boston, Bequest of Charles Hitchcock Tyler.*

Figure 27. Fitz Henry Lane, *View of Gloucester from Rocky Neck*, colored lithograph, 1846. [21½ x 35½ in.] *Cape Ann Historical Association, Gloucester, Massachusetts.*

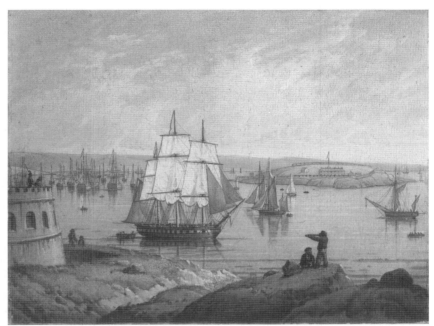

Figure 28.
Robert Salmon,
Plimouth Sound,
oil on panel,
1837.
[9½ x 12⅜ in.]
*Museum of Fine
Arts, Boston, Gift
of Maxim Karolik
for the M. and M.
Karolik Collection
of American
Paintings, 1815–
1865.*

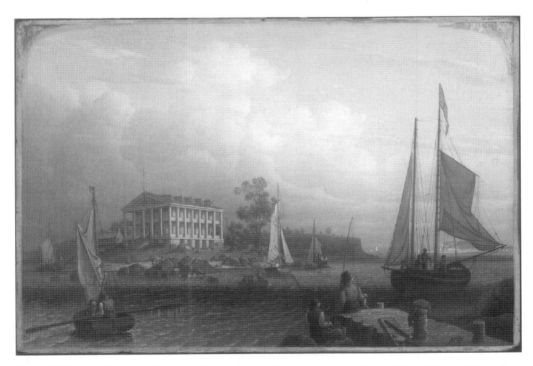

Figure 29. Robert Salmon, *Rainsford's Island, Boston Harbor,* oil on panel, ca. 1840. [16½ x 24¼ in.]
*Museum of Fine Arts, Boston, Bequest of Martha C. Karolik for the M. and M. Karolik Collection of American
Paintings, 1815–1865.*

Figure 30. Unidentified photographer, Captain Robert Bennett Forbes, albumen print. ca. 1885. *Peabody Essex Museum, Salem, Massachusetts, Gift of Robert F. Herrick, 1940.*

Figure 31. Fitz Henry Lane, *Auxiliary steam packet ship Massachusetts*, lithograph, 1845. [Sheet 36.7 x 50.7 cm.; image 24.7 x 36.1 cm.] *Boston Athenaeum.*

AUXILIARY STEAM PACKET SHIP MASSACHUSETTS.

Figure 32. Fitz Henry Lane, *Departure of the "Jamestown" for Cork, Ireland: R.B. Forbes commander. Boston March 28th, 1847*, lithographed frontispiece, 1847. [Sheet 52 x 76.1 cm.; image 40.5 x 68.3 cm.] *Boston Athenaeum.*

Figure 33. Fitz Henry Lane, *Steam Demi Bark Antelope, 615 tons*, lithograph, 1855. [11⅜ x 14½ in.] U.S. Nautical Magazine and Naval Journal, *October 1855.*

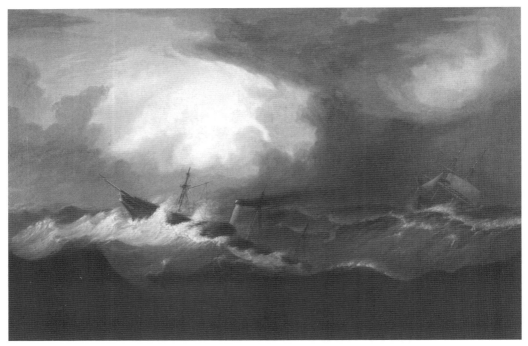

Figure 34. Fitz Henry Lane, *Cunard Liner "Britannia,"* oil on canvas, 1842. [29¾ x 41¼ in.] *Peabody Essex Museum, Salem, Massachusetts.*

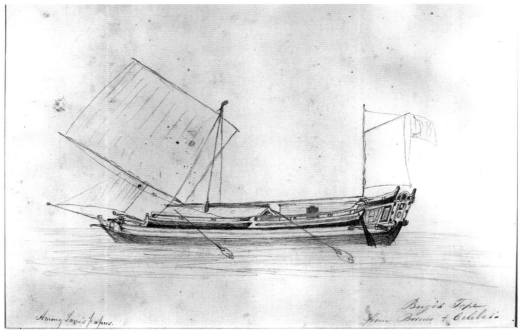

Figure 35. Fitz Henry Lane, *Bugis Tope from Borneo and Celebes*, pencil on paper, 1850s. [9½ x 13¼ in.] *Cape Ann Historical Association, Gloucester, Massachusetts.*

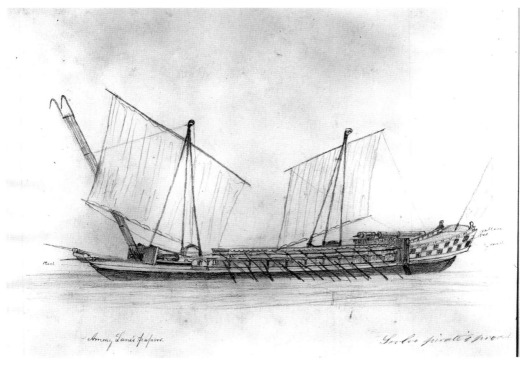

Figure 36. Fitz Henry Lane, *Sooloo Pirate's Proa*, pencil on paper, 1850s. [9½ x 14¼ in.] *Cape Ann Historical Association, Gloucester, Massachusetts.*

Figure 37. Thomas Doughty, *Beach Scene with Rocks II*, oil on canvas, 1835. [18 x 24 in.] *Museum of Fine Arts, Boston, Bequest of Maxim Karolik.*

Figure 38. Fitz Henry Lane, *Ten Pound Island from Pavilion Beach*, oil on canvas, 1850s. [21½ x 35½ in.] *Cape Ann Historical Association, Gloucester, Massachusetts.*

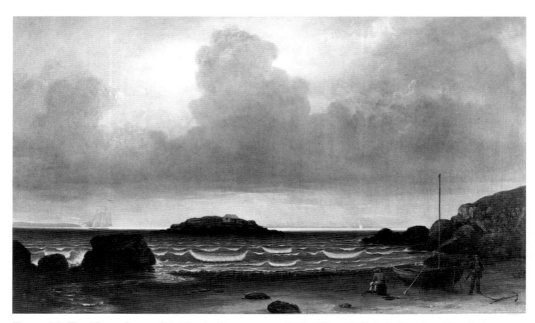

Figure 39. Fitz Henry Lane, *Salt Island*, oil on canvas, 1859. [27 x 46 ½ in.] *Cape Ann Historical Association, Gloucester, Massachusetts.*

Figure 40. Asher B. Durand, *Progress (The Advance of Civilization)*, oil on canvas, 1853. [48 x 72 in.] *From the Warner Collection of Gulf States Paper Corporation and on view in The Westervelt-Warner Museum of American Art, Tuscaloosa, Alabama.*

Figure 41. Asher B. Durand, *A Pastoral Scene*, oil on canvas, 1858. [21⅞ x 32⅜ in.] *National Gallery of Art, Washington, D.C., Gift of Frederick Sturges Jr.*

Figure 42. Alvan Fisher, *Landscape with Cows*, oil on panel, 1816. [28 x 40⅛ in.] *Museum of Fine Arts, Boston, Gift of Margaret A. Revere.*

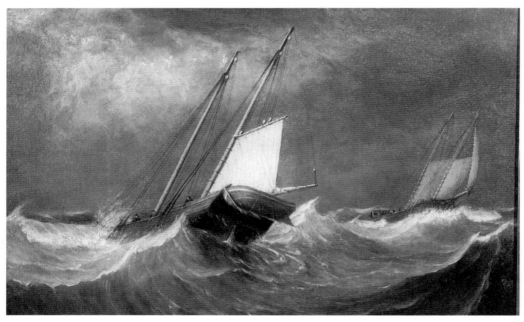

Figure 43. Fitz Henry Lane, *A Smart Blow*, oil on canvas, 1856. [10 x 15 in.] *Cape Ann Historical Association, Gloucester, Massachusetts.*

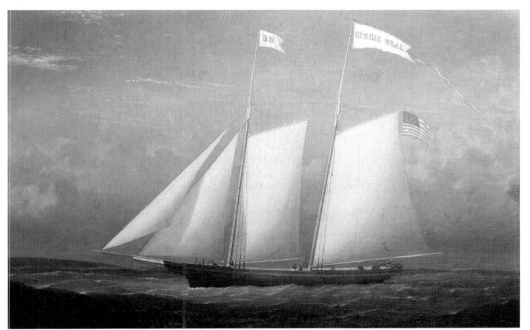

Figure 44. Fitz Henry Lane, *Schooner "Bessie Neal"*, oil on canvas, ca.1853. [20 x 30¾ in.] *Private collection*.

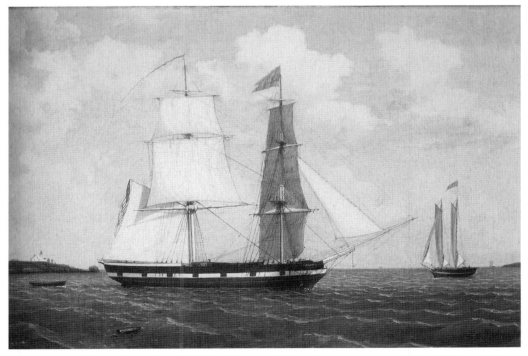

Figure 45. Fitz Henry Lane, *Brig "Cadet" in Gloucester Harbor*, oil on canvas, late 1840s. [15¼ x 23½ in.] *Cape Ann Historical Association, Gloucester, Massachusetts*.

Figure 46. "Party boat" with tourists; detail from left foreground of Fitz Henry Lane, *Gloucester Harbor from Rocky Neck*, 1844. *Cape Ann Historical Association, Gloucester, Massachusetts.*

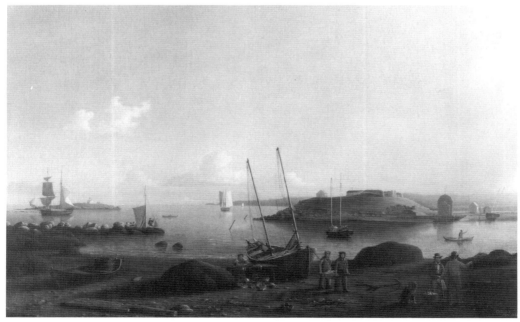

Figure 47. Fitz Henry Lane, *View of Gloucester Harbor*, oil on canvas on panel, 1848. [27 x 41 in.] *Virginia Museum of Fine Arts, Richmond, The Adolph D. and Wilkins C. Williams Fund.*

Figure 48. Fitz Henry Lane (?), from unidentified Gloucester newspaper, advertisement for Gloucester Hotel, ca. 1836. *Cape Ann Historical Association, Gloucester, Massachusetts.*

Figure 49. Fitz Henry Lane, *St. John's Porto Rico*, oil on canvas, 1850. [23¼ x 36¼ in.] *The Mariners' Museum, Newport News, Virginia.*

Figure 50. Fitz Henry Lane, *View at Bass Rocks Looking Eastward*, pencil on paper, 1850s. [10¼ x 43½ in.] *Cape Ann Historical Association, Gloucester, Massachusetts.*

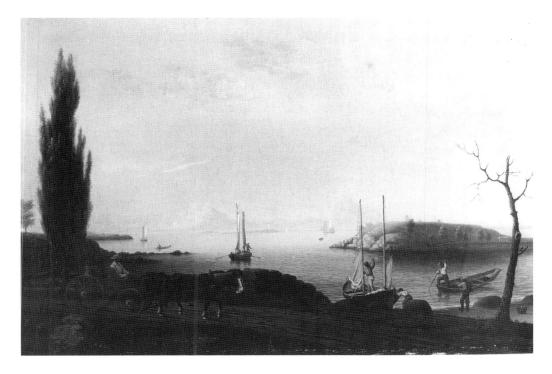

Figure 51. Fitz Henry Lane, *Good Harbor Beach, Cape Ann*, oil on canvas, 1847. [20 3/16 x 30⅛ in.] *Museum of Art, Rhode Island School of Design, Jesse H. Metcalf Fund.*

Figure 52. Pavilion Beach, from *Gloucester Picturesque*, 1890. *Negatives by Walter Gardner.*

Figure 53. The Pavilion Hotel, from *Gloucester Picturesque*, 1890. *Negatives by Walter Gardner.*

Figure 54. Eastern Point Light, from *Gloucester Picturesque*, 1890. *Negatives by Walter Gardner.*

RAFE'S CHASM, SHOWING STEAMER, CITY OF GLOUCESTER.

(10)

Figure 55. Rafe's Chasm, from *Gloucester Picturesque*, 1890. *Negatives by Walter Gardner.*

Figure 56. Norman's Woe, from *Gloucester Picturesque*, 1890. *Negatives by Walter Gardner.*

BASS ROCKS, SHOWING SALT AND THATCHER'S ISLANDS.

(6)

Figure 57. Bass Rocks, from *Gloucester Picturesque*, 1890. *Negatives by Walter Gardner.*

Figure 58. Brace's Rock, from *Gloucester Picturesque*, 1890. *Negatives by Walter Gardner.*

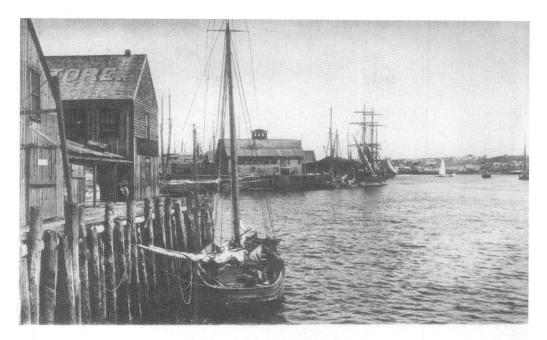

VIEW FROM THE FORT.

SHOWING THE ATLANTIC HALIBUT CO.'S PLACE OF BUSINESS.

(20)

Figure 59. Harbor view from Fort Point from *Gloucester Picturesque*, 1890. *Negatives by Walter Gardner.*

Figure 60. Fitz Henry Lane, *Ten Pound Island in Gloucester Harbor*, pencil on paper, 1864(?). [10½ x 15 in.] *Cape Ann Historical Association, Gloucester, Massachusetts.*

Figure 61. Fitz Henry Lane, *Sketch for Gothic Revival Cottage*, pencil on paper, n.d. *Cape Ann Historical Association, Gloucester, Massachusetts.*

Figure 62. Negotiation of easement between Fitz H. Lane and his neighbors Frederick G. Low and William Babson, November 9, 1849. *Cape Ann Historical Association, Gloucester, Massachusetts.*

Figure 63. Fitz Henry Lane House, Duncan's Point, Gloucester, Massachusetts. *Photo by Kathleen Craig 2005.*

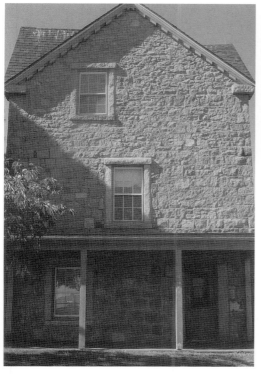

Figures 64 and 65. Asymmetrical windows, Fitz Henry Lane House. *Photo by Kathleen Craig, 2005.*

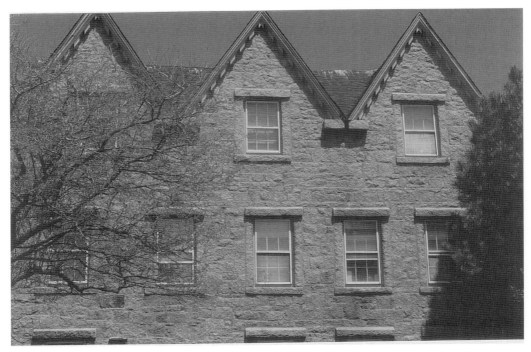

Figure 66. Gables (three of seven), decorated with simple Greek modillions, and western façade, Fitz Henry Lane House. *Photo by Kathleen Craig, 2005.*

Figure 67. Interior staircase, Fitz Henry Lane House. *Photo by Kathleen Craig, 2005.*

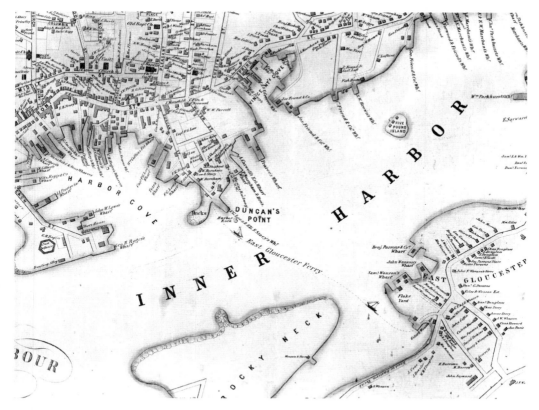

Figure 68. *Map of Gloucester Harbour Village* (detail of Duncan's Point area), 1851. Note the location of F. H. Lane's house, labeled "Winter & Lane." *Cape Ann Historical Association, Gloucester, Massachusetts.*

Figure 69. Burnham Brothers Marine Railway, with Fitz Henry Lane House on far left; detail from Fitz Henry Lane, *View of Gloucester*, 1855. *Cape Ann Historical Association, Gloucester, Massachusetts.*

Figure 70. Fitz Henry Lane, *View Across Gloucester Inner Cove, from Road near Beach Wharf*, pencil on paper, 1850s. [9½ x 22 in.] *Cape Ann Historical Association, Gloucester, Massachusetts.*

Figure 71. House of the Seven Gables, Salem, Massachusetts, ca.1890. *Collection of the House of the Seven Gables Museum, Salem, Massachusetts.*

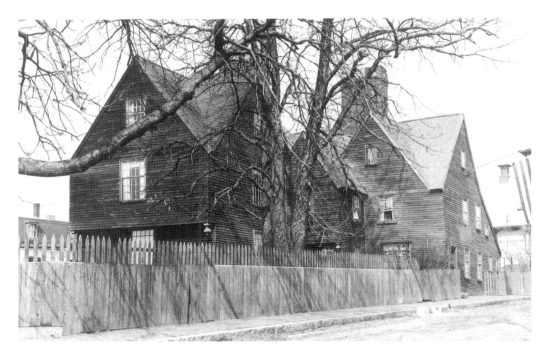

Figure 72. House of the Seven Gables, Salem, Massachusetts, ca. 1918. *Library of Congress.*

Figure 73. Inward taper of exterior walls, Fitz Henry Lane House. *Photo by Kathleen Craig, 2005.*

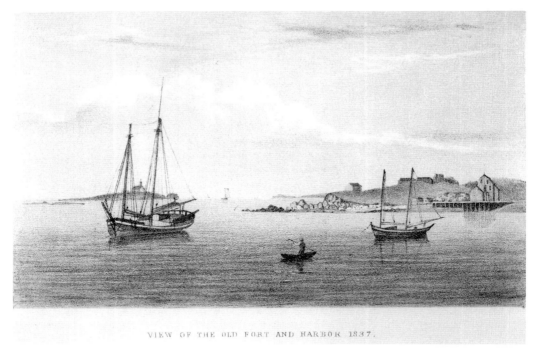

Figure 74. Fitz Henry Lane, *View of the Old Fort and Harbor, 1837*, lithograph, ca. 1860. [4 x 6¾ in.] *John J. Babson,* History of the Town of Gloucester, Cape Ann, 1860.

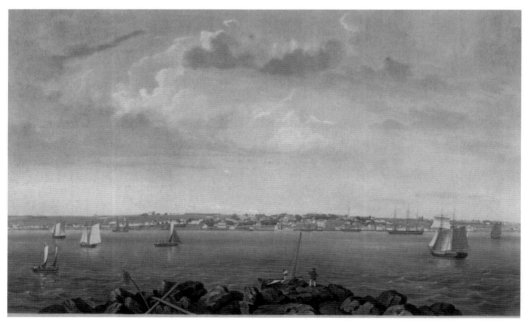

Figure 75. Fitz Henry Lane, *Castine from Hospital Island*, hand-colored lithograph, 1855. [Sheet 63.5 x 89.6 cm.; image 52.5 x 85.2 cm.] *Boston Athenaeum.*

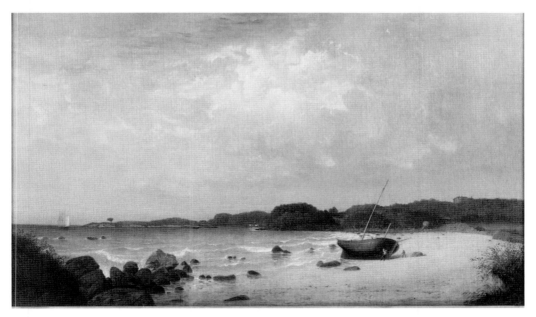

Figure 76. Fitz Henry Lane, *Dolliver's Neck and the Western Shore from Field Beach*, oil on canvas, 1857. [18½ x 32¾ in.] *Cape Ann Historical Association, Gloucester, Massachusetts.*

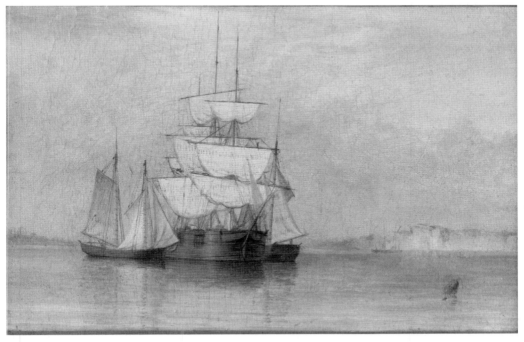

Figure 77. Fitz Henry Lane, *Study of Vessels*, oil on cardboard, 1857. [6¼ x 9½ in.] *Cape Ann Historical Association, Gloucester, Massachusetts.*

North East View of Owl's Head Aug.t 1851 Taken from Steamer's decks in passing—
by F. H. Lane

Figure 78. Fitz Henry Lane, *Northeast View of Owl's Head*, pencil on paper, 1851. [10½ x 16 in.]
Cape Ann Historical Association, Gloucester, Massachusetts.

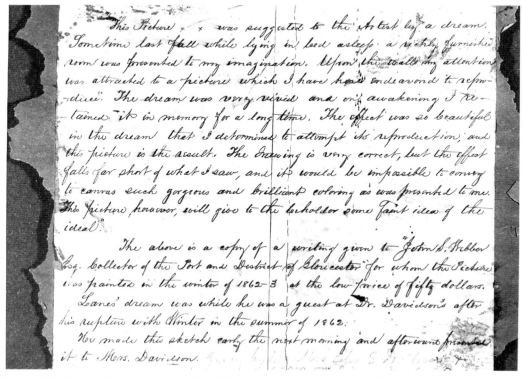

This Picture × × was suggested to the Artist by a dream.
Sometime last fall while lying in bed asleep a richly furnished
room was presented to my imagination. Upon the walls my attention
was attracted to a picture which I have had endeavord to repro-
-duce. The dream was very vivid and on awakening I re-
-tained it in memory for a long time. The effect was so beautiful
in the dream that I determined to attempt its reproduction; and
this picture is the result. The Drawing is very correct, but the effect
falls far short of what I saw, and it would be impossible to convey
to canvas such gorgeous and brilliant coloring as was presented to me.
This picture, however, will give to the beholder some faint idea of the
ideal."

The above is a copy of a writing given to "John S. Webber
Esq. Collector of the Port and District of Gloucester" for whom the Picture
was painted in the winter of 1862–3 at the low price of fifty dollars.
Lanes' dream was while he was a guest at Dr. Davidson's after
his rupture with Winter in the summer of 1862.
He made this sketch early the next morning and afterward presented
it to Mrs. Davidson.

Figure 79. Handwritten account of Fitz Henry Lane's *Dream Painting. Cape Ann Historical
Association, Gloucester, Massachusetts.*

Figure 80. Fitz Henry Lane, *Alcohol Rocks*, lithograph (sheet music cover?), 1842. [10¼ x 8 in.] *Library of Congress*.

Figure 81. Fitz Henry Lane, *John H. Hawkins*, lithograph, 1842. [10½ x 9 in.] *Library of Congress*.

Figure 82. Fitz Henry Lane, *William H. Harrison, Late President of the United States*, lithographed commemorative print, 1841. [12 x 9 in.] *Library of Congress.*

Figure 83. Mary Mellen, *Two Ships in Rough Waters* (detail), oil on canvas, 1865. [14¼ x 24⅛ in.] *Cape Ann Historical Association, Gloucester, Massachusetts.*

Figure 84. Attributed to Mary Mellen, *Moonlight Scene: Gloucester Harbor*, oil on canvas, 1870s. [13 x 20¼ in.] *Shelburne Museum, Shelburne, Vermont.*

Figure 85. Mary Mellen, *Field Beach, Stage Fort Park*, oil on canvas, 1850s. [24 ¹/₁₆ x 34 in.] *Cape Ann Historical Association, Gloucester, Massachusetts.*

Figure 86. Fitz Henry Lane, *Gloucester, Stage Fort Beach*, oil on canvas, 1849. [24 x 36¼ in.] *Private collection.*

Figure 87. Fitz Henry Lane/Mary Mellen, *Coast of Maine*, oil on canvas, 1850s. *Cape Ann Historical Association, Gloucester, Massachusetts.*

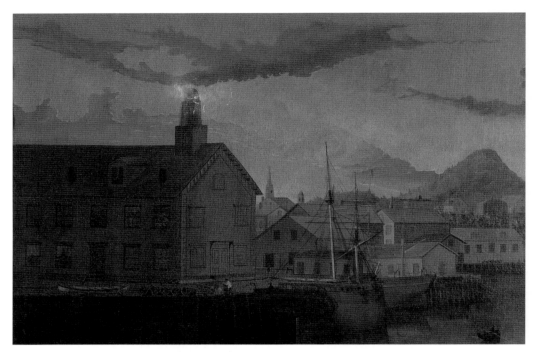

Figure 88. Architectural forms and stone wall; detail from left foreground of George Merchant Jr., *Port of Pico, Azores*, n.d. *Cape Ann Historical Association, Gloucester, Massachusetts.*

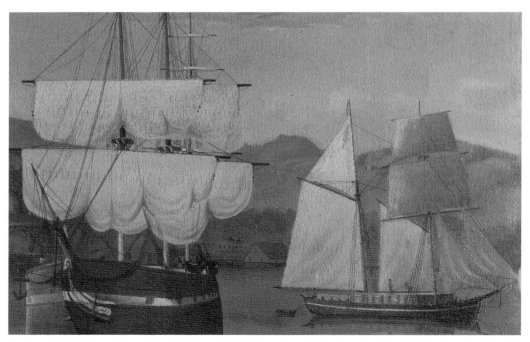

Figure 89. Sails; detail from right midground of George Merchant Jr., *Port of Pico, Azores*, n.d. *Cape Ann Historical Association, Gloucester, Massachusetts.*

Figure 90. Compositional devices; detail from right foreground of George Merchant Jr., *Port of Pico, Azores*, n.d. *Cape Ann Historical Association, Gloucester, Massachusetts.*

Figure 91. Fitz Henry Lane, *Owl's Head from the South*, pencil on paper, 1851. [10¼ x 15¾ in.] *Cape Ann Historical Association, Gloucester, Massachusetts.*

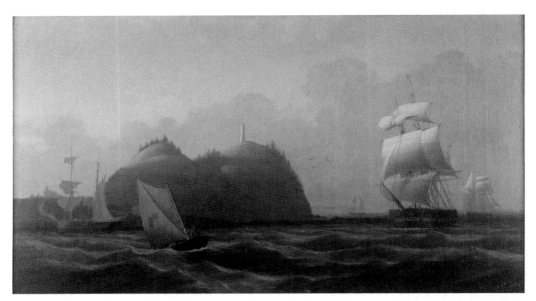

Figure 92. Fitz Henry Lane, *Off Owl's Head, Maine*, oil on canvas, 1852. [21 x 36¾ in.] *Cape Ann Historical Association, Gloucester, Massachusetts.*

Figure 93. Fitz Henry Lane, *Gloucester Outer Harbor, from the Cut*, pencil on paper, 1850s. [10½ x 29 in.] *Cape Ann Historical Association, Gloucester, Massachusetts.*

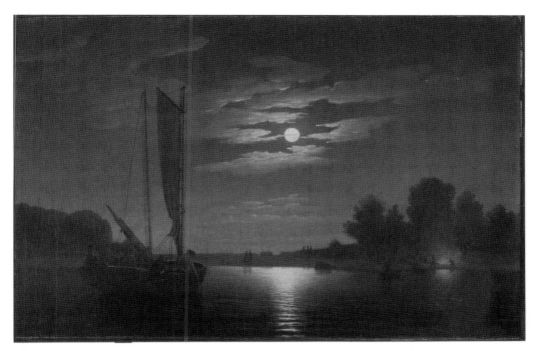

Figure 94. Fitz Henry Lane, *Fishing Party*, oil on canvas, 1850. [19⅝ x 30¼ in.] *Museum of Fine Arts, Boston, Gift of Henry Lee Shattuck.*

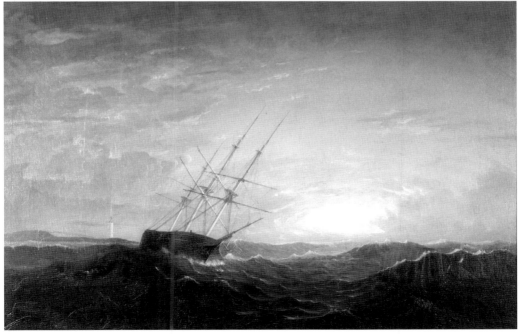

Figure 95. Fitz Henry Lane, *A Rough Sea*, oil on canvas, ca. 1860. [23½ x 35½ in.] *Cape Ann Historical Association, Gloucester, Massachusetts.*

Figure 96. William Prior Floyd, *Photographers' Studios, Queen's Road, Hong Kong*, albumen print, 1865–74. *Peabody Essex Museum, Salem, Massachusetts, Gift of Mrs. W.F. Spinney, 1923.*

Figure 97. Fitz Henry Lane, *Steamer "Harvest Moon," Lying at Wharf in Portland*, photograph and pencil on paper, 1863. [9¾ x 10½ in.] *Cape Ann Historical Association, Gloucester, Massachusetts.*

Figure 98. Fitz Henry Lane, *The Western Shore with Norman's Woe*, oil on canvas, 1862. [21½ x 35¼ in.] *Cape Ann Historical Association, Gloucester, Massachusetts.*

Figure 99. Fitz Henry Lane, *Beached Hull*, pencil on paper, 1862. [14 x 15 in.] *Cape Ann Historical Association, Gloucester, Massachusetts.*

Figure 100. Fitz Henry Lane late in life, photograph, ca. 1860. *Cape Ann Historical Association, Gloucester, Massachusetts.*

COMMONWEALTH OF MASSACHUSETTS.

ESSEX, ss. PROBATE COURT. *Charles W. Dennison*

To *Benjamin F. Somes,* ~~*Samuel L. Stacy*~~

and ~~*Salisbury S. Tuckerman*~~ *Charles E. Grover* GREETING:

YOU are hereby appointed to appraise, on oath, the estate and effects of *Fitz H. Lane* late of *Gloucester* in said County of Essex, *artist* deceased, which may be in said Commonwealth. When you have performed that service, you will deliver this order, and your doings in pursuance thereof to *Thomas L. Stevens and T. Sewall Lancaster* Execut*ors* of the will of said deceased, that he may return the same to the Probate Court for said County of Essex.

Witness my hand and the seal of said Court, this *third* day of *October* in the year of our Lord one thousand eight hundred and sixty-*five*.

Geo. F. Choate Judge of Probate Court.

ESSEX, ss. *November 15th* A. D. 186*5*. Then the above-named *Benj. F. Somes, Charles W. Dennison and Charles E. Grover* personally appeared and made oath, that they would faithfully and impartially discharge the trust reposed in them by the foregoing order.

Before me,

A. Kressin Justice of the Peace.

Pursuant to the foregoing order, to us directed, we have appraised said estate as follows, to wit:

Amount of Real Estate, as per schedule exhibited, $
Amount of Personal Estate, as per schedule exhibited, $ *4887.51*

Benj. F. Somes
Chas. W. Dennison } Appraisers.
Chas. E. Grover

ESSEX, ss. *Feb. 23d* A. D. 186*6*. Then personally appeared *T. Sewall Lancaster* one of the Execut*ors* of the will of said deceased, and made oath that the foregoing is a true and perfect Inventory of all the estate of said deceased that has come to h*is* possession or knowledge.

Before me,

A. Kressin Justice of the Peace.

Figure 101. Probate Court inventory (page 1) of the estate of Fitz H. Lane, late of Gloucester, October 3, 1865–February 23, 1866. *Commonwealth of Massachusetts, Essex County Probate Court.*

		Dolls.	Cts.
	Household Furniture, Paintings, Books, Maps, Spy Glass & Barometer 432.61		
Legacies	Painting of Gloucester Harbor 100.		
"	Family Portraits 60		
"	Wax Flower Wreath 20		
"	Watch & Chain 100		
"	Breast Pin 25		
	Cash 10	737	61
	Interest in Guy Stock	70	
	Promissory Note	4080	
		$ 4887	61

Figure 102. Probate Court Inventory (page 2) of the estate of Fitz H. Lane, late of Gloucester, October 3, 1865–February 23, 1866. *Commonwealth of Massachusetts, Essex County Probate Court.*

Know all Men by these Presents,

That I, Joseph L. Stevens Jr. of Gloucester, in the County of Essex and Commonwealth of Massachusetts,

in consideration of *Five Thousand Dollars* to me

paid by *Frederick G. Low of same Gloucester*

the receipt whereof is hereby acknowledged, do hereby give, grant, bargain, sell, and convey, unto the said *Frederick G. Low his heirs and assigns forever a certain piece or parcel of land situate at the corner of Locust Street, so called, and Ivy Place (or Court) so called, in said Gloucester on Duncans Point, with the Stone Dwelling House and all other buildings, and improvements thereon, and is bounded and described as follows, viz:— Beginning on said Locust Street at land of Thomas Hall, thence North 63° East by said Street, Sixty nine feet to the commencement of a curve, which place is Six feet six inches from the point of intersection of the two streets, thence curving into Ivy Place to a point Six feet nine inches from said intersection, thence South 27° East One hundred Seventy nine feet more or less, to land of Joseph Shepherd thence South Westerly by said Shepherds land Twenty one feet, thence South Easterly Six feet to bolt in rock, thence South Westerly by the side of the wall and abutment between these premises and land of said Shepherd & Francis Sheveree Seventy & one half feet to the corner, thence Northerly by lands of McEachren, Riggs, Cameron & Hall Two hundred & twenty four feet more or less to Locust Street, the place of beginning. Containing more or less.*

Being the same premises conveyed to

by .. ' by deed dated

and recorded with .. Deeds.

To have and to hold the above granted premises, with all the privileges and appurtenances to the same belonging, to the said *Frederick G. Low* his heirs and assigns, to their use and behoof forever.

Figure 103. Transferral (page 1) of Lane House from the ownership of Joseph L. Stevens Jr. to Frederick G. Low, November 16, 1866. *Cape Ann Historical Association, Gloucester, Massachusetts.*

And I the said grantor for *myself* and *my* heirs, executors, and administrators, do covenant with the said grantee *his* heirs and assigns, that *I am* lawfully seized in fee simple of the aforegranted premises; that they are free from all _____ incumbrances, *except a Mortgage Deed dated Jan 15. 1863 to N. E. Davidson Trustee for payment of Twenty five hundred dollars in five years, which payment is assumed by Grantee as part of aforesaid consideration to Grantor* that *I* have good right to sell and convey the same to the said grantee *his* heirs and assigns, forever, as aforesaid; and that *I* will, and *my* heirs, executors, and administrators, shall warrant and defend the same to the said grantee *his* heirs and assigns forever, against the lawful claims and demands of all persons.

In Witness whereof, I the said *Joseph L. Stevens Jr together with my wife Caroline S. Stevens She joining with me in this conveyance*

in token of *her* release of all right of or to both dower and homestead in the granted premises, have hereunto set *our* hands and seals this *fifteenth* day of *November* in the year of our Lord eighteen hundred and sixty *six.*

Signed, sealed, and delivered
in presence of
David W. Low *Joseph L. Stevens Jr*

Emma F. Trindall *Caroline S. Stevens.*

COMMONWEALTH OF MASSACHUSETTS,
Essex ss. *November 16th 1866.*
Then personally appeared the above named
Joseph L. Stevens Jr
and acknowledged the above instrument to be
his free act and deed. Before me,
David W. Low
Justice of the Peace

Essex. ss. Rec'd Nov. 23. 1866.
16 m. past 11 AM
Recorded Book 714 leaf 158
exam'd by Ephm Brown Regr
Received and entered with
Deeds. Lib. Fol.

Figure 104. Transferral (page 2) of Lane House from the ownership of Joseph L. Stevens Jr. to Frederick G. Low, November 16, 1866. *Cape Ann Historical Association, Gloucester, Massachusetts.*

Figure 105. Plan for Fitz Henry Lane Memorial, 1865. *Cape Ann Historical Association, Gloucester, Massachusetts.*

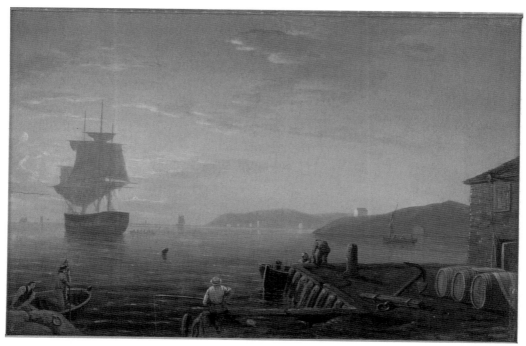

Figure 106. Fitz Henry Lane, *On the Wharves, Gloucester Harbor*, oil on panel, 1847. [9¾ x 14½ in.] *Cape Ann Historical Association, Gloucester, Massachusetts.*

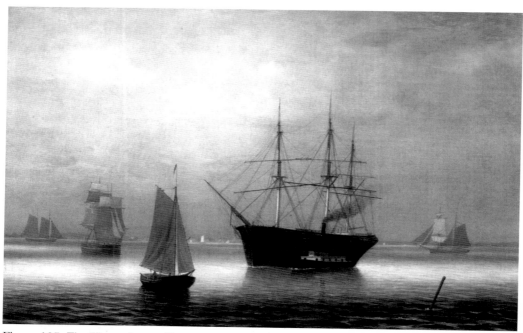

Figure 107. Fitz Henry Lane, *Gloucester Harbor*, oil on canvas, 1859. [20 x 13 in.] *Cape Ann Historical Association, Gloucester, Massachusetts.*

Figure 108. Fitz Henry Lane, *Salem Harbor*, oil on canvas, 1853. [26⅛ x 42 in.] *Museum of Fine Arts, Boston, Bequest of Maxim Karolik.*

IMPORTANT PAINTINGS OF THE SEA

Fitz Hugh Lane, "The Cunard Steamer *UNICORN* in Salem Harbor, 1840". Oil on canvas; Size: 15" x 23". Framed. This early painting by Lane shows the *UNICORN* on a brief visit to Salem in 1840. The painting has been described by an authority on Lane's work as "one of his earliest dated oils and one of only three known, dated 1840."

Exceptional marine works purchased.

Marine Arts Company
127 ESSEX STREET
SALEM, MASSACHUSETTS 01970
PHONE: (617) 745-5000 OR (617) 922-0025 HOURS: 9-6 MON.-SAT.

Figure 109. Advertisement for *The Cunard Steamer "Unicorn" in Salem Harbor, 1840.*

132

Property of Sotheby's

132 △ 'Fitz Hugh Lane
(1804-1865)

"UNICORN" IN SALEM HARBOR
signed *F.H. Lane* and dated
1840 l.l.
oil on canvas
16 by 24in. (40.6 by 61cm.)

$200,000–300,000

302,750

According to John Wilmerding, *Unicorn in Salem Harbor* is one of Fitz
Hugh Lane's earliest known oil paintings, and one of only three known
from 1840. It shows the arrival of the Cunard Lines steam packet.
Unicorn on its maiden voyage from England. During the early part of his
career, Lane was evidently keen to cultivate the shipping magnate, Samuel
Cunard, as a client, since several of his works dating from this period
depict Cunard line boats. In a letter of June 25, 1971, John Wilmerding
writes: "Lane's painting of the Cunard Steamer, *Unicorn* is . . . closely
related in subject and composition to one of the others from this year,
S.S. Britannia in Boston Harbor which is in a private collection. Together
they are exemplary of Lane's early interest in shipping activities along the
New England coast as he became familiar with it during his youth in
Gloucester and his apprenticeship at Pendleton's Lithography shop in
Boston . . . The *Unicorn in Salem Harbor* shows the impact of Lane's
graphic training on his early style in oil painting. His astute sense of
contrasting lights and darks, his preference for seeing forms primarily as
silhouettes, and his reliance on clear, careful draughtsmanship–all derive
from his early work as a lithographer."

Provenance:
Private Collection, New England

Figure 110. Advertisement for *"Unicorn" In Salem Harbor.*

would successfully build a lucrative patronage among Boston's seafaring elite, a patronage that would continue to serve him well through the 1850s and into his final years. His ship portraits were numerous. *Ship "Samuel Lawrence" Picking Up a Boston Pilot*, 1851; *Clipper Ship "Southern Cross" Leaving Boston Harbor*, 1851 [plate 14]; *Ship "Winged Arrow" in Boston Harbor*, 1852 ; *Clipper Ship "Radiant" and "John Land,"* 1853; *Bark "Eastern Star" of Boston*, 1853 [plate 16]; *Ship "National Eagle,"* 1853 [plate 15]; *Ship "Starlight,"* 1854; *Bark "Smyrniote" of Boston*, 1859; *Ship "Starlight,"* 1860; *Steam Bark "Edith,"* (n.d.); and *Brig "Antelope" in Boston Harbor*, 1863, are just some of the numerous ship portraits Lane crafted on commission for the investors and owners of Boston's merchant fleet. As Boston's merchant-mariners were a tight, sociable business group, favorable praise via word of mouth from just a few pleased patrons would have gone far in gathering future clients for Lane.

The departure of Salmon and the inevitable vacuum his absence created cannot be ignored as a factor in Lane's rise to artistic prominence, as this event now permitted Lane to take his place as the premier naval artist in Boston. Local Boston papers verify this with statements such as "Since Salmon's death, we have no one who can paint a ship and ocean prospect like [Lane]. His 'squalls at sea' are the best things of the kind that we remember to have seen,"[169] and, after Salmon's death in 1856,

> *I suppose it is generally known that Mr. Lane stands highest—as a marine artist, —in the world. Salmon, by many was considered his superior, while others gave Lane the precedence. Salmon has passed away with the last year, leaving his immortal gifts and laurels to Europe, while Mr. Lane still lives to bring down the glorious clouds, and make the mighty ocean subservient to his tastes. —May he long live to gladden the world with his precious gifts.*[170]

The publication of his lithographs in highly visible naval journals and popular accounts was, beyond a doubt, also instrumental in his drawing the notice of Boston shipowners, something to which Lane obviously owed a heavy debt to R.B. Forbes. The abovementioned litho *Steam Demi Bark Antelope* was fashioned as an accompanying illustration to the October 1855 issue of *U.S. Nautical Magazine and Naval Journal*. Created specifically as a means to publicly urge for improvements in American ship designs while celebrating the far-sighted innovations of progressive shipwrights, this journal would serve as the first periodical on shipbuilding to ever be published in North America. Forbes's associations with this magazine ran deep, as he was one of the most progressive and innovative shipowners of that time. By his associations with Forbes, Lane's work now graced a national publication aimed specifically at shipwrights, shipowners and merchant-mariners—a testimony as to how highly Forbes regarded Lane's talents as a marine artist, as well as assuring that Lane's artistic abilities were exhibited to a wide, discerning audience. As with his cover sheet illustrations for the work of composer Henry Russell, Lane again fashioned illustrations for the leader of a particular professional caste.

It is during the late 1840s and early 1850s that we also see Lane's reputation as a marine artist moving beyond Boston. Shipowners and sea captains down in New York began

calling upon him to portray their vessels upon the canvas as well. Lane was most likely introduced to the New York market by word of mouth, probably through the personal recommendation of R.B. Forbes, as the Forbes family had numerous family members and business associates centered in Manhattan. An endorsement may also have come from Sidney Mason, another known Lane patron who resided in both Gloucester and New York at the time, and who was a member of New York's exclusive social circles, including the New York Yacht Club. (One of Lane's canvases of a New York Yacht Club regatta was actually commissioned by Mason personally.[171])

Lane would pay particular attention to the New York Yacht Club regattas off of Newport and New Bedford, painting four large canvases of the 1856 New Bedford regatta alone.[172] The New York Yacht Club was a consortium of Manhattan's wealthy merchant-mariners with an insatiable lust for the sea, men whose patronage would easily translate into dollars for the marine artist whose work could catch their eye. That Lane did business with members of the yacht club—and that the work he did for them was some of the most profitable he ever acquired—is attested to by John Trask, who commented that Lane "painted two yacht races off Newport and received five hundred dollars each for them,"[173] some of the highest sums Lane would ever claim for a painting in his lifetime. Once again, Lane's strategizing had paid handsomely.

As his reputation as a marine painter continued to grow, it appears that Lane garnered the interest of people not only beyond Boston, but sometimes even beyond the United States. Trask noted that Lane once

> received a letter from Liverpool, accompanied by a picture which had been painted by an unknown artist, the subject a ship under full sail. He was requested to take out the one fault which everyone saw but could not explain. After entirely painting in new rigging it was returned to the owner. For this he received a large sum.[174]

In 1841, one year before Salmon embarked for Europe, Lane not only publicly declared himself a marine painter, but also participated in his first public art exhibitions, the most important of which was held at the Boston Athenaeum.[175] Here Lane would offer up only two works for public scrutiny, one piece vaguely titled *Sea Beach*, the other sporting the equally vague name *Scene at Sea*.[176] While the ultimate fate of these two early works is unknown, their importance in the career of Fitz H. Lane stands as being virtually incalculable, given that they mark the culmination of nine years spent seeking artistic direction, and the beginning of his career as an artist in earnest. The 1841 exhibition at the Boston Athenaeum would also mark the beginning of a relationship with that institution which would last for the rest of his life. Nineteen different works by the artist would be exhibited upon the Athenaeum's walls between the years 1841 and 1865, with some, like *Sea Beach* and *Scene at Sea*, being offered for sale by Lane personally, while others were displayed by their proud owners.[177]

Exhibiting at the Boston Athenaeum was not just a simple means by which Lane could

display his creations publicly, nor was it a mindless imitation of what Salmon had done for so many years before. In fact, it was nothing less than Lane making the most pronounced entrance onto the Boston art scene possible, for the Boston Athenaeum was far more than just a private library. Founded in 1807 with the intentions of forming "an establishment similar to that of the Athenæum and Lyceum of Liverpool in Great Britain; combining the advantages of a public library [and] containing the great works of learning and science in all languages,"[178] it was almost inevitable that such an institution would attract both the wealthiest and most learned of Boston's citizens (especially as that city lacked both a library and a museum of fine arts at that time) and would soon become the focal point of high culture within the Hub, hosting lectures, discussion groups and, beginning in 1827, art exhibitions. "The Athenaeum was a natural location for these events…it was the leading arm—i.e., the main literary resource center and main point of assembly—of the Boston Literati of the period."[179]

The Athenaeum's list of proprietors included authors such as Henry Wadsworth Longfellow, Ralph Waldo Emerson and Richard Henry Dana; author and publisher James T. Fields; William Ellery Channing, "the Star of the American Church"[180] and Boston's foremost Unitarian preacher and prime influence behind the formation of transcendental thought; Jared Sparks, historian, Unitarian minister and president of Harvard College; Lucius Manlius Sargent, reformer, author, art critic and collector of marine art books and paintings by Robert Salmon; Dr. John Collins Warren, initial proponent of Boston's first hospital, advocate for the mentally ill and the first surgeon of modern times to ever perform an operation with the aid of anesthesia; and Dr. Jacob Bigelow, noted physician, architect, head of the Massachusetts Horticultural Society and founder of the garden cemetery movement in America.

Men such as these, along with wealthy merchants and investors like Colonel Thomas Handasyd Perkins, Samuel Cabot, J.P. Cushing, John Murray Forbes and (his brother) Robert Bennett Forbes helped to make the Athenaeum "the unchallenged center of intellectual life in Boston, and by 1851…one of the five largest libraries in the United States."[181] Its fame and resources made it a place of pilgrimage for men and women across the nation, and the world. Among the signatures of foreign ambassadors, merchants and naval officers, the signatures of many of New England's literati, including Nathaniel Hawthorne, Amos Bronson Alcott, Henry David Thoreau, Ellery Channing and the reclusive Emily Dickinson, appear with varying levels of frequency between the 1830s and 1850s in the Athenaeum's *Book of Strangers*. Industrialists and inventors such as Samuel Colt, and architects such as Benjamin Latrobe were drawn to the Athenaeum, as were, of course, artists, including John J. Audubon and Thomas Cole.[182] Lane's decision to exhibit his works in an institution such as the Boston Athenaeum can thus be seen as a bold (and logical) attempt to draw notice from Boston's most learned, wealthy classes and gain their patronage.

It is also probable that Lane used the Athenaeum as a research tool in the creation of rather difficult compositions. Within the Cape Ann Historical Association's voluminous

collection of Fitz Henry Lane sketches, among so many drawings of the New England coast and the watercraft that cruised along it in Lane's time, we find two anomalies. Titled *"Bugis Tope" from Borneo and Celebes* [figure 35] and *Sooloo Pirate's Proa* [figure 36], these two sketches are unusual in that they are representations of vessels hailing from halfway around the world, in the waters surrounding Indonesia. As we have no record of Lane ever having traveled to that distant corner of the earth, we are left to wonder how Lane managed to execute two faithful, technically accurate drawings of watercraft he never saw firsthand, in a part of the world he never traveled to. The answer would seem to be the Athenaeum. It must be noted that the Boston Athenaeum does not list Lane as ever having been a member of their institution (something that would have been beyond his means to afford), and he would not have been able to just walk in off the street given that it was a private institution. Yet it was permitted for guests in the company of a proprietor to visit the library and make use of its collection. Given its place as "one of the five largest libraries in the United States," the Athenaeum stands as the one logical place in all of Boston where Lane would have turned to for information on a topic such as Indonesian sail craft. Easily enough we can imagine a patron of Lane's such as Forbes (if not Forbes himself) permitting him access to the Athenaeum's collection for just such a purpose. This would not have been the first time such an arrangement had occurred within the Athenaeum. During the winters of 1827 and 1828, architect (and at that time Pendleton's lithographer) Alexander Jackson Davis would, despite his status as being a non-member of the Athenaeum, make regular use of its collection in the furthering of his architectural studies.[183]

Further evidence exists of Lane having made use of the Athenaeum's collection. When "called upon to illustrate the precursor to the gaff rig of schooners for Babson's history of Gloucester,"[184] Lane, having no current-day examples to draw upon, would have had to research such a design in a marine dictionary. One might even be so bold as to declare which dictionary he turned to in the midst of his investigations, as "His engraving follows closely that of Jal's *Glossaire Nautique*,"[185] a French text published in 1848 that was found in the collection of the Boston Athenaeum.[186] And Lane did more than just make use of the Athenaeum's book collection. As a repository of fine art, we find the Athenaeum to have possessed the most extensive collection of copies of Greek and Roman statuary in the city of Boston at that time. As the central figure featured within Lane's 1840 music sheet cover illustration *The Maniac* was stylistically based upon Greco-Roman statuary (as evidenced by his classical drapery and curly locks) logic would dictate that to have crafted such a figure, Lane would have turned to the Athenaeum for examples of classical sculpture to sketch and study.

The Boston Athenaeum appears to have served several roles for Lane. By exhibiting his art there, Lane was able to advertise his skills and seek patrons from among the wealthiest and most learned minds in America. As a library it enabled him to conduct research necessary for mastering the finer points of commissioned works that went beyond his usual oeuvre. The Athenaeum quite well may have served as a means by which Lane gained entrance into the world of Boston reformers and philosophers. Yet one other

possible application for the Athenaeum in Lane's career is the expansion of his artistic vision, given the other artists who regularly exhibited there. Athenaeum proprietors would recurrently loan works from their personal collections executed by such old-world masters as Diego Velázquez, Peter Paul Rubens, Nicolas Poussin, Tintoretto, Tiepolo, Carravaggio, Rembrandt and Raphael, among so many others, thus affording Lane the chance to study firsthand the compositions of some of the greatest artists ever.[187] In addition, several of America's foremost artists then living were showing their works there. Benjamin Champney stated, "At this time there were few artists in Boston. Alvan Fisher and Thomas Doughty were painting landscapes."[188] It is clear what effect Salmon had on Lane's artistic vision, but what of these other two great artists, living and working within Boston at the same time as the Gloucester artist?

We know that Lane was afforded numerous opportunities to view the works of these artists at the Athenaeum's yearly exhibitions. Between the years 1832 and 1848, pioneer American landscape painter Thomas Doughty, "the forerunner of the school of American landscape painters," would exhibit twenty-nine pictures at the Boston Athenaeum art shows.[189] Among these was his *Desert Rock Lighthouse, Maine*, of 1836,[190] the first major painting of a Maine subject, depicting an area that Lane would frequent regularly during summer excursions to Maine beginning in 1848. Alvan Fisher, another early pioneer in the rising genre of landscape painting, would prove even more prodigious, exhibiting no fewer than seventy-two works during this same time period.

From the lips of Lane's close personal friend Joseph L. Stevens Jr. we discover that Lane was quite familiar with Boston's (as well as New York's and Philadelphia's) artists:

> *Lane was frequently in Boston, his sales agent being Balch who was at the head of his guild in those days. So in my Boston visits—I was led to Balch's fairly often—the resort of many artists and the depot of their works. Thus through Lane in various ways I was long in touch with the art world, not only of New England but of New York and Philadelphia.*[191]

In addition to Thomas Doughty and Fitz H. Lane sharing an affinity for the coast of Maine, they also shared the same sales agent for the selling of their art, the abovementioned William T. Balch of 10 Tremont Row, Boston.[192] As regards Alvan Fisher, we find that he held an admittedly tenuous connection to Pendleton's lithography shop, since he would partner with Pendleton's to publish a lithograph of his portrait *Casper Spurzheim M.D.*[193]in 1832, as well as exhibiting at the Athenaeum in 1830 a portrait of Lane's employer titled *Mr. Wm. Pendleton*.[194]

While Lane would have been hard-pressed *not* to have seen the works of Doughty and Fisher, and while it seems quite probable that he crossed paths with them regularly enough to have held at least a professional acquaintanceship with them, there is no known evidence alluding to Lane having sought instruction from these two great artists. We find that Lane's work ultimately holds little in common with their artistic offerings in matters of style and technique. Fisher would employ broad, thick brush strokes as opposed to

Lane's thin glazes, and would prove far more accomplished in imbuing his figures with a sense of life and personality. Fisher would also place little detail into his foreground foliage while investing far greater detail into the mid-ground foliage—the direct opposite of Lane. Doughty as well, though he painted waves in a similar stylistic manner to what Lane would one day execute (compare Doughty's *Beach Scene with Rocks I*, 1834 [figure 37], to Lane's *Ten Pound Island from Pavilion Beach*, 1850s [figure 38], and *Salt Island*, 1859 [figure 39]) and used driftwood in his canvases as a compositional device, employed a brush stroke and use of impasto quite unlike that of Lane's.

Though technical and stylistic similarities between their creations and Lane's may be few and far between, we find the realm of subject matter to be an altogether different matter. In a decision that would take him far beyond the example of Robert Salmon, Fitz H. Lane would choose to invest ample effort and time within the emerging genre that Doughty, Fisher and several other American painters were at that moment tirelessly pouring their energies into—the world of landscape painting.

> *And can there be a country in the world better calculated than ours to exercise and to exalt the imagination—to call into activity the creative powers of the mind, and to afford just views of the beautiful, the wonderful, and the sublime? Here Nature has conducted her operations on a magnificent scale…This wild, romantic, and awful scenery is calculated to produce a correspondent impression in the imagination—to elevate all the faculties of the mind, and to exalt all the feelings of the heart.*[195]

In his 1816 address at the American Academy of Fine Arts, Governor De Witt Clinton of New York would exhort American artists to turn to the American landscape for their inspiration, urging them to create a new art form independent from the traditions of Europe, one that would celebrate the promise and hope their new nation held, as embodied within the pristine grandeur of the American landscape. In issuing this challenge, Governor Clinton was calling for nothing less than the codification of a national identity, as reflected in the creations of artists.

America as a nation was growing self-conscious at this time in its history. Western expansion had opened people's eyes to the majesty and beauty their new nation held, global trade had opened them up to different cultures and highlighted America's emerging place within the global community, industrialization and technology were blooming, transforming life by leaps and bounds. And amid this tumult of change and growth, Americans eagerly sought to define their nation and gain a sense of direction and purpose by which to guide their country (and themselves) forward. Consequently, art would serve as one of several means by which to answer this call for a national identity, celebrating the continent, technology and commerce, all while underlining the optimism of the age. Landscape paintings—a subject matter that was until that time seen as inferior to paintings focusing upon historic subject matter—would begin to rise in popularity as Americans found the works of Doughty and Fisher, as well as New York

landscape painters such as Thomas Cole and Asher B. Durand, to exemplify the ideals they felt their nation held.

In response to this new fervor, Fitz Henry Lane, who had been heavily influenced if not outright trained by Boston's premier marine painter, and who had busily developed a clientele among Boston's merchant princes by painting ship and harbor portraits aplenty, would, by the late 1840s, begin to craft works of art solidly akin to the themes and ideals of America's great landscape painters. While visions of industry and labor parallel to Durand's *Progress* (*The Advance of Civilization* [figure 40]) may be found in so many of Lane's harbor portraits and "working waterfront" paintings, pastoral subjects abound as well. Lane's *The Annisquam River Looking Towards Ipswich Bay*, 1848; *Gloucester, Stage Fort Beach*, 1849; *Riverdale*, 1863 [plate 22]; and *Babson and Ellery Houses, Gloucester*, 1863 [plate 23], stand as paintings that share the same focus upon bucolic country living as works such as Durand's *A Pastoral Scene*, 1858 [figure 41], and Fisher's *Landscape with Cows*, 1816 [figure 42]. The notion that industry could live beside if not supplement the beauty of the natural world can be found echoed in Lane paintings like *New England Inlet with Self Portrait*, 1848, and *Lanesville, The Mill*, 1849, while expansive celebrations of the American wilderness, complete with its spiritual undertones and promise of better days ahead, are to be encountered in his *Looking up Squam River from "Done Fudging,"* mid-1850s [plate 26]; *Bear Island, Northeast Harbor*, 1855 [plate 27]; and especially *Annisquam Marshes, Near Gloucester, Massachusetts*, 1848.

Lane would also, like Thomas Cole, proffer compositions that hint at warning for America. In the 1844 exhibition at the short-lived Boston Artists Association, Fitz Henry Lane presented for sale a five-piece series of paintings collectively titled *The Voyage*. While the whereabouts of these five works is presently unknown, the catalog for the 1844 show details the individual title of each piece, and thus gives us an insight into the central theme of the series. In order, *The Departure*, *Fine Weather*, *Stiff Breeze*, *Storm and Wreck* and *Calm after the Storm* seem to follow a vessel's journey from its beginning to its apex and destruction, finally arriving at a state of tranquility and quietude. This progression falls in sync with Cole's 1836 five-painting series *The Course of Empire*, in which the first painting, *The Savage State, or Commencement of Empire*, finds a fictional civilization within the early morning of its beginning, having made the departure from barbarism. In the second work, *The Arcadian, or Pastoral State*, Cole's imaginary society is, like Lane's vessel, enjoying a blissfully smooth passage forward, progressing toward its zenith, which we encounter in the third painting, *The Consummation of Empire*, a direct parallel to Lane's *Stiff Breeze*, being of course the ideal condition for a ship's passage. Yet immediately following this, "the summit of human grandeur,"[196] we find both Lane's vessel and Cole's civilization experiencing the same fate. Cole's *Destruction*, and Lane's *Storm and Wreck* speak of the downfall of the primary subject within each artist's respective series, with Cole's painting even offering the commentary "The heavens are darkened by a tempest, and the storm of war rages beneath."[197] Lastly, *Desolation* reveals Cole's empire rendered into nothing but crumbled ruins, lost amidst the tranquil stillness of a peaceful dusk, the violence that had destroyed it, like its grandeur, a

forgotten event long past. The last painting in Lane's series, *Calm after the Storm*, would by its title seem to harbor similar sentiments.

Though we do not have the five Lane paintings on hand to compare directly to Cole's, the description in the Boston Artists Association's 1844 show catalog nevertheless leaves us with the distinct impression that Lane borrowed heavily from the example of Thomas Cole's series. Indeed, aside from Lane having changed the allegorical main subject from a classical society to a simple ship, he has adhered well to *The Course of Empire*'s central theme, that being one of ascent, climax, inevitable decline and repose. And given that *The Course of Empire* series was not exhibited at the Boston Athenaeum until 1854,[198] ten years after Lane had created his *The Voyage* paintings, we can even speculate that Lane had probably encountered Cole's handiwork back in 1839, when he was creating his *View of Norwich from the West Side of the River* lithograph for the Sarony & Major firm of New York.

As to why Lane would elect to move beyond maritime works and pursue landscapes and pastoral subject matter, the obvious advantages of catering to a more diverse clientele stand as a prime motive. That landscape painting was a lucrative pursuit, one that served as another avenue towards courting wealthy patrons is confirmed by the example of Thomas Doughty, who intentionally "chose the romantic and classical themes because they were favored by patrons of the time. Doughty could turn a quick profit to support his large family."[199] By reviewing the Boston Athenaeum's exhibition records, we find further evidence to corroborate the assertion that landscape painting was gainful, with wealthy individuals like J.P. Cushing patronizing Thomas Doughty, and Colonel Perkins patronizing Doughty, Fisher and Cole.[200] Yet several clues intimate that Lane was creating Hudson River–inspired paintings (again) with the specific intention of reaching beyond Boston and establishing a New York–based clientele. For Lane, compositions akin to those being created by New York artists could reasonably enough be expected to sell for a good price in the streets of that great port, especially as "New York's art world had been transformed, owing in considerable part to the burgeoning of the landscape school of painting."[201]

The New York market became even more attractive to Lane as a varied assortment of cultural institutions centered on the fostering and appreciation of the fine arts arose. One such institution was the American Art Union. Borne out of the Apollo Association for the Promotion of the Fine Arts in the United States, the American Art Union would come into being in 1840, and by the close of the decade had 18,960 members hailing from all corners of the nation[202] (including Lane's close friend Joseph L. Stevens Jr. of Gloucester, who served as an honorary secretary of the Art Union in 1849[203]).

> *The advent of the American Art-Union was the single most important occurrence in the art life of mid-century New York, in that it immensely broadened public patronage, which helped to finance young painters, and thereby invited them into the profession.*[204]

Given the stature and success of the American Art Union, it is no surprise to find Lane contributing works to its exhibitions. Here was an institution that existed exclusively to

promote artists, unlike the Athenaeum, whose primary function was that of a library. Here, as well, he had an audience that was composed of every tier of New York society: "The retired merchant from Fifth Avenue, the scholar from the University, the poor workman, the newsboy, the beau and the belle, the clerk with his bundle—all frequent the Art-Union." [205]

It would appear that Lane had first elected to introduce himself to the New York market in 1839, with his lithograph *View of Norwich from the West Side of the River* for the Sarony & Major firm of New York. Three years later, in March of 1842, he contributed his first painting to a New York show, a work titled *Ship in a Gale*, which was exhibited at the American Art Union's predecessor, the Apollo Association. [206] Lane seems to have found enough of a market to warrant repeated trips to New York, where he would continue to exhibit works at the American Art Union in the years 1847, 1848, 1849, 1850 and 1852. [207] He also exhibited at the Albany Gallery of Fine Arts in 1848. [208] Lane's investment of time and effort in New York paid off, as he would both successfully sell paintings at Art Union exhibitions and gain commissions from more than a few wealthy New York shipowners. As well, Lane would begin to draw favorable notice from newspapers in both Boston and New York during these years, with articles attesting to his growing reputation and skill as an adept marine painter.

> *And yet there are a few good pictures, among many abominations, on the walls of the Art-Union. Hinckley has contributed one of his fine cattle-pieces; and Lane a harbor scene, very good, but inferior to many of his marine views owned in Boston. The farther Lane gets out to sea the more at home he seems to be. There is nothing in the Dusseldorf collection, in the way of marine views, that can be called equal to the best of Lane's. His ships in a squall, his sketches of Cape Ann seaside scenery, and all his salt-water and boating scenes are unequalled in their fidelity to the ocean's varying aspects. For the information of those, who are not familiar with the merits of this artist, I would say, he is a resident of Gloucester, Massachusetts, where nautical subjects have been his study from a boy, and that he deserves to be better known.* [209]

One final reason for Lane's investment of time and effort within the American Art Union would be that it was a far more stable enterprise than similar unions and associations then forming in Boston. For, despite her wealth, pragmatic Puritan values continued to exert their influence on Boston's citizenry, and the fine arts simply would not court the interest of Boston's general populace as well as they had New York's. As early as 1842, when he was making every effort to establish himself in the public eye as a professional artist, Lane joined the short-lived Boston Artists Association, a rather high-minded institution, as the preamble to its constitution evidences:

> *The artists of Boston, deeply impressed with the importance of their profession, and with the necessity of a systematic course of study for its successful culmination; also with the*

advantages to be derived from mutual co-operation and support, resolve to form themselves into an Association for the furtherance of these objects. In so doing, they pledge to each other their honor as gentlemen, to lay aside all ungenerous, envious, or selfish feelings, and to seek the advancement of the Arts alone, for the Art's sake.[210]

As a member of this apparently egalitarian association, Lane would congregate and associate with a host of aspiring painters, engravers and architects hailing from Boston, and would once again be afforded the opportunity to rub shoulders with affluent patrons and several artists of note and renown. Washington Allston would serve as president of the association in 1842, Henry Sargent, in 1844. Thomas Cole, Asher B. Durand, Thomas Doughty and Alvan Fisher all exhibited at the association's shows, and, as with the Athenaeum expositions, Lane would even have been afforded the chance to view works by Dutch and Italian old master painters, like Rembrandt and Tintoretto.[211]

Another short-lived artist's union headquartered in Boston that Lane belonged to was the New England Art Union. This group existed for roughly a year, and we know almost nothing of Lane's dealings with it outside of a tiny blurb written up in the Boston *Daily Evening Transcript* concerning the one show they managed to put together: "The [New England] Art Union has some excellent paintings on exhibition at its room. Among them we notice…a view of Gloucester Harbor by Lane."[212]

In addition to the numerous exhibitions to which Lane would contribute his efforts and the mounting responsibilities of tending to the needs of his expanding clientele, Fitz H. Lane embarked upon one other venture during the 1840s. Partnering with fellow Pendleton/Moore apprentice John W.A. Scott, Lane formed a lithography company. In operation between 1844, when they began producing lithographs like *George W. Simmons' Popular Tailoring Establishment, "Oak Hall," Boston*, and 1847, when Lane was making preparations for his return to Gloucester, the two partners would manage a firm that produced several lithographs filled with characteristically competent renderings of ships, landscapes and architectural forms. That the venture was a success is evidenced by the prosperous businesses and individuals who comprised their clientele, including, among others, R.B. Forbes. (It was during this time that the firm of Lane and Scott produced *Auxiliary steam packet ship Massachusetts*, 1845, and *Departure of the Jamestown for Cork, Ireland: R.B. Forbes commander. Boston March 28th, 1847*.) Lane and Scott also engaged the services of former Pendleton/Moore co-workers, for among lithos of advertisements, city views and ship portraits, we find Benjamin Champney to have contributed to their operation, as evidenced by the lithograph *A sketch of Mr. W.A. Barnes: after the wreck of the Anglo Saxon, wrecked off Duck Island, Nova Scotia, Saturday Evening May 8th, 1847.*

Lane's departure from the firm in 1847 was an amicable one, as his reasons for leaving were based not upon professional differences but rather a desire to return to Gloucester and devote more time to his painting practice. Even after his leaving, with the firm now being under the title of Scott's Lithography, we find Lane continuing to contribute lithographic compositions, as in *View of Providence, R.I., 1848*. John W.A. Scott would

produce exceptional lithographs well into the 1850s, and would remain friends with Lane, visiting the Cape Ann area regularly enough to have executed his own paintings of the area and to court patrons from among the area populace, including a Mr. Samuel Sawyer, patron of several artists, including Fitz Henry Lane.

Art unions, Athenaeums, yacht clubs, wealthy patrons and lithography firms—Lane's involvement with these varied institutions testifies once again to the great Gloucester artist's determination and methodical planning, as he successfully made use of these avenues so as to establish an enthusiastic, affluent patronage roughly in the space of just seven years. Again we see an example of a man making bold, calculated moves as he endeavored to wrest a living from the artist's trade. And yet with the arrival of the year 1848, Lane would leave Boston, turning his back on a successful lithography practice and a city that was about to embark upon its finest hour.

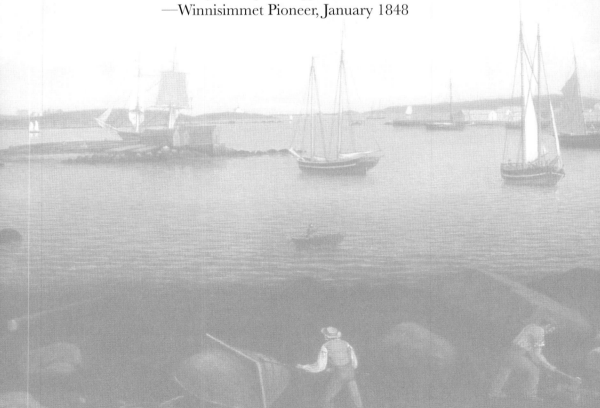

Part III: From the Return to Gloucester to the Final Days

We are gratified to learn from some of the leading papers, that the Marine Paintings of Mr. Lane, of Boston, are well known and appreciated. Mr. L. was our playmate and next door neighbor, in early childhood, and we have always felt a strong interest in his welfare. We rejoice that a discerning public has showered upon him that approbation, without which genius must often droop in disappointment.
—Winnisimmet Pioneer, January 1848

Chapter 7
Gloucester in 1848

It was in the year 1848 that Lane would enter into the third and final epoch of his life, one that would involve a constant chain of exhibitions, travel and the creation of his finest, most celebrated compositions. This was to be the season in which the fruits of his labors would ripen and bloom; a shimmering, golden, halcyon summer, as beautiful and boundless as any stretch of sky he ever portrayed upon the canvas. Fittingly enough, the apex of this man's career would not unfold within the bustling streets of Boston but rather, along the quiet granite shores of his native Cape Ann.

When Lane left Gloucester in 1832 it was a poor and destitute hamlet, wallowing in the malaise of a post-war depression and overwhelming commercial competition from Boston. Yet even as he applied himself to the mastering of the artistic process and the promotion of his career thirty miles to the south, Lane would visit his old stomping grounds repeatedly during his fifteen-year absence. From his *View of the Town of Gloucester, Mass.*, 1836, to *Gloucester Harbor*, 1847, the endeavor to capture the scenic subject matter of his hometown gave Lane good reason to make the journey north numerous times. For even as he resided in Boston, pursuing commissions and clients aplenty, Lane was simultaneously committing Gloucester to canvas and stone.

Lane may have been residing in Gloucester again possibly as early as 1847. The earliest known reference to his having returned to the Cape Ann area on a permanent basis is found within a personal correspondence from June of 1848 between Gloucester resident George Saville and W.E.P. Rogers, Saville's brother-in-law, who was then residing in Haverhill:

> *Fitz Lane has moved from Boston and lives on our street. I stepped into his room after dinner and found him painting a portrait of Eli F. Stacy's little daughter and her little dog by her side. It will be a beautiful thing I think when completed.*[213]

While we know the year of Lane's return, the underlying motives behind his homecoming are not so readily evident. If anything, his decision to return in 1847–48 strikes us as paradoxical, for Boston was at that moment about to embark upon its finest hour. The commercial and intellectual giant of mid-century America, the city that had nourished

Lane's talent, exposed him to the most brilliant minds of his time and offered him a host of devoted, wealthy patrons, was on the edge of attaining her apex in matters of wealth and prestige. To make his exit at a moment when his talents were about to become most in demand smacks of bad timing and missed opportunities, and would seem to reveal poor judgment on the part of Lane, who up until this point had made nothing but precise, calculated, well thought out decisions concerning his career. Of course, a deeper look tells us otherwise.

First to be considered as a reason for initiating a move back home would be the health and welfare of Fitz Henry Lane's mother. It would appear that Sarah Haskell Lane was in need of assistance, either financial or physical, as she lived with her son, daughter and son-in-law until her death in 1853.[214] Second to be considered would be Lane's own general health and welfare. At forty-two years of age, Lane had already surpassed what for a nineteenth-century American was middle age. "Most people did not survive much past the beginning of today's retirement age, and proportionately there were simply fewer Americans around in their seventies and eighties…—a white man or woman of twenty-one could expect to live into his or her mid-sixties."[215] As well, "people in their twenties, thirties, and forties, although with a good chance of surviving into their sixties, still had death as a far more serious possibility in their lives [than Americans living today]."[216] Like every American living through the nineteenth century, Lane's life expectancy was directly determined and affected by the general lack of medical knowledge, public health measures, effective treatments for illness and antiseptic precautions that were to be encountered at that time in history. Taking this into account, along with the daily stresses and strains his handicap would have presented him with, a recipe for less than perfect health emerges. In such a state, an aging Lane would have required a certain amount of assistance in his daily living. The notion that Lane returned home due to a growing dependency upon others is only strengthened by the fact that once back home he would choose to never live alone.

We find Lane in 1847–48 moving in with his brother Edward, an arrangement that seems to have lasted until, as nephew Edward would remember, "after stopping with my father for a few years my uncle Fitz went to live with his sister Sarah; in the house owned at that time by Capt. Harvey C. Mackey [sic] on Elm street."[217] Here Lane would live under the same roof with his sister and brother-in-law while a home of his own design was being constructed. Significantly though, upon the completion of its construction, Lane did not move in to his new home alone but instead took his sister, brother-in-law and mother in with him. Here they would live together, with his sister keeping house until a falling-out occurred in the summer of 1862. And even after the ejection of sister Sarah and her husband from the house, Lane would continue to reside in the company of others, this time with a live-in maid.

Another possible reason for this move back to Cape Ann would be that Lane had accomplished what he had sought to do in Boston, and thus felt no further reasons for remaining in residence there. As historian John Babson wrote, "after a residence of several years in Boston, he came back to Gloucester with a reputation fully established."[218] Lane

had effectively obtained for himself an education in the artistic process, built up a patronage through which he could capably support himself, all the while amassing a sizeable sum of money, as evidenced by the large, expensive home of hand-hewn granite he built in 1849. Lane had effectively created a successful career as an artist, and could now afford to return to Gloucester, which was most likely always his intention.[219]

That Lane returned to Gloucester a success is verified by the following article that appeared within the *Winnisimmet Pioneer*:

> *We are gratified to learn from some of the leading papers, that the Marine Paintings of Mr. Lane, of Boston, are well known and appreciated. Mr. Lane was our playmate and next door neighbor, in early childhood, and we have always felt a strong interest in his welfare. We rejoice that a discerning public has showered upon him that approbation, without which genius must often droop in disappointment.*[220]

In addition, by 1847, Boston was now easily accessible from Gloucester due to the inauguration of rail travel between the two cities. With the first run of its Gloucester branch on November 2, 1847, the Eastern Railroad Company ushered in a period of quick, smooth and reliable traffic between the Hub and her North Shore neighbors, replacing forever the day-long stagecoach ride that had been the primary means of regular travel between the two since 1788.[221] As Lane had never been completely divorced from Gloucester during his fifteen-year absence, so now would the opposite unfold, the artist remaining in contact with those patrons and friends he had made in Boston all while residing back home. Benjamin Champney verifies that Lane, though living in Gloucester, continued to pursue his craft in Boston, having maintained a studio space within the Tremont Temple: "That winter [1849] I took a studio in the old Tremont Temple to paint pictures from my summer studies. The rooms on the upper floor were occupied mostly by artists. Among them were: John Pope, Hanley, and F.H. Lane of old lithographic days, and now a marine painter."[222]

Lane would produce a number of skillful, soulful depictions of Boston Harbor throughout the 1850s, representing that great port in all her majesty. (*Boston Harbor at Sunset*, 1850–55 [plate 8], arguably being the most stunning of these.) Portraits of vessels owned and operated by Boston shipping magnates would also command his attention right through to the 1860s. Intended specifically for his Boston patrons, and being so rich in complex detail, nuance and topography as to have necessitated regular visits with the Boston waterfront or her shipbuilders, these works stand as proof of the artist's continued contact with that city and his clients, and assure us that Lane had not expressed poor judgment and bad timing by leaving America's Athens when he did. Rather, the Gloucester branch of the Eastern Railroad Company had effectively permitted Lane the chance to enjoy the familiar environs of his beloved Gloucester all while still working in and reaping rich rewards from a Boston that was then at the height of her power. For all intents and purposes, Lane had never really left Boston.

The third factor behind F.H. Lane's return lies within Gloucester's dramatic economic rebound of the 1840s. After nearly three decades of lassitude, false starts and failed promises, Gloucester as a city was moving beyond a mere subsistence economy and once again witnessing substantial profits from the sea. As Annette Babson, one Gloucester resident, would comment, "It is pleasant to walk around our town and see the improvements going on. New houses are being erected, old one's remodelled [*sic*] or repaired. New vessels fitting away for fishing and various operations seem to repeat prosperity. I rejoice in it. I believe that our town is looking up as the saying is."[223]

The basis for this dramatic revival in commerce and exchange can ultimately be attributed to two seemingly disparate factors: the Gloucester branch of the Eastern Railroad Company, and ice. Young Frederick Tudor of Boston would weather a gale of mockery and cynicism in the early 1800s when he first broached the idea of cutting ice from his father's Saugus, Massachusetts, pond in wintertime and shipping it to the tropics.

But by the 1820s, Tudor was the owner of an ice empire, with regular shipments heading off to the West Indies, Cuba, Jamaica, Charleston and New Orleans, supplying Massachusetts ice to populations mad with the desire for chilled drinks.

The practice of removing ice from ponds in wintertime, and the technology Tudor developed for its temperature-stable storage, was applied directly toward the fishing industry in Gloucester, replacing the practice of salting fish to cure and preserve, and allowing Gloucestermen to offer fresh, unsalted fish for sale.

Gloucestermen had since 1623 been salting fish as a means of preserving it, either upon land or aboard ship immediately after catching them. Being the best option the technology of the time permitted, the one obvious drawback to this method of preservation was that of taste. Reconstituting salted fish involved an arduous process of washing, rinsing and soaking the filet in five or more separate water baths, the reward for which was a bland creation suited more for stews than anything else, given that it was still highly infused with the preserving agent of choice. Though salted fish was perfect for barter and trade overseas, local tastes began to demand fresh fish, and the race was on to satisfy this need. Ingenious designs such as the well smack (a fishing vessel equipped with a "live well," a partitioned section within the hold where seawater flowed freely, thus permitting a catch to be brought home alive) sufficed for only so long, as demand quickly outstripped that which the well smacks could carry home.

Enter Frederick Tudor's innovative methods for harvesting and storing ice. With holds full of "Yankee coldness," fishermen could now conveniently freeze their catch on board immediately after landing it, keeping it fresh while simultaneously permitting the taking on of greater hauls than were ever possible in well smacks (due to the amount of space a live well demanded). Gloucester was thus able to successfully supply the emerging demand for fresh, unsalted fish—at least on the local level—and profits began to trickle in.

Yet by itself, the fresh fish market would only have had limited applications. Alone, it could not be the stuff by which economic revivals are made. Fortunately, the Gloucester branch of the Eastern Railroad Company would make its timely arrival.

The railroad, combined with the preservative qualities of ice, opened innumerable new markets to Gloucester, and fueled a powerful financial resurgence. The public's demand for fresh fish would prove insatiable, and in response new fisheries centered on the exploitation of mackerel and halibut joined the traditional pursuit for cod. The fishing fleet expanded by leaps and bounds. By the year of Lane's return 167 fishing vessels were registered in Gloucester, with 18 of these having joined the fleet in just a four-month period of time.[224]

This boom along the waterfront would also permit Gloucester to make a grand re-entry into her most famous and lucrative of ventures: the Surinam trade. By the 1840s, intrepid Gloucester shipowners took newly gained profits from the expanding fisheries and invested them into a re-opening of this fabled trade. Here the greatest of profits were to be realized, as merchants made from five to ten times their initial investments year after year, lasting until Boston absorbed the trade in the late 1850s, bringing it to a halt in Gloucester, and thus forever ending her days as a global trade port.

Yet Gloucester's second most successful (and long-lived) of industries would ultimately prove to be tourism. In 1846 the *Gloucester Telegraph* wrote: "As a fashionable watering place our Cape is destined to become one of the most frequented. The facilities for fishing and bathing, and the many pleasant rides and picturesque views, need only to become known to be enjoyed. Even now strangers are beginning to visit us, the facilities for getting here being so abundant."[225]

The practice of traveling for pleasure had emerged among prosperous Americans during the 1820s. Wealthy Southern plantation owners sought to flee the torrid summer heat by spending their summers in such places as Northampton, Massachusetts, and Litchfield, Connecticut. Newly married couples that could afford to embarked upon "nuptial journeys," while those in search of cure or respite from illness mounted pilgrimages to mountain retreats and medicinal springs. The beginnings of tourism on Cape Ann can be traced back as far as 1839 with the establishment of Hutchings' House, a modest boardinghouse with limited services. What drew visitors to Gloucester was its unique combination of "cool breezes, romantic scenery, beautiful harbor, hard, white sand beaches, and bracing air,"[226] features that promised respite to both those seeking escape from city heat, and those looking for a curative environment to whatever illness plagued them. It would not be until 1847, though, that this fledgling industry would truly take off. Enabled by that same invention which had allowed for the re-emergence of the fisheries and facilitated Lane in his commutes to Boston, the railroad now carried an ever-increasing number of affluent Bostonians north in search of escape from summertime swelter. Having the means and the desire to linger there for the entire season if they wished, these wealthy holidaymakers would be in need of food, lodging and other amenities. By 1850 three full-size hotels—the Pavilion, Gloucester House, and Union House—were in operation, employing locals and making profits aplenty off of "all who mean to desert the dust and din of the city to live easy a month or two, and recreate their weary bodies with the delights of the sea-side."[227]

This dramatic and multi-faceted economic rebound would create a ripe market for the arts. Once again, as had transpired in the days before the Revolution and in the years between that conflict and the War of 1812, the wealthy of Gloucester would seek to immortalize their interests and concerns, and artists would arise to fulfill the need. Itinerant portraitist Susanna Paine would recount in her autobiography *Roses and Thorns*:

> *I had an appointment to visit Cape Ann, where I had been invited…with a guarantee that I should have plenty of business, to fill up my time…I went accordingly; a most beautiful and pleasant summer I spent there. The scenery was delightful; and the people just to my liking. Everything was free, easy and agreeable. I found enough painting to make my stay profitable.*[228]

Fitz Henry Lane's art reflects most every aspect of Cape Ann's revived trade and prosperity. Naturally enough, he would throw a spotlight upon the fishing industry, it being, after all, the essential lifeblood of the town and her main source of income and employment. Oddly though, Lane would create few outright depictions of the fisheries in action. In fact, only two are known. The first, *At the Fishing Grounds*, from 1851, portrays a schooner crew engaged in the then-relatively new trade of mackerel jigging during a gloriously sunny calm day. In *A Smart Blow*, 1856 [figure 43], we again encounter schooners at work upon the fishing grounds, only now the sea is a storm-tossed fury and the quarry is no longer mackerel, but rather the venerable cod. Here, with characteristic attention to detail, Lane illustrates the centuries-old practice of hand lining, a technique Yankee fishermen were still employing regularly in the nineteenth century.

The only other example of Lane representing the fisheries as the primary subject of his canvases is to be found in his *Bessie Neal*, ca.1853 [figure 44], the only formal ship portrait of a Gloucester fishing schooner by Lane known to exist.[229] While executed with all the attention to detail and deft brush strokes he would put into his many depictions of stately clippers, ships and barks, this work stands as being unique due to the same reason for Lane having created so few depictions of the fisheries in action: though their trade was rebounding dramatically, those who made their living from the fisheries were neither the wealthy nor the prestigious of mid-century Gloucester, dwelling instead in the shadow of those who plied the Surinam trade. Thus, few could afford Lane's handiwork, and rather than seeing the fishing industry represented front and center in his art, we find it instead populating Lane's paintings with a subtle, unassuming, yet ubiquitous presence, revealed in canvas after canvas.

Gloucester Inner Harbor, ca.1850 [plate 5], is one such work. Inshore fishermen, their equipment and their boat quietly occupy the center foreground of this canvas, yet this is just the beginning of what proves to be a composition saturated with fishery-related imagery. In the bottom-left corner we see a strange wedge-shaped object, most alien to anything we are apt to encounter along the Gloucester waterfront today. This item, a lobster car, is akin to modern lobster tanks found in today's supermarkets, as it served to keep lobsters, crabs

and other shellfish fresh and alive until they were brought to market. When immersed, seawater would freely enter the lobster car and circulate within via the holes we spy along the top of this container. Access was permitted through the trap door located atop the car, while a crude anchor called a killick (nothing more than a stone bound by a simple wooden yoke, attached to a rope) keeps the lobster car from floating away with the tide. Immediately above the lobster car two men stand beside a yawl boat, about to partake in the pursuit of hunting shore birds, a necessary measure needed to reduce the population of herring gulls, which proved to be "pests" by stealing and defecating on fish left out to be salted and dried. The vast number of watercraft we encounter crowding about the inner harbor are almost entirely devoted to the fishing trade. Aside from two lumber brigs off on the far right sitting ingloriously in the shallows at odd angles, and a Surinam brig almost completely engulfed by the knot of boats just left and above the "double ender," this corner of the harbor is completely dominated by well over a dozen fishing craft. Though not glaringly obvious, the fishing industry is omnipresent throughout the canvas.

Vessels outfitted for voyages to Surinam, such as the brig surrounded by fishing craft in this painting, appear in Lane's work as early as 1836. In his lithograph *View of the Town of Gloucester, Mass.*, Lane inserted at center a black-hulled, square-rigged ship that would have had few other applications outside of that particular trade with South America. By the time of his return to Gloucester, with the Surinam trade making a roaring comeback, we find Lane referring to it in a myriad of manners, including commissioned ship portraits, such as his *Brig "Cadet" in Gloucester Harbor*, from the late 1840s [figure 45]. As the Surinam trade showered riches upon those involved, Lane would prove the natural choice among Gloucester's shipowners and merchants for honoring the source of their livelihoods upon the canvas. From the large craft directly center in his *Gloucester Harbor from Rocky Neck*, 1844 [plate 3], and that found off to the left in *Gloucester Harbor*, 1852 [plate 7], to the brig to the left and off along the horizon in *The Old Fort and Ten Pound Island, Gloucester*, 1850s, and the *California*, the ship depicted in *Three Master on the Gloucester Railway*, 1857 [plate 9], time and again we encounter Lane inserting "Surinamers" into his canvases in an understated and modest manner most akin to his presentation of inshore and deepwater fishing craft.

Lane also featured the Eastern Railroad Company, that vital link to the outside world, in two known paintings. In *New England Inlet with Self Portrait* from 1848, the train appears at far left, about to vanish from view due to the presence of a large boulder as it makes its way back to Boston. In the misnamed *Lanesville, The Mill*, 1849, we see it just behind the house in the upper-right portion of the canvas, steaming along on its way toward Gloucester.

The tourism industry, enabled by the railroad, plays a constant yet low-key role in Lane's paintings too. Boat parties were a common occurrence in Gloucester Harbor during the summer months, and Lane does not fail to include a boatload of frolicking tourists here and there in his work. In *Gloucester Harbor from Rocky Neck*, 1844 [figure 46], we find one of these vessels, loaded with men and women, engaged in a sightseeing or fishing trip. Similarly, an excursion boat is found in *View of Gloucester Harbor*, 1848 [figure 47], off on the left mid-ground, at the tip of a spit of rocks, again loaded with revelers. Hotels do not

escape the attention of the Gloucester artist either. It is possible that Lane's first depiction of a Gloucester hotel may have been while employed at Pendleton's. In an unsigned, undated lithograph produced at that famous shop no later than 1836 [figure 48] we find the Gloucester Hotel advertised. Remembering the words of Benjamin Champney, that, "F.H.Lane...did most of the views, hotels, etc.,"[230] and considering the fact that the owner of the Gloucester Hotel, John Mason, was the brother and business partner of Sidney Mason, a prosperous client of Lane's, the possibility that Lane was the artist that crafted this piece is plausible. In *Early Morning, Pavilion Beach, Gloucester*, he portrays the celebrated Pavilion Hotel, which we also see in *Gloucester Harbor*, 1852 [plate 7], as the distinctive structure with a tropical flair included at far left. Opened in 1849, this establishment offered lodgings on a grand scale, catering to the elite of not only Boston, but New York and Philadelphia as well.

A quick overview of Lane's art readily tells us what he was painting, but can it tell us why? And for whom? It is here that our investigation of the great Gloucester artist grows difficult, for Lane is in many ways an anomaly in the world of nineteenth-century American artists. Because he was never a direct participant within a particular artistic school of thought, because he did not attend an art academy and due to an intense regional focus fostered by limited mobility, Lane's compositions stand slightly apart from those of his contemporaries, being somewhat "off center" and quite unconventional. What to the modern viewer, trained to regard art as deeply personal expressions emanating from the artists themselves, may appear to be a scenic composition executed purely for aesthetic reasons, reveals itself upon closer inspection to be a harbor portrait with specific allusions toward the patron who commissioned the piece. A depiction of a vessel at sea may be a ship portrait, or it may stand as something crafted only with the intention of being sold to the general public at a gallery show.

With these thoughts in mind, a second look at *Gloucester Harbor*, 1852, yields a far different impression than at first glance. What to many is but a scenic picture of Lane's hometown, we find instead was crafted with a particular audience in mind, in this case a Mr. Sidney Mason, Gloucester native, former American consul to Puerto Rico, merchant and, with his brother John, part owner of the Pavilion Hotel. *Gloucester Harbor*, 1852, is in fact just one of at least four paintings Mason commissioned from Lane, the others being *St. John's Porto Rico*, from 1850 [figure 49]; *First Regatta of the New York Yacht Club*, 1856,[231] and a portrait of New York harbor. During his years as American consul in Puerto Rico Mason would acquire a substantial fortune, in no small part due to his ownership of a plantation upon the island. In *St. John's Porto Rico*, the men in the left foreground are gathering logs of mahogany most likely felled upriver at the Mason plantation, floated downriver and then collected for shipment abroad in the harbor of San Juan, where Mason lived from 1820 to 1835. New York, where the former consul resided after his return to America in 1835, would be the scene of several of his merchant enterprises. Thus, we find Lane alluding in each commissioned canvas to a specific facet of Mason's dealings and financial interests, commemorating them against the backdrop of the locales where his fortune was acquired.

Rather than simply being decorative objects, the paintings make up a series in homage to Mason's entire far-reaching business empire.

We again find Lane glorifying a waterside business in his *Three Master on the Gloucester Railway*, 1857 [plate 9]. What at first may be taken for a scenic, narrative portrayal of dockside activity stands out instead as being another example of commissioned work, in this case, one meant to advertise Gloucester's Burnham Brothers Marine Railway. We know the painting to have been employed as an advertisement for the railway,[232] with "each building, particularly houses belonging to owners of the railway and adjacent businesses."[233] As well, the large ship being worked upon in the center is no mere generic vessel. Instead, we know it to be the ship *California*, owned by one of Gloucester's most successful merchants engaged in the Surinam trade, George H. Rogers (a patron of Lane's who, given the *California*'s place of prominence within the advertisement, as well as his many and varied business interests, was most assuredly a major investor in the railway). We even find the placement of the buildings having been dictated by the needs of the client rather than the artist's prerogative. Comparison between the placement of the structures within Lane's painting and Gloucester city street maps reveals that the artist has intentionally moved and shifted buildings about, deliberately posing the houses and business interests of the railway owners in the choicest spots, in some cases moving them over from several blocks away.[234] Again, what would at first appear to be a simple scenic view of the Gloucester waterfront proves instead to have been one Lane was hired to create, his artistic expression taking second place to the demands of his client.

Another Lane painting created with business advertisement in mind is one that we know of only by its preliminary sketch, as the painting itself has been lost to time. Titled *View at Bass Rocks Looking Eastward*, 1850s [figure 50], we know due to the notation inscribed upon it that it was a "Sketch for a picture for John J. Piper and G.H. Rogers."[235] As to why these two gentlemen commissioned Lane to paint this particular corner of Cape Ann, we turn to the following biographical information concerning George H. Rogers:

> George H. Rogers (1808-1870)…began his career in Gloucester as an apothecary and then shifted to the Surinam trade about 1831, where he soon built up a large business, owning much property and many vessels. When that commerce declined, he turned to real estate…Among his early undertakings was the development of Fort Point around 1850… He erected many new buildings and wharves in East Gloucester, and opened up the Bass Rocks area as a summer resort, buying the old pasture rights, carving out roads, building a summer estate for himself, and a hotel.[236]

With such information in hand, it becomes obvious that these two men, Rogers the real estate baron and Piper, editor of the *Gloucester News and Semi-Weekly Messenger* and probable co-investor, commissioned Lane to paint a portrait of the Bass Rocks area in (speculative?) advertisement of the development that sought to profit on the tourism trend increasing on the Cape just then. Rogers in particular seems to have been a regular patron of Lane's,

given the sheer number of paintings by Lane depicting his real estate developments. Indeed, Lane's entire series of paintings depicting the Fort Point and Inner Harbor area from the late 1840s to early 1850s are nothing more than an account of Rogers building up of the area, turning it from a sleepy, little-used corner of the harbor (see *The Old Fort and Ten Pound Island, Gloucester*, 1840s [plate 18]) to a bustling maritime center, filled with watercraft and industry (see *Gloucester Inner Harbor*, ca. 1850 [plate 5]).

Just how many of Lane's paintings were crafted specifically with patrons in mind is still up for debate, but it would appear that commissioned work was common fare for the Gloucester marine painter, if not the outright majority of his work. Notes along the tops and bottoms of his sketches (most often inscribed by Lane's close friend Joseph L. Stevens Jr.) inform us as to how many paintings were derived from each sketch, and for whom. Not surprisingly, residents of Boston and Gloucester appear to have made up the majority of Lane's commissioned works. Many of these individuals were among the more successful strata of society, including shipowners, doctors, reverends, booksellers and business moguls like G.H. Rogers and Sidney Mason. Interestingly, a large portion of Lane's patrons would significantly prove to be women.

All of Lane's paintings were not created as commissions, though. Exhibition records from shows in Boston, Worcester, New York and Albany reveal that Lane was actively offering completed works for sale to the general public well into the 1850s. As well, we know that Lane sold artwork in New York and Boston through sales agents. Lane at this time also exhibited at the American Art Union in New York, and the New York papers would roundly praise his contributions to the May 1850 show.[237] And while several sketches inform us as to whom he painted for, many sketches bear no names at all, leaving us to conclude that the corresponding paintings were meant for general sale rather than a particular patron. Yet to assume that these works were less carefully crafted or without a specific audience in mind would be folly. After all, if his work did not resonate with the discriminating tastes of potential buyers, it simply would not sell. As to who his "off the street" customers were, we must once again look within the subject matter of Lane's paintings.

Three decades of economic stagnation had for the most part separated Gloucester from the world at large—a world that had experienced rapid progress during those thirty years due to the inventions and conveniences of the age. Now, with her sudden re-emergence into that transformed world, Gloucester was rapidly catching up, eagerly embracing all that was modern as she sought to shed her provincialism and once again become a player within the larger world beyond Cape Ann. Lane's scenes of growth and activity along the Gloucester waterfront reveal the interest and pride of his neighbors concerning their revived city. Hearty, optimistic celebrations of work are a constant of Lane's craft in the late 1840s and 1850s. Whether it be fishermen shoving off in the early morning light of *Good Harbor Beach, Cape Ann*, 1847 [figure 51], nameless toilers of the quay engaged in industrious labor in *Gloucester Harbor*, 1847 [plate 4], or men hauling in a gill net, as in *Gloucester Harbor*, 1852 [plate 7], we find F.H. Lane candidly capturing the myriad activities that were unfolding in his town, so suddenly awakened and revitalized.

The good times had come again, people wished to rejoice in them, and Fitz Henry Lane was there to celebrate them. Thus, given the subject matter present, we can easily divine that Lane was enjoying a considerable patronage among those who were directly profiting from Gloucester's renaissance of industry and trade. From shipowners to merchants to hotel owners, Lane was making a living by being of service to his hometown's captains of commerce. And yet, as was the way of Lane, he would also paradoxically be of service to those who shunned this development. For not all of Gloucester's citizens embraced their town's newfound growth, as with growth inevitably comes a heavy price.

Of all his views of Gloucester Harbor, three certain geographical features seem to have appeared with an unerring consistency: Ten Pound Island, Fort Defiance and Stage Rocks. While certainly picturesque, a closer look tells us once again that these features of the waterfront hold a greater meaning beyond their pictorial qualities. To begin, all three hold significance in the history of Gloucester itself. Stage Rocks was the sight where the first English settlers landed and constructed their first settlement upon Cape Ann, the term "stage" referring to the fish flakes they would erect there for the salting and drying of cod. Fort Defiance had been the heart of the defense for Gloucester through two wars, the primary means for sheltering and protecting her inhabitants from British raiders. Its very name was a tribute to Gloucester's determination to defy King George, and stood as a reminder of the role she had played in America's birth, as well as the sacrifices past generations had endured in the cause of freedom. It served as the sight for Fourth of July festivities, and as late as the American Civil War would be the choice location for hosting recruitment parties for the Union cause, so deep did the associations of duty and service to country run here. As well, it held for many Gloucestermen memories of golden youth, of playing and capering about the battlements while alternately watching the on and offloading of merchant ships back from distant voyages. Ten Pound Island also had ancient roots in the town, having been named as far back as 1644, in reference to its usage as a place for grazing rams (as a "pound" was an old English unit of measure pertaining to how much land a sheep or ram would need for grazing): "Ten Pound Island shall be reserved for Rams onlie [sic]; and whoever shall put on anie [sic] but great Ramms [sic] shall forfeit 2s. 6d. per head."[238]

Lane's desire to paint these three facets of Gloucester's proud history time and again ultimately must lie within the tastes of their intended audiences. And in mid-nineteenth-century Gloucester, there were two distinct audiences he would have been catering to: his fellow townsmen, and tourists. The appeal these sites would have had among neighbors who were less than infatuated with the changes their town was experiencing would have been quite strong. While the inventions and wonders of that industrial age were accelerating everything from travel to meal preparation, Yankee Gloucester, after more than two hundred years of white Anglo-Saxon Protestant hegemony, was experiencing its first taste of cultural diversification as Irish immigrants escaping the horrors of the potato famine and Portuguese immigrants from the Azores in search of greener pastures found themselves living and working amid Gloucester's narrow lanes and busy waterfront.[239]

The presence of so many individuals who by their foreign birth had no knowledge of or respect for the time-honored customs of Gloucester's ancient families proved most unsettling to a people who, from generation to generation for more than two centuries, had all been cut from the same communal cloth. The presence of this new, overwhelmingly destitute element amid their community gave rise to many a scathing indictment, with most, predictably, being leveled upon the Irish:

> *They are so Catholic, so superstitious! Their wakes and funerals are so rowdy! Tsk, tsk, what little the priest does get for them they drink up, and the Charitable has to take care of their families…Yes, and their brains are put in backwards as well as upside down.*[240]

For the people of Gloucester, living amid a time of dramatic and unprecedented change, Lane's depictions of Fort Defiance (such as *Watch House Point*, ca. 1852; *The Old Fort and Ten Pound Island, Gloucester*, 1840s [plate 18]; and *Gloucester Harbor*, 1848) and Stage Rocks (*Gloucester, Stage Fort Beach*, 1849; *Stage Fort Rocks*, 1850s; and *Stage Fort across Gloucester Harbor*, 1862 [plate 24]) would have proved a comfort. These paintings served as a bedrock, a firm foundation for one to lean upon while drawing strength from past generations amidst those shifting times. Representing these monuments would also serve as a means of escape, a way to retreat from the modern world and dwell within an earlier, "simpler" time, filled with romanticized figures and historic events. An article in a Gloucester newspaper dated from October 23, 1850, concerning a Lane painting of Gloucester's Bass Rocks area, reveals that these sentiments of escape and reverie were a prime attraction of Lane's art to the people of Gloucester:

> *As a place to dream in, a refuge from the drudgery of our employment, endeared by the remembrance of pleasant converse with friends, we and not a few of our readers will consider "Bass Rocks" unrivalled by any of the wild and beautiful localities so common to Cape Ann.*[241]

Ten Pound Island would have a similar significance, though not so much to do with its history, as with its unchanging features. Gloucester's revived fisheries and trade with Surinam, coupled with its immigrant influx, meant growth. All along the Inner Harbor new buildings and wharves were springing up in the quest to accommodate a steadily expanding fishing fleet and the men whom it employed. Construction of hotels like the Pavilion, which was erected in 1849, displaced those who for generations had fished and bathed where it now stood. New York art critic Clarence Cook, when visiting Fitz Henry Lane in 1854, would condemn the "ugly, yellow" Pavilion Hotel, located "on the rocks where I used to sit hour by hour watching the lapsing waves upon the beach below."[242] Many citizens also bemoaned the loss of Ignatius Webber's windmill, a beloved landmark of the town's waterfront since 1814, removed so as to make way for the Pavilion.

It took me a good many years to forgive the Masons for taking away the windmill which stood where the Pavilion was built…Yes, I missed the windmill for a long time, but not half so bad as Lot Peach…The day the windmill was dismantled Lot…pulled out his kerchief and blubbered like a schoolboy. [243]

All along the Inner Harbor change was afoot, with but one glaring exception. Lying right in the middle of it all, Ten Pound Island defied the trends of the time, refusing to be swallowed up by hotels, wharves and ice houses, if only due to its being an island. To an inhabitant of Gloucester just then, Ten Pound Island would have been more than merely picturesque; it was an unchanging landmark, a spot visible from any vantage point along the harbor that stood above the hectic, transitional experience unfolding everywhere else in the town at that moment. Again, such would have proven a comfort to a people witnessing their town and their lives being thoroughly transformed, assuring them that, indeed, some things were permanent and unalterable amidst an increasingly developed landscape.

Perhaps most telling though is what Lane does *not* include within his canvasses. For nowhere in his body of work do we find a depiction of the innumerable work camps set up along the waterfront to accommodate the sudden influx of transient foreign workers to the area. As well, we see no candid portrayal of an immigrant neighborhood, despite the fact that they made a long-lasting impression upon Gloucester's citizenry:

This would remind Charles of how his mother, who had lived on select Fort Point in Gloucester, had seen the first cabbage on a front window sill and the first garbage in the gutter, both of which unsavory events occurred…on the very day the first Irish family somehow got into a house at the foot of the Fort.

From that moment on…cabbages and broken panes stopped with dirty sacking steadily increased, and garbage crept up the hill like the tide on the beach until every respectable family was driven out. [244]

Lane was not one to shy away from the occasional unpleasant subject matter. Whether bloody cod heads strewn about the harbor floor at low tide or men stoking the fires of a smelly pitch pot, Fitz did not object to realistic portrayals of the gritty and the unpalatable. So it seems odd that Cape Ann's immigrant community is so conspicuously absent in his paintings. When viewed from the point of view of his patrons' sensibilities, the reason becomes obvious: the last thing his patrons wished to be reminded of was this element within their neighborhoods—an element they were trying to ignore and forget about through his art.

The possibility that tourists would have found these pictures of great interest, both as sentimental reminders of their vacation and as a means for showing family and friends where they had spent their holiday, is most plausible when we consult with *Gloucester Picturesque.* This souvenir picture book, manufactured specifically for tourists, testifies as to the enduring interest the landmarks Lane painted held for visitors to Gloucester some

twenty years after he had created his canvases. We find such scenic spots as Pavilion Beach, the Pavilion Hotel, Eastern Point Light, Rafe's Chasm, Norman's Woe, Bass Rocks, Brace's Rock and a host of harbor views (one even executed from Lane's beloved Fort Point) appearing in this souvenir photograph book. [See figures 52, 53, 54, 55, 56, 57, 58 and 59.] Postcards and other souvenir-related tomes of the late nineteenth and early twentieth centuries would feature these picturesque local scenes as well.[245]

The inherent history Lane's paintings represented would not have been lost on the average sightseer. Easily enough, a visitor to Cape Ann could appreciate the significance of a place like Stage Rocks. Dramatic images of vessels being tossed about in an angry sea were a perennial favorite of the time, while the ruins of Fort Defiance baking in the sun and visions of natural beauty and wonder such as the Annisquam River, Rafe's Chasm and Norman's Woe would have been something the average caller to the Cape would have found themselves responsive to as well. Comparable scenes were already quite popular with mid-century Americans, given the analogous portrayals of old-world ruins, Niagara Falls and the Hudson River Valley that were being offered by commercially successful New York painters.

The phenomenon of an artist depicting an area recently opened up to tourism would not be novel in nineteenth-century America. Existing parallels between Lane's experience in Gloucester and those of his friend Benjamin Champney in New Hampshire's White Mountains, or Hudson River School painters Jerome Thompson, Sanford R. Gifford and Richard Hubbard in the Green Mountains of Vermont, are numerous and significant. Like Gloucester, the mountain ranges of New Hampshire and Vermont would be opened to tourism with the introduction of the railroad. The sudden influx of visitors to these regions would predictably hasten the creation of many tourism-based ventures, from resort inns such as Vermont's Summit House hotel to souvenir picture books and guidebooks aplenty. And like Lane, these artists would immortalize on canvas the sights tourists were drawn to, in particular the heights of Mount Washington and Mount Mansfield. Jerome Thompson would, like Lane, even go so far as to include a party of tourists within his painting *The Belated Party on Mansfield Mountain*, 1858, though in his picture the tourists take center stage in the foreground, while in Lane's work they often enjoy a peripheral placement at best.

The idea that Lane was painting for the tourist dollar gains further credence when we consider a sketch like his *Ten Pound Island in Gloucester Harbor* [figure 60]. Questionably dated from 1864, we find in the lower-left corner notes (inscribed by his friend Joseph Stevens) attesting that Lane had made two paintings from this sketch, and died while in the midst of making a third. What is of particular note is that all three of these customers, James Houghton, the Reverend William Phillips Tilden and Mrs. S.G. Rogers, all hailed from the Boston area, and yet were specifically commissioning paintings of a Gloucester landmark. It is much the same with his *Brace's Rock, Eastern Point*; *Brace's Cove, Eastern Point*; *View from Rocky Neck, Gloucester*; *Norman's Woe*; and *Stage Rocks and Western Shore of Gloucester Outer Harbor* sketches, where, among easily discernible Gloucester names, we find the names of Bostonians and citizens from other locales beyond Cape Ann commissioning works

from him as well. We also see Lane selling paintings of Cape Ann vistas to people with no immediate connection to the area, as in 1848, where Lane sold his painting *Ipswich Bay* to a Major Philip Kearny of New York, and his *Landscape—Rockport Beach* to an Ebenezer Collamore, also of New York.[246]

One thing that is not readily apparent when viewing Lane's artwork in this book is their sizes. Many are surprisingly small, such as *Three Master in Rough Seas*, early 1850s, 15½ by 23½ inches [plate 31]; *A Smart Blow*, 1856, 10 by 15 inches; or *Looking up Squam River from "Done Fudging,"* mid-1850s, 12 by 20 inches [plate 26]. These small canvases are hardly the type of work someone would commission, yet their sizes make them perfect for the tourism trade. Similarly, Martin Johnson Heade, fellow painter and rough contemporary to Lane, would cater specifically to the tourist trade in Florida in the 1880s (and beyond) by producing small still lifes and landscapes centered on local subject matter.

It is hard to imagine a man like Lane, who time and again demonstrated his determination to garner clients and capitalize on trends, not taking advantage of the opportunities tourism on Cape Ann would have opened up for him. With wealthy, affluent Bostonians, New Yorkers and Philadelphians flocking to his hometown every summer, Lane was assured to have an audience with the means and the desire to buy his works. Thus, residing in Gloucester afforded him something Boston could not: Lane could now build up clienteles within several East Coast cities without having to travel to them.

And perhaps this, among so many other motives, was the single greatest reason for his return to Gloucester.

Chapter 8
The House at Duncan's Point

Looming over Gloucester's Inner Harbor, a solitary structure stands atop a lone hill. More akin to a medieval tower than a house, its presence is neither grand nor humble, imperious nor meek. Rather, behind its calm façade of weatherworn granite, whipped and hammered by salty winds for well over a century now, we find an enigmatic quiet, one that betrays no secrets, and offers no clues as to how this artifact seeming to be from another continent and another age ever came to find itself perched upon the edge of Gloucester's waterfront.

Upon his return home in 1848, Fitz Henry Lane found himself in obvious need of shelter. As his nephew Edward informs us, the first place Lane resided was the home of his brother. The decision to move in with his brother was a natural one, for his brother's home, the "old Whittemore house" on Washington Street, was the residence the Lane family moved into when their patriarch, Jonathan Dennison Lane, passed on in 1816.[247] This house was consequently the second structure Fitz Henry would come to think of as "home," as he had spent the majority of his Gloucester years within its four walls. Unavoidably, during this time under his brother's roof, Lane would be in need of a studio, and nephew Edward obliges us with a brief account of it:

> I…well remember during my childhood my Uncle Fitz's "painting room," as everyone called it. I often went in when a boy to look at his paintings and remember the oval picture he painted on the fireboard that we used to hide the old fashioned fire place.[248]

Edward also informs us that the studio was located in "the western room on the first floor," as well as it having been Lane's "first studio in Gloucester."[249] But Lane would not tarry here for too long, choosing instead to move in with his sister Sarah and brother-in-law Ignatius Winter by the year 1849.[250] His reasons for moving out were never recorded, and we have no cause to believe there was an element of family strife involved in his vacating the premises. Rather, it was probably due to a want for larger space, or perhaps, if Lane physically needed tending to by one degree or another, his sister and brother-in-law proved more able and willing to do so. During his brief sojourn with sister Sarah

and her family in their Elm Street apartment, we find Lane again setting up a studio and exhibiting from his new place of residence, as testified to by an article dated August 4, 1849: "Mr. Lane has now on exhibition at his studio in Elm St., four paintings…Mr. Lane's Rooms are open at all hours of the day, and we advise all our readers who have any love of art to call there and look at his paintings."[251] Unfortunately though, this second home did not belong to the Winters, being instead the property of Captain Harvey Coffin MacKay (captain of the Packet ship *Boston*, the very same vessel Lane had immortalized in his 1830 watercolor.) Brother, sister and spouse appear to have been united in their desire to move beyond this living situation, and soon began to make the necessary preparations for owning a home to call their own.

As nephew Edward recalled, "Together Mr. Winter and my uncle built the stone house on Duncan's Point."[252] Lane, with his brother-in-law, would partake directly in the construction of his new home. As to how and in what manner he participated in its fashioning, John Trask tells us, "After his return to Gloucester [Lane] bought of Captain F.G. Low land at Ivy Hill and built a stone house designed by himself."[253] This testimony has recently been corroborated with the discovery of a previously unrecorded sketch by Lane, found at the Cape Ann Historical Association in the summer of 2005 [figure 61]. Uncovered by Marcia Steele and Moyna Stanton of the Cleveland Art Museum, Cleveland, Ohio (with scholars Henry Travers Newton and Erik A.R. Ronnberg Jr. offering technical assistance), this sketch of a structure executed in the Gothic revival style—the same style Lane's home would be built in—does much to confirm that the Gloucester painter was the source for planning and conceiving the design of his abode. As no such corresponding structure appears within any known Lane painting, we can thus by and large exclude the theory that the sketch was done in preparation for a painting.

As well, it would seem Lane served as the primary source of capital for constructing the house, and would be the person to purchase additional land from and negotiate easements with his neighbors [see figure 62]. In all documents relating to the ownership of the house and the property it stands upon, it is Lane's signature—and Lane's alone—that we find inscribed upon them. Whatever role Sarah and her husband played in all this thus seems to have been somewhat small. It is possible that they contributed some money toward defraying the costs of construction, and though we are told that brother-in-law Ignatius Winter assisted in the construction of the edifice, his talents would have been of limited use, for Winter was a carpenter by trade, and the house he and Lane were collaborating on was to be composed of stone.

That Lane conceived his new home with particular, uncompromising ideas concerning its appearance and location is quite evident, simply by considering the expenses and headaches he would endure in seeing this project through. It must be remembered that, for the money he was soon to spend, Lane easily could have purchased a pre-existing structure instead, rather than choosing the more expensive option of building his home outright. And had he chosen to construct his home with wood instead of hand-hewn granite, Lane could have either saved a small fortune, or at least built a much larger house with the

money he otherwise would have saved. And rather than build atop an open, affordable tract of land along the outskirts of town, he instead would go to the trouble of seeking out a narrow spot beside the harbor, sandwiched between other lots atop a particular knoll christened Duncan's Point, along an alley dubbed (depending upon the source) Ivy Lane, Ivy Place and Iva Place.[254] Since land beside much of the Inner Harbor was at that moment being voraciously absorbed for commercial uses, it proved to be increasingly pricey, and yet money seems to have been of little concern to Lane. Neither were the difficulties of dealings with abutters and negotiating easements with neighbors (which, admittedly, seem to have gone rather well). Obviously, Lane had very specific ideas as to the environment where he would live, letting no obstacle stand in his way.

Local legend asserts that Lane and the Winters moved into their new home a few days after New Years Day 1850. The finished product, still standing today upon its original foundation, is an unusual creation for the conservative Cape Ann area [figure 63]. Unusual, for it is but one of only a handful of area houses ever fashioned from local granite (despite a granite quarrying industry flourishing for roughly a century), and it is fashioned in the Gothic revival tradition, an architectural theme that is by and large absent upon Cape Ann. Tall and towering, with three full floors, asymmetrical windows [figures 64 and 65], Gothic vaulting within the third-floor studio and a roofline comprising seven peaked gables, decorated with simple Greek modillions in place of bargeboards [figure 66], the house at Duncan's Point stood out dramatically from its neighbors just as much in 1850 as it does today.[255]

As Lane's home, it seemingly defies the fact that he was ever paralyzed from the waist down, as it stands atop a hill, and sports steep, narrow staircases within [figure 67]. And when one considers the widely accepted local claims that Lane set up his studio on the third floor, beneath those seven gables, doubts truly begin to emerge, for everything about the house's design smacks of handicapped *in*accessibility. Yet we know that Lane did indeed do more than merely live within the stone house. Two accounts from neighborhood children tell of an artist who not only worked within his home, but was also (with certain conditions) most tolerant and welcoming toward juvenile visitors.

Mrs. Sarah Fischer, who as a child lived nearby, remembers standing behind his chair watching [Lane] paint, being admitted to his studio on condition that she should not talk, also of being allowed to inspect the various collections scattered about the room, if she wouldn't "make any noise." [256]

Another Gloucester youth, Charles Sawyer, had similar recollections:

Mr. Sawyer said that as a boy about four or five years old he used to come over with his mother to spend the summer months…And he well remembers playing with Jimmie Winter, who was the son of Mr. and Mrs. Ignatius Winter, the mother being the sister of Fitz Lane and kept house for him in the stone house on Ivy Court. Jimmy Winter was about the age

*of young Sawyer and many was the time that they two would creep into the studio of Mr.
Lane and watch him at work upon his pictures. He easily recalls how Mr. Lane appeared
and the little things that made up his personality.*[257]

An article lifted from the pages of the Gloucester papers dating from 1850 informs us
that here in his new home Lane was, like before at his sister and brother-in-law's abode,
exhibiting art to the public.

*PAINTINGS. Two fine views from Gloucester Beach, from Fort Point and Canal Rocks,
by Fitz W. [?] Lane, Esq., may be seen at the artist's rooms. They are not surpassed in
beauty of finish by any of Lane's productions, and the accuracy with which every object in
the vicinity of the beach is delineated, will render them particularly interesting to the citizens
of Gloucester and those familiar with its scenery.*[258]

An article in the *Telegraph and News* in 1856 titled "Our Artist At Home" only confirms
that it was a common practice for Lane to exhibit from out of his house:

*It was my good fortune, in the company of a few friends, to visit Mr. Lane's studio where
are several fine paintings. Among them were a night scene with the full moon shining upon
the dark tranquil waters—with a fire in the distance, which uniting with the soft rays of
the moon gave it a most delightful effect. Also a view of Boston Harbor with its magnificent
harbor, on which are many fine vessels, steamboats, &c…*[259]

Aside from these stray news clippings and bits of memory culled years after the fact,
we have only one other known testimony concerning Lane's existence under that many-
gabled roof. Found at the tail end of a surviving fragment of personal correspondence, we
find none other than the artist himself tersely commenting upon the working conditions
within his studio: "One o'clock, it is very hot, the glass indicates 84 degrees in my room,
with the windows open and a light breeze from the east. This is the warmest day."[260]

Local historian John J. Babson would in 1860 describe the neighborhood Lane moved
into as being "the center of a seat of the fishing business, which, for activity, enterprise,
and extent, has no equal on this continent."[261] A moment spent pondering Babson's words
quickly reveals just why Lane chose Duncan's Point as the place for his home. Much like
his mentor Robert Salmon, Lane had elected to live amongst the noise, clutter and stink
of an industrial site due to its immediate proximity to his chosen subject matter. Duncan's
Point was right in the middle of the working waterfront [see figure 68], the source for
Lane's inspiration and theme, and had close by not only sail lofts and ships' chandleries but
also the Burnham Brothers Marine Railway, which afforded him uninterrupted up-close
access to numerous vessels, especially when out of the water [see figure 69]. Despite the
cost for such a property, despite the inconveniences of having to negotiate easements with
his neighbors and despite the fact that Gloucester offered far more fashionable precincts

within which to dwell, Lane sought with direction and purpose to locate himself amid the very heart of it all. The article from the *Telegraph and News* conveys to us well the appeal Duncan's Point held for Lane the artist:

> *His residence commands one of the finest water prospects in town. Standing upon the threshold of his delightful home, we witnessed one of those glorious sunsets which can only be seen in our New England Springs, and as we looked abroad, my friend remarked, "truly Mr. L. has made the waste places glad."* [262]

The location of his home thus stands as a boldface statement of the devotion Lane held for his career, and when looking at his house as a studio first, home second, those "illogical decisions" mentioned above suddenly begin to make sense. "Form follows Function," so the old adage goes, and Lane's gothic tower is no exception to this architectural principle. Lane chose to live beside the working waterfront because he wished increased access to it. For a man paralyzed from the waist down, to have his home and workspace down along the waterfront meant easier contact with that dockside world. And as his home's location held purpose, so did the contradictory decision of a handicapped man to place his three-story home atop the highest elevation within Gloucester's Inner Harbor, with his studio upon its top floor. From his third-floor studio Lane would obviously hold the ideal position for studying the comings and goings of the harbor below. This is verified by the artist's own hand, in his sketch *View Across Gloucester Inner Cove, from Road near Beach Wharf*, 1850s [figure 70], where we observe not only the cluttered neighborhood within which he dwelled and his home itself at top-center of the piece, but also that Lane designed his workspace so as to see beyond the rooflines of his neighbors, beholding a view that encompassed the harbor as a whole. Yet there was more behind his design than just a view of the harbor. Of far greater importance was his need to have an expansive view of the sky, so as to study it in its many moods, as well as a means to behold light, particularly in such dramatic moments as sunrise and sunset, two times of the day Lane held a particular affinity for. (Lane may have gotten the idea for a third-floor studio from his days of renting studio space within Boston's Tremont Temple, which had a large cupola with several windows that afforded a superb view of Boston Harbor, the Boston waterfront and the sky, all with ample light.)

It must also be noted how the orientation of his house's windows by and large falls westerly. In fact, as shown in figure 66, the western side of the house sports the single greatest number of windows (and gables) by far. Such orientation was obviously no accident. Lane was working at a time before electricity, with sunlight as the primary source of illumination, as well as being the choicest light for an artist to work by. We also know that when living with his brother Edward, he set up his "painting room" in "the western room on the first floor."[263] Thus, we see that Lane intentionally designed his house with a westward orientation specifically so as to collect as much sunlight as possible, regardless of the time of year.

As the design of Lane's home reveals the devotion of the artist toward his profession, so does the choice of construction materials attest to the state of his finances. Blocks of

hand-hewn granite, though quarried locally, were still quite expensive, and the number of laborers needed to put them into place would have been both large and recruited from beyond Cape Ann—probably from Boston, where massive granite edifices were the rage of civic architecture from the 1820s to the 1850s and beyond. Hence, contemporary statements that speak of his having returned to Gloucester a success can be taken to mean not only in terms of his artistic abilities but also as concerned his commercial stature. From being part owner of a lithography shop to having gained some of the wealthiest merchants in the country as clients upon Salmon's departure, Lane had amassed a sizeable sum of money.

While the reasoning behind Fitz Henry's choice of location for his home readily becomes evident, his choice of architectural motif for the house does not reveal its secrets so easily. It has been claimed that Lane's choice was inspired by "the well-known House of Seven Gables made popular by Hawthorne's romantic tale."[264] Statements like this have perpetuated a belief for decades now that Lane, due to the fact his home had seven gables, derived the exterior appearance of his house from either the fictional edifice found within Nathaniel Hawthorne's classic novel *The House of the Seven Gables*, or from the actual seventeenth-century structure that inspired it.

The House of the Seven Gables was immensely popular and widely available upon its release, proving in time to be both one of Hawthorne's greatest commercial successes and one of America's premier literary jewels. However, the novel was published in 1851, a full year after Lane had conceived, designed, built and moved into his home at Duncan's Point. And as to the notion that Lane could have been somehow privy to Hawthorne's manuscript before its publication, while Lane may have left us fragmentary evidence concerning his daily comings and goings, Nathaniel Hawthorne and his wife Sophia opted to do the direct opposite, leaving us with journals and personal correspondences aplenty that offer intimate insights into their life together. It is through these written records that we know Hawthorne crafted his novel in semi-seclusion out in the Berkshire Mountains of western Massachusetts, an area at the other end of the state that Lane apparently never set foot in. Indeed, we even know what Hawthorne was wearing as he proceeded to write his famous tale (a man's purple damask gown), that his study faced toward Monument Mountain and that the desk he wrote at had formerly belonged to his wife's deceased brother, so detailed are the accounts husband and wife jotted down.[265] Yet nowhere in these accounts do the Hawthornes ever mention a crippled marine painter from Gloucester knocking at their door, and nowhere in the journals and correspondence do we ever find the name Fitz Henry Lane.

Since the book could not possibly have played a role in inspiring Lane's architectural design, is has been wondered if, perhaps, Lane was moved to copy the very same house that Hawthorne based his book upon. While it is always possible that Lane could have come across that house at some time before 1850 (it being located just a handful of miles down the coast in the port of Salem, Massachusetts) it is ultimately impossible for that property to have stirred him into replicating its seven-gabled roofline, for this structure did not have

seven gables at any point within F.H. Lane's lifetime. Though the house in question sported six, possibly seven "acutely peaked gables"[266] by the close of the seventeenth century, in the late eighteenth century three to four gables would be removed, thus leaving the house with only three (as seen in figure 71), remaining so until the year 1912, when architect Joseph Chandler would "restore" the home's roofline to its seven-gable configuration, as the house was then being turned into a museum[267] [figure 72].

In actual fact, the only similarity between Lane's home and Hawthorne's fictional residence is the coincidental number of corresponding gables, leaving us to concur with the words of Gloucester's gentleman scholar Alfred Mansfield Brooks, "that because it has seven gables its design has been attributed, absurdly, to Hawthorne's House of the Seven Gables which it as little resembles as chalk does cheese!"[268]

As to where Lane *did* draw his inspiration for such an unusual structure, it is important that Lane's design be seen for what it is: an expression of the artist himself. Simple, unimaginative attempts to find similarities with other domiciles must be discarded, for Lane's home is anything but the product of mimicry and banal copy work. Instead, like his art, Lane's home is a unique, thoroughly thought out, well-executed, one-of-a-kind expression, one that offers us perhaps the deepest insights into his psyche, beyond even those of his canvases (as his paintings were done with the client in mind, while his home was for himself).

"Architecture is a language," so another time-honored maxim informs us, and with this truism in mind, we must look again at the house on Duncan's Point, seeking to divine what ideals and beliefs may be embodied within its granite walls. With its stone exterior, steep gables, accentuation of the vertical, and general asymmetry, this structure stands firmly within the Gothic revival architectural movement that arose in England in the mid-eighteenth century. By the mid-1840s, Gothic revival had entered America, borne out of a backlash to the restrained, imperious order and stiff symmetry of Greek revival, a style that had dominated the American landscape since before 1820. With its stress upon asymmetry, verticality, irregular shapes and "rustic" building materials and accents, the Gothic stood in sharp contrast to the Greek, which favored flawless lines of perfect symmetry and balance, commanding horizontal proportions and austere, refined building materials. And as the Gothic Revival stood in flagrant opposition to the manner, style and form of the Greek, so did it stand in regard to the ideals the Greek revival had embodied. The rise of Greek revival architecture had run parallel with the young American nation's emergence from the fledgling insecurities of the Federalist era into the zealous confidence of an increasingly maturing Jacksonian age. The wild forests (and inhabitants) of the continent were being conquered, replaced instead with the orderly world of settlement, law and progress. Industrialization, technology and invention promised a perfect world, free from the troubles and drudgery of the past. Americans were well aware and rightly proud that they were building a civilization unlike any that had ever graced the world before, and an architectural style was called for to reflect the progress of the age, immortalize their efforts and embody the stability and order they were then imposing upon a previously untamed environment.

The Gothic could not have been further from this mentality. By the 1840s, the earlier promises of a perfect world were quickly dissipating as cheerful optimism gave way to the grim realities of the Industrial Revolution. Industrialization had, as promised, caused an increase in the living standards of the average American, but such convenience had come with its price. Invention had introduced unforeseen complexities into daily life, and this ever-changing environment had in turn bred confusion as regarded everything from humanity's place in the world to gender roles.

The conquest of the wild, untamed wilderness had come with its price as well. Americans had witnessed a once-bold frontier evaporate within half a century's time. Where a man could once stand nose-to-nose with the raw powers of nature now had been largely erased, replaced instead with tilled fields, factories, cities, pollution and disease. A sense of loss—for many a sense of *spiritual* loss—was increasingly felt among the nation's citizenry.

Gothic revival architecture was but one part of a widespread, popular movement to address the problems of the present by reconnecting with the ideals of the past. For its part, Gothic architecture sought to return humanity to the landscape, revisiting a "simpler time" of pastoral bliss and connection to the earth and all that was organic and pure. "It is in the solitude and freedom of the family home in the country which constantly preserves the purity of the nation and invigorates its intellectual powers," Andrew Jackson Downing would pen in his *The Architecture of Country Houses*, capturing in one sentence the soul of this aesthetic crusade.[269] If America was to survive the mounting chaos of rampant, unchecked growth, if her people were to persevere beyond the blind, shortsighted policies of their present day, they would have to abandon their civilization and turn again to the ways of the natural world to find their direction and purpose. And for those who heard this call to reject the present and return to the bygone age, Gothic architecture was the motif of choice when building a home.

The Gothic Revival movement would stretch beyond architecture, permeating several components of American high culture. Not surprisingly, one way was through the visual arts. Upon the painted canvas, artists of the Hudson River School, first and second generations, would encapsulate all the hope, yearning and pining for that return to a simpler, uncomplicated, even heroic time, when man walked in the Garden of Eden and the earth was new. Asher B. Durand's *Early Morning at Cold Spring*, 1850, and his *The Morning of Life* and *The Evening of Life*; Frederick Church's *A Country Home*, 1854; and Thomas Cole's *The Departure* and *The Return*, both from 1837, and his *The Past* and *The Present*, both from 1838, are but a few of the numerous images wherein the Gothic ideal was portrayed in all its unabashed glory.

As men like Thomas Cole, Jasper Cropsey and Frederick Church would celebrate and advocate the Gothic's reverence for nature within their artwork, so would they within their homes. Lane is not the only artist to have made his home in the Gothic style. Cropsey would reside within two Gothic revival households during different stages of his career, one being titled *Alladin* and the other, *Ever Rest*. Landscape painter Edward W. Nicholls would commission architect Alexander Jackson Downing to build for him a Gothic cottage at

Llewellyn Park in Orange, New Jersey, while Frederick Church would inhabit the breathtaking *Olana*, a structure that, while ultimately borne of Oriental exoticism rather than Western medievalism, still holds numerous Gothic ideals within its landscaping and planning.

Olana and *Ever Rest* stand out as holding particular parallels to Lane's home. Like Lane's tower, both of these structures would be constructed with a particular eye toward serving as studios. As Lane sought to be in close proximity to his subject matter, complete with ample viewing space of the Gloucester waterfront, so would Church's and Cropsey's homes be located upon hilltops specifically chosen for their views of the surrounding topography and skies they would paint. Church's *Olana* afforded him sweeping vistas of the Catskill Mountains, the Taconic Hills and of course the Hudson River, while *Ever Rest* would provide Cropsey with similarly wide views of the Hudson River and the Palisades. The studios of these two men would also, like Lane's, be specially designed to capture and manipulate light for the optimal usage by the artist.

The grounds upon which their homes sat would feature landscaping consistent with the Gothic landscape garden. Lane himself would plant a large terraced garden upon his property, as attested to by more than a few of those who knew him:

> *Mrs. Charles Rogers also remembers being taken by her mother as a little girl to see* [Lane's] *wonderful garden laid out in terraces and cared for by himself—she remembers especially very large balsams that resembled roses.*[270]

John Trask also speaks of Lane's home having "a fine garden,"[271] and Helen Mansfield declares, "The gardens were beautifully laid out."[272] Yet perhaps the best description of just what was in that garden comes from Lane himself, in a letter to Joseph Stevens: "[you] will fully appreciate all that I have done in my garden, in ornamenting it with flowers and plants, Rustic Arbors and Statues."[273]

Since he designed his own home, many have wondered if Lane was proficient in the trade of the architect as well as that of the marine painter. A study of the House at Duncan's Point reveals that its designer was indeed most competent in the architectural trade. Granite construction, as stated earlier, would have been beyond the skills of the local Cape Ann housewrights. Lane clearly possessed a working knowledge of architectural engineering, specifically as concerned the properties of granite, a temperamental stone known for its immense weight, solid durability and, if not careful, proclivity toward fracturing. He would have to have been versed as well in the physics of constructing with stone, knowing how to calculate weights and where to properly place major load-bearing members. Also, it is apparent that Lane had been trained in some of the finer "tricks" of the architect's trade. Of particular note is how the exterior walls gently taper inward as they make their ascent toward the roofline [figure 73]. This design feature serves to produce a subtle optical illusion, suggesting even greater height. Originally employed by the ancient Greeks in the construction of the Parthenon, this technique had been rediscovered by English architects of the eighteenth century, and was soon readily adopted. The mere incorporation of this

feature into the building fabric betrays the hand of someone thoroughly trained in the finer points of the architect's vocation at work.

It stands to reason that, in order to accurately represent architecture, whether in a lithograph or a painting, one must understand architecture. As Lane threw himself into the study of naval architecture, visiting mold and sail lofts, shipyards and shipowners, we imagine him doing the same with domestic architecture, haunting the many construction sites then to be found in a steadily expanding Boston during his time there. In his quest for learning, the Boston Athenaeum would again have served as a prime repository for knowledge and study, having the resources on hand to thoroughly ground him in the principles of the trade. Turning to the Athenaeum for instruction in the ways of the architect would not have been an unorthodox approach, as former Pendleton's lithographer (and staunch advocate of Gothic revival style) Alexander Jackson Davis spent two winters in Boston specifically to study architecture at the Athenaeum and sketch Boston's buildings.[274]

Lane was also afforded the opportunity to converse with many architects while a member of the short-lived American Art Association. A brief perusal of its membership list reveals the names of several designers, men who may very well have shared their secrets and imparted upon Lane the knowledge of how to construct edifices. Lane may also have learned the science of architecture from something as simple as a builder's manual. Having begun to appear in large numbers during the 1840s, architectural handbooks and builder's manuals enjoyed immense popularity around the time Lane built his home, and could have been instrumental in teaching him some of the essentials needed to make the structure he envisioned a reality. Yet it must also be remembered that, in nineteenth-century America, the line between artist and architect was only beginning to be clearly drawn. For many, architecture *was* an art, and the principles of design, draughtsmanship and measure proved complementary between the two disciplines. The artist as architect in America can be traced back to the Scottish-born eighteenth-century painter John Smibert, the New World's first classically trained portraiture painter, who while plying his trade in Boston would also design that city's original Fanueil Hall. By the 1840s, despite the fact that a widening gulf was forming between artists and architects, several painters continued to pursue both professions simultaneously, most notably Thomas Cole and Jasper Cropsey. In addition to Cropsey's two distinctly Gothic homes that he designed for himself and resided in, he also designed several structures for paying clients, such as his design for the Elevated Railway Station at Sixth Avenue and Fourteenth Street, a design that ironically reeks of the Gothic sensibility. Cole himself would gain accolades aplenty for his design work. His plan for the Ohio State Capitol, while classical in concept, was incorporated by Alexander Jackson Davis[275] into the final architectural arrangement for that building.[276] With the similarities in training and general fluidity found between the two professions of artist and architect, Lane could very well have gradually accrued the knowledge needed to build his tower over time.

Yet perhaps the last and most revealing of legacies Lane's home imparts is the further confirmation of his having Romantic sensibilities. Fitz Henry Lane's selection of Gothic

revival was by no means arbitrary. Easily enough, Lane could have chosen an architectural style both easier and cheaper to build. He also could have chosen a design more in keeping with the conservative, pragmatic sensibilities of the community within which he resided. It is plain to see that Lane did not select his home's design motif on a whim. Rather, his decision to construct a home in the Gothic tradition was a deeply personal affair, as evidenced by the complications and expenses inherent in its building and the particular functions incorporated within its design. The choice of materials and motif employed in the construction of his home are perfectly in line with contemporary examples of known Romantics like Church and Cropsey, and thus, to have chosen the Gothic revival style, we see Lane making a boldface statement of his allegiance toward the ideals these artists and the Gothic Revival movement advocated. Ideals that, while not as overt and blatant in his art as they are within the works of Cole, Durand, Church, and others, can be found readily present.

Chapter 9
Looking Beyond the Canvas

It is only natural for us, the modern public, to find our interest in Fitz Henry Lane lying primarily within his artwork. After all, Lane was the creator of many breathtaking canvases, works that charm us with their beauty while simultaneously offering intimate, frank details and depictions of a world that no longer exists. Compounding this, we find that Lane has left us few artifacts beyond his artwork by which we can come to understand and "flesh out" his daily life. Lane would never wed, thus leaving us without the personal testimonies of a wife or children by which to reconstruct his life. Apparently he did not keep a diary or journal of any sort, and of the personal correspondences he authored, we are only aware of a stray few that have survived.

With only a handful of private letters, newspaper clippings and reminiscences with which to guide us, an image of Lane has formed over time, one of a man who was dour, taciturn and lonesome. Contemporary quotes describing him as "nervous, quick, and dyspeptic,"[277] have been interpreted by modern art historians to somehow mean that Lane was also "a somewhat saddened and introspective figure…often prone to moodiness with friends,"[278] and that his existence was one of "quiet loneliness."[279]

Sad? Moody? Lonely? Is this an accurate image of Lane? For a more informed opinion of Lane, the testimonies of his associates and acquaintances must be taken into account. Lane's friend John Babson described him as possessing a "characteristic kindness."[280] Gloucester's Helen Mansfield remembers a similar Lane:

> I well recall my aunt telling me that one morning Mr. Lane came in with a picture beautifully framed which he handed to her, saying, "Well, Lizzie, I hear your [sic] going to marry Capt. David Plumer, [sic] and so I have brought you this present." [281]

Mrs. Sarah Fischer and Charles Sawyer both reveal that Lane held no objection to children visiting and exploring his studio,[282] and his eulogists would, upon his passing, describe his life as having been "industrious, genial, and unpretending,"[283] and remembered him as being of a "pure and gentle spirit" that "won the respect and esteem of a refined circle of friends," all while "his kindness of heart and obliging disposition attached him

fondly to all."[284] And John Trask, the very man who testified to Lane being "quick, nervous, and dyspeptic," also informs us:

> [Lane] *was always hard at work and had no moods in his work. Always pleasant and genial with visitors. He was unmarried having had no romance. He was always a favorite and full of fun. He liked evening parties and was fond of getting up tableaux.*[285]

A brief review of the testimonies of those who knew him enlightens us to the fact that Lane was a far more complex and amiable man than we have previously been led to believe. In fact, not one account contemporary to when Lane was alive has surfaced featuring the adjectives "sad," "moody," "lonely" or any other words that would convey the same notions. It would seem that previous modern-day attempts at describing Lane were both misinformed and unsubstantiated.

Yet perhaps it is the claim of his having dwelled within a "quiet loneliness" that proves to be the most unfounded of all the misrepresentations handed down to us over the past thirty-five years. In one of the several obituaries printed after his passing in 1865, we discover, "No man was more heartily admired in the town where he has resided so many years, and no death can be more lamented."[286] Old friends from Boston came calling upon his door as late as 1864, less than a year before he died. From notations inscribed upon his sketch *Folly Cove, Lanesville—Gloucester*, 1864, we learn Lane was hosting Benjamin Champney, his old friend from Pendleton's in that year:

> *Lane and Champney took a drive around the Cape. Champney sketched Folly Cove in colors, Lane in pencil. This was* [Lane's] *last excursion in that vicinity.*[287]

Another friend, John W.A. Scott, would also visit the Cape repeatedly in the 1860s, as attested to by the diary of Lane's patron and friend Samuel Sawyer,[288] sketching the Cape Ann shores, presumably (like Champney) in the company of Fitz H. Lane. And for someone supposedly so lonely, we find Lane regularly enjoying the company of visitors, such as Annette Babson, who reports, "After dinner we went to Mr. Lane's our native artist, and saw a lovely picture taken from my favorite spot—'Stage Rocks.'"[289] As well Lane himself visited others on a regular basis, like Dr. Herman Davidson, as Lane's nephew Edward makes known: "Dr. Davidson…was one of [Lane's] close friends, and almost every Sunday, weather permitting, would find them together at the Doctor's home."[290]

From Helen Mansfield we know that Lane's circle of friends was no mean gathering of hard-drinking sailors and crude fishermen, but rather that he enjoyed the genteel company of Gloucester's most prominent men of business.

> *My aunt at the time she received this gift was assistant in the store of T. Sewall Lancaster, Esq., which was situated at the corner of Main and Short streets. Mr. Lancaster was one*

of the representative men of Gloucester in his day, was Postmaster and for a great many years town treasurer…

> *At the time my aunt tended there, a good many of the prominent men of the town used to drop in to talk over town affairs with Mr. Lancaster practically every day and as my aunt was of a very bright disposition she easily became a favorite not only with the customers, but with these friends of Mr. Lancaster, among whom were John J. Babson, the local historian, Ben. Franklin Somes for many years cashier of the Gloucester Bank and Fitz Lane, the artist.* [291]

Given that his childhood was spent growing up on Gloucester's prosperous Middle Street (home at that time to wealthy merchants and sea captains) and considering the connections his father would have held along the waterfront, it would appear that Lane had been acquainted with men such as these well before his departure for Boston in 1832. Some of these high-ranking men surely remembered him from his days as a neighborhood youth, and could well have taken a paternal interest in him and his work, while those closer in years seem to have by and large grown up with him, having been his playmates and chums in the streets of Federalist-era Gloucester. An article from the *Winnisimmet Pioneer*, written in the late 1840s at about the time of Lane's return to Cape Ann, defines this relationship:

> *We are gratified to learn from some of the leading papers, that the Marine Paintings of Mr. Lane, of Boston, are well known and appreciated. Mr. L. was our playmate and next door neighbor, in early childhood, and we have always felt a strong interest in his welfare. We rejoice that a discerning public has showered upon him that approbation, without which genius must often droop in disappointment.* [292]

Though the author of these words is unknown, we know that Lane was associated with at least two newspapermen. W.E.P. Rogers, the man John Trask credits with having helped introduce Lane to the Pendleton's workshop, was the publisher of the *Gloucester Telegraph* from 1827 until 1833. [293] And John J. Piper, businessman, investor and editor of (among others) the *Gloucester News and Semi-Weekly Messenger* between the years 1848 and 1851 and the *Fitchburg Weekly Reveille* from 1852 to 1869, [294] was indeed a personal friend of Lane's.

Evidence that Lane circulated among the top tier of Gloucester society is also to be found within the records of the Gloucester Lyceum, formed in the year 1830. We find among the list of original subscribers for membership within that institution (dated February 15, 1830) many of the men who would become Lane's patrons or who would testify in later years as to having been his friend. The abovementioned newspaperman W.E.P. Rogers; Benjamin Franklin Somes, cashier of the Gloucester Bank; and historian John J. Babson were original members of this institution, as was George H. Rogers, the great Gloucester merchant and one of Lane's most prosperous and frequent local clients. Harvey C. MacKay, captain of the packet ship *Boston*, which Lane painted afire on the high seas that

very year in watercolor—the man who was also landlord to Lane, his sister and brother-in-law when they were residing at his Elm Street property in 1849—appears on the list as well. The signature of Addison Gilbert, a Gloucester merchant who "had business interests in Boston as well as his native city," and "was at one time or another selectman, assessor, town moderator, school committeeman and state representative, among other civic positions, and president of the City National and Cape Ann Savings banks,"[295] can be found listed on this document, along with Gorham Parsons Low, shipmaster, "founding president of the Bank of Cape Ann,"[296] and the man whose wife would commission Lane to paint Gloucester's Brace's Rock in 1863.[297] Even the Reverend Hosea Hildreth, pastor of the First Parish church—the same church Lane had been baptized in and presumably grew up worshiping in—and Judith Millett, the most probable candidate for having schooled Lane in his childhood years, were original members of the Lyceum.

Fitz H. Lane officially became a member of the Gloucester Lyceum on March 1, 1831.[298] We find Lane's signature immediately below that of his close friends Joseph L. Stevens Jr. and John J. Piper, a strong indication that the three had known one another previous to their joining. Within the March 1 list of new members we also find the name Elias Davis Knight, first mate of the packet ship *Boston*, and the man who gave Lane the sketch by which he based his painting of the *Boston* a year previous.

From among this learned, prominent class we find Lane associating with men of leisure and affluence in ways that extended beyond the realm of mere business arrangements and shared professional associations. Some of these individuals have, like Lane himself, left us little by which to reconstruct their lives and their daily interactions with the great Gloucester painter. A Mr. Horace R. Wilbur of Boston would be remembered prominently by Lane in his will,[299] yet aside from his having been a bookkeeper living in Boston and their having shared an interest in Spiritualism there is little else we know at this moment concerning their friendship. T. Sewall Lancaster, Esq., and Benjamin F. Somes would be entrusted by the artist respectively with the tasks of being executor of his last will and testament and conducting the probate inventory of his estate,[300] and though we know them both to have been friends with Lane through Mr. Lancaster's store, as to the nature and depth of their friendships we can only speculate.

Others, like historian John J. Babson, have left us with ample information as to who they were, but only tantalizing hints as to how well they were acquainted with Lane. Born in 1806, we know Babson to have been "an enterprising and prosperous merchant, engaged in both domestic and foreign trade," a Superintendent of Schools who "revolutionized the [Gloucester] school system,"[301] a tireless legislator who served in the Massachusetts House of Representatives, State Senate and Banking Commission, and author of the definitive text on Gloucester history, *History of the Town of Gloucester, Cape Ann*.

Babson's associations with Lane intimate at having run quite deep. From the article penned by Helen Mansfield we know both these men frequented Mr. Lancaster's shop. From the records of the Gloucester Lyceum we know that in 1849 Babson served as president of the Lyceum at the same time as Lane and John J. Piper were directors

and Joseph L. Stevens Jr. filled the role of recording secretary.[302] Lane would create for Babson and his brother a ship portrait of the Surinam brig *Cadet*, of which they were co-owners,[303] while for Babson's relatives Maria and Emma Babson, Lane would fashion two paintings, *Riverdale*, 1863 [plate 22], and *Babson and Ellery Houses, Gloucester* [plate 23], also from that year. As well, the very illustrations for John Babson's 1860 history of Gloucester were crafted by Lane, such as *View of the Old Fort and Harbor*, 1837 [figure 74]. Babson also appears to have played a major role in referring Lane to the historian J. Wingate Thornton, who in 1858 was in need of a cover illustration for the re-release of his book *The Landing at Cape Anne* [*sic*], a text detailing the founding of Gloucester's first settlement. In a series of letters from Thornton to Lane securing the arrangements for the illustration, Thornton declares: "Mr. Babson's opinion of your success [concerning the cover illustration] is very flattering."[304]

Perhaps most telling, though, is the relaxed, intimate manner with which Babson describes Lane in his *History of the Town of Gloucester*, or the very fact that he takes the time to include Lane, who was still very much alive in 1860, in a book dedicated to Cape Ann's past. Indeed, Lane is one of only a handful of contemporary Gloucester citizens referred to in the text, and among these, the only person to whom Babson devotes such frank attention.

Samuel Sawyer, early contributor to the Lyceum, founder of Gloucester's public library (the aptly named Sawyer Free Library) and friend to such artists as Albert Bierstadt, was also a patron and friend of Lane's.[305] From his diaries we discover Sawyer to have ordered two paintings from Lane on August 8, 1864, "to be done [when] he is at leisure,"[306] and we know him to have commissioned at least a third four years earlier, the estate portrait *Sawyer Homestead*, 1860 [plate 21], for which he paid $100.[307] Sawyer would also purchase a Lane painting for $50 in 1864 at a "Sailors Fare."[308] From Sawyer's diary we also find him visiting Lane for what appears to have been purely social reasons, as his entries make no characteristic mention of business transactions.[309]

Given how he was so well acquainted with the personal history and daily habits of F.H. Lane, we must concede that John Trask was a close friend of his. As to how these two gentlemen became acquainted, we may speculate that they met through Trask's paint shop, as he was the most likely source for Lane's painting supplies in Gloucester. (His paint shop was only a few hundred feet from Lane's front door. Trask also gives a testimony concerning the specifics of Lane's color palette.[310]) We know their relationship to have been professional, as it appears that Trask was the owner of Lane's *Three Master on the Gloucester Railway*, 1857 [plate 9], that was displayed upon the premises of Trask's paint shop as an advertisement for the Burnham Brothers railway complex, of which Trask's shop was a part (in the painting workers are in fact busily applying paint to the hulls of the vessels featured). Trask donated the work to the City of Gloucester in 1876.[311] Yet their associations were personal as well, with Trask volunteering alongside Lane in a fundraising effort for a "Lyceum Library,"[312] and being privy to so many of his personal nuances.

Like Babson, Sawyer and Trask, John J. Piper was a prosperous member of the Gloucester business community, being a newspaper editor, business partner of George

H. Rogers and senior officer of the Gloucester Lyceum.[313] As well, we find him to have been a patron of Lane's art. It becomes clear that this arrangement went beyond that of mere artist/patron dealings by the familiar tone with which Lane discusses the creation of a work for Piper to their mutual friend Joseph L. Stevens: "I yesterday made a sketch of Stage Fort and the surounding [sic] scenery, from the water. Piper has given me an order for a picture from this point of view, to be treated as a sunset."[314]

It is John J. Piper who stands out as being the most likely of Lane's known acquaintances to have penned the article in the *Winnisimmet Pioneer* concerning his burgeoning art career. As fellow directors of the Lyceum in 1849,[315] Lane and Piper would work together toward planning the Lyceum's lecture schedule for the following year. Lane and Piper also served as the organizers of a floral procession for an 1849 Fourth of July celebration in Gloucester. A local newspaper described how "After this came the Chief Marshal of the Floral procession, Mr. J.J. Piper, accompanied by Fitz H. Lane, Esq. in an open carriage,"[316] while at the article's conclusion Lane and Piper together would pen words of appreciation to the many individuals who had contributed their time and labor to the parade:

> *ACKNOWLEDGEMENT. The undersigned, managers of the Floral Procession on the Fourth, would render their earnest thanks to the ladies who undertook with so much zeal and perseverance to prepare the schools for the occasion. The complete success which attended this undertaking, novel here and difficult to accomplish in so short a time, is wholly attributable to the promptness with which they accepted and carried out our hasty designs. While they will feel amply repaid for their laborious exertions, by the success of the undertaking, and the pleasure it has afforded to so many of our young friends, we shall remember their kind assistance as a pleasing token of approbation.*
>
> *John J. Piper*
> *Fitz H. Lane* [317]

Another Lyceum comrade with whom Lane would keep company with was Dr. Herman Davidson. Serving at different times as a director and corresponding secretary of the Gloucester Lyceum, we know from Edward Lane that "almost every Sunday, weather permitting," Lane would pay a visit to Dr. Davidson at his home. He would also produce several paintings for the doctor and his wife, including the stunning *View of Coffin's Beach*, 1862 [plate 29]. Perhaps the most significant indication as to how close these two men were is encountered when pondering the falling out between Fitz Henry Lane, his sister Sarah and her husband Ignatius. For of all the friends, clients and associates Lane could have turned to while in the midst of his familial quarrel, it was under the roof of Dr. and Mrs. Davidson that he would temporarily reside.

If there is any one individual who can claim the distinction of having been Lane's closest, truest friend, that honor must fall to Mr. Joseph L. Stevens Jr. A resident of Gloucester

and Castine, Maine, Stevens managed a dry-goods business while alternately pursuing an interest in cultural and artistic affairs. As a member of the Gloucester Lyceum Stevens functioned as the recording secretary from 1847 straight on through to 1852 (and possibly far longer, though we cannot be certain as the Lyceum's records possess gaps after 1852).

In a letter to Samuel Mansfield, Stevens reveals the nature of his relationship with Lane:

Boston, Oct. 17, 1903

Dear Mr. Mansfield

…Lane was much my senior and yet we gradually drifted together. Our earliest approach to friendship was after his abode began in Elm Street as an occupant of the old Prentiss house, moved there from Pleasant. I was a frequenter of his studio to a considerable extent, yet little compared with my intimacy at the next and last in the new stone house on the hill. Lane's art books and magazines were always at my service and a great inspiration and delight—notably the London Art Journal to which he long subscribed…

Lane was frequently in Boston, his sales agent being Balch who was at the head of his guild in those days. So in my Boston visits—I was led to Balch's fairly often—the resort of many artists and the depot of their works. Thus through Lane in various ways I was long in touch with the art world, not only of New England but of New York and Philadelphia. I knew of most picture exhibits and saw many. The coming of the Dusseldorf Gallery to Boston was an event to fix itself in one's memory for all time. What talks of all these things Lane and I had in his studio and by my fireside!

For long series of years I knew nearly every painting he made. I was with him on several trips to the Maine coast where he did much sketching, and sometimes was was [sic] his chooser of spots and bearer of materials when he sketched in the home neighborhood. Thus there are many paintings whose growth I saw both from the brush and pencil. For his physical infirmity prevented his becoming an outdoor colorist.

During my two-and-a-half years' absence in the West he kept me so well informed of studio doings that on the resumption of Gloucester home life there were few broken threads to pick up with him. The beginning of my work in Boston some months later changed our relations somewhat without narrowing them.

And so our companionship went on through after years to that sad day when I watched the drawing of his last breath.

Sincerely Yours,
Joseph L. Stevens[318]

Yet it was Stevens's involvement in the American Art Union that probably held a greater common interest between him and Lane.

AMERICAN ART-UNION. —We are indebted to Mr. Joseph L. Stevens Jr, secretary of the American Art-Union for this town, and vicinity, for copies of the "Transactions," for 1848, and the April number of the monthly Bulletin of this Association…Among the landscape paintings distributed, we find in the catalog two by Fitz H. Lane Esq. of this town, viz. "Rockport Beach" and "Ipswich Bay." [319]

Stevens seems to have taken a keen interest in Lane's artistic career. From such simple acts as being the "chooser of spots and bearer of materials when he sketched in the home neighborhood"[320] to sending copies of the "Transactions" to local newspapers, we find Stevens performing an active role in the furthering of Lane's career.

Another means by which Stevens promoted Lane and his art was by embarking together "on several trips to the Maine coast where he did much sketching,"[321] apparently as early as 1848. Stevens, a prominent resident of the town of Castine, Maine, was undoubtedly a major and direct influence in persuading Lane to paint Maine subject matter, especially since, with the exception of his painting *Twilight on the Kennebec* from 1849, all his paintings and sketches involving that state would center on the Penobscot Bay and nearby Mount Desert areas, two regions of the Maine coast where Castine holds a central position. In what is surely but one of several such correspondences, Stevens in January of 1851 warmly encouraged Lane to visit Maine in the upcoming summer, tempting him with the promise of scenic vistas yet to be captured, offerings of hospitality aplenty and eager patrons.

…There are several points of view which you did not see, and to which it will be my pleasure, next summer, to carry you. I know many of our citizens would be gratified to have this done by you. Our house we shall expect to be your home, and if as you suggested in Gloucester, you should come in your Boat, this place could be made a rendezvous, from whence you could start to any place that convenience and inclination might dictate. I will only say that my wife and myself will spare no efforts on our part to make your visit agreeable, and perhaps useful. You have not or did not exhaust all the beauties of Mt. Desert scenery, and perhaps there may be other spots in our Bay, that you may think worthy of the pencil. [322]

This neighborhood also proved to be quite lucrative for Lane, given the influx of tourism and overall burgeoning industries coming into the Penobscot Bay at that time. In the September 11, 1850 *Gloucester Daily Telegraph*, Stevens would publish a lengthy and thorough description of his and Lane's August voyage around Penobscot Bay and Mount Desert Island, his picturesque prose serving to whet readers' appetites for both the Maine wilderness and Lane's depictions of it. Stevens even makes a point to mention how "Lane who was with us, made good additions to his portfolio."[323]

And from a letter dated January 29, 1851, we know that Stevens was actively displaying to the public a Lane painting within his home in Castine (one which Lane had composed for Stevens as a gift), and would even go so far as to broker the publication of a lithograph

by Lane entitled *Castine from Hospital Island*, 1855 [figure 75], a litho that was specifically targeted toward garnering subscription sales from the people of Castine.

> *Several gentlemen who have called to see the painting have expressed a desire to have a drawing from you of our town, similar to yours of Gloucester, which they much admire, and, if lithographed, I have no doubt copies enough could be disposed of to remunerate you.*[324]

And as to whether or not Lane held his friend in equally high regard, all indications point out that indeed he had, with Lane expressing his affection and gratitude in a most fitting of ways:

> *Since writing you last I have painted but one picture worth talking about and that one I intend for you if you should be pleased with it. It is a view of the beach between Stage Fort and Steep bank, including Hovey's Hill and residence, fresh water cove, and the point of land with the lone pine tree. Fessenden's house likewise comes into the picture. The effect is a mid-day light, with a cloudy sky, a patch of sunlight is thrown across the beach and the breaking waves. An old vessel lies stranded on the beach with two or three figures. There are a few vessels in the distance and the Field rocks which come in to destroy the monotony of a plain sand beach, and I have so arranged the light and shade that the effect I think is very good indeed; however, you will be better able to judge of that when you see it.*[325]

This painting, known to us today as *Dolliver's Neck and the Western Shore from Field Beach*, 1857 [figure 76], was one of several Lane gave to the Stevens family over the years as tokens of respect and amity. Some, like his *Study of Vessels* from that same year [figure 77] and *Seashore Sketch*, 1854 [plate 20], even bear personal inscriptions on the back, such as "Fitz H. Lane to his friend Joseph L. Jr., Gloucester, February 14, 1857,"[326] and "F.H.Lane to J.L. Stevens, Jr. 1854."[327] Oddly though, several of the paintings Lane gave to Stevens were oil sketches rather than fully prepared canvases. Indeed, this is exactly what *Study of Vessels* and *Seashore Sketch* are, as well as *Island with Beacon*, 1851, which is made more engaging by the inclusion of a tiny sailboat and a man fishing off its side. Others, like *Dolliver's Neck and the Western Shore from Field Beach*, while being full oil-on-canvas works, are far from being Lane's best efforts. Yet Lane, rather than merely pawning off oil sketches and uninspired compositions to the Stevens clan, would also craft exquisite works for them, works created specifically with the Stevenses in mind. In a letter to Lane penned by Joseph Stevens's wife Caroline, we easily detect the immense pleasure one such painting held for them:

> *Castine, February 9th, 1853*
>
> Dear Sir:
>
> *We received a few days since, the painting of our daughter's residence, executed by you. It affords us a twofold gratification, in being able to recognize in it, the home of a dear*

child, and of knowing that you still remember us. Please to accept in return our sincere and heartfelt thanks. It is indeed a beautiful picture, independent of the pleasing associations connected with it...

Again, please allow me to express our sincere thanks for the little "Brown Cottage."

Yours very respectfully,
D.[sic?]L. Stevens[328]

Another work that would draw rapturous praise from the Stevenses was one based upon the sketch *Northeast View of Owl's Head*, August 1851 [figure 78]. Within the bottom-right corner, Joseph Stevens made the annotation, "This sketch was painted in moonlight effect and presented to my mother."[329] Recently discovered, this painting [plate 25] proves itself to be a splendid composition, worthy of the acclaim Stevens would heap upon it.

Castine, January 29, 1851

My dear Sir,

...I can no longer defer the expressions of our warmest acknowledgements for a present, in itself so valuable, and endeared to us by many associations, as a representation of scenery often admired, and which I have many times wished could be transferred to canvas, although very far from that wish would ever be gratified. You must permit me, however, to say that the Painting, valuable as it is as a work of Art, and pleased as I may be as the possessor of it, is less appreciated by us than the delicate and very generous manner in which its acceptance has been tendered...I feel, too, under great obligations for the drawing of the "Siege"—I had no expectations you could have produced anything so good from so rough a copy. I shall have it framed for preservation and future reverence...

We look forward with great pleasure, to your visit next summer, providence permitting, and in the meantime beg leave to assure you of the sincere esteem and respect.

Of yours, most truly
Joseph L. Stevens[330]

Through their fond remembrances and candid words the friends and neighbors of Fitz Henry Lane allow us precious insights into his private life. From personal correspondences to published accounts, men like Stevens, Trask and Babson make known traits and quirks Lane's art alone could never have led us to know. These men even present us with insights into the themes present within Lane's art. Yet while friends and acquaintances grant us many revelations, it is within the various institutions and reform movements Lane participated in that we find a window into understanding Lane's convictions, beliefs and attitudes toward life in mid-nineteenth-century America.

The Gloucester Lyceum stands out as one such window. As stated within its constitution, the Lyceum's objectives were "the improvement of its members in useful knowledge and the advancement of popular education."[331] This was immediately in keeping with a much larger trend sweeping America at that time, a movement dedicated toward self-edification and personal enrichment that had started in Massachusetts just four years earlier with the founding of Millbury Branch, Number 1, of the American Lyceum. Named for the school of the Greek philosopher Aristotle, Lyceums sought to promote the circulation of practical information and the intellectual advancement of the community by training teachers, founding public libraries and museums, and by playing host to a number of lectures, debates and classes revolving around a dizzying array of topics. From the practical to the educational to the inspirational, the Lyceum served as the place for a proper forum of discussion and debate within a community.

The rise of the Lyceum movement ran parallel with that other great intellectual awakening that occurred in Massachusetts at that time: transcendentalism. In fact, the two were inextricably linked. Transcendentalists sought to attain nothing less than the "Perfectability of Man." Perceiving man as being a constantly evolving spiritual entity, striving toward a perfect, god-like state, they sought to aid and encourage this progression toward the divine by the pursuit of study, art, poetry, debate and philosophy. Lyceums, by their very function and given their incredible popularity,[332] served as the perfect vehicle by which adherents of transcendentalism could further their personal quests for "Perfectability," while for transcendentalist thinkers like Emerson, Thoreau, Jones Very, James Freeman Clarke, Theodore Parker, Frederic Henry Hedge and numerous others, Lyceums enabled them to deliver transcendentalist philosophies across the entire nation.

Transcendentalism itself was paradoxically borne of and yet a backlash to the prevailing trends in America at that time. New England's place of prominence within the Industrial Revolution and global trade, complete with the wealth these two institutions brought along with them, had created a learned class with the time and the means to invest in intellectual pursuits. Industrialization had brought with it the hope for a perfect world, while global trade carried not only foreign commodities in the holds of ships, but also foreign forms of thought and expression in each vessel's wake. Yet increasingly, Americans were growing disillusioned as the Industrial Revolution proved to not be all progress and wonderment. Like any great undertaking, it came with its price. People were reeling as cherished institutions and timeless ways of living were upset and transformed with startling rapidity. Trained artisans and craftsmen were put out of work overnight with the arrival of factories and mass production. Institutions like the textile mill, by actively recruiting the daughters of New England farmers to work their looms, radically altered the place of women in the workforce. Lives that had moved to the rhythm of the seasons were now governed by the hands of the town clock as the pace of life increased dramatically.

Meanwhile, evolutionary theory challenged the very notion of where we came from and who we were, while the sciences of archaeology and geology proved the world to be

far older than the Bible claimed. Scientific reason begged a question that a hundred years before for most would have been unthinkable: is there a God?

Given the impact the Industrial Revolution had upon the daily lives of America's citizens, it is little surprise that nineteenth-century America was swept with a large number of movements seeking to re-define man's role in the world.

> *What many Americans called a "spirit of reform" prompted them to examine and often to reconstruct their social arrangements and patterns of behavior—most explosively slavery, but also drink, schooling and childbearing, dietary and sexual habits, the role of women and of wage labor, and the care of criminals and the insane. They created an "age of association," covering much of the nation with thousands of voluntary associations from sewing circles to Masonic lodges, and establishing new social and economic institutions on a state and national level.*[333]

The nature of these movements ran the full spectrum, stretching from the conventional, such as religious revivals and new political parties, to the odd and the outright bizarre. Yet from the midst of a wide assortment of wildly differing belief systems that had emerged in response to the demands of a rapidly changing society, the genuine philosophical doctrine of transcendentalism would emerge, offering the American people answers and solutions to the challenges of their day.

Transcendentalism itself was the amalgamation of several different philosophies and belief systems, including Platonic Idealism, Far Eastern and Native American religious thought and the words of Immanuel Kant, Samuel Taylor Coleridge, Thomas Carlyle and William Wordsworth. The man responsible for germinating this seed of thought in America would prove to be a Harvard-educated, eighth-generation minister (who resigned from the ministry in 1832) with a penchant for theology, philosophy and lecturing. Beginning with the publication of his essay *Nature* in 1836, Ralph Waldo Emerson would grow to become the lead figure in a movement that would ultimately come to define the character of the American nation. The concepts of self reliance ("Trust thyself: every heart vibrates to that iron string."[334]), nonconformity ("Whoso would be a man must be a nonconformist."[335]), individualism ("Nothing is at last sacred but the integrity of our own mind,"[336]) and a bold desire to achieve ("God will not have his work made manifest by cowards."[337]), as well as a love for the natural world, can ultimately be traced back to the lectures and treatises of Ralph Waldo Emerson.

In a response to the rising need for stability amidst the constant changes American society was experiencing at the time, transcendentalists like Emerson advised Americans to seek the permanent spiritual reality that lay beyond transitory physical experiences. To accomplish this, transcendentalism proscribed a reliance not upon rational thought but rather, intuition. Such an attitude was ultimately derived from Platonic Idealism, the belief being that true reality was spiritual rather than physical, and that the spiritual was

permanent, while the physical was transitory. Rational thought had, after all, been the engine that had powered the scientific advances of the Age of Reason, and thus permitted the birth of the Industrial Revolution in the first place. By choosing to embrace a mystical approach to the world rather than one of logical thought and reason, transcendentalists were rebelling against the modern order, following their instincts and emotions instead of the cold calculations of science. Transcendentalism encouraged its devotees to turn away from the wonders of science, technology and their associated by-products altogether, and counseled them to instead seek their guidance from the natural world.

It was within nature's functions and processes that the transcendentalist saw the path to knowing God, a notion that in its simplest form could be summarized as: God is good. God made nature. Thus, nature is good. And in matters of art, it has been roundly argued that these sentiments toward the natural world are echoed time and again in the landscapes of Cole, Durand, Gifford, Church and so many other American painters of the early to mid-nineteenth century, including Fitz H. Lane.

Over time, many scholars have wondered what connection Lane may have had with this popular yet, at the time, controversial intellectual movement. Fitz Henry Lane's membership and active participation within the Gloucester Lyceum would certainly seem to infer that he was in fact a transcendentalist, but this association by itself can only be taken so far, as not everyone who participated in the Lyceum movement necessarily held a kindred interest in the words of Emerson and company.

In the quest to find an answer, we must turn to the very beginnings of the Gloucester Lyceum itself:

> *The Lyceum was established in 1830, with the chief design of developing the talents of its members in lectures, essays, and debates. To this end of its formation, the labors of that wise and earnest friend of education, Rev. Hosea Hildreth, constantly tended.*[338]

It was in 1825 that the Reverend Hosea Hildreth came to Gloucester, having accepted an invitation from the town's First Parish Church—the church in which Lane was baptized and his family worshiped—to serve as its pastor.[339] Having been trained as a Congregational minister, Hildreth found himself ascending the pulpit of a fractured church, one rent asunder by divisions concerning the fundamental doctrines of Calvinism, a phenomenon then sweeping through innumerable parishes across New England and known to us today as the "Unitarian Controversy."[340] Hildreth's reign at the First Parish Church began "with the fairest prospects of success," and found him "constantly active in endeavoring to promote the moral and intellectual improvement of the whole town."[341] It was from such endeavors that Hildreth raised the Gloucester Lyceum in 1830, serving in such critical roles as its corresponding secretary, representative delegate to a Lyceum "County Convention" and member of the lyceum's "Committee to Prepare a Constitution," "Committee to Propose Questions for Debate" and "Committee of Exercises."[342] (Hildreth would even lecture at the Lyceum several times, covering such

topics as *Electricity*, *Chemical Attraction* and *Prismatics*.[343]) Unfortunately, despite his efforts among the parish and greater community of Gloucester, the schism within the First Parish proved too great to mend, and Hildreth himself stepped down from his pastorship (at his own request) on December 31, 1833.[344]

It was most likely through the preaching of the Reverend Hosea Hildreth that Fitz Henry Lane was introduced to and began to equate himself with the Unitarian faith. Though Hildreth was trained as a Congregationalist minister, we find him ultimately investing his beliefs within the Unitarian cause, being expelled by the Essex Association in 1834 for "exchanging with Unitarians," and serving a Unitarian congregation in Westboro, Massachusetts, upon the eve of his passing in 1835.[345] Babson remarked that Hildreth "did, indeed, enforce good works more than good belief,"[346] revealing Hildreth to have upheld one of the hallmark beliefs of Unitarianism, the principle that Christ-like deeds are the true mark of one's faith, a stance that ran contrary to the traditional Calvinist notion of salvation through belief, to which Unitarians balked in rebellion.

That Lane, though born and raised a Congregationalist, considered himself a Unitarian is quite evident from the fact that a Unitarian minister, the Reverend Mountford of Boston, conducted his funeral services in 1865.[347] Another clue confirming Lane's Unitarian leanings is his membership in a little-known organization active in mid-century Boston known as "The Religious Union of Associationists."

Boston, Sunday, Jan'y 3, 1847

A meeting of persons desirous of forming a religious union in this city was held this afternoon at 3 o'clock at the house of J. Fisher No. 10.3 Harrison Avenue: about 40 persons were present. The meeting was opened with sacred music from the piano of John S. Dwight of Brook Farm: Mr. W.H. Channing then read selections from the scriptures; at the conclusion of which he stated briefly the object of this meeting, and expressed the desire that was felt by himself and others to unite in a Union with all who felt themselves ready to devote their lives to the establishment of the Kingdom of God on Earth.[348]

In 1847 Fitz Henry Lane became a member of the newly formed Religious Union of Associationists.[349] Led by the reform-minded Unitarian minister William Henry Channing, the Union would attract the attention of several religious liberals, free thinkers and former members of America's first experimental commune, Brook Farm, including former Unitarian Minister George Ripley, founder of that failed cooperative. (Channing himself had been involved with Brook Farm, contributing to the papers they published while living on-site during the summer of 1846.) The Union, like its founder, was strongly influenced by the spirit of reform then prevalent in New England. As stated in a tract circulated by the Religious Union in 1848, "The Religious Union of Associationists—or the Church of Humanity, as it has been named—has for its aim the reconciliation of the

Christian Church and Social Reform."[350] It was here that they saw the means by which to work toward "the establishment of the Kingdom of God on Earth," believing "In Faith, that it is the Will of God, by the ministry of man, to introduce upon this planet an Era of Universal Unity."[351]

The Association's focus upon combining social reform with Christian theology was a direct influence of William Henry Channing's uncle (of whom William Henry was a devout follower), the Reverend William Ellery Channing. Christened with the title "Star of the American Church" by none other than Ralph Waldo Emerson himself,[352] and described as "the most serious preacher and most remarkable author of the present time in America" by Alexis de Tocqueville,[353] William Ellery Channing had come to find himself regarded as Boston's foremost Unitarian preacher due to his treatises that served to define and ultimately defend the Unitarian faith during the Unitarian Controversy. Yet it was his 1830 Election Day sermon *Spiritual Freedom* that would ultimately draw the praises of men like Emerson, for within that sermon, concepts of self-reliance, individualism, nonconformity and a trust in intuition, as well as references to light and the ability to see beyond the transitory physical world and peer into the true Spiritual realm, are all to be found.[354]

Having consecrated themselves "unreservedly to the service of our Heavenly Father in the purpose to live for the fulfillment of the design of His Providence,"[355] the Religious Union of Associationists would prove to be an amorphous commingling of church, lecture hall and reform advocacy group, all with strong strains of transcendental mysticism and Unitarian conviction running throughout. Services involved a candelabrum holding three candles, each representing one of the three unities of man with God, humanity and nature, while an empty chair beside the altar symbolized "the Invisible Presence."[356] Discussions concerning phrenology, Spiritualism and mesmerism shared the floor with topics such as "Indigence," "The tendencies of Good and Evil in this country," "Prevailing Sophistries in relation to social evils" and "Human Nature—its primitive springs of action and the natural method of its development."[357]

It was the interest expressed by the Union concerning phrenology, Spiritualism and mesmerism that was particularly in keeping with the more mystical side of transcendentalism, as several transcendentalists saw these disciplines as being a means "to attain a higher consciousness and become the 'Transparent Eyeball' to which Emerson refers," and "to access higher levels of awareness, and the transcendental insight that accompanies it."[358]

Lane's involvement in the Religious Union of Associationists confirms not only a deliberate, intentional devotion to Unitarian principles and social reform, but also an interest in matters that we today would call mystical. That the Union's interest in phrenology, Spiritualism and mesmerism was shared by Lane is confirmed by the blunt statement found within John Trask's testimony: "[Lane] was a strong spiritualist,"[359] as well as Lane's having prominently remembered Horace B. Wilbur, trustee of the New England Spiritualists' Association, in his last will and testament.[360] In addition, the Reverend Mountford, the Unitarian clergyman from Boston who performed Lane's funeral rites, would eventually resign from the Unitarian faith and join the Spiritualist church.

Yet it is the following letter [figure 79], penned by Lane himself, in explanation of how he came to produce his *Dream Painting* of 1862, that we encounter perhaps the most compelling evidence of this fascination with the mystical.

> *This picture, the property of John S. Webber, Esq., Collector of the Port and District of Gloucester, was suggested to the artist by a dream. Sometime last fall while lying in bed asleep, a richly furnished room was presented to my imagination. Upon the wall my attention was attracted to a picture which I have here endeavored to reproduce. The dream was very vivid and on awakening I retained it in memory for a long time. The effect was so beautiful in the dream that I determined to attempt its reproduction, and this picture is the result. The drawing is very correct, but the effect falls far short of what I saw, and it would be impossible to convey to canvas such gorgeous and brilliant coloring as was presented to me. This picture, however, will give to the beholder some faint idea of the ideal.*[361]

At first glance it would appear that Lane was simply inspired by a dream to take brush in hand and compose a painting. But a comparison between Lane's letter and a correspondence written by Thomas Cole to Asher B. Durand in 1838 wherein Cole recounts the creating of his painting *Dream of Arcadia*, holds interesting similarities.

> *I took a trip to Arcadia in a dream. At the start the atmosphere was clear, and the travelling* [sic] *delightful: but just as I got into the midst of that famous land, there came on a classic fog, and I got lost and bewildered. I scraped my shins in scrambling up a high mountain — rubbed my nose against a marble temple — got half suffocated by the smoke of an altar…and~ was tossed and tumbled in a cataract.*[362]

Cole's account, while both fictitious and humorous, nevertheless underlines a common practice among nineteenth-century mystics, romantics and artists—the employment of dreams as a means of experiencing alternate realities and gaining inspiration. From recording one's dreams, to using the dream as a popular literary device, nocturnal visions figured prominently in poetry, literature and fine arts contemporary to Lane. Nathaniel Hawthorne's short story *The Celestial Railroad* is framed from beginning to end as being the product of a dream. Samuel Taylor Coleridge's poem *Kubla Khan or, A Vision of a Dream, A Fragment* is exactly what it claims to be, a poem borne out of an intense reverie, much like Lane's painting (except that Coleridge's was aided by narcotics). And Thomas Cole would paint *The Architects Dream*, a composition that "represents the creative process as one in which artists and poets attain a kind of semiconscious state in which ideas are imparted to them from a higher spiritual source."[363]

This nineteenth-century fascination with dreaming can perhaps best be summed up by the words of Nathaniel Hawthorne, who described a poet as a dreamer "who must be isolated from external life…for it is only when the physical world has utterly vanished before his eyes that the ideal world is fully revealed to him."[364] Emerson would only second

Hawthorne's statement by declaring: "Through his dream power, the writer unlocks our chains and admits us to a new scene."[365]

In order to encourage and attain visionary dreams, nineteenth-century mystics would employ a number of tools. Certain Christian groups (especially Shakers) sought to enter ecstatic states through regimented dancing, and often recounted visions of heavenly realms aplenty upon regaining their senses. Swedenborgians and transcendentalists both would keep dream journals and seek to enter into trance-states via hypnotism and mesmerism. Lane's description of finding inspiration within his dream, especially when compared against the popular trends involving dreaming and the arts prevalent in his time, and his membership within an organization that held a fascination with this topic—coupled with other romantic clues, like the motif he employed in the construction of his house—reveal him to have indeed been of a mystic and a romantic mindset.

Lane's involvement with the Religious Union of Associationists also makes public a devotion to transcendental thought by the great Gloucester artist. While membership within the Gloucester Lyceum by itself did not confer transcendental associations upon him, his membership in an organization specifically dedicated to the study and implementation of Unitarian and transcendental beliefs does so beyond doubt. And though the group would exist for three brief years (its end coming in 1850), the legacy the Union imparted upon Lane would continue for the remainder of his years.

Soon after his return to Gloucester in 1848, we find Lane serving upon the board of directors for the Gloucester Lyceum for the first time. (Lane would hold the position during the years 1849, 1851, 1852 and 1858.[366]) As one of the four directors upon that panel, it was incumbent upon Lane to help determine the program and lecture schedule for the coming year, and as the Gloucester Lyceum's records fail to note any occasion where the directors' suggested curriculum was ever rejected or modified by the ruling president, it would seem that the directors exercised free reign in determining what topics were to be discussed, and by whom. In what is surely no coincidence, subjects such as phrenology, mesmerism, hypnotism and Spiritualism appear as matters for lecture and debate for the first time in the Lyceum's records beginning in 1849.[367] As well, we find William Henry Channing receiving his first ever invitation to lecture at the Gloucester Lyceum in December of that very same year, the focus of his talk being, of all things, "Association."[368] Channing would be but the first of several highly prominent reformers and transcendental thinkers who would speak at the Gloucester Lyceum during Lane's tenure on the board of directors. Henry David Thoreau, Orestes Brownson, Horace Mann, James Freeman Clarke, Richard Henry Dana, Edward Everett, Henry Ward Beecher, Theodore Parker and Ralph Waldo Emerson all made the trek north to impart their beliefs and philosophies upon the people of Gloucester,[369] with Emerson proving to be the speaker most frequently invited back, lecturing no fewer than six times between the years 1849 and 1853.[370]

Though no record is known to exist testifying that Lane attended these lectures, it seems a given that he would have as he had played a direct role in inviting these lecturers up to Gloucester. And as we can imagine Lane attending these lectures, so can we imagine him

meeting with men like Emerson, Mann, Thoreau and Dana before or after an address. This possibility becomes an almost certain reality when we consider that Lane's close friend Dr. Davidson, who at different times would serve as a director and the corresponding secretary of the Gloucester Lyceum, being charged with the task of sending forth letters of invitation to lecturers, would as part of his duties as corresponding secretary regularly serve as host to Ralph Waldo Emerson during his stays in Gloucester while lecturing at the lyceum.[371]

It seems quite likely that Lane could have met these men long before they began lecturing up in Gloucester. Emerson, Thoreau, Mann and Beecher (among so many others) lectured in Boston frequently, the publication of their works was centered in that city and, perhaps most interesting, between the years 1845 and 1847 Lane rented a studio in one of the upper floors of the Tremont Temple,[372] haunt of Boston's artists, literati and reformers, and one of the prime lecture venues in Boston at that time. Thus, Lane was literally upstairs from the very epicenter of the transcendentalist movement, with almost unlimited opportunities to attend lectures by these great minds happening right beneath his studio. It is hard to imagine Lane, who, once back in Gloucester, joined an organization specifically dedicated to lectures and intellectual enrichment, and who in just a few years would be instrumental in bringing these men to Gloucester, *not* taking advantage of the opportunities the Tremont Temple offered him.

Lane would have had the opportunity for direct access to these men through William Henry Channing and the Religious Union of Associationists, as well. Channing was a close friend of Thoreau's, the two having forged a lasting friendship on Staten Island, New York, in 1843.[373] As well, Channing was a close associate of Ralph Waldo Emerson's, being "the clergyman and abolitionist to whom Emerson was to inscribe the fiercest of his odes."[374] Through the Religious Union of Associationists Lane would also have been circulating among individuals who were either directly or indirectly associated with those who lectured at the Gloucester Lyceum between 1849 and 1853—George Ripley, James T. Fisher and Elizabeth Palmer Peabody, an avowed spiritualist, to name but a few.[375]

Interestingly, Pendleton's lithographic workshop also presented Lane with a similar opportunity to have personally grown acquainted with intellectuals of a transcendentalist bent fairly early on in his Boston sojourn, in particular through Sophia Peabody, future wife of Nathaniel Hawthorne, sister to Mary Peabody (who would one day marry the great education reformer Horace Mann) and sister to the tireless reformer and intellectual Elizabeth Palmer Peabody. As Sophia was a longtime sufferer of chronic, debilitating headaches, it was the older (and at times overbearing) Elizabeth who urged and arranged for Sophia to receive artistic training from more than a few of Boston's top artists, all in the hopes of finding a pursuit suitable for Sophia's delicate health. In 1829, at the age of twenty, Sophia's training had begun with drawing lessons from the young German art teacher Francis Graeter.[376] Soon she would move on to none other than Thomas Doughty, Chester Harding and Washington Allston for instruction,[377] her talents developing considerably and to the warm praise of her teachers, until she even proved good enough to exhibit

at the Boston Athenaeum in 1834.[378] Yet it was Francis Graeter, illustrator and "a fine draughtsman, painstaking and thorough,"[379] who would encourage Sophia Peabody to pursue illustration.

In 1833, Sophia Peabody finally took Francis Graeter up on his suggestion and, as revealed in letter from an S.A. Clarke to William B. Fowle of Boston, created a host of images for an upcoming publication aimed at school children. Most significant to the story of Fitz Henry Lane is the particular technique that Miss Peabody employed when executing these illustrations.

> *Dear Sir,*
>
> *I send you the proposal for the completion of Miss Peabody's course of Historical study, and it is such a novel and magnificent scheme that I hope you will subscribe for a copy in the name of the Monitorial School. These drawings, which are to awaken an interest in the youthful mind in the dark mythology of Ancient Greece…Miss Sophia Peabody who is to execute the copies on stone draws with the most remarkable correctness and grace.*[380]

As the above letter clearly states, Sophia Peabody executed the copies "on stone," that being, of course, lithography. In that year, Boston had only two lithography firms in operation, Annin, Smith, & Co. and Pendleton's.[381] While Annin, Smith, & Co. (a short-lived firm, only in business from 1831 to 1833) would certainly do so as well, we find Pendleton's to have embarked upon a particularly vigorous campaign to encourage women to experiment with lithography, even going so far as to have the illustration for their business trade card feature an image of a seated woman drawing on a lithographic stone.[382] To date at least eight women are known to have been associated with the Pendleton workshop: Mary Jane Derby (later Peabody), Eliza Ann Farrar, Eliza Goodridge, Orra White Hitchcock, Louisa Davis Minot, Eliza Susan Quincy, Catherine Scollay and Margaret Snow (who married William S. Pendleton in 1831).[383] While completely possible that Sophia Peabody received her lithographic training and executed her 1833 illustrations of "the dark mythologies of Ancient Greece" at Annin, Smith, & Co., it would appear more likely, given their spirited recruitment of women and her sister Elizabeth's determination to procure the best instruction available for her, that Sophia drew on stone at Pendleton's shop in 1833. If indeed so, then Lane might well enough have come across Sophia Peabody amid the small, cluttered precincts of Pendleton's. If he had, Lane would have run the distinct chance of meeting many reformers and intellectuals through the gregarious Sophia, including not only Emerson (whom she was both a friend and admirer of), her sisters and such, but also "an especial friend of hers,"[384] Dr. Walter Channing, father to transcendentalist poet Ellery Channing, brother of the Reverend William Ellery Channing and uncle to Reverend William Henry Channing.

Lane also had the opportunity to become acquainted with Ralph Waldo Emerson and his associates through two of his patrons, Robert Bennett Forbes and Sidney Mason. In

the case of R.B. Forbes, we know his brother John Murray Forbes to have been a close personal friend of Emerson's, sharing among other interests the cause of abolition. Sidney Mason would hire Emerson's brother Edward as a secretary in his counting house down in Puerto Rico.[385]

One other possible early connection between Fitz Henry Lane and the world of Boston poets and philosophers resides once again with the Reverend Hosea Hildreth, in particular through the temperance movement. In the year 1831, when the Reverend Hosea Hildreth founded the Gloucester Union for the Promotion of Temperance and Economy,[386] the temperance movement in America was the province of the nation's most learned doctors, ministers, merchants and philosophers. Far from being a knee-jerk reaction to the presence of "demon rum" in a local community, the temperance movement was centered upon a cogent doctrine of social reform, economic responsibility, public safety and proper health, engineered in response to the host of health and social problems that arose with the average American's habit of consuming the equivalent of four gallons of pure, two-hundred-proof alcohol per year.[387]

The same year Hildreth founded the Gloucester Union for the Promotion of Temperance and Economy, he would also issue his *Address of the Gloucester Union, for the Promotion of Temperance and Economy; to Their Fellow Citizens, Reported and Accepted March 4, 1831.* Published by none other than W.E.P. Rogers of Gloucester,[388] the homily served as a call for Gloucester to embrace temperance, claiming, "intemperance is a great evil among us – that we are much less virtuous, and less happy, as a people, in consequence of this vice. It is a notorious fact that there are many intemperate people of both sexes among us – that intemperance makes a great many individuals, and a great many families poor, unhappy, and wretched."[389] Hildreth's argument focused primarily upon the economic negatives alcohol presented for Gloucester, especially as that town was in the midst of a depression, as well as the detrimental effects it posed to the human constitution. It would appear that the good Reverend's words were heard far beyond Gloucester though, for in the records of the Massachusetts Society for the Suppression of Intemperance, a powerful, state-wide lobbying group dedicated to the temperance cause, we find Hildreth filling the role of corresponding secretary for the society just two years later, with only the organization's president (Dr. John Collins Warren) and vice-president holding a higher rank above him.[390]

Hildreth's associations with the group can be traced back at least as far as May 22, 1830, where his name appears in the organization's records as having introduced two gentlemen into the society as members: a Mr. John H. Rogers and Gloucester's Lucius Manlius Sargent.[391] Within this organization Hildreth, especially given his high station, would have been laboring beside some of the men who would one day be lecturing at the Gloucester Lyceum, like the Reverend Ralph Waldo Emerson, who officially joined the society on May 20, 1829,[392] and Horace Mann, who served as vice-president of the outfit for several years.[393] And while William Henry Channing is not found listed among the society's ledgers, we find the name of his uncle, Dr. Walter Channing, appearing

prominently in the records beginning in 1833.[394] As well his father, the venerable William Ellery Channing, would author and orate *An Address on Temperance*, which was "delivered by request of the Council of the Massachusetts Temperance Society, at the Odeon, Boston, February 28, 1837."[395] The speech would be presented on a day specifically appointed for simultaneous meetings for "Friends of Temperance"[396] throughout the world. (The Massachusetts Society for the Suppression of Intemperance had elected to change its name to the Massachusetts Temperance Society in 1835.)

John J. Babson declared that Lane "often contributed a production of his pencil for the promotion of a benevolent enterprise,"[397] and we find this to be especially true in regard to the cause of temperance. Lane's role as co-organizer of the 1849 Fourth of July festivities in Gloucester was one which "held a distinct political theme" for him and his friend John J. Piper, that theme being temperance.

> *Immediately succeeding the Cadets of Temperance was placed a cask of the pure element in an arbor of green boughs, this was frequently resorted to on the route and very appropriately brought up the rear of the procession devoted to the Temperance cause.*
>
> *After this came the Chief Marshal of the Floral procession, Mr. J.J. Piper, accompanied by F. H.Lane Esq. in an open carriage. To these gentlemen succeeded the Banner of the procession, which was carried as were all the other banners, by boys who were evidently wide awake. And under what more appropriate Sign could we marshal our children than the portrait of the Patriot and Hero whose fame and whose memory are their pride? Encircled by a garland of Oak leaves the cherished features of Washington were surrounded by the motto "First in war, first in peace, and first in the hearts of his countrymen." This banner was surmounted by an Eagle, so perfectly designed and executed that we supposed it to be one of those proud birds which have been recently hovering o'er the Cape, perched upon the banner, until we were informed that it was the production of Mr. Lane, assisted by a lady who is ever zealous in good works.[398]*

Though the author of the article claims that a cask of water "brought up the rear of the procession devoted to the Temperance cause," there were in fact more temperance-themed cars in the procession, decorated by Lane himself.

> *...Next to the Public Schools came a laureled [sic] car ornamented with boughs and wreathes, containing two paintings appropriately designed and executed by Mr. Lane for the occasion, one representing the effects of Intemperance, and the other a sparkling fountain of pure water; this arbor was adorned by two of the residing geniuses of the rocky Cape, Hope and Temperance, well and tastefully personified by young ladies. The calm yet joyous features of Hope inspired the beholder with fairest visions of the future, and a firm confidence in the strength of her anchor—a good cause: and—*
>
> > *"Drink to me only with thine eyes,*
> > *And I'll not ask for wine,"*

must have been the involuntary thought of every one who looked upon our modern Goddes [sic] of the fountain.

...To Mr. F. H.Lane Esq. whose Skill as an artist is so well known and appreciated, the Floral procession was indebted for much of its beauty, especially for the banners and paintings; his whole time of several days having been devoted with his usual liberality to the success of the undertaking.[399]

Lane's contributions to and position of prominence within this parade brings to light his involvement in the temperance movement, which was probably inspired by Hildreth's 1831 address. In fact, Hildreth's establishing of a Lyceum in Gloucester and his creating a temperance society may have been inextricably linked, as the founder of the Lyceum movement, Josiah Holbrook, explicitly stated that the Lyceum was "intimately connected with the diffusion of intelligence and with the elevation of character among the agricultural and mechanic classes; and to the friend of moral improvement, it offers a source of peculiar gratification, as a sure preventative of those insidious inroads of vice, which are ever ready to be made on hours of leisure and relaxation."[400]

The temperance movement had a strong presence on Cape Ann, evidenced by its omnipresent influence, creeping into everything from the generous (if not outright flattering) coverage their parade received in the papers and the participation of no less than four Gloucester-based temperance societies,[401] to the presence of "Temperance Houses"—inns where "No ardent spirits will be kept"[402]—in town. In 1842, Lane would produce two lithographs directly related to temperance: *Alcohol Rocks* [figure 80] and *John H. Hawkins* [figure 81]. The degree of involvement Lane held in the commissioning of these pieces is presently unknown, but given his penchant for employing his artistic skills toward "a benevolent enterprise," it seems most likely that he was more than merely fulfilling a customer's request when composing these works.

The first item, *Alcohol Rocks*, while appearing to have been created as an illustration for a music sheet cover, could just as easily have been intended as a broadside or advertisement. The illustration—fittingly enough employing a nautical theme to further its message—offers a dramatic and obvious juxtaposition between the two vessels, the wrecked ship sporting the label "Intemperance," while the other serenely sailing past flies a pennant emblazoned with the counterpoint "Temperance." The other lithograph, *John H. Hawkins*, is also temperance related. Derived "from the original Portrait Painted & Presented to the Washington Total Abstinence Society of Boston by T.M. Burnham,"[403] the lithograph is a portrait of a man who would rise to become the nation's foremost and most ardent of spokesmen for the temperance cause, a reformed alcoholic who traveled and lectured across America until his passing in 1858. Lane's litho was created at the beginning of Hawkins's temperance mission, and undoubtedly served to spread far and wide Hawkins's burgeoning reputation.

It was through his participation in this movement that Lane could well have grown acquainted with men such as Horace Mann, William Ellery Channing and Ralph Waldo Emerson. Yet the temperance movement would not hold a monopoly on Lane's

talents. Another organization to which Lane would lend his artistic abilities was the Whig Party.

> The Whig party in their big parade here [Gloucester] in the 1840 Harrison campaign made a point on this matter by having a large banner painted by Artist Lane, on which was depicted a huge sea serpent with its head reared from the water with the inscription: "The Deep has Felt the Attack Upon her Interests and Sends Her Champion to the Rescue."[404]

Formed in 1834 to challenge the political power of Jacksonian Democrats at both the state and national levels, the Whig Party would prove to be many things to many people, playing off local disaffections with the Democratic Party state by state in its quest for power, thus never establishing a uniform national platform. Nevertheless, the party's members held a general interest in prison reform, educational reform, limited liability for corporations, the abolition of capital punishment and, perhaps most appealing to Fitz Henry Lane, temperance.[405]

While his contribution to a political rally in support of William Henry Harrison, the Whig candidate for the 1840 presidential election, stands undoubtedly as an example of Lane supporting a local interest (Democrats were trying to repeal Federal bounties for the fisheries, something to which the fishermen and merchant classes of Gloucester were vehemently opposed), his 1841 lithograph *William H. Harrison, Late President of the United States* [figure 82] is altogether different. Harrison died only one month into his presidency of pneumonia, and Lane's commemorative print—a memento mori dripping with the romantic sensibilities of his times—celebrates the deeds and accomplishments of the late Whig president. And in what may well be a nod toward temperance, on the left-hand banner hanging down from the cross Lane included a prime iconographic symbol of the movement: "a sparkling fountain of pure water," akin to that which he featured in the 1849 floral procession.

Lane would also contribute his talents to such causes as the Gloucester Sailor's Fair in 1864, a Civil War relief benefit, where he contributed a painting valued at fifty dollars to be sold in the quest for raising funds. (Lane's patron and friend Samuel Sawyer would purchase the painting.[406]) And he would also lend his talents toward raising funds for the establishment of a library in Gloucester, a goal dear to the heart of Sam Sawyer. In 1849 Lane would volunteer "to furnish a painting which should sell for at least fifty dollars," as part of a fundraiser to create a "library for the exclusive use and benefit of [the Gloucester Lyceum's] members."[407] Remarkably, despite the fact that "a circular was proposed, furnished, and sent to various Sons of Gloucester" advertising the painting by Lane, "No Son of Gloucester replied."[408] Nine years later, with the drive for establishing a library still going on, Lane was still contributing his talents:

> The Ladies of Gloucester who are interested in the Lyceum Library, and who projected the recent Festival in its behalf, take this method of returning their sincere acknowledgements;

To Messrs. F. H. Lane, Addison Center, and John Trask, for their arduous and truly artistic labors in the preparation of Tableaux.[409]

One final facet of Fitz Henry Lane's life that cannot escape mention is his role as an art teacher. Perhaps out of a need for extra income (assuming he charged for his lessons), or perhaps out of his "characteristic kindness" (assuming he *didn't* charge for them), we find Lane to have taken it upon himself to instruct others in the art of painting. To date, the only student art historians have been aware of has been a lady by the name of Mary Blood Mellen.

Mary B. Mellen; born in Sterling, Mass.; her parents, Rueben and Sally Blood, still residing there in green old age…She was instructed by the late Fitz Henry Lane of Gloucester, Mass.; and as he was unquestionably one of the best marine painters in the country, it is no wonder that in after years the pupil received a large mead of praise for her originals and copies.[410]

All signs point to Mary Mellen's artistic studies under Lane having begun with her arrival in Gloucester in the late 1840s. That she was no stranger to painting is determined by the words of her biographer, Phebe Hanaford, who tells us, "This artist can hardly remember when she began using the brush, so early did she manifest an interest in painting. She was taught to use water-colors in her native place, at a boarding school conducted by Miss Thayer."[411] Her husband, a Universalist minister by the name of. C.W. Mellen, would only encourage her talents, as he was a man "whose taste and culture enabled him to take a lively interest in her efforts at oil-painting."[412] For someone like Mary Mellen, living in mid-century Gloucester and looking to expand and refine her artistic skills, Lane was the logical (if only) choice for instruction, given his stature and abilities. Mellen would study with Lane for several years, and the friendship that would grow out of their art lessons would last through to Lane's last days, as he would remember Mary Mellen in his will.

Given that she spent several years under Lane's tutelage, the question is often asked: "How does the work of Lane's pupil match up to his own?" In the quest to answer this question, many have turned to the following testimony:

Mrs. Mellen is so faithful in the copies of her master, that even an expert might take them for originals. Indeed, an anecdote is related of her, which will exemplify her power in this direction. She had just completed a copy of one of Mr. Lane's pictures when he called at her residence to see it. The copy and the original were brought down from the studio together, and the master, much to the amusement of those present, was unable to tell which was his own, and which was the pupil's.[413]

In the last fifteen years this statement has been employed (especially by art auction houses) as the foundation for claiming that indeed Mary Mellen was as good a painter as her instructor.

> *In recent years, scholars have discovered that the relationship between Lane and Mellen,*
> *which has often been presented as one of master artist and student, was really more than*
> *that. Although Mellen's style is clearly a derivative of Lane's, she actually completed several*
> *copies of his work, it is now believed that the Lane and Mellen relationship was really much*
> *more of a collaboration than was originally thought. In fact, scholars have noted that there*
> *are several canvases that without strong provenance to suggest that they were by Mellen, could*
> *have been easily ascribed to Lane himself.*[414]

Given that art auction houses generate their income solely from the sale of fine art, we would be right to be cautious before embracing claims such as this. After all, a definite incentive exists to "talk up" the quality of a Mary Mellen composition, given that six decades of collecting by museums and private owners have caused paintings by Lane to become truly rare, and thus truly expensive. A small Lane painting like *A Storm, Breaking Away, Vessel Slipping Her Cable*, 1858, was valued at $350,000–$500,000 as of 2005,[415] while Mary Mellen's *Three Master in Rough Seas*, nd., a painting similar in subject (though slightly smaller) was valued at only $8–$12,000 two years before.[416]

In consideration of the much-touted quote transcribed above, it clearly states the story of Lane being unable to discern Mellen's work from his is an anecdote. Thus, to take this story at face value is to put credence in a secondhand yarn being told twenty years or more after the fact, in a publication rife with flattering prose for the artists whom its very purpose was to celebrate. Yet even if this story were completely truthful, we must conclude that Fitz H. Lane was merely being kind to his student, for there are several ways to easily discern a painting by Mary Mellen from one by Lane.

Looking back over Lane's handiwork, today's top naval historians find themselves echoing the praises of his contemporary critics, especially as regards his depictions of rigging and sail plan. Declarations such as: "Lane's drafting technique and sensitive eye for detail and proportion were undisputedly as good as those of the best specialists in ship portraiture of the day, and in some respects, even superior…in most cases he was able to convey the geometry of the hulls and the perspective of the rigging very convincingly,"[417] and, "Lane left an accurate and detailed pictorial record of the maritime world he witnessed,"[418] readily spill from their lips. However, such can not be said for Mary Mellen's work.

The most telling and immediate way by which to discern whether a marine painting was executed by Lane or his pupil is by an examination of the rigging, sail plan and other technical aspects of nineteenth-century ship design. To aid us in our investigation, we turn to two works, a Lane and a Mellen, and compare them on their technical aspects: Lane's *Three Master in Rough Seas*, early 1850s [plate 31], and Mellen's *Two Ships in Rough Waters*, 1865 [plate 32]. The reasoning behind choosing these two works for comparison is far from arbitrary. *Three Master in Rough Seas* is one of the finest of Lane's depictions of a vessel in stormy weather, and demonstrates his intimate knowledge of not only the placement of a ship's rigging, but also as concerns the stress and strain on individual rigging lines, how wind fills a sail, the manner with which a vessel moves through the water and even

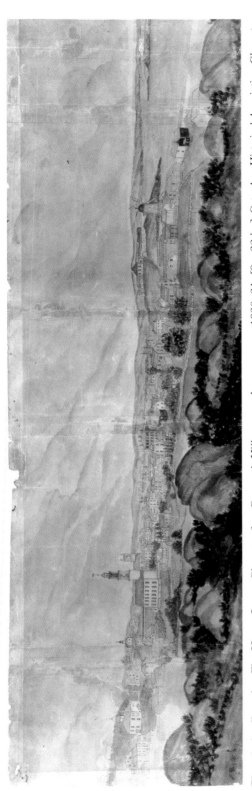

Plate 1. Attributed to Fitz Henry Lane, *Gloucester from Governor's Hill*, watercolor on paper, 1830–31. [9 x 32 in.] *Cape Ann Historical Association, Gloucester, Massachusetts.*

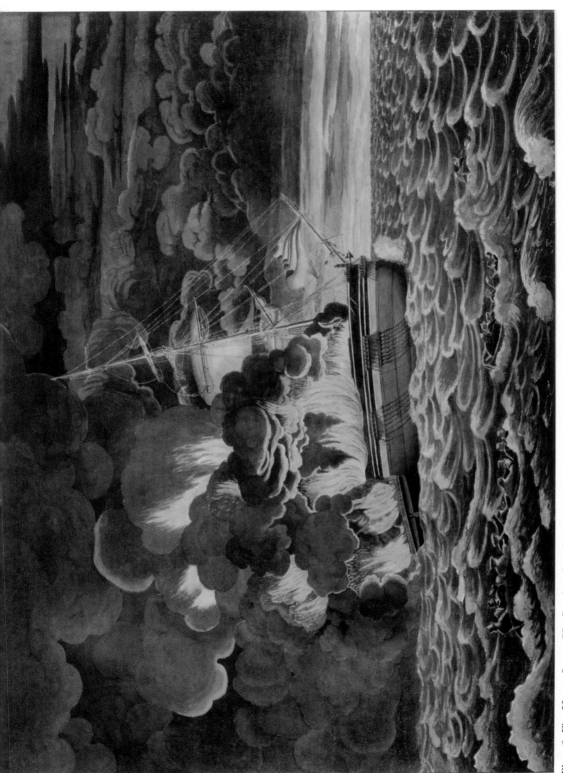

Plate 2. Fitz Henry Lane, *The Burning of the Packet Ship "Boston,"* watercolor on paper, 1830. [19¼ x 27 in.] *Cape Ann Historical Association, Gloucester, Massachusetts.*

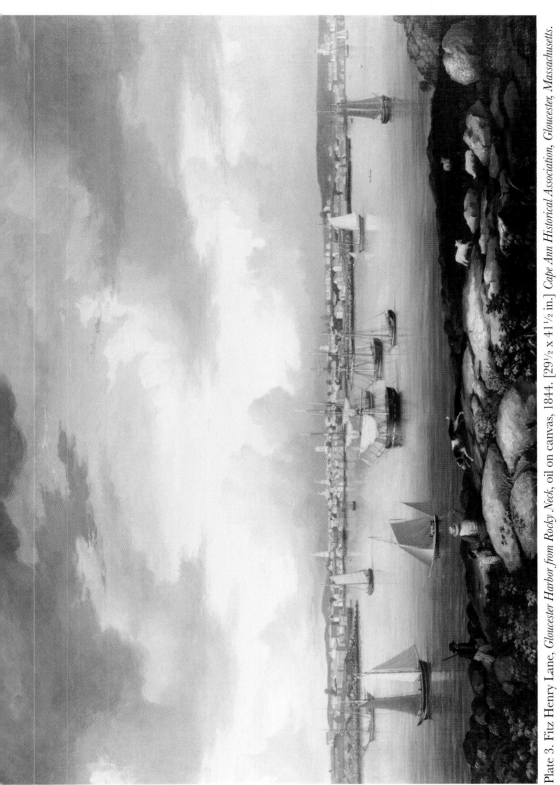

Plate 3. Fitz Henry Lane, *Gloucester Harbor from Rocky Neck*, oil on canvas, 1844. [29½ x 41½ in.] *Cape Ann Historical Association, Gloucester, Massachusetts.*

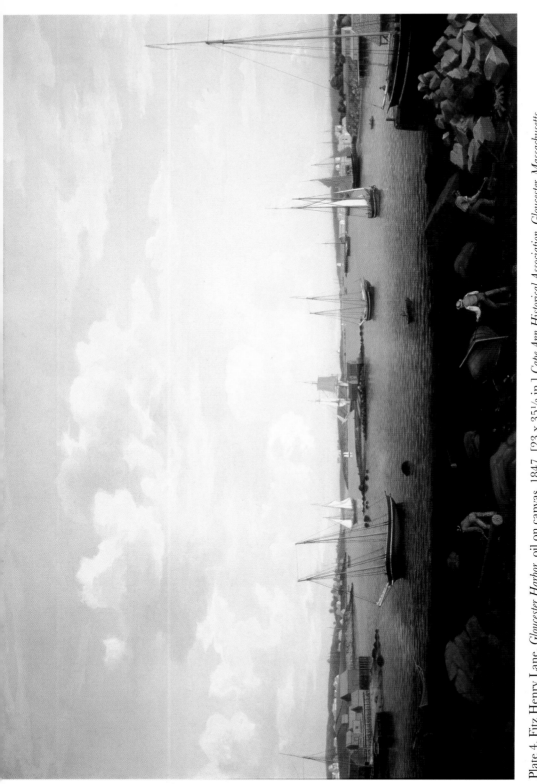

Plate 4. Fitz Henry Lane, *Gloucester Harbor*, oil on canvas, 1847. [23 x 35½ in.] *Cape Ann Historical Association, Gloucester, Massachusetts.*

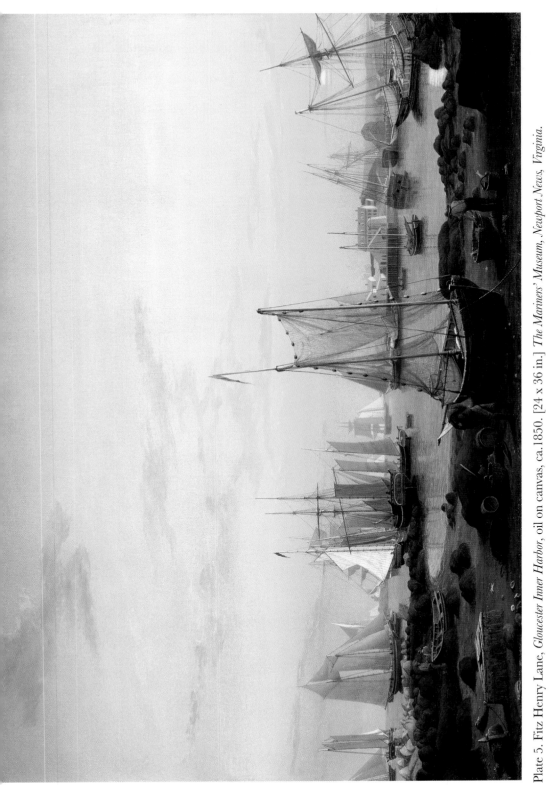

Plate 5. Fitz Henry Lane, *Gloucester Inner Harbor*, oil on canvas, ca. 1850. [24 x 36 in.] *The Mariners' Museum, Newport News, Virginia.*

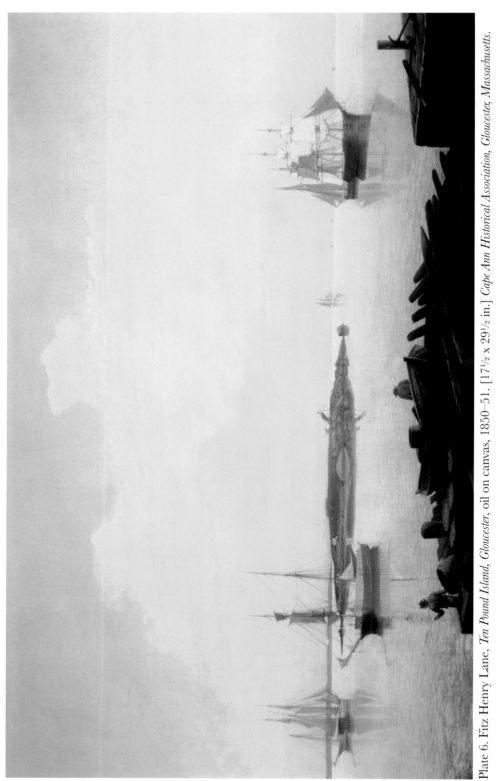

Plate 6. Fitz Henry Lane, *Ten Pound Island, Gloucester*, oil on canvas, 1850–51. [17½ x 29½ in.] *Cape Ann Historical Association, Gloucester, Massachusetts.*

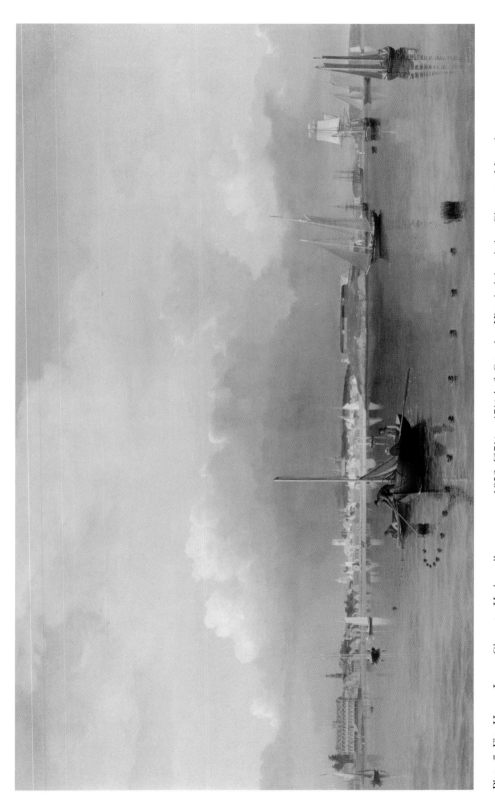

Plate 7. Fitz Henry Lane, *Gloucester Harbor*, oil on canvas, 1852. [27¼ x 47½ in.] *Cape Ann Historical Association, Gloucester, Massachusetts.*

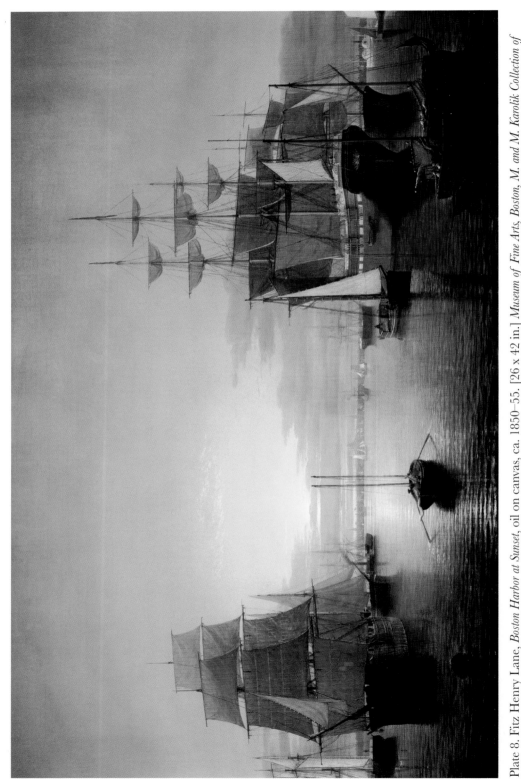

Plate 8. Fitz Henry Lane, *Boston Harbor at Sunset*, oil on canvas, ca. 1850–55. [26 x 42 in.] *Museum of Fine Arts, Boston, M. and M. Karolik Collection of American Paintings, 1815–1865.*

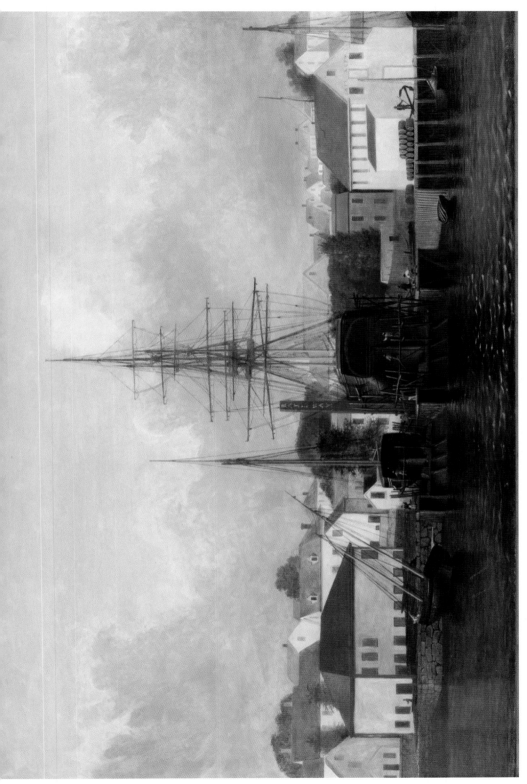

Plate 9. Fitz Henry Lane, *Three-Master on the Gloucester Railway*, oil on canvas, 1857. [39¼ x 59¼ in.] *Cape Ann Historical Association, Gloucester, Massachusetts.*

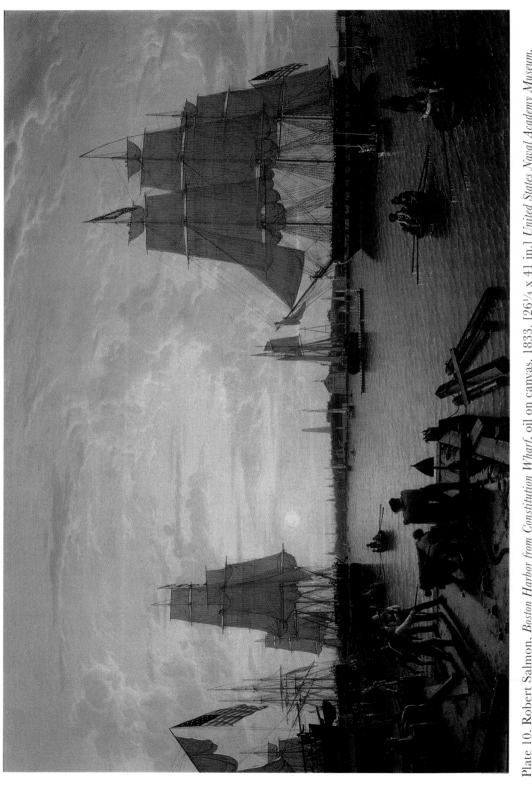

Plate 10. Robert Salmon, *Boston Harbor from Constitution Wharf*, oil on canvas, 1833. [26¼ x 41 in.] *United States Naval Academy Museum, Annapolis, Maryland.*

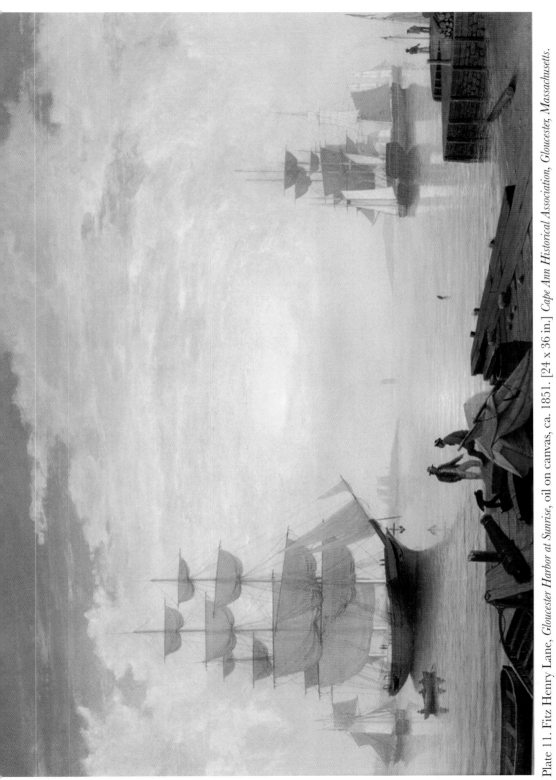

Plate 11. Fitz Henry Lane, *Gloucester Harbor at Sunrise*, oil on canvas, ca. 1851. [24 x 36 in.] *Cape Ann Historical Association, Gloucester, Massachusetts.*

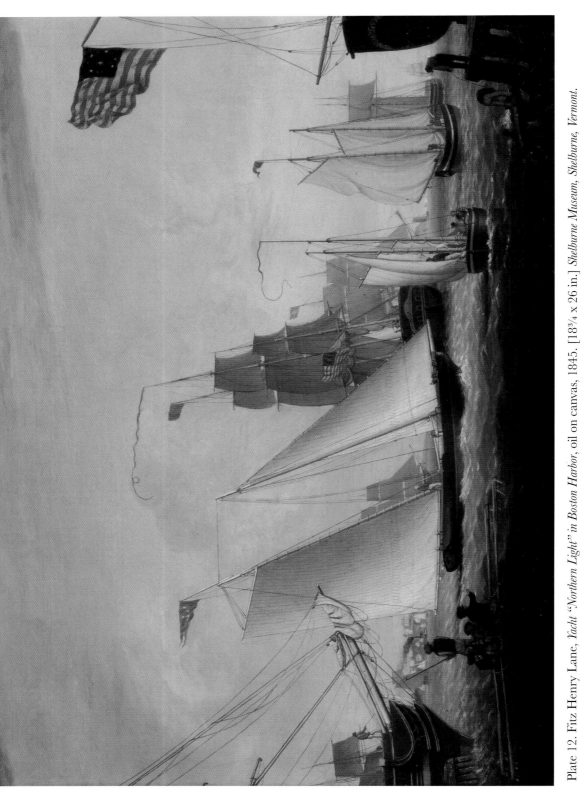

Plate 12. Fitz Henry Lane, *Yacht "Northern Light" in Boston Harbor*, oil on canvas, 1845. [18³⁄₄ x 26 in.] *Shelburne Museum, Shelburne, Vermont.*

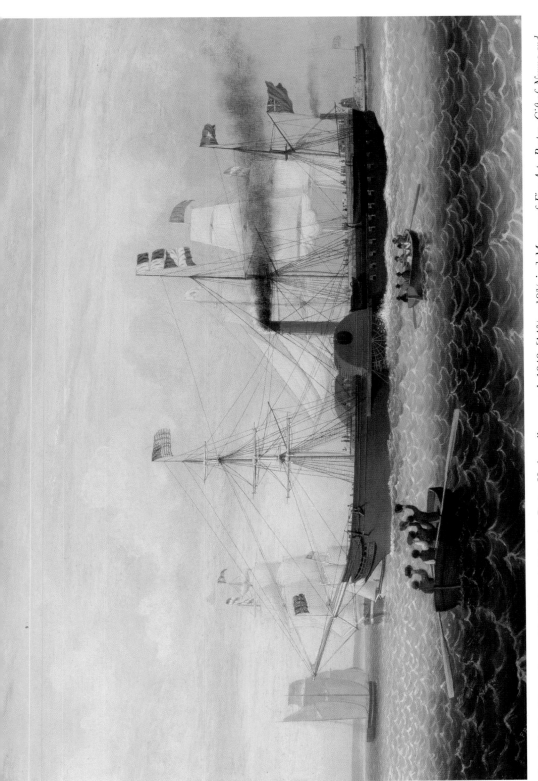

Plate 13. Fitz Henry Lane, The "Britannia" Entering Boston Harbor, oil on panel, 1848. [14¾ x 19¾ in.] Museum of Fine Arts, Boston, Gift of Norma and Roger Alfred Saunders.

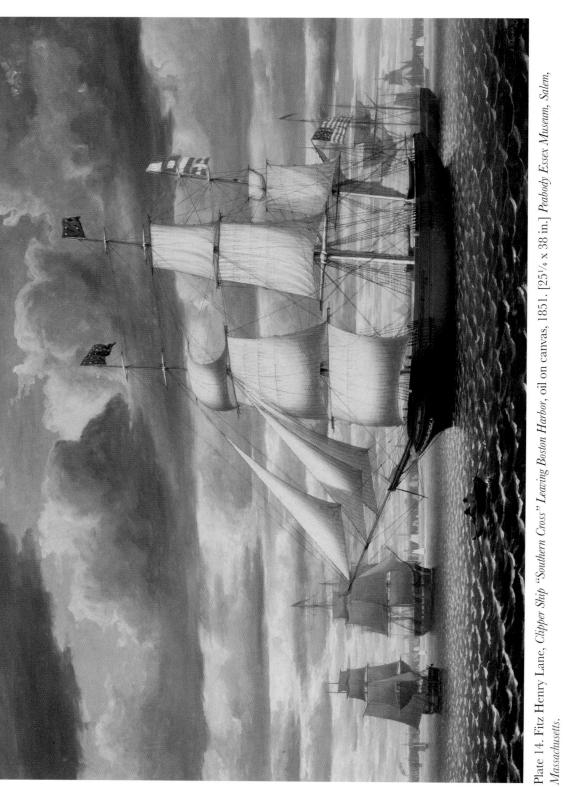

Plate 14. Fitz Henry Lane, *Clipper Ship "Southern Cross" Leaving Boston Harbor*, oil on canvas, 1851. [25¼ x 38 in.] *Peabody Essex Museum, Salem, Massachusetts.*

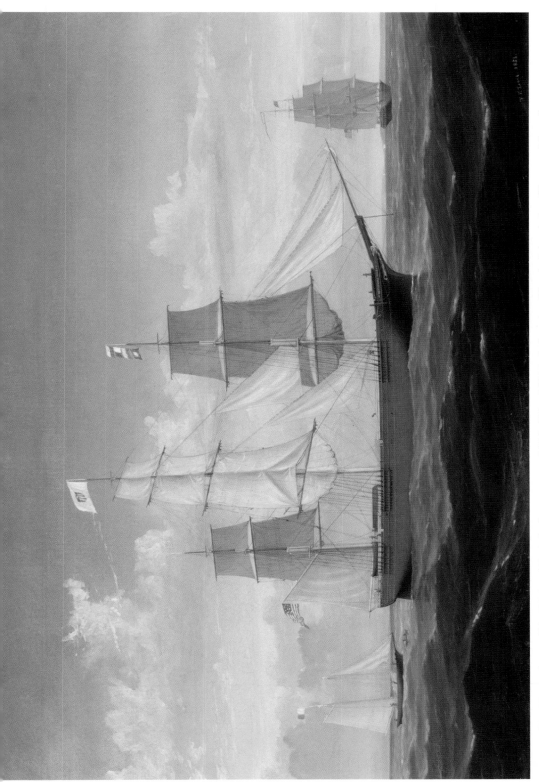

Plate 15. Fitz Henry Lane, Ship "National Eagle," oil on canvas, 1853. [36 x 23½ in.] Cape Ann Historical Association, Gloucester, Massachusetts.

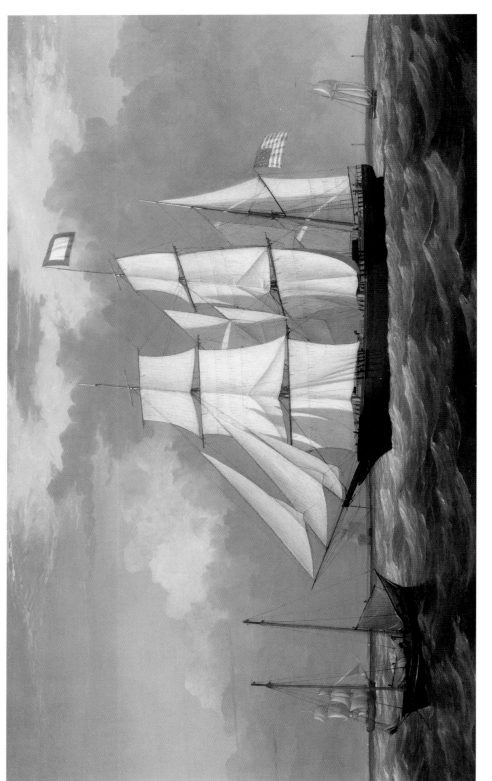

Plate 16. Fitz Henry Lane, *Bark "Eastern Star" of Boston*, oil on canvas, 1853. [23 x 39 in.] *Private collection.*

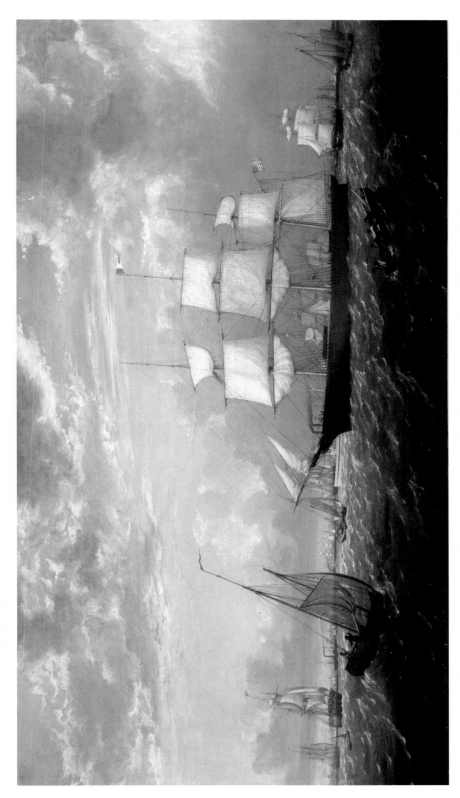

Plate 17. Fitz Henry Lane, *The "Golden State" Entering The Harbor of New York*, oil on canvas, 1854. [26 x 48 in.] *The Metropolitan Museum of Art; Purchase, Morris K. Jesup Fund, Maria De Witt Jesup Fund and Rogers Fund, 1974.*

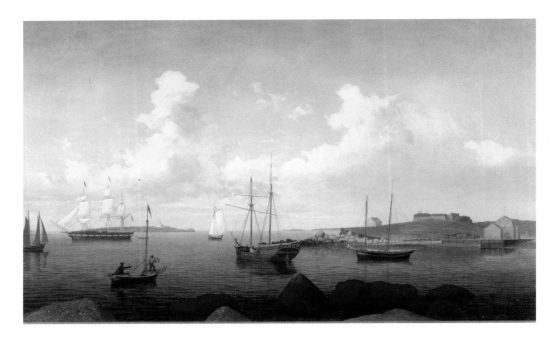

Plate 18. Fitz Henry Lane, *The Old Fort and Ten Pound Island, Gloucester*, oil on canvas, 1840s. [22 x 36 in.] *Cape Ann Historical Association, Gloucester, Massachusetts; on deposit from Addison Gilbert Hospital.*

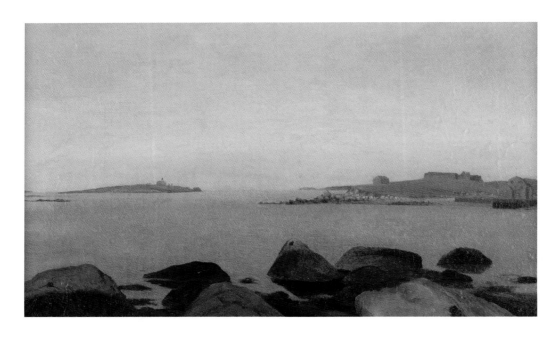

Plate 19. Fitz Henry Lane, *The Old Fort and Ten Pound Island, Gloucester*, oil on board, 1840s. [12 x 21¼ in]. *Cape Ann Historical Association, Gloucester, Massachusetts.*

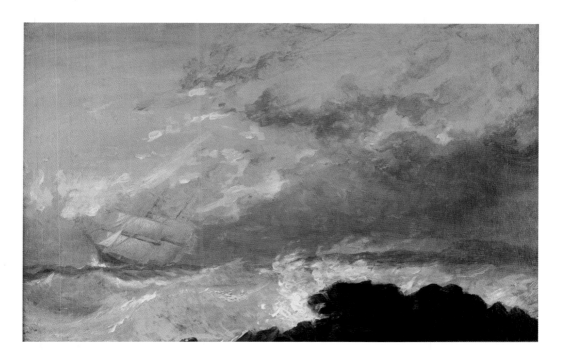

Plate 20. Fitz Henry Lane, *Seashore Sketch*, oil on panel, 1854. [6¼ x 9½ in.] *Cape Ann Historical Association, Gloucester, Massachusetts*.

Plate 21. Fitz Henry Lane, *Sawyer Homestead*, oil on canvas, 1860. [23½ x 40 in.] *The Board of Trustees of the Sawyer Free Library, Gloucester, Massachusetts*.

Plate 22. Fitz Henry Lane, *Riverdale*, oil on canvas, 1863. [21½ x 35¼ in.] *Cape Ann Historical Association, Gloucester, Massachusetts.*

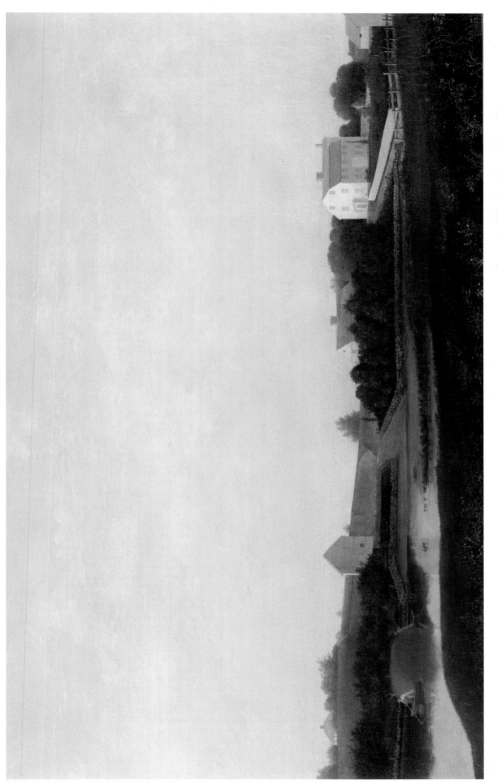

Plate 23. Fitz Henry Lane, *Babson and Ellery Houses, Gloucester*, oil on canvas, 1863. [21¼ x 35¼ in.] *Cape Ann Historical Association, Gloucester, Massachusetts.*

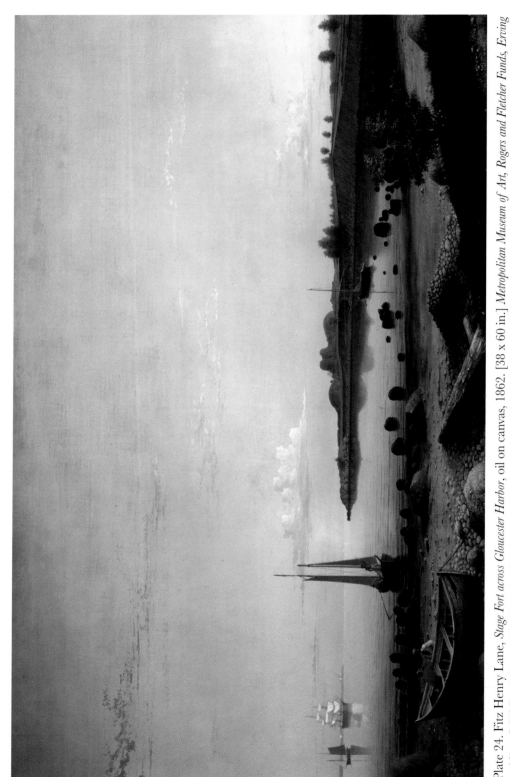

Plate 24. Fitz Henry Lane, *Stage Fort across Gloucester Harbor*, oil on canvas, 1862. [38 x 60 in.] *Metropolitan Museum of Art, Rogers and Fletcher Funds, Erving and Joyce Wolf Fund, Raymond J. Horowitz Gift, Bequest of Richard De Wolfe Brixey, by exchange, and John Osgood and Elizabeth Amis Cameron Blanchard Memorial Fund, 1978.*

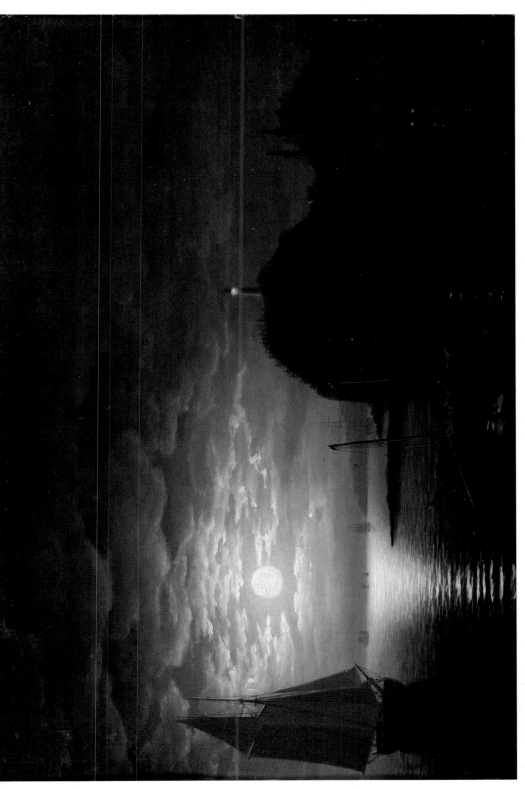

Plate 25. Fitz Henry Lane, *Moonlight, Owl's Head, Northeast View*, oil on board, 1851. [12 x 18¼ in.] *Courtesy of Northeast Auctions; Portsmouth, New Hampshire.*

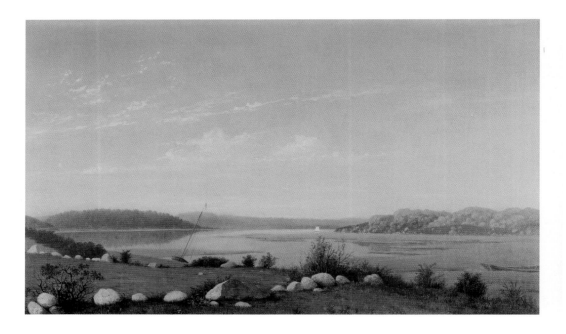

Plate 26. Fitz Henry Lane, *Looking up Squam River from "Done Fudging,"* oil on canvas, mid-1850s. [12 x 20 in.] *Cape Ann Historical Association, Gloucester, Massachusetts.*

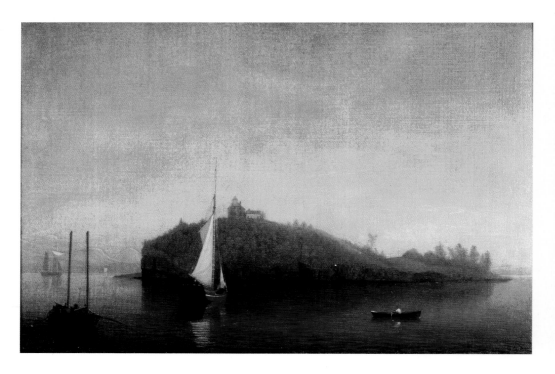

Plate 27. Fitz Henry Lane, *Bear Island, Northeast Harbor*, oil on canvas, 1855. [14 x 21 in.] *Cape Ann Historical Association, Gloucester, Massachusetts.*

Plate 28. Fitz Henry Lane, *Coffin's Beach*, oil on canvas, 1860s. [22½ x 36¾ in.] *Cape Ann Historical Association, Gloucester, Massachusetts.*

Plate 29. Fitz Henry Lane, *View of Coffin's Beach*, oil on canvas, 1862. [20 x 33⅛ in.] *Museum of Fine Arts, Boston, Gift of Mrs. Barclay Tilton in memory of Dr. Herman E. Davidson.*

Plate 30. Fitz Henry Lane, *Norman's Woe, Gloucester*, oil on canvas, 1862. [28 x 50 in.] *Cape Ann Historical Association, Gloucester, Massachusetts.*

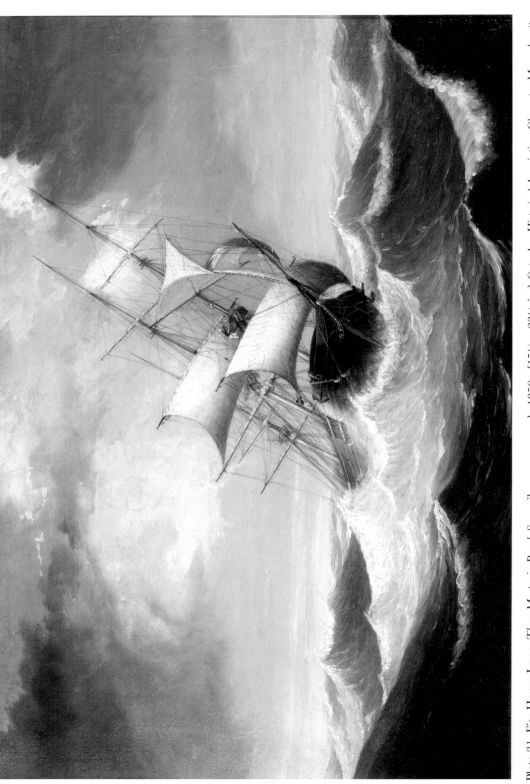

Plate 31. Fitz Henry Lane, *Three Master in Rough Seas*, oil on canvas, early 1850s. [15½ x 23½ in.] *Cape Ann Historical Association, Gloucester, Massachusetts.*

Plate 32. Mary Mellen, *Two Ships in Rough Waters*, oil on canvas, 1865. [14¼ x 24⅛ in.] *Cape Ann Historical Association, Gloucester, Massachusetts.*

Plate 33. George Merchant Jr., *Port of Pico, Azores*, oil on canvas, n.d. [28¼ x 48¼ in.] *Cape Ann Historical Association, Gloucester, Massachusetts.*

Plate 34. D. Jerome Elwell, *Burnt Ruins of Town House on Dale Avenue*, oil on canvas, 1869. [15 x 24 in.] *Cape Ann Historical Association, Gloucester, Massachusetts.*

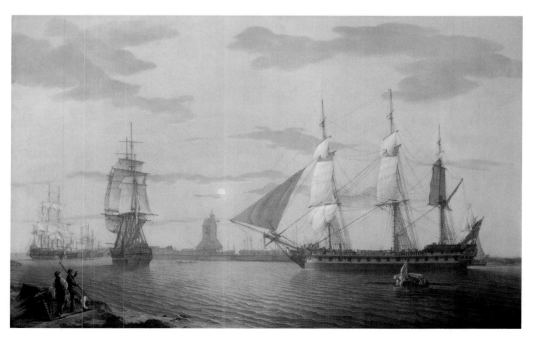

Plate 35. Robert Salmon, *The East Indiaman "Warley,"* oil on canvas, 1804. [915 x 1442 mm.] *Greenwich England National Maritime Museum.*

Plate 36. Antonio Canal (Canaletto), *Greenwich Hospital from the North Bank of the Thames*, oil on canvas. [685.8 x 1066.8 mm.] *Greenwich England National Maritime Museum.*

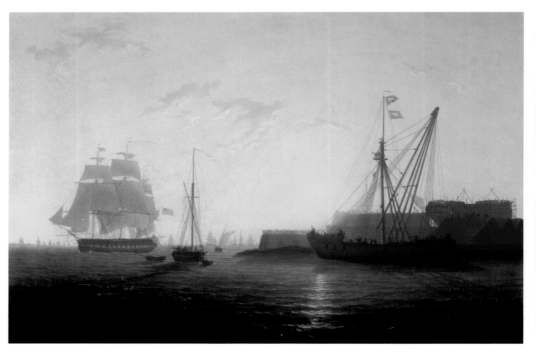

Plate 37. William Joy, *HMS 'Clyde' Arriving at Sheerness After the 'Nore' Mutiny, 30 May 1797*, oil on canvas. [610 x 915 mm] *Greenwich England National Maritime Museum.*

how a ship's rigging can malfunction, as a close look at this painting reveals that the chain holding the starboard sheet of the fore topsail has sprung, a problem common for these types of rigs in high winds. Mary Mellen's *Two Ships in Rough Waters* stands as a perfect comparison due not only to the similarity in subject matter and the presence of the same three-masted type vessel in both works, but also due to the inscription found upon the lower-left back of its frame: "oil copy of last picture on Fitz Hugh [*sic*] Lane's easel at time of death by Mary B. Mellen."[419] Since Lane had passed on by the time Mary Mellen made this painting, *Two Ships in Rough Waters* stands as a prime representation of the apex Mary Mellen's artistic abilities would attain under Lane's tutelage. Simply put, *Two Ships in Rough Waters* is as good as Mary Mellen would ever get under Lane's instruction, as he was now dead. Any further improvements (if any) would be either by her own hand, or under the instruction of someone else.

In comparing these two works, we readily find that Mary Mellen did not understand ship's rigging, both in matters of placement and function. [See figure 83.] If a sail craft were to sport the rigging Mary Mellen has painted in, these vessels would not be able to sail. Having no comprehension of the function of a ship's rigging, Mary Mellen has simply included lines to give the semblance of rigging, rather than assembling them with the eye toward technical accuracy and realism, for which Lane is so known for. And while she has sought to include a sprung starboard sheet of the fore topsail, it smacks of banal mimicry, being something that she had picked up from Lane during her instruction, rather than being drawn from a firsthand knowledge of sails and their rigging. A close look confirms this, revealing that Mellen, unaware that it is a chain that holds down the sail in question, has merely painted in a rope line instead.

While the depiction of rigging may be the most obvious way with which to separate a Lane from a Mellen, it is not the only way. Turning back to these two compositions again, we find Mellen is also unable to properly illustrate how wind fills a sail. Sails, depending upon the force of the wind and the direction from which it is blowing, can manifest a number of appearances, and Lane proved masterful at capturing their many moods. A brief perusal of the Lane images within this book will readily give evidence of this. Mary Mellen, unfortunately, proves to be fairly limited in her lexicon of sail forms, with the sails often appearing much like they do in *Two Ships in Rough Waters*, being neat, tidy and full of wind, while never hinting of stress or strain.[420] Her depictions of how a vessel moves through the water are also quite lacking, possessing none of the realism and force Lane exhibits in *Three Master in Rough Seas*, or any other nautical painting he crafted. Instead, due to a general ignorance by Mellen concerning hull forms and their function, her portrayals of watercraft actively moving give the impression that one is viewing toy boats afloat in a bathtub. Unfortunately, her depictions of vessels careened on a beach, like *Moonlight Scene: Gloucester Harbor*, 1870s [figure 84], and *Moonrise Gloucester Harbor* appear toy-like as well. Mellen also fails to capture the cadence of ocean waves and the many moods of the sea, once again proving able to only offer up a semblance of such rather than an accurate depiction based upon firsthand study of the ocean itself.

Some other distinguishing features between the two artists are Mellen's blatant inclusions of Christian iconography, as found along the far-right of her *Moonlight Scene: Gloucester Harbor*, 1870s—something which never occurs in a Lane canvas—and her endeavors to mimic Lane's luminous skies, which in matters of her color palette take her into the realm of colors that are not naturally occurring, such as the purple hues that prevail in *Two Ships in Rough Waters* and her *Blood Family Homestead*, ca. 1859. The fact that a Lane canvas always holds narrative details and tells a story, while a Mellen creation consistently *fails* to tell a story, is yet another way to discern between the works of these two artists. One final feature that sets the two apart is the overall lack of fine definition within a Mellen composition. Her *Field Beach, Stage Fort Park*, nd. [figure 85], a copy of Lane's *Gloucester, Stage Fort Beach*, 1849 [figure 86], promptly reveals this. From the foliage in the foreground and tree on the left to the granite outcroppings, to even the cows, Mary Mellen's brush lacks the crispness and fine detailing of Lane's. Mellen's lines tend toward being "fuzzy," something that becomes a true detriment as concerns her horizon lines, which consistently fail to provide the viewer with a convincing sense of depth.

The striking similarities between Mellen's *Field Beach, Stage Fort Park* and Lane's *Gloucester, Stage Fort Beach* underline the primary relationship between Lane and Mellen: that of a master artist and his student. Though she would begin to create her own original canvases after his passing, Mary Mellen's work time and again proves to be in direct imitation of her instructor's. Her *Ten Pound Island* is but a copy of Lane's *Ten Pound Island at Sunset*, as is her *Blood Family Homestead* of her instructor's *Blood Family Homestead*, 1859, and from what was inscribed upon its back, we know *Two Ships in Rough Waters* to be but a copy of an unfinished Lane. As to why Mary Mellen produced so many copies of Lane's handiwork, the most logical explanation would be that it was via copying that she was learning to paint. Copying a master's compositions was a centuries-old practice employed as a means for instruction, one that was well in effect in nineteenth-century America. In fact it was the standard for their time. It was, by all indications, how Lane was trained in Pendleton's workshop, and there is no reason to assume Mary Mellen's instruction would have proceeded any differently.

Evidence that this was in fact the manner with which Ms. Mellen was trained can be found along the back of another canvas, *Coast of Maine*, 1850s [figure 87], where we find the signatures of both Lane and Mellen present. While those seeking to make more of the Lane/Mellen relationship than there truly was are quick to interpret this as meaning that "the Lane and Mellen relationship was really much more of a collaboration,"[421] the presence of both signatures is perfectly in keeping with the traditional teacher/student relationship. As Lane would apply a brush stroke, so next would Mary Mellen, as she endeavored to match that of her teacher's to the best of her ability.

So narrow has the academic focus been upon Mary Mellen that a general belief has arisen declaring her to have been Lane's only student. This is simply not true, as Mary Mellen was neither his only apprentice, nor, if we are to believe the words of John Trask, his most accomplished. It has never been a secret that Lane gave painting instruction to

the daughter of his patron Sidney Mason. "Lane knew the Mason family well; he gave painting lessons to Mason's daughter Harriet and in 1849 presented her with a still life he had painted."[422] As well, we know Lane gave instruction in lithography to Benjamin Champney while Champney was an apprentice at the firm. Yet what has been unknown to the general public until now has been the fact that Lane gave ample instruction to a certain George Merchant Jr. of Gloucester, fishing boat captain, consultant to the United States Fish Commission and holder of local public office. His obituary in the *Gloucester Daily Times* tells us:

> At one time Mr. Merchant contemplated the life of a marine artist, and to this end he studied with the lamented Fitz H. Lane. While the project was given up later, numerous canvasses in the possession of his family and friends attests his skill with the brush.[423]

The credit for this discovery belongs to Erik A.R. Ronnberg Jr., who first brought this obituary to the author's attention, and to a descendant of George Merchant Jr. who made the Merchant family history available. As to the nature of Merchant's artistic work, we find ourselves with few examples to analyze, despite the claim of his having produced "numerous canvases." It is known that "G. Merchant, Jr., copied Lane's *Smart Blow* in 1863,"[424] though the location of this painting is, to the author's knowledge, presently unknown.

One example of George Merchant Jr.'s handiwork that we can look at is his untitled painting, presently within the collection of the Cape Ann Historical Association, of the port of Pico [plate 33], located in the Azores archipelago.[425] While by no means as accomplished a painting as any crafted by his instructor, George Merchant Jr.'s creation exhibits several Lane characteristics, such as a draftsman's eye toward depicting architectural forms, placing individual attention upon each piece comprising a stone wall; an interest in light [figure 88]; representing sails in interesting, atypical fashion [figure 89]; and the employment of such compositional devices as driftwood, spars and a red shirt [figure 90]. In matters of color palette, proportion, realism and overall competence this piece falls well short of Lane's standards, but given how little we know of Merchant's work we may be viewing an ambitious attempt fairly early in his training.

While George Merchant Jr.'s skill with a brush falls below that of Lane and Mary Mellen, that of another student of the great Gloucester artist easily surpasses Merchant and Mellen both, and comes to vie with Lane's in matters of superiority. If the words of John Trask are to be believed, then Lane was instrumental in the training of another painter, and quite a good one at that. As John Trask tells it, "Bradford studied with him [Lane]."[426] This appears to be a reference to William Bradford, America's *other* great nineteenth-century marine painter. Trask thus confirms what scholars have long suspected, that Fitz Henry Lane had played an active role in the development of William Bradford's artistic vision.

BRADFORD LAUNCHED his career as an artist at the same time Fitz Hugh [sic] Lane's was at its zenith. Whether the two met during the New York Yacht Club's regatta at New Bedford in 1856, or elsewhere at other times, is likely but remains undocumented. What cannot be doubted is that Lane's style had a deep influence on Bradford's early work and that Lane was the conduit through which the European drafting methods, the sweeping views and perspectives of Canaletto, and the meticulous detail in Salmon's ships were handed down to him…his work was Bradford's greatest source of guidance and inspiration in the latter's first decade of painting.[427]

It would appear that Lane's influence on Bradford predated the year 1852,[428] as similarities between Bradford's *Schooner Yacht America at Cowes, England*, ca.1852, and Lane's *The Yacht "America" Winning the International Race*, 1851, while not exact, reveal a shared interest in a particular subject matter and source material. Bradford's and Lane's attention to the regattas of the New York Yacht Club, Boston Harbor and the merchant vessels that sailed out from that port only further this similarity. In works by Bradford we discover that "the treatment of water and sky show the strong influence of Lane,"[429] and that "Bradford was to borrow from Lane's methods to create these effects [luminous light and atmosphere]."[430]

Yet if Bradford were truly a student of Lane's in any serious capacity, we would expect to see more than a shared interest in subject matter, and find, as we do with Mary Mellen and George Merchant Jr., actual copies of Lane canvases. Happily, we do.

In Bradford's clipper ship portraits, the influence of Lane is plain to see, and in at least one instance he obviously copied Lane. The Clipper ship Northern Light, built in 1851, was probably painted by Lane in the same year…Bradford's 1853 copy of Northern Light is the same composition with the ship carrying a bit more sail…While essentially a copy, there is some attempt by Bradford to show a little originality, but the stylistic debt to Lane is overwhelming.[431]

Another question that arises is, did Lane and Bradford's other instructor (and sometimes collaborator) Albert Van Beest ever meet, and if so, was there a cross-fertilization of ideas between the two marine artists? We know that the professional relationship began between Van Beest and Bradford in 1854, in New York. We know Lane to have been in New York that very same year, as evidenced by his *The Golden State Entering New York Harbor*, 1854 [plate 17], a masterful work that would have necessitated trips to New York to study and sketch *The Golden State*. A close look at *The Golden State* reveals that this painting, especially in its depictions of waves and the small watercraft that inhabit the foreground, owes a heavy debt to the Dutch maritime tradition. While Lane may have obtained an understanding of the Dutch perspective through the study of Dutch works, it is possible that he just as easily could have gained some instruction from Van Beest when he and Bradford began their professional acquaintanceship in New York that year. We also know the three to have been

in New Bedford, Massachusetts, in the summer of 1856, painting the New York Yacht Club's yachting regatta that year.[432]

Lane may have taught other students as well. The brothers Daniel Jerome and Kilby Elwell of Gloucester together produced several marine paintings of Cape Ann that bear the heavy mark of Lane's influence. Of Daniel Jerome Elwell, Helen Mansfield did write:

> *He doubtless saw all he could of the artist Fitz H. Lane; but whether he ever received any instruction from Mr. Lane, the writer is not aware. He admired his work, and once said of a marine by Mr. Lane, then owned by James H. Mansfield: "He painted that sky con amore, didn't he?"*[433]

As well, we find inscribed along the back of Lane's *Ten Pound Island at Sunset*, 1851, "Composition, F.H.Lane to J.L. Stevens, Jr. D. Jerome Elwell touched upon, March 13, '91."[434] Occasional similarities in color palette, particularly between the blue sky found in D. Jerome Elwell's *Burnt Ruins of Town House on Dale Avenue*, 1869 [plate 34], and that found in the upper left corner of Lane's *Norman's Woe, Gloucester*, 1862 [plate 30], only add to the tantalizing possibilities. As well, existing similarities between Lane's compositions and those of others now necessitate a second look. Just as George Merchant Jr.'s copy of Lane's *A Smart Blow* was held to merely be the product of someone "who worked in Lane's manner,"[435] so have the canvases of others, like Henry J. Pierce's "exact replica of [Lane's] *Ships in Ice off Ten Pound Island*,"[436] James Hamilton's *Fishermen at Sea*—a work so akin to Lane's handiwork that it "was at one time thought to be Lane's work"[437]—and the marine works of Gloucester's Addison Center. (Addison Center not only created works akin to Lane's, but also, like D. Jerome Elwell, retouched a Lane painting, in this case his *Three Master on the Gloucester Railway*, 1857 [plate 9].[438]) Could these paintings, like George Merchant Jr.'s, actually be the product of firsthand instruction by Lane?

In looking beyond the canvas, we find Fitz Henry Lane to have been far more than the painter of stunning sunsets and crowded harbors. Instead we encounter a complex, multi-dimensional man, a man for whom his art was but one component in a rich and varied life. In discovering the many ways through which Lane interacted with his world, we find him to be a vibrant, lively participant in nineteenth-century America. Had he indeed been the lonely, brooding recluse previous scholars have sought to portray him as, Lane's art would have proven a shallow creation at best. It is precisely because Lane *chose* to boldly embrace life and rise up to its challenges, despite his handicap, that we find ourselves blessed with this incredible legacy of beauty.

Chapter 10

The Changing Canvas, Part One
Transitions in Color Palatte
and Technique

I f there were to be one consistency found within Lane's artistic career, one facet to be hit upon that proved fixed and immovable, it would have to be his ever-evolving, ever-changing artistic style. In matters of stylistic technique, color and even subject matter we find Lane to be quite adaptable, being both eager to experiment and willing to adopt new approaches to his art, even at the expense of previous "tried and true" techniques. Indeed, the many variations in style we encounter in Lane's works are, like his fickle attitude toward signing and dating his canvases, at times a major difficulty in matters of properly dating and attributing his creations. Lane's ease at reinventing his art has left us with a trail of works that, if we were not familiar with his career and the outside influences that affected him, would lead us to conclude that we were viewing the works of different painters, rather than just one man. Further convoluting matters is the fact that the constant evolution of Lane's process was both gradual and nonuniform, proceeding in fits and starts, while at times even retreating back into previous modes.

Transitions within Fitz Henry Lane's technique begin to emerge soon after the creation of his earliest works. Here we see examples of a self-trained competence crafted within a vacuum, eagerly incorporating whatever stray artistic examples happened to cross his path, such as the stylistically Asian waves in *The Burning of the Packet Ship "Boston,"* 1830 [plate 2]. While ambitious and even at times expressive, these earliest attempts ultimately prove to be devoid of the discipline and deft craftsmanship needed to place them beyond the realm of the amateur. They are, by the standards of today, little more than highly accomplished pieces of "folk" art. If Lane were to enjoy commercial success as a painter, he would have to excel beyond the mediocre workmanship of the average itinerant painter, especially since his handicap precluded his being able to effectively compete within this particular market, one that required unfettered mobility. Thus, in what would consequently precipitate the first major transformation within his art, Lane sought employment within Pendleton's lithography shop in the quest to acquire the training by which he could hone and mature his skills, and so become a far more marketable (and sedentary) painter.

During his years of apprenticeship and employment as a lithographic artist Lane's skill would rapidly develop as the secrets of draftsmanship imparted upon him the ability to create convincing images. Yet lithography could only increase Lane's artistic abilities so far. While his training at Pendleton's educated him in matters of perspective, balance, geometric forms, tonality and the discipline of freehand drawing, it could not divulge unto him the finer points of working with oil paints. Issues involving color palette, brush stroke, glazing, etc.—issues completely foreign to the lithographic medium—could not be addressed within Pendleton's workshop. Thus, to move beyond the lithographic medium Lane would need a mentor in the ways of oil painting. Enter Robert Salmon and the second great transition within Lane's artistic vision. Pendleton's had taught him the basics of drawing and composition. Now, Salmon could not only teach Lane the basics of how to properly manipulate oil paints into forceful compositions, but could also offer an example of how his career should proceed. Salmon showed that the calling of the marine painter could be a profitable one, and with his departure for England in 1842, he opened wide the Boston market to Lane.

It is within the twin forces of lithography and Robert Salmon that we find the firm bedrock upon which Fitz Henry Lane's artistic career was founded. Questions of technique and subject matter can unhesitatingly be credited to these two sources, as their influence is found time and time again within Lane's artwork. Lithography, being a practice dedicated to documenting the landscape and those who inhabit it, called for crisp lines and precise to-scale detail. It is thus little wonder that after dedicating fifteen years of his life to the art of lithography, Lane would approach his paintings with that same attitude. Pick any painting or pencil sketch by Lane and you will readily see the legacy of his lithographic training being put to use. Hyper-accentuated foliage, the individual cracks and crevices distinguished upon a boulder, the lines of a vessel's rigging, each and every rooftop of the Gloucester skyline, including the weathervanes atop her churches—from the start of his career as a marine painter to its conclusion, Lane would pour his focus and energies into capturing the most minute of details. The individual attentions we see paid to each leaf and boulder in the bottom-left corner of his lithograph *View of the Town of Gloucester, Mass.*, 1836 [figure 9], we find repeated in paintings as late as his *Norman's Woe, Gloucester*, 1862 [plate 30]. Architectural features, whether in his *View of the Old Building at the Corner of Ann Street*, 1835, or *Sawyer Homestead*, 1860 [plate 21], are represented with a lithographic eye, regardless of the medium employed, and regardless of what year in his career they were crafted.

Lane would not always be successful in his attention to detail though, as his sketch *Owl's Head from the South* [figure 91] tells us. Having been hurriedly executed "from steamer's deck while passing,"[439] this sketch would lead to an almost fantastical depiction of that island in his *Off Owl's Head*, Maine, 1852 [figure 92], the island having attained proportions it simply does not possess in reality. And though quite rare, we do find Lane at times tweaking the landscape to suit his sense of aesthetics, as seen when comparing the bottom-right corner of his sketch *Gloucester Outer Harbor, from the Cut* [figure 93] with that of his painting *Stage Fort*

across Gloucester Harbor, 1862 [plate 24]. Such examples are rarities though, as we almost always find instead a perfect match between the details present within his pencil sketches and the paintings they are derived from.

While this attention to detail would remain a constant in Fitz Henry's work, other aspects of his lithographic training would not prove to be as enduring. Stretching into the 1850s, the way with which he portrayed clouds would remain in line with the style he exhibited as a lithographic artist. A comparison between the clouds featured in lithographs like his *View of the Town of Gloucester, Mass.*, 1836 [figure 9], and *View of the City of Bangor, Maine*, 1835, and those found in paintings such as *Gloucester Harbor from Rocky Neck*, 1844 [plate 3]; *Gloucester Harbor*, 1847 [plate 4]; and *Gloucester Harbor*, 1852 [plate 7], illustrates for us how deeply ingrained Lane's technique of representing clouds was, seeming almost habitual in its nature.[440] Yet beginning in the late 1840s, Lane would come to gradually abandon this technique, producing works akin to his *Boston Harbor at Sunset*, 1850–55 [plate 8], with increasing frequency until, by the 1860s, most of his skies were but empty expanses devoid of all but the wispiest of cirrus clouds and saturated with light, as in *Norman's Woe, Gloucester*, 1862 [plate 30].

His employment of figures within the foreground would change in time as well. In early paintings such as *Gloucester Harbor from Rocky Neck*, 1844, the men in the foreground serve merely as compositional devices with which to direct the viewer's eye. From the gentleman in the red shirt gesturing toward the harbor to the musket borne across the shoulder of the man at left, we see these figures as being no different from those found in lithographs like *View of Providence, R.I.*, 1848, or *View of Gloucester from Rocky Neck*, 1846 [figure 28], where the gesturing figure here motions toward the object of attention, and the telescope, like the musket, points our eye in the desired direction. Yet in just a few years this as well would change, as the figures within the foreground became less of a means to move the viewer's eye about the canvas, and instead took on far more engaging narrative roles, such as in *Gloucester Inner Harbor*, ca. 1850 [plate 5]; *Fishing Party*, 1850 [figure 94]; and *Gloucester Harbor*, 1852.

Surprisingly, the influence of Robert Salmon (and, via Salmon, Luigi Canaletto) would in many ways prove less enduring in the years following Lane's return to Gloucester. While early works such as his *Yacht "Northern Light" in Boston Harbor*, 1845 [plate 12], are rife with the unmistakable imprint of Salmon's instruction, many of these traits would disappear as Lane's personal artistic vision grew stronger and more defined. One Salmon-inspired device that would soon fade from Lane's repertoire would be his penchant for inserting vessels abruptly severed along the pieces' borders. In *Yacht "Northern Light" in Boston Harbor*, 1845, and *Gloucester Harbor*, 1847, we encounter this device, yet as early as 1847 we find it being discarded, with perhaps its last employment in a painting being found in *Gloucester Inner Harbor*, ca. 1850, and *Baltimore Harbor*, also from that year. Salmon's and Canaletto's characteristic scalloped waves are another particular technique that enjoyed but a short life upon Lane's canvases. Featured most prominently in his *The Britannia Entering Boston Harbor*, 1848 [plate 13], we see them featured very rarely afterward, making a few isolated appearances, as in *Clipper Ship "Southern Cross" Leaving Boston Harbor*, 1851 [plate 14], and

even then, never with the same "Salmon-esque" presence as found in the *Britannia* painting. The overwhelming verve of motion, congestion and activity within a harbor scene is another trait that would fall out of fashion in Lane's work as the 1850s progressed in earnest. Yet one Salmon-inspired trait that *would* remain far longer within Lane's lexicon of imagery would be the interplay of light and dark shadow across the water. As late as 1860, we find the alternating bands of light and darkness falling across the water in his *Approaching Storm, Owl's Head*.

Apart from the influences of lithography and Salmon, other artistic examples would find their way onto Lane's canvases as well. Certain compositional and thematic elements hailing from the Hudson River School painters, the Dutch and the English marine art traditions seem to have played a role in shaping Lane's artistic vision as well. His *A Rough Sea*, 1860 [figure 95], would even seem to suggest a touch of the French marine art tradition.

One reason that Lane may have altered his techniques so often may be as simple as trying to relieve tedium and boredom. Different techniques called for a different repertoire of brush strokes and compositional devices, and Lane's vacillations between these different styles may have served as a means by which he could maintain interest within his work, consistently keeping things fresh and clear of monotony. It is quite obvious that Lane chose to challenge himself in his works, as exampled by his ship portraits. Forever popular among shipowners of the seventeenth through the nineteenth centuries, portraits of merchant vessels served to celebrate as well as advertise the wealth and prestige of those who owned the ship depicted. This line of work, the common fare of marine artists, became in the hands of even the best painters formulaic and generic. The typical mid-nineteenth-century ship portrait possessed certain standard iconographic traits found time and again within the genre, namely, that the vessel being portrayed stands as the lone star of the painting, shown front and center in a perfect two-dimensional profile. The presence of other vessels, invariably of a smaller stature, merely serves to increase the significance and prominence of the ship being represented, while details and landmarks concerning the port are on hand so as to lend an air of the exotic, while informing those with a discerning, knowledgeable eye where exactly in the world it is that your business takes you. The overall impression of such a painting, while it may strike us today as a touch charming, is ultimately one of monotony and two-dimensionality, rounding out a portrait that in the end is but a piece of propaganda, a way for the merchant to glorify and even advertise his business, and little more.

Given how lucrative the practice of ship portraiture was, Lane would execute many portrayals of vessels for their owners. *Ship "National Eagle,"* 1853 [plate 15], is one such portrait. On the surface it would appear to be a rather typical and mundane composition, with its flat broadside portrayal of the subject at hand, and the smaller vessel behind it. A deeper look, though, reveals that Lane, in what strongly seems to be an attempt to make the creation of this piece more engaging for himself, has added narrative details that make *National Eagle* of greater interest than it would at first appear to possess. A glance at the *Eagle*'s sails reveal that the packet has "heaved to," or stopped. The smaller vessel, rather

than existing simply to elevate the stature and importance of the *Eagle*, serves instead a distinct purpose in the painting, as it is a harbor pilot's boat. What we are witnessing here is the *National Eagle* as a harbor pilot boards her, specifically so as to guide the vessel into port. This desire to enliven a mundane topic can also be found in his *Bark "Eastern Star" of Boston*, 1853 [plate 16]. In what is beyond doubt one of the finest portrayals of ship's sails ever to be found in a ship portrait, Lane has depicted the *Eastern Star* directly due east of Cape Ann, tacking expeditiously, with her jibs backwinded, rather than serenely sailing along with sails full of wind, which would have been far easier yet less interesting to portray. As well, we find Lane placing extreme detail into the lesser vessels within this composition, such as the pinkey directly left of the *Eastern Star* in the foreground, something most uncharacteristic of the typical ship portrait, while the very composition itself has far less of the feel of a traditional ship portrait, and could be mistaken by some as a scenic marinescape if they were not looking carefully. Thus, we find Lane taking a simple subject matter, commissioned works done purely for money, and making them unique, interesting, engaging and always showing good seamanship, for both himself and the viewer.

The ship portrait *Clipper Ship "Southern Cross" Leaving Boston Harbor*, 1851, as well speaks to us of an artist intentionally challenging himself and making things deliberately complicated. Like *Bark "Eastern Star" of Boston*, this painting is quite unconventional from the typical ship portrait of the day. The star of the painting, the *Southern Cross*, is set amidst a busy harbor featuring a myriad of other hull forms, all executed in great detail and at varying angles. As well, it is positioned in a more interesting (and, for the artist, technically demanding) pose than the standard broadside, all while a complex mass of clouds cloaks the sky, the artist having elected to paint an overcast sky rather than a far easier one of clear azure blue.[441]

Lane's stylistic changes also reflect the demands of his clients. And as evidenced in the examples of the technically demanding lithographs Lane's patron Robert Bennett Forbes commissioned from him,[442] Lane probably conferred with clients before creating a commissioned work, taking into consideration their particular individual needs. It is thus no surprise that, as Lane created his lithographs with the client in mind, so he did with his paintings. We take as an example of this phenomenon three Lane ship portraits: *The Britannia Entering Boston Harbor*, 1848; *Clipper Ship "Southern Cross" Leaving Boston Harbor*, 1851; and *The "Golden State" Entering The Harbor of New York*, 1854 [plate 17]. All three are identified as ship portraits, but we find the styles employed in their creation to be distinctly different. In both *Britannia Entering Boston Harbor* and *Clipper Ship "Southern Cross"* Lane made use of a style most akin to that of his mentor, Robert Salmon, especially as concerned the water and the intermittent bands of light and darkness playing across the water's surface. *Britannia* even possesses a lyrical quality akin to that found in the English maritime painting tradition, no doubt a trait imparted by Salmon's instruction. *Southern Cross*, though showing signs that Salmon's influence upon Lane had grown more sedate in the passing of three years, still holds distinctive touches that can readily be traced back to the Englishman.

Meanwhile, in *The "Golden State,"* we immediately realize that the style employed by Lane here holds little in common with that found within his *Britannia* and *Southern Cross*

portraits. By comparing the wave pattern and the smaller craft in this portrait to any number of Dutch works from the seventeenth and eighteenth centuries we realize that Lane has specifically chosen to borrow from the Dutch marine painting tradition. Again, a consideration of whom these paintings were created for explains Lane's divergent techniques. From its founding in the seventeenth century, New York had originally been a Dutch colony christened New Amsterdam. Through successive periods of English ownership and early American independence, New York's Dutch community and their cultural traditions persisted, even at times merging into mainstream American society (as the celebration of Christmas would by the 1830s). This cultural persistence included works crafted by Dutch marine painters, whose paintings remained within some of the old New York seafaring families for generations. By embracing the Dutch marine tradition in this work, Lane was intentionally seeking to fulfill the aesthetic expectations of a clientele used to Dutch seascapes. So was the reasoning behind *The Britannia Entering Boston Harbor* and *Clipper Ship "Southern Cross,"* executed in a style akin to that of Salmon, as the Boston clients commissioning these works were both familiar with and responsive to this style of painting.

During the 1850s, while Lane's technique would move back and forth between various styles, his color palate would undergo its own transformations, with his documentarian portrayals of sky and cloud forms being gradually superceded in time by works with a focus upon the atmospheric effects of light. Nowhere is this more obvious than by comparing examples of Lane's color sketches. In his *The Old Fort and Ten Pound Island, Gloucester*, 1840s [plate 19] (the preliminary color sketch for the painting *The Old Fort and Ten Pound Island, Gloucester*, 1840s[443] [plate 18], which was executed out doors, "on the spot") we can plainly see that Lane's primary focus falls upon matters of topography, the buildings that populate the landscape and their specific coloration. While attention has been lavished upon everything from the boulders in the foreground and midground to the structures and the forms and contours of the terrain, we find that water and sky have been neglected, as both are merely washed in a thin glaze that bears no relation to the finished product. Here Lane has laid bare before us his artistic process, a process wherein his primary concern falls upon accurate pictographic drafting, with issues of light, wave and cloud patterns to be dealt with later in his studio. In comparison, Lane's *Seashore Sketch* [plate 20] informs us that by 1854 a complete reversal in his focus and approach to painting was beginning to emerge. Where once land forms and boulders within the foreground had been given primacy, we now find them as amorphous blobs of paint merely hinting at the presence of rock. Realism is simply not a concern here. What we do encounter is an attempt to capture the seething fury of the ocean crashing against the boulders and the sense of motion within the vessel at left and the conflicted heavens above. We see a fixation upon the manner with which light plays upon the frothy tops of the waves crashing against rock, and how it passes through the storm clouds in varying gradations. Where sky and sea had once been neglected, left to the whim and imagination of Fitz Henry to appear as he pleased, we now see him going out of his way to capture and express the water and sky, making them the new focal point of his endeavors.

While attempts have been made to pinpoint the moment of this transition down to one particular painting, such efforts have always left us with nagging questions and blatant contradictions. For example, *Twilight on the Kennebec*, 1849, has been lauded as being the painting in which Lane had made an impressive leap toward abandoning previous modes of expression and embracing a new, exciting artistic vision.[444] And yet we find works such as *Stage Rocks and Western Shore of Gloucester Outer Harbor* being produced in 1857—works firmly embracing the painting styles and color palette he had practiced back in the mid-1840s. As well, we find other works like his *Boston Harbor*, 1847, featuring a luminous, light-soaked sky in the same vein as *Twilight on the Kennebec*, all the while predating its creation by at least two years, if not more.

Simply put, Lane chose to be as fluid in his color applications as he was in matters of technique. His earlier oil-on-canvas panoramic compositions, such as *Gloucester Harbor from Rocky Neck*, 1844 [plate 3], and *Gloucester Harbor*, 1847 [plate 4], feature skies filled with towering clouds, convincingly and truthfully portrayed with the lithographic attitude for near-photographic detail. As well the colors employed here seek to offer the human eye a truthful, faithful vision of the skies above Gloucester, as the artist has gone out of his way to mix colors that reflect naturally occurring hues.

This method for depicting cloud and sky would continue to find employment upon Lane's canvases for several years to come. Yet even while Lane still executed unerringly realistic skies like those found in *"Southern Cross" Leaving Boston Harbor*, 1851 [plate 14], and *Gloucester Harbor*, 1852 [plate 7], Lane had already embarked upon a dramatic new manner with which to paint the heavens, one that would require a radically different color palette. *Boston Harbor*, 1847; *Annisquam Marshes, Near Gloucester, Massachusetts*, 1848; *Twilight on the Kennebec*, 1849; *Gloucester Inner Harbor*, ca. 1850 [plate 5]; and *Ten Pound Island, Gloucester*, 1850–51[445] [plate 6], stand as among the first known examples of this new, vivid approach. Having completely broken with realistic cloud depictions, Lane instead fully embraces the atmospheric effects of light. Deep and inviting, the sky has been rendered in a glorious effulgence of color, creating in effect a light that crosses over into the realm of the incredible.

Skies filled with roseate hues would come to take increasing prominence within Fitz Henry Lane's later works, as evidenced by pieces like his *Bear Island, Northeast Harbor*, 1855 [plate 27]; *Norman's Woe, Gloucester*, 1862 [plate 30]; *Coffin's Beach*, 1860s [plate 28]; and *View of Coffin's Beach*, 1862 [plate 29]. Yet Lane's fascination with light would manifest itself in other ways as well. Within the misnamed *Gloucester Harbor at Sunrise*[446] [plate 11], executed most probably during the early summer of 1851, we find Lane both lavishing realistic detailing upon the clouds and placing an emphasis on the presence of light—in this case how it refracts off of an early morning mist beside the sea—all while refraining from splashing rosy-pink tones across the sky. *The Fort and Ten Pound Island*, 1848, and *Entrance to Somes Sound from Southwest Harbor*, 1852, also effectively portray the presence of light without having to resort to this new color palette.

Several external factors are suspected as influencing the change in Lane's color palette. One that has long been suggested was the advent of photography. In 1839 the world

of art would forever be changed by Louis-Jacques-Mandé Daguerre, inventor of the daguerreotype, the world's first true photographic process.[447] Until that year, art forms such as lithography, engraving and painting had been the primary media by which one could visually document a person, an event or a land or seascape. These processes, though, were time-consuming and though their numbers were growing, by the mid-1800s the number of American artists possessing the competence and imagination needed to accurately depict choice subject matter was still relatively small. Yet now with photography, images could be captured quickly and cheaply. No long period of formal training was required to open up a photographic studio. In fact, contemporary announcements especially celebrated the fact that photography "requires no knowledge of drawing" and that "anyone may succeed…and perform as well as the author of the invention."[448] With a camera, someone who wished to have their portrait taken had only to sit down for as little as ten to thirty seconds (depending on how much light was available), rather than an hour or more.[449] Faster, cheaper and far more accessible to the public, photography offered most everything a customer could ask for from a painting, with greater realism—with a few obvious exceptions.

Since color photography would not be available until the twentieth century, color would prove to be a major advantage painting held over the camera. Another advantage would be the ability to capture fine and atmospheric details, something that early photography lacked, given the problematic blurring and fuzziness caused by long exposure times. Thus we find photography having a rather selective effect upon the visual arts in mid-nineteenth-century America, wreaking havoc among itinerant portrait painters and forcing many to quit the business by the mid-1840s. The medium did not even begin to have an impact upon the world of the marine ship painter, though, until far later in the century. Part of the reason for this was the many complications that came with the daguerreotype process. "In the earliest years, necessarily long exposure times, the uncontrollable variables of sunlight and reflection, and the movement of both clouds and water were enough to chase all but the most intrepid photographers back into their studios."[450]

With so many obstacles to negotiate in the creation of a marine photo, few artisans could create a pleasing image of a ship with a camera. Photographer W. Parry describes some of the trials inherent in taking a picture of a ship:

> *The picture of a ship with numerous others behind, with their forest of poles, spars, and rigging, looks confused and mixed up, producing a very unsatisfactory photograph, and one not at all likely to please. If you have the vessel moved a few feet into a more suitable position, you are treated as if you wanted the world moved, and are subjected to a large amount of abuse from self-important underlings.*[451]

It would not be until the advent of glass negatives and paper printing techniques in the early 1860s that the process of photographing a ship would begin to become less daunting and thus more accessible.[452] And yet the ship-portrait painter persisted. As seen in the photograph *Photographers' Studios, Queen's Road, Hong Kong, 1865–74* [figure 96], many

marine photographic studios also offered the services of a ship-portrait painter, the two mediums existing side by side *within* the studios themselves. Unlike in the case of miniature portraits, photography ultimately failed to supercede the traditional hand-painted ship portrait during Lane's lifetime, for even after the photographic process had been improved enough to enable a ship's photo to be taken with ease, the image itself was a small affair, being of course in black and white, without atmospheric details, as orthochromatic plate emulsions made capturing clouds nearly impossible. Such an image lacked the all-important presence a painted ship's portrait was meant to possess. Whether dramatic, imperious, adventurous or quietly dignified, the large size, atmosphere and color of a painted ship's portrait ensured that they would easily hold their own against the camera for years to come.

Ultimately, the competitive challenge photography forced upon other painting genres could not have played a major factor in motivating Lane to focus upon light and color in his work, given that it did not begin to have a viable presence in marine painting until the 1860s, a full decade after Lane's artistic transformation began to unfold. And even then, that presence was small and rather unrelated to the Gloucester artist's work. It would seem that the only presence photography ever held in Lane's work may be found in his *Steamer "Harvest Moon" Lying at Wharf in Portland* [figure 97], a photograph dated from 1863, where we discover Lane has penciled in a grid over an image of a steamship. Done so that a to-scale depiction of the *Harvest Moon* could be plotted and ultimately transferred upon a canvas (in this case for the creation of a ship portrait "for Lang & Delano"[453]), it becomes obvious that Lane was not afraid to use a camera in place of his sketchpad, at least on this one singular occasion.[454]

One factor that we *can* be fairly certain had a hand in Lane's palette transition was the arrival of cadmium pigments. Previous to the Industrial Revolution, artists found themselves employing a rather limited palette consisting largely of earth colors made from expensive semiprecious stones, fugitive colors or highly toxic compounds. We know Lane to have employed such a palette, given the words of John Trask, who informs us "[Lane] used coarse, crude color in painting as chrome green, chrome red, white lead, dry ultramarine and ground them himself for laying in."[455]

Advances in chemistry in the first half of the nineteenth century, though, would lead to the creation of a new color palette derived from inorganic pigments. Made by heating compounds such as cobalt and aluminum to temperatures of more than two thousand degrees Fahrenheit for extensive periods of time, the colors this process brought forth were unlike anything ever seen before. Permanent and affordable, they would revolutionize the fine arts, permitting painters to replicate every hue within the color spectrum.

Cadmium paints thus afforded Lane the chance to explore the properties of light upon his canvases. Now, with a palette that held no boundaries, he could convey to the viewer expressive moods and emotional textures that simply had not been previously possible. Yet Lane was by no means revolutionary in his increased focus on light and its presence upon the canvas. Marine artists and landscape painters had been investing a great amount of

effort into capturing the stunning essence and atmospheric effects of light well before he was born. One of these painters was Robert Salmon. While many paintings by the English artist were, like Lane's early works, concerned far more with accurate detailing rather than light, examples do exist of Salmon creating skies akin to those roseate creations of his pupil. Salmon's *The East Indiaman "Warley,"* 1804 [plate 35], would certainly seem to share a common interest with Lane's clean skies suffused with pink tones.[456] As well, the last two paintings Salmon would ever create, *View of Palermo* and *View of Venice*, also feature dramatic atmospheric effects courtesy of rose-colored pigments.

Robert Salmon himself, though, was but the latest in an incredible tradition of British maritime artists (mostly centered in Liverpool) interested in mastering the effects of light within their works. As early as 1775, British artist William Hodges, appointed by the British Admiralty to document the lands discovered by explorer Captain James Cook, specifically sought to convey through his canvases the textures of tropical light and color as witnessed by Cook's expedition amid the tropical isles.[457] In so doing, delicate pink hues streak across his skies. Daniel Turner, William Anderson, Ambrose-Louis Garneray, George Chambers Sr. and John Christian Schetky also shared this interest in light and atmosphere, despite the limits of their color palettes, while William Joy, in his *HMS 'Clyde' Arriving at Sheerness After the 'Nore' Mutiny, 30 May 1797* [plate 37], painted in 1830 a sky in almost every way identical to those which Lane would fashion eighteen years later. Turner, Hodges, Salmon, Garneray and Schetky would also create works that not only featured ethereal, roseate skies, but would also accentuate horizontal planes. That Lane was familiar with the works and techniques of British marine painters is well established, given not only the prime example of Robert Salmon and his creations, but also via his subscription to the *London Art Journal*.[458] We also know from John Trask that Lane held correspondence with patrons in Liverpool, England, and even touched upon and corrected a painting by a Liverpool artist. It seems most probable that Lane had examples like those mentioned above in mind when he painted the sky featured in works like his *Boston Harbor*, 1847; *Twilight on the Kennebec*, 1849; and *Gloucester Inner Harbor*, ca. 1850.

Even if Salmon and the English marine painting tradition did not play an influential role in steering Lane toward a deeper interest in light's atmospheric effects, the works of his American contemporaries most surely did. Painters like Thomas Doughty, Thomas Cole and Asher B. Durand created numerous quiet, often atmospheric landscapes, and exhibited their works at the Boston Athenaeum during and after Lane's tenure at Pendleton's. Later painters like Frederick Church, Jasper Cropsey, Sanford R. Gifford and John Frederick Kensett would do so as well. Here Lane would have been confronted with works created by men who were enjoying a reasonable to substantial degree of critical and commercial success at the time, and Lane was not averse to incorporating certain aspects of their art into his. As to why Lane does not appear to have followed the examples of Cole, Doughty and Durand as concerned light until the late 1840s, the most likely reason would appear to be patronage. The pragmatic, conservative sea captains, shipowners and naval officers of Boston who made up Lane's early clientele would have been less than receptive

to works featuring these atmospheric effects, seeing them as bearing overtly religious or transcendental associations at best, and at worst, notions of effeminacy most contrary to the seafarers' masculine identity. Indeed, we see that Lane to our knowledge never painted a ship portrait with pink, light-saturated skies, instead keeping with his traditional, conventional depictions of sky and clouds. If this is indeed the reason for Lane not coming forth with a work like his *Boston Harbor* before 1847, then it would seem a good indication that Lane was embarking not so much upon a new means of artistic expression in his light-suffused works, but rather was taking up the pursuit of a new market containing a clientele more amenable to these roseate skies and the associations they held in mid-nineteenth-century America.

The possibility that Lane's patrons would have been less than receptive toward his compositions featuring light-soaked skies due to associations with transcendentalism begs an interesting question. Could the changes within Lane's color palette have been due to transcendental philosophy? In addition to the changes in Lane's techniques, we also find a transformation of the *soul* of Fitz Henry Lane's paintings, as he would increasingly turn away from depictions of the working waterfront with its laborers and numerous watercraft, and instead embrace scenes of pristine nature. What would compel Lane to venture along the rocky shores of Maine with sketchbook in hand, despite his handicap? And what would he find there?

Chapter 11
The Changing Canvas, Part Two
Transitions in Subject Matter
and Ideals

Stretching through the 1850s and into the 1860s, Fitz Henry Lane's art would undergo several transitions in technique and color palette. Yet in comparing paintings created during his early days as a professional marine painter with those fashioned toward the twilight of his career, we see more than just a change in color and stylistic traits unfolding. As well we see an uneven yet inevitable change in subject matter, and thus a clear change in the ideals this subject matter conveys.

In *Gloucester Harbor from Rocky Neck*, 1844; *Gloucester Harbor*, 1847; *Fort and Ten Pound Island, Gloucester*, 1848; and *Gloucester Inner Harbor*, ca. 1850, we discover superb examples of the subject matter Lane chose to immortalize upon the canvas in his early years. We of course have the bustling port, filled with ships of widely varying size and utility. Figures are present in the foreground, always engaged in a trade particular to the waterfront.[459] Most notable throughout these pieces, though, is the heavy emphasis on the presence of man and his technological impact upon the environment, as revealed through the numerous vessels and the thick jumble of church steeples, towering masts and innumerable structures that comprise the Gloucester skyline.

Works like these are not just depicting a moment in time along the waterfront. They are revealing as well an attitude that was prevalent in America at this period in its history. These paintings, by focusing so heavily upon the men in the foreground, become a celebration of labor, industry and the common workingman, the notion of the American Dream in practice. Lane was living through one of the greatest periods of change in human history—the Industrial Revolution. Technological advances were sweeping the nation, transforming households, work environments, healthcare, eating habits, travel, communication. There was not one facet of daily life that stood untouched and unaffected by the innovations of the era. This, coupled with America's status as a new, expanding nation, eager to both prove and distance itself from the old ways and attitudes of Europe, made for an era filled with both an awareness of civilizations past and a hearty "can-do" optimism concerning the nation's own collective future.

Henry David Thoreau captured this spirit in an article for the *Atlantic Monthly* in 1862:

> *Some months ago I went to see a panorama of the Rhine. It was like a dream of the Middle Ages. I floated down its historic stream…under bridges built by Romans, and repaired by later heroes, past cities and castles whose very names were music to my ears, and each of which was the subject of a legend…I floated along under the spell of enchantment, as if I had been transported to an heroic age, and breathed an atmosphere of chivalry.*
>
> *Soon after, I went to see a panorama of the Mississippi, and as I worked my way up the river in the light of to-day, and saw the steamboats wooding up, counted the rising cities, gazed on the fresh ruins of Nauvoo, beheld the Indians moving west across the stream, and, as before I had looked up the Moselle now looked up the Ohio and the Missouri…—I saw that this was a Rhine stream of a different kind; that the foundations of castles were yet to be laid, and the famous bridges were yet to be thrown over the river; and I felt that this was the heroic age itself.* [460]

Artists contemporary to Fitz Henry Lane would come to reflect such sentiments in their works time and again. Employing traditional European aesthetic values, American artists crafted works rife with symbols of prosperity and optimism. Lane's early works are ultimately no different. From cluttered ports, throbbing and teeming with traffic and activity, to the latest wonders of the modern age, such as steamships and railroads, Lane, like the men in the foreground of his *The Britannia Entering Boston Harbor*, 1848, doffed his cap in salute to the achievements of modern man. Though narrowly centered upon the maritime world of America's East Coast—primarily Boston, Gloucester and later coastal Maine—rather than her distant frontiers and primeval wilderness (due to the limitations of his handicap more than anything else), and lacking in the more flowery and fanciful expressions of his peers (no doubt due to the pragmatic tastes of his conservative clientele), Lane's work nonetheless stands shoulder to shoulder with that of Thomas Cole and his Hudson River School peers. The men in the foreground of a Lane painting are Thoreau's "heroes," those who by their toil are laying the foundations of castles and throwing up bridges over rivers. Their ships and wharves, their bustling harbors and burgeoning cities in effect *are* the castles and bridges of their time, and like Thoreau, Lane readily knew that *"this was the heroic age itself."*

During the late 1840s and early 1850s, we find Lane still producing busy harbor scenes like *Gloucester Inner Harbor*, ca. 1850, and *Gloucester Harbor*, 1852. As well, we find Lane beginning to indulge in pastoral scenes, and canvases that turn their back on busy seaports. From the time of his return to Gloucester, Lane was crafting such works, as evidenced by his *The Annisquam River Looking Towards Ipswich Bay*, 1848, and *Gloucester, Stage Fort Beach*, 1849 [figure 86]. (Bucolic scenes filled with simple pleasures would remain a constant within Lane's artistic *oeuvre*, continuing uninterrupted through the 1850s and into his last years.) These works stand as being most akin to the compositions of his New York contemporaries, speaking of a balance between humans and nature, with human industry

and habitation coexisting beside and even complementing the beauty of the natural world. The paintings of Fitz Henry Lane were no different in rejoicing in this ideal.

And yet it is during this time that Lane also began to proffer works that stood apart from his earlier depictions of the "working waterfront." *Annisquam Marshes, Near Gloucester, Massachusetts*, 1848; *Twilight on the Kennebec*, 1849; *Gloucester Harbor at Sunrise*, ca. 1851; and *Ten Pound Island, Gloucester*, 1850–51, stand out as being quite disparate from Lane's previous harborside endeavors. Perhaps the first difference to strike one's sensibilities would be the sense of serenity and stillness these works exude. *Gloucester Harbor at Sunrise*, ca. 1851 [plate 11], for example, while still a harbor scene, is far more tranquil than the throbbing bustle depicted in the abovementioned pieces from the 1840s. In this painting, far fewer buildings and vessels are present, and the few watercraft that are to be found are all quietly lying at anchor. The harbor is calm and placid, with even the men in the foreground, rather than building ships or gutting fish, being engaged in idle conversation instead.[461] In another harbor scene, *Ten Pound Island, Gloucester*, 1850–51 [plate 6], we come upon a wharf in the midst of its construction, the large pointed timber stacked upon it being the spiles (pilings) that will serve to support the pier. The men atop the wharf, rather than laboring away, are, like their counterparts in *Gloucester Harbor at Sunrise*, engaged in a more leisurely pursuit, in this case fishing. In what proves to be both a radical and most telling of departures from the previous norm, we find that Lane, despite his enthusiasm for portraying the various tasks and chores of the waterfront, has intentionally abstained from showing us the actual construction of a wharf. The man who had relished in celebrating the common toiler of the waterfront in action, revealing in minute detail such activities as shipbuilding and boat repair, has instead chosen to turn his back on a perfect opportunity to portray a wharf being built and instead offers us a more serene if not outright lazy scene. In *Twilight on the Kennebec*, 1849, we find Lane's figures to again be idle souls, in this case looking out onto the vista before them, presumably lost in silent reflection, and once more the artist has abstained from showing us the loading of lumber into the vessel in the foreground (which, contrary to speculation, has *not* been abandoned[462]). Yet in this painting, what stands as being most significant is that it is a scene derived from the state of Maine, rather than his native Cape Ann. As in his *Annisquam Marshes, Near Gloucester, Massachusetts*, 1848, Lane has done more than turn his back upon the frenetic bustle of his times. He has gone beyond the mere pastoral, and instead has chosen to portray a new subject matter: the American wilderness.

As the 1850s progressed, the great Gloucester artist's creative vision grew more disparate. While he busily painted glorious canvases of Boston Harbor and exciting yachting regattas off Long Island and New Bedford, Lane was also creating compositions like *Looking up Squam River from "Done Fudging,"* mid-1850s [plate 26], and *Bear Island, Northeast Harbor*, 1855 [plate 27]. As evidenced by these pieces, Lane's attraction to nature painting was not a flight of fancy but rather a deep-rooted interest, one that would continue to beckon him until his last days. Paintings like these reveal as well an

increasing drift not only toward nature, but also away from any vestige of civilization whatsoever. Indeed, if not for the boats (and lighthouse in *Bear Island*) found in these pictures, they would have been depictions of unbridled, untamed wilderness, so absent is the hand of man here.

By the 1860s, Lane was still pursuing rustic images of rural country life, as seen in his *Riverdale*, 1863 [plate 22], and *Babson and Ellery Houses, Gloucester*, 1863 [plate 23]. Ship portraits like *Brig "Antelope" in Boston Harbor*, 1863, were still a priority for him as well. Yet in matters of his depictions of the natural world, Lane in his last years had begun to produce works that went far beyond his pastoral scenes, offering the viewer a perspective on nature so dramatic, austere and still that they have come to be described by some critics as "apocalyptic." Executed during the last years of his life, the focus and ideals of paintings like *Norman's Woe, Gloucester*, 1862 [plate 30]; *View of Coffin's Beach*, 1862 [plate 29]; and *Coffin's Beach*, 1860s [plate 28], had come a long way since Lane's early work. Within this piece we find a complete rejection of technology, industry and growth, as not one building is present, no human figures inhabit the foreground, and Lane's beloved vessels, those creations to which he had dedicated countless hours of study and painstaking detail, are now barely present, and this at a time when "Gloucester Harbor was neither empty nor inactive."[463] Rather, we find nature to be the star here. Boulders have taken the place of dockworkers within the foreground; the rooflines of houses have been replaced with a lush tree line instead and, most stunning of all, the sky has been rendered in a glorious color.

The single-minded determination Lane showed in his seeking out places of natural beauty, both on Cape Ann and in Maine, once again offers us an example of Lane's intense devotion to his craft. In order to sketch these places of pristine natural and pastoral beauty, Fitz Henry Lane would have to head off in search of the last remote reaches of Cape Ann. Being "off the beaten path," hard to reach and privately owned, areas such as Brace's Cove, Norman's Woe, the Annisquam River and Coffin's Beach were the last vestiges of land upon Cape Ann that had yet to be swallowed up by the fishing and tourism industries. In this quest for scenic vistas replete with the glories of the natural world Lane would also embark upon several trips to the state of Maine.

Maine at that time, to quote Thoreau, was "virtually unmapped and unexplored, and there still wave[d] the virgin forest of the New World"[464] With dark, primeval woods, a relatively small population given her size and only rudimentary industries to sustain her, the Maine of the 1840s and '50s stood as a perfect place for a poet or painter to experience a world relatively free from the impact of modern man and his inventions. It would seem that the first of Lane's voyages "Down East" had taken place somewhere in the summer of 1848, as alluded by the presentation of two paintings featuring Maine vistas the following year at the American Art Union of New York (*Twilight on the Kennebec* and *View on the Penobscot*).[465] From possibly as early as 1848 to at least as late as 1863 he would journey north in the company of friends, most notably his fellow Lyceum associate and connection to the American Art Union, Joseph L. Stevens Jr. Sailing across bays and poking into inlets, exploring mountaintops, enjoying hearty repasts of country fare and

fishing for mackerel, Lane would visit Maine at least six times in his life. From the journal of William Howe Witherle, prominent merchant of Castine and traveling companion with Lane on an 1852 excursion around Isle au Haut, Blue Hill Bay, the Lower Penobscot and Mount Desert Rock, we gain an intimate look into one of the Gloucester painter's summer outings.

Witherle tells us that Lane, like any true Gloucesterman, "has a decided knack for frying fish and gave us a specimen of fried cod for supper, which was most excellent."[466] As well, Witherle reports that, "when we got back to our Sloop we found Lane and Getchell doing a brisk business catching mackerel…and had fine sport for an hour or so."[467] Lane also seemed to enjoy the simple pleasures of sailing and sightseeing as they tacked around the waterways of the Lower Penobscot. Perhaps most surprising, though, is Mr. Witherle's testimony concerning an expedition the party (Lane, Stevens, Witherle, George F. Tilden, Samuel Adams and a Mr. Getchell, the pilot for the sloop *Superior*) embarked upon to the top of a mountain:

> [We] *got into the Boat and rowed across the Sound two or three miles—to a favorable point to ascend one of the highest Mountains—we found a pretty good path about ¾ the way up—we had to wait once in a while for Lane who with his crutches could not keep up with us—but got along better than we thought possible—the climb up after we left the path was somewhat severe—as it was very hot and not even at the top of the Mountain was there a breath of Air Stirring—Lane got up about an hour after the rest of us—*[468]

It soon becomes obvious when reading William Howe Witherle's journal entries that for Lane, these voyages north were undertaken for more than merely recreation. With sketchbook in hand, Lane would capture the expansive, majestic vistas of such areas as Penobscot Bay, Mount Desert, Owl's Head and Bear Island, as well as the burgeoning towns of Camden and Castine, and over the winter months back home in Gloucester, would transform freehand pencil sketches into magnificent works on canvas.

The lengths to which Lane was going in sketching the natural beauty he found in Maine cannot be understated. After having gone to so much trouble and expense to locate himself down along Gloucester's waterfront, placing himself within close, convenient proximity of the subject matter he was earning an income portraying, Fitz Henry Lane was now increasingly going out of his way to find far-off, unspoiled areas free from the presence of industry and commerce. And he was doing this despite his handicap. From Witherle's testimony, we gain the vivid description of Lane, propped up by his crutches, scaling a mountain whose climb was "somewhat severe" on a day that was "very hot, and not…a breath of Air Stirring." Others remember how, "on one occasion [Lane] was hoisted up by some contrivance to the mast-head of a vessel lying in the harbor in order that he might get some particular perspective that he wished to have."[469] We know from looking at the terrain featured in the foreground of his paintings that, to gain entrance to many of the untamed places he sketched, Lane would find himself traipsing across boulder-strewn

beaches, descending steep banks, negotiating marshy and sandy stretches—even the very act of traveling to Maine was no mean feat for this man. One must keep in mind that if any of the vessels he sailed upon had capsized or sunk, Lane would surely have drowned. This was a man prepared to endure discomforts and obstacles aplenty, a man willing to risk even the possibility of losing his life, all in the quest to sketch a new subject matter.

Noticing the parallel between Lane's first visit to Maine and the debut of his first nature-oriented works, art scholars have hypothesized that the state of Maine itself was a prime reason (if not *the* reason) behind his increasing focus upon pastoral and nature-based subject matter.[470]

> *For Lane, the experience of Maine worked a slower, more profound, change leading him away from crowded, busy compositions towards the purified vision of his late style. Like Thoreau at Walden, who wished "to front only the essential facts of life," Lane responded to the challenge of Maine by redefining the very essence of his art.*[471]

In heading to Maine, Lane would not be the first to seek artistic inspiration amid her ancient hills and deep woods. In 1836 Thomas Doughty made the first major painting of a Maine subject, with Alvan Fisher and Thomas Cole visiting the state as well during the 1830s and 1840s. Lane, who as we have seen was both aware of the art of these men and not above incorporating traits of their artistic visions into his, may well have been copying their example when he began to capture the wild splendor of that state in 1848. A much more potent force behind his Maine excursions, though, would have been his close friend Joseph L. Stevens Jr. Being a well-connected, influential resident of Castine, Stevens was an obvious avenue for introducing Lane to a host of new clients. We know that Stevens accompanied Lane on at least four of his six known trips to that state, and more than likely was present at the other two, even if his attendance was not recorded. We also know Stevens to have played an active role in promoting Lane's handiwork and trying to build for him a clientele among the populace of Castine. And by simply turning to a map and looking up the towns and geographic features Lane sketched on his trips north, we find that, rather than taking in the expansive coast of Maine in all its breadth and grandeur like so many of his artistic contemporaries did, Lane instead limited himself within the relatively small area of Penobscot Bay, the neighborhood wherein Stevens's Castine is to be found, as well as nearby Mount Desert Island. Lane's work itself stands as evidence that he was heading to Maine with the express intent of developing and serving the needs of a local clientele, as evidenced by the paintings he executed in and around Castine (*Castine, Maine*, 1850 [figure 21]; *Castine from Fort George*, 1856; *Castine*, 1850s; *Castine Homestead*, 1859.) None of these paintings stand as being nature-based. Nowhere do we find rose-colored skies or quiet woods and if we do find bucolic scenes of farmers engaged in honest labor, they are incidental details, rather than being the focus of the work. Instead, we find these paintings to be traditional Lane harbor and house portraits, the type of works that are not only contrary to his nature-inspired pieces, but also were intended specifically for

the residents of that town, as they would have held little interest for those not familiar with the Castine area. (Indeed, we find his *Castine, Maine*, 1850, and *Castine from Fort George*, 1856, to essentially be repetitions of his earlier painting and lithograph portraits of a city from atop a height, like *View of Norwich, Connecticut*, 1847, and *View of Baltimore from Federal Hill*, 1850.) Lane's lithograph *Castine from Hospital Island*, 1855, not only screams of a return to his traditional harbor portraiture, but was also sold by subscription to the people of Castine, having been published by none other than Joseph L. Stevens Jr. Much as it seems he had done in Gloucester back in 1836, Lane had crafted this lithograph so as to advertise his talents among a people not familiar with his work (though it most certainly served as an attempt to draw profits from sales to Castine's citizenry as well).

That tourists visiting that area were a target audience for his work is confirmed by paintings like his *View of Indian Bar Cove, Brooksville*, 1850, and its nocturnal twin, *Fishing Party*, 1850 [figure 94], two paintings that place a singular focus upon tourist excursion parties enjoying the simple pleasures of an outing along a Maine waterway. *Castine*, 1850s, has yet another tourist excursion boat cruising across the canvas dead-center in the foreground. Beginning with the close of the War of 1812, Maine had begun to thrive, especially in the ports of Portland, Boothbay and Bangor, where lumber and fish had begun to be exported directly out into the wider world.[472] With Bangor lying upstream, Penobscot Bay subsequently became a heavily trafficked waterway. In 1824, the Penobscot Bay area would be opened up to steamships and thus, to tourism. Departing Boston every Tuesday, the steamship *Patent* would head for Portland and Bath, where access to the Penobscot was granted by transferring to the steamboat *Maine*, which would then proceed to Owl's Head, Camden, Belfast, Sedgwick and the Cranberry Isles, all of which are close neighbors by water to Castine. By 1833 the area had intensified in popularity, prompting the establishment of a direct route from Boston to the Penobscot, as well as the replacement of the *Maine* with a larger, more capable craft, the *Bangor*, a vessel that itself would be replaced by an even larger ship in 1842.[473] Nearby Mount Desert Island was as well beginning to open its doors to "rusticators" by mid-century, with taverns and private boarding houses dotting the island. For Lane, Mount Desert Island and the Penobscot Bay area of Maine would have been a market most akin to Gloucester in 1847. Here again he would find townships enjoying largess derived from the sea, with people eager to have their particular hometown celebrated upon the canvas. And as the train had opened Cape Ann to tourism, so now would the steamship slowly open up these two areas to those in search of a rustic experience amid natural splendor.

In the mid-1840s, Mount Desert Island was a remote and inhospitable wilderness. Its discovery by these artists [Thomas Cole, Thomas Doughty, Fitz Hugh [sic] Lane, Frederick Church and Sanford R. Gifford] and its promotion through their paintings and in prints, travel books and photographs began a transformation of the landscape into scenic representations that became symbols of national identity. The marketing of

these paintings in New York and Boston established Mount Desert as a new, unspoiled wilderness and a highly attractive travel destination. A new tourist culture stimulated by beliefs in the transcendent value of the wilderness experience and an appreciation of landscape emerged.[474]

For the great Gloucester artist it would seem profit was the first and foremost reason behind his six trips "Down East," with artistic expression taking a distant second in matters of priority. For Fitz Henry Lane, Maine was a new market to exploit, one within which he possessed the inside track (given his connection to Stevens), where he could, as he had done in Gloucester, derive income from creating works aimed at prosperous locals and visiting tourists.

Thus the state of Maine cannot be credited as the sole reason for Lane's shift toward nature and pastoral paintings. To claim such is to offer the general impression that Lane was more or less painting for himself, expressing his personal attraction toward the natural world (with perhaps his interpretations on life in the nineteenth century included), with little thought as to the wider community beyond his studio, and ultimately failing to take into account the tastes of his audience. From the detailed inscriptions written upon his surviving sketches, we know that Lane was typical of nineteenth-century artists in that many (if not the majority) of his works were commissioned. And though we know from exhibition records and his sketches that Lane created several canvases for sale rather than by commission, his creations would still have been methodically prepared with a specific audience in mind. After all, if it did not resonate with the discriminating (at times even rigid) tastes of antebellum America, it simply would not sell. Even for an artist of stature like Thomas Cole, we know that exhibitions were not an effective means by which to sell paintings, given his claim, "I think I never sold but two pictures in Exhibition in my life."[475]

If an American artist of the mid-nineteenth century was to make a living by painting canvases, it would have to be through commissions. From Cole we also know that it was a rare treat for artists to express themselves in pure, unbridled fashion. His most fanciful and romantic of works, such as *The Departure* and *The Return* from 1837, or his *The Past* and *The Present*, of 1838, were only possible due to patrons who gave him a great deal of latitude in the creating of these compositions.[476] Such moments were rare, as the average customer had specific requirements and instructions in mind when they hired a painter. In some cases, Cole's artistic vision would run afoul of his client, much like when the architect Ithiel Town rejected the painting Cole had produced for him on commission, known to us today as *The Architects Dream*, finding it to be both high priced and too large for his tastes.[477]

Lastly, it must be stated that contrary to some claims, Maine was not Lane's first attempt at celebrating a nature-oriented landscape devoid of the presence of man. A whole year before the creation of his *Twilight on the Kennebec*, 1849, a piece that has been much lauded as being the initiator of "a new personal and national artistic vision,"[478] and "a much more intense vision of nature than is found in Lane's previous works, suggesting that the

initial impact of Maine on the artist was indeed decisive,"[479] we find the Gloucester artist producing his *Annisquam Marshes, Near Gloucester, Massachusetts*, 1848. Featuring a light-infused sky equal (if not superior) in drama to that within *Twilight on the Kennebec*, and with even fewer traces of civilization to be found, we discover that Lane was already creating near-wilderness landscapes like *Twilight on the Kennebec* a whole year before he had ever set foot in Maine.

Ultimately, we must attribute the reasons for Lane's increasing focus upon nature-oriented subject matter as being due to the demands of his clientele. Paintings filled with rustic, pastoral subject matter were part and parcel of an emerging national identity, one that sang the praises of prosperity, growth and optimism. But what of those works executed within his last years, those featuring light-soaked skies and empty, quiet air, where the human presence is almost completely absent?

Between the years 1948 and 1954, art historian John I.H. Baur would author three articles concerning the work of F.H. Lane and Lane's contemporary of later years, Martin Johnson Heade. In penning these articles, Baur would be the first to offer serious scholarly study to Lane's work. As well, he would be the first to propose a concept known popularly today as American Luminism.

> *The beginnings of American luminism were everywhere and nowhere. It was never an organized movement and it had no founders or acknowledged leaders. It arose spontaneously in the second quarter of the nineteenth century, at the same time that American landscape painting began to flourish…Luminism reached its fullest expression during the 1850s and 60's, particularly in the work of two men, Fitz Hugh [sic] Lane and Martin J. Heade…Lane's technique was a polished and meticulous realism in which there is no sign of brushwork and no trace of impressionism, the atmospheric effects being achieved by infinitely careful gradations of tone, by the most exact study of the relative clarity of near and far objects and by a precise rendering of the variations in texture and color produced by direct or reflected rays.[480]*

Noting similarities in matters of light, atmosphere, a strong horizontal orientation of water and land forms and an empty quietude in many of Lane's and Heade's works (as well as those of George Caleb Bingham and William Sidney Mount), Baur had proposed the theory that the similarities he had discovered in his investigations constituted nothing less than a school of thought in the mid-nineteenth-century American art world, one that reflected the ideals of transcendentalism.[481] Baur's theory that such a movement existed was encouraged by the arguments of art scholar Barbara Novak's *American Painting of the Nineteenth Century: Realism, Idealism, and the American Experience* of 1969. Both authors would turn to the writings of Emerson and Thoreau in an attempt to codify and explain these similarities of clear, clean light and empty landscape, establishing parallels between their philosophies and the subject matter found within Lane's later paintings.

There is no direct proof that Lane knew (Ralph Waldo) Emerson's essays or that he ever heard him on any of the frequent occasions when Emerson visited Boston, and even Gloucester, to lecture, though on the evidence at hand, it seems unlikely that he could have escaped him. Lane left no diary and few letters, and we still know too little about him. Yet his art is perhaps the closest parallel to Emerson's Transcendentalism that America produced: of all the painters of mid-century, he was the most "transparent eyeball."[482]

We know that Lane crossed paths with more than one transcendentalist author during his days in Boston and most assuredly after his return to Gloucester. We know he was a member of two organizations firmly rooted within the transcendentalist movement, as well as belonging to other movements and political parties that appealed to the sensibilities of transcendental thinkers. Novak describes the Gloucester artist creating his later works with an egoless persona most akin to Emerson's "transparent eyeball," and makes comparisons between Emerson's description of Thoreau's observant faculties toward nature and Lane's eye for capturing every nuance of his environment with his brush.

To Novak's and Baur's credit, it must be stated that several of the paintings Lane executed in his last years contain various traits that could suggest the transcendental influence at play. In his *View of Coffin's Beach*, 1862; *Norman's Woe, Gloucester*, 1862; and *Coffin's Beach*, 1860s, we immediately notice the almost complete and total absence of man in these works. In each the shore is barren, utterly devoid of human industry. As well, vessels are diminished in their presence, serving only to balance the compositions as unobtrusively as possible. In a complete rejection of his earlier subject matter, it is the beauty of nature— ancient boulders, sandy shores, endless stretches of sky—that now dominates the canvases. Lane, like so many in the transcendental movement, chose in these works to turn his back on man's achievements, leaving the viewer to ponder the quiet landscape, uncluttered and unfettered. Rather than a collection of sailors and longshoremen hard at work, we find boulders to be the subject of the foreground. Ancient, enduring and reeking with sentiments of timeless stability, to the transcendentalist these rocks echo the notion of "permanent spiritual reality." Steamships and railroads may have their day, cities may stretch from one end of the continent to the other, but ultimately these achievements will prove short-lived. While man's presence upon the landscape will prove fleeting, spiritual truth, like these boulders, will endure. It was here before man learned to walk upright, is here now and will remain long after man's departure.

Lane's depictions of water as well hints at transcendent sensibilities. As found in the abovementioned works, as well as his *Twilight on the Kennebec*, 1849; *Entrance to Somes Sound from Southwest Harbor*, 1852; *The Western Shore with Norman's Woe*, 1862; his *Brace's Rock* series, and numerous others, the calm, tranquil, placid waters found within can appear to be more a mirror than a sea or river. And to the transcendentalist mind, these mirror-like surfaces are mirrors inviting introspection. Mirrors figure prominently in transcendental literature, both as tools of contemplative inward thought and as windows into the state of one's soul. Nathaniel Hawthorne would declare: "I am half convinced that the reflection is indeed

the reality—the real thing which Nature imperfectly images to our grosser sense."[483] As well, within several of his tales we find transcendental ideals and iconography present, including reflective surfaces:

> *Hawthorne…adorned his imagined rooms and landscapes with mirrors of every size and nature—not only looking glasses but burnished shields, copper pots, fountains, lakes, pools, anything that could reflect the human form…and always they served as "a kind of window or doorway into the spiritual world."*[484]

In his art, Lane may very well have been echoing this idea of soul-searching and introspection, one which smacks of Platonic idealism, as well as inviting the viewer to partake of the meditative process and look within themselves.

> *Fitz Hugh [sic] Lane's art concurs with Emerson's concept of light as the "reappearance of the original soul." For Lane, as for Emerson, "the universe becomes transparent, and the light of higher laws than its own shines through it." Creating a "celestial geometry," Lane "turned the world to glass."*[485]

It is within the sky that we find what is perhaps the greatest single piece of transcendental iconography in Lane's art: light. Transcendental thought revered light as an emanation of the divine, enlightening and renewing all that it cast its magnificence upon. Emerson wrote:

> *It is often necessary to the enlargement of the soul that it should thus dwell alone for a season, and when the mystical union of God and man shall be completely developed, and you feel yourself newly born a child of light, one of the sons of God, you will also feel new ties to your fellow men; you will love them all in God, and each will be to you whatever their state will permit them to be.*[486]

Also, with the light in Lane's paintings being almost otherworldly in its hue and depth, it may be seen as, like his depictions of water, reflecting the Platonic ideal that *this* physical world of matter is transitory, while the spiritual world is true, real and everlasting. Light is the way to peer beyond the veil of the physical world, and see into the world of the spirit.

Yet perhaps the most intriguing possibility of transcendental ideals existing within Lane's compositions involves, of all things, a boat. First proposed by Erik A.R. Ronnberg Jr.,[487] it has been hypothesized that the appearance of a particular watercraft, termed the "Two-Masted Boat," or the "New England Boat" by nautical historians,[488] and known colloquially as a "double-ender," may very well hold symbolic meaning in Lane's compositions, given the frequency of and the circumstances surrounding its appearance in his works.

In *Good Harbor Beach, Cape Ann*, 1847 [figure 51], we find the first inclusion of this doughty little boat. Two brand new double-enders hoist their sails and shove off into the brilliant early morning light, in what could well be their first voyagings. The double-

ender returns in many of Lane's subsequent paintings, appearing again in *View of Gloucester Harbor*, 1848 [figure 47], and *Gloucester Inner Harbor*, ca. 1850 [plate 5], both times within the center foreground. The light in both these works hints of the sun having passed its meridian, something that is confirmed by the lengthening shadows upon the ground. As well, in *Gloucester Inner Harbor*, ca. 1850, we observe the vessel bearing the scars of years of hard use. Nicks and patches mar its sun-bleached wood, offering us a vision of a watercraft that is beginning to show its age. By the time we encounter this boat again, in *Stage Fort across Gloucester Harbor*, 1862 [plate 24], Lane has chosen to depict the boat in a stage of decrepitude. A hollow shell abandoned on Pavilion Beach, it slowly molders away as the shadows grow long and the sun begins to set. We last see the double-ender in Lane's *Norman's Woe, Gloucester* [plate 30], a painting tentatively dated 1862. Tucked into the bottom-right corner, the vessel is but bare bones now, with only its bottom timbers and planks remaining, forgotten amidst the growing darkness of dusk.

Given that it by and large spans the course of his career as a marine painter, following an inevitable pattern of genesis, aging and decay—a pattern that coincides with the movement of the sun as seen within the works and the progression of the years in his career—it would seem a virtual certainty that Lane's depictions of the double-ender are no accident but rather a symbolic rendering of transcendental philosophy. With the passing of the double-ender from brand new to wreck we see the transitory state of mankind's civilization, especially as contrasted against the eternal landscape. Here Lane speaks to us of the enduring "permanent spiritual reality" that humanity should place its hopes for salvation in, rather than the frail, doomed machines of man. Furthermore, the progression of the sun, from morning light to fading twilight, repeats on a microcosmic scale the progression found in Thomas Cole's *The Course of Empire* series, wherein a fictional civilization begins its ascent toward empire in the brilliant light of early dawn, attains the height of its glory by mid-day, only to decline and be left a ruin amid the mounting darkness of dusk. Like the landscape within Lane's paintings, we find in Cole's *Empire* series that while the civilization of mankind goes through its various transformations and guises, the mountain within the background stands serene and unchanged.

One other explanation for the depiction of the double-ender would be that it is a symbolic representation of the transcendental view of death. Centered upon the notion that as one neared the time of their passing they would arise to new levels of awareness, which would enable them to "perforate the avenues of the senses," transcendental thought decreed that an individual would actually be able to see beyond the transitory material world and into the spiritual. Is it merely a coincidence that the vessel in question's progressing state of disrepair and decrepitude coincides with Lane's increasingly Luminist skies? That, as the vessel grows more and more battered, the painting itself becomes more and more saturated with idealized, otherworldly light? Perhaps Lane was actually documenting his own journey through life—for painted upon the fallen mast of the double-ender in *Norman's Woe, Gloucester*, we find three initials, F.H.L.

It must be acknowledged that there was a significant market for artwork featuring transcendental iconography in the Northeast in Lane's time.[489] And in consulting the notations written upon Lane's drawings, we find that many of his customers who were commissioning works from him were women. Mrs. S.G. Rogers, Mrs. William F. Davis. Mrs. Dr. Herman Davidson, Florence Foster, Maria Babson, Emma Babson, Mrs. G.P. Low, Mrs. Fremont—the names of these and other ladies appear repeatedly within the margins of Lane's sketches, attesting to his having held a significant female patronage.[490] Women appear to have both commissioned works from Lane and to have as well purchased them outright from his dealer in Boston, William Balch. (One of these customers was none other than Mrs. Josiah Quincy, wife of the famous Boston mayor, as stated in Lane's sketch *Somes Sound, Looking Southerly*, 1850.[491]) The significance behind this trend is made evident by the following quote, drawn from the *Gloucester Telegraph* in regard to the opening of the Gloucester Lyceum's 1849 lecture course:

> *As usual the ladies predominated in numbers, as they are superior in intelligence and a desire for information. They are far more ready to leave their firesides for the purpose of receiving or imparting information than are men to leave their places of business or their haunts of leisure.*[492]

Several of the abovementioned ladies commissioned paintings that resonate with transcendental and Luminist iconography, like Mrs. S.G. Rogers and Mrs. Dr. Davidson, who would each request a painting of Brace's Rock, Eastern Point.[493] Lane's Brace's Rock/ Brace's Cove series stands as being one of the more striking examples of his transcendental empty shore/empty sky paintings, complete with reflective water and, except for a decaying shipwreck, the complete absence of man. Florence Foster would commission from Lane *The Western Shore with Norman's Woe*, 1862 [figure 98], another work filled with transcendentalist leanings. (Florence Foster, of whom so little is known, is further seen as having leanings of a transcendentalist bent due to her having written an inscription in a friend's autograph album in 1863, "expressing the neoplatonic religious sentiments of that period."[494]) Others enjoyed close ties with the Gloucester Lyceum. Maria and Emma Babson were relatives of John J. Babson, recording secretary, director and president of the Lyceum, and upon the eve of their moving to California they would receive from their father Nathaniel two Lane works, the pastoral *Riverdale*, 1863, and *Babson and Ellery Houses, Gloucester*, 1863.

Mrs. Davidson (the same who had commissioned a painting of Brace's Rock, Eastern Point) also enjoyed close ties to the Gloucester Lyceum, as her husband would serve at different times as a director and as its corresponding secretary. From Lane's nephew Edward, we know Dr. Herman Davidson was a close friend of Fitz Henry Lane. This is the same Dr. Davidson with whom Lane would briefly live in 1862, after falling out with his sister Sarah and brother-in-law, Ignatius, and for whom he would paint the transcendental Luminist canvas *View of Coffin's Beach*, 1862. It was while living under their roof that Lane

experienced the vivid dream that lead him to create the mystical "Dream Painting," to which he gave Mrs. Davis the initial sketch [figure 99] and sold to her husband the actual painting for the sum of fifty dollars. Most significantly, Dr. Davidson would also regularly serve as host to Ralph Waldo Emerson during his stays in Gloucester while lecturing at the lyceum.[495]

Perhaps the best window into understanding the appeal of Lane's transcendental Luminist works among his female patronage can be found in the journal of the young Miss Annette Babson. Though to our knowledge she never commissioned a painting from Lane, Annette stands as a perfect example of the typical female patron of Lane's, given her education, similar social position and family connection to the great Gloucester artist. Her brother Edward, a Gloucester sea captain, had commissioned Lane to paint a portrait of his Surinam brig (*Brig "Cadet" in Gloucester Harbor*, late 1840s) while her other brother John is the same John Babson who filled various roles in the Gloucester Lyceum, and was a close personal friend to Fitz Henry Lane. Annette herself was familiar with Lane, having visited him in his studio:

> *After dinner we went to Mr. Lane's our native artist, and saw a lovely picture taken from my favorite spot—"Stage Rocks." The shore, the ocean, the beach, the rich sunset radiance falling upon all with dark shadows here [and] there make up a perfect picture….No one could mistake it—so true to nature has he drawn it. What would I give if I had such genius—but there I would prefer the use of my limbs, which he has not to enable me to move at my pleasure. Thus he has genius to make good the law of compensation.*[496]

Having both the time and means to dedicate herself to the notion of "self-improvement," Annette would devote herself to investigating the nineteenth-century American intellectual landscape, turning to several local institutions in her quest for enlightenment, namely the Gloucester Lyceum, and the city's Unitarian, Universalist and Swedenborgian churches.

Annette was also willing to journey beyond the precincts of Cape Ann in her thirst for knowledge, traveling with friends to Boston in 1846 for the anniversary of the Unitarian Association, hosted at the Boston Federal Street Church. It would be at this anniversary meeting that Annette would hear a lecture by William Henry Channing, founder of the Religious Union of Associationists of which Lane would become a member. From her journal we know Miss Babson to have been quite receptive to the words of Channing, perhaps finding within his teachings the same ideals that drew Lane to his Religious Union just a year later. It was after another of Channing's lectures (held conveniently enough at the Gloucester Lyceum) that Annette felt compelled to declare within her journal how, if she had been born a man, she would be a "reformer for I often dwell in mournful meditation on the abuses of society."[497]

Another intellectual to whom Miss Babson found herself nodding in kindred agreement with was the Reverend Amory Dwight Mayo, minister of Gloucester's Universalist church. Mayo stands out as having been a fervent promoter of transcendentalist thought on Cape

Ann, serving on the Lyceum's board (at the same time as Lane), founding a reading circle centered on transcendentalist literature and incorporating transcendental teachings into his sermons and lectures. One reason for Annette finding herself drawn to the preachings of Mayo may be how similar they were to William Ellery Channing's, as "both Channing and Mayo believed that aesthetic beauty as a reflection of divinity played a crucial role in moral education. They also believed that nature provided the one source of metaphysical enlightenment which was accessible to all classes."[498]

That the sermons of the Reverend Mayo were replete with references to aesthetic beauty and the spiritual influences of nature, and that they moved Annette (and surely others of a similar ilk) profoundly can be found in the following passage from Annette Babson's journal:

> *Mr. Mayo…preached…on the beauty of holiness – the beautiful in Nature, Art and Life… He thought that we were all more affected by beauty than we were oft to suppose – that it influenced us to refinement, purity and finally to PIETY. He disclaims against those who whine about Nature in a sickly sentimental strain and prayed that no one word of his should ever [encourage] such nonsense. He took a Christian view of it and urged us to cultivate a love of nature art because it was an emanation of the beautiful spirit of God [and] because it would lead us up to the creator. After tea my brother W[illiam] and J[ohn] accompanied me to Bass Rocks. I do not often walk on Sunday but a storm last eve I knew had agitated the waves and I thought a Sabbath twilight in view of the scene would be <u>awfully</u> <u>holy</u>. I turned from the written page to read from the book of Nature…My thoughts as I stood by those thundering waves were almost too deep for utterance…We gazed in wonder and awe – words trembled on our tongues but the voice of God in the rushing of the sea hushed our own feeble voices.*[499]

Mayo would also uphold in his sermons the belief that nature, art and literature served a similar function as religion, namely, that they were a means by which to perceive the divine.[500] Contending that someone who was able to look beyond the mere utilitarian properties of nature and see the spirit within "lifts the thin veil that is between this and another world and sees the Eternal One in all his glory," Mayo would go on to claim the same for someone who could look beyond the technical properties of a painting, and see the sprit within. "When he gazes upon a beautiful work of art…[he] feels overpowered by his emotions, and all around him is solemn and filled with sublimity."[501]

Is this what Lane was trying to do in his later works? Was it Lane's intention that when someone gazed upon *Norman's Woe, Gloucester*, 1862, or *Coffin's Beach*, 1860s, they were beholding the "Eternal One"? The clues are certainly compelling. Given his known connections with the transcendentalist movement, the custom-tailored approach he held toward his commissioned work and how multiple aspects of his art seem to reflect transcendental ideals, it would not be a wild leap of the imagination to declare "yes" to these questions. That transcendentalism was known to the people of Gloucester (as well

as Boston and New York) in Lane's time is beyond debate, as is the fact that several of his patrons were drawn from that group who so readily embraced transcendentalist sensibilities. Annette Babson was not alone in mid-century Gloucester, both as regarded her interests and her beliefs. At the very least, Annette's example demonstrates that transcendental ideals were present upon Cape Ann, specifically among those who were buying those paintings by Lane that seem to so readily speak of such ideals. Ultimately, in looking at his paintings of later years, it is readily apparent that these works were being commissioned by and held a definite appeal among an audience prone to a mystical bent—one that perhaps strove to see "the Eternal One in all his glory."

Epilogue

He has left behind him a name synonymous with all that is excellent in art and lovely in character. No man was more heartily admired in the town where he has resided so many years, and no death can be more lamented.
— Boston Daily Evening Transcript, August 16, 1865

Placid waters, a glorious sunset, uncluttered seas and empty skies—the last years of Fitz Henry Lane's voyage through the nineteenth century are in many ways akin to his last paintings. For rather than concluding in calamity, or ending at the height of his fame, the life and career of Lane the artist would silently slip over the far horizon, much like the rays of a dying sun gently faded into the dark descent of night.

Indeed, the 1860s would see Lane creating several works that in hindsight are just as beautiful as any he had ever produced before, but yet are suffused with a soulful texture, haunting and still, radiant and peaceful. Lane would remain at work until the very end. At the Boston Athenaeum he would exhibit works personally until the year 1860. (Athenaeum proprietors would display works created by Lane from their own personal collections until the year 1865.[502]) He would travel north to Maine at least as late as 1863,[503] and from the testimony of others we know him to have been hosting old friends and driving around Cape Ann sketching scenery as late as 1864.[504]

In 1864 the Gloucester waterfront would experience a devastating fire—the second in that century—and in the midst of this conflagration, the last copies of Lane's 1855 lithograph *View of Gloucester, Mass.*, would be lost, having been for sale within several of the local businesses that were destroyed. Though now a gaunt, hard-worn man in his late fifties or early sixties [figure 100], Lane would be actively painting up until his death in 1865. Upon his passing, friends would find within his studio at least three paintings in various stages of completion. Mary Blood Mellen's *Two Ships in Rough Waters* is known to have been a copy of one composition upon "Lane's easel at time of death,"[505] and as told by the notations of Joseph L. Stevens Jr., Lane was in the midst of creating two paintings for a Mrs. S.G. Rogers, of Roxbury, Massachusetts, one of Ten Pound Island[506] and one of Brace's Cove.[507]

The decline began for Lane in the winter of 1864, and with various ups and down, reached its inevitable conclusion on Sunday, August 13, 1865:

> *Fitz H. Lane the celebrated marine painter died at his residence in this town Sunday, August 13. He was very sick last winter but contrary to the expectations of his friends he rallied and was able to resume painting. After getting out he had a fall but was not apparently seriously injured. He was taken suddenly ill on the sixth and remained very low until his death. Funeral services were held Tuesday from his residence, the service being conducted by Rev. Mr. Mountford, a Unitarian clergyman of Boston.*[508]

Boston and New York papers were quick to offer up eulogies in praise for the late artist as well, thus testifying to the high regard he had held within these two cities in life. Drama critic and Gloucester native William Winter stands as the probable author of the following obituary that appeared in both the pages of the New York *Tribune* and the *Gloucester Telegraph*:

> *FITZ H. LANE. It is with no ordinary feeling of sorrow that we notice the decease of the distinguished artist, whose recent death deprived this community of a most estimable citizen, and the World of Art of one of its noblest ornaments. It is not the notice of this brief notice to enlarge upon the finely developed character of the deceased, however grateful that might be; it is enough to say that it was marked by most sterling integrity, joined to great acuteness of intellect.*
>
> *Mr. Lane in early youth exhibited uncommon proof of capacity, by drawings of wonderful vigor and truthfulness. These were so admirable, under all the circumstances, that they attracted the notice of the best judges, and among others of Mr. Pendleton, the pioneer of the art of Lithography, who took a generous interest in the young artist, and invited him to Boston, where greater opportunities could be afforded him for study and improvement. This great promise of early life was fully redeemed in riper age, when, self taught, he mastered the difficulties of the Art, and took his place in the front rank of Marine Painters in this country.*
>
> *An afflicting malady, which made him crippled for life, prevented his taking very extensive journeys for picturesque material, but wherever it was possible for him to reach striking and especially characteristic views of our coast scenery, he visited; and the number of his fine works distributed throughout the country show with what judgement he selected his subjects, and how happily he rendered them.*
>
> *Mr. Lane was eminently conscientious, never deviating from an accurate copy of nature as presented to his view. His pictures were carefully considered in reference to perspective, and he never sacrificed truth of delineation for picturesque effects. He even carried this faithfulness at times, perhaps, to too great an extent; but even in such cases the eye was gratified by the exactitude with which individual objects of interest were rendered. His vessels and other marine objects were perfect portraits.*

In the industrious, genial, and unpretending life of Mr. Lane we see an illustration most touching to all who knew him, of the great truth that genius is always energetic, cheerful, modest, and self-possessed; and that while it does not seek its own, it strives continually and patiently to beautify and enoble [sic] whatever comes within its influence.

— W. [509]

The Boston *Daily Evening Transcript* printed similar words of honor in tribute, words quite possibly penned by William Balch, Lane's art dealer in Boston:

THE LATE F. H. LANE, MARINE ARTIST. The death of this gifted artist may almost be considered a national loss, at least so far as art is concerned. Mr. Lane was undoubtedly the finest marine painter in this country. We have never seen any paintings equal to his in perfect accuracy in all the details of marine architecture and thought, and true natural position on the canvas and complete equipment of vessels…It is this faithfulness in the delineation of vessels, that procured him orders from the largest ship owners of New York and Boston, who did not consider their counting rooms (and even their parlors sometimes) furnished, without one of Lane's paintings of some favorite clipper.

But Mr. Lane's genius was not limited to the painting of ships alone; he was great also in the whole details of the seacoast; the harbor or haven with its many or few vessels, in storm or in calm, at sunset or sunrise; the rock bound coast with its gigantic boulders lashed by the surges of the storm, or gently washed by the still waters of a summer sea; the pebbly shore and smooth sandbeach, with the adjacent cliffs, light-houses and cottage. All of these various scenes were the frequent objects of his almost magical pencil, and scores of his paintings portraying those sea-shore views will now be valued as they never were before.

It will be long before the rugged shores of Massachusetts Bay produce again such a gifted pencil as his, to illustrate so truthfully the dear scenes he loved so well. His pure and gentle spirit won the respect and esteem of a refined circle of friends, and his kindness of heart and obliging disposition attached him fondly to all.

-W.B. [510]

From Lane's probated and bonded will (appearing here in print for the first time in its entirety as appendix 1) and the probate inventory done of his estate upon his passing, we gain more than just a glimpse of the artist's personal possessions and their value. As well, we are given an idea of the people he valued, and how much he thought of those who were his friends and family.

Notably absent are his sister and brother-in-law, the rift between the three having obviously not healed. Lane's will and the probate inventory done of his estate [figures 101 and 102] also reveal that the man who had returned to Gloucester an artistic and monetary success by 1848 was by 1865 living a life that could hardly be called prosperous.

Valued only at $4,887.51, we discover $4,080.00 of his estate to have been but a promissory note, with Lane having only $10.00 in actual cash in his possession by the

time of his death. As to what service or commodity Lane had exchanged in return for the promised $4,080.00 dollars, we can only surmise it to have been his house, as no real estate is accounted for in his probate records.

Using his home as a source of alternate income was nothing new for Lane. On July 25, 1856, Lane was discharged from any further payment obligations to a William P. Dolliver, Mr. Dolliver "having received Payment and satisfaction for which the within mortgage was given."[511] On July 22, 1859, Lane would be discharged from all duties concerning another mortgage, this one for $1,000, paid on time and in full to the Cape Ann Savings Bank.[512] Lane also had a mortgage deed on the property to Dr. Davidson for $2,500 at the time of his death.[513]

The reason for Lane's having been forced to use his home as a means of gaining income is readily revealed by the low prices his paintings were valued at in the inventory. At Bleeker's (Lane's art dealer in New York), Lane was drawing as little as twenty dollars for a painting in February of 1861,[514] this low value signifying a drop in demand for his works while directly translating into reduced fortunes. Even among his friends and patrons in Gloucester, Lane was drawing as little as fifty dollars a canvas, all while his Hudson River contemporaries were still receiving payments for their creations that averaged in the thousands. Lane's finances were suffering because his career was suffering.

Of noticeable absence in the probate inventory are Lane's painting and drafting tools, yet we do find listed maps and a spyglass—items that most surely were put to good use within his third-floor studio. As for Lane's house, the ultimate fate of this property would be decided on November 16, 1866, when Joseph L. Stevens Jr. sold the property to Frederick G. Low, Lane's (former) next door neighbor, for the sum of $5,000 [figures 103 and 104]. This suggests that Lane deeded his house to Stevens in return for the promissory note (probably for about $7,000) from which he paid off his mortgage to Davidson and paid for ongoing living expenses. On Lane's death, Stevens would still own the house and receive any residual money not willed to others. The 1866 sale of the house reflects the usual delays in probate procedures and rules out ownership of the house by Davidson due to time constraints.

The final place of repose for Fitz Henry Lane would be Gloucester's Oak Grove cemetery. In a final declaration of how highly he regarded his deceased friend, Joseph L. Stevens Jr. would lay Lane to rest in the Stevens family plot, beside where he and his wife Caroline would one day recline. As well, plans were also drawn for a large memorial to forever mark the great Gloucester artist's grave, to be paid at Stevens's own expense [figure 105]. Unfortunately, it was never to happen. The memorial Stevens had planned for Lane's gravesite was for reasons unknown never built. The man who had "mastered the difficulties of the Art, and took his place in the front rank of Marine Painters in this country" would in but a few years' passing become largely forgotten. Given the highly localized, specialized focus of his art, Lane had inadvertently ensured that his works would not be exposed to a wide audience across the country. Though he had painted from Maine

to Puerto Rico, Lane had never once pushed inland, and so a whole continent never grew aware of his talents beyond his lithographs. And of the East Coast ports he did paint, only three—Boston, New York and Gloucester—had seen enough of his work and held enough of his clients to give cause for printing a proper eulogy with his passing.

Yet perhaps the final reason behind Lane's name disappearing so quickly from the American art scene was the arrival of French impressionism. Soon the works of Lane and his contemporaries were to become regarded as passé. The devotion they showed toward investing their work with near-photographic detail had been rendered unnecessary by the ultimate triumph of the camera and unfashionable by the impressionists' newfound ways of conveying mood, emotion and texture. Lane's paintings became quaint remembrances of former family glories and past fortunes drawn from the sea, hanging nameless over a mantle or sideboard, or chucked into an attic corner. Aside from the rapidly fading recollections of those who knew him and a few stray reminiscences printed up now and then in the Gloucester papers, the name Fitz Henry Lane slowly slipped into oblivion, all while his earthly remains were left to molder in an unmarked grave.

The rediscovery of Fitz Henry Lane's artistic genius would have to wait until the twentieth century, and even then, it would unfold gradually in fits and starts. One factor that would greatly aid in Lane's rediscovery had ironically been a prime reason for the rapid decline of his fame to begin with. Because his works were so highly localized and specialized in their content, and because they had fallen out of fashion so quickly, Lane's paintings had generally failed to migrate out of the areas where his patrons had lived. Thus, when a Russian tenor opera singer from Saint Petersburg settled in Boston in the early 1920s and began collecting early American art, a ready supply of long-neglected Lane masterpieces were to be found on hand in that city's dingy antique shops, just waiting to be uncovered.

Maxim Karolik, the great champion of American art, insisted that he and his wife Martha be thought of in regard to their civic philanthropy in only one way: "We are not 'Patrons of Art' or 'Public Benefactors.' We refuse to accept these banal labels. We accept with pleasure only one label: 'Useful Citizens.'"[515] Karolik developed shortly into his Boston residency a love for early American art, seeing within it the ideals of the democratic experiment represented in all the humble, pure innocence of its roots. Together, he and his wife Martha, a well-heeled Bostonian and collector of eighteenth-century Americana whom he married in 1927, would amass not one, but *three* colossal collections of eighteenth- and nineteenth-century American fine art, folk art and furnishings, all with the specific intention of donating them to Boston's Museum of Fine Arts "as a celebration of [Karolik's] adopted country."[516] In so doing, the Karoliks would do nothing less than completely revolutionize the world of American art.

It is for their taste in paintings that the Karoliks are best remembered, for before them it had been generally assumed that there was no art worthy of the name in mid-nineteenth century America. The Karoliks were among the first to champion Fitz Hugh [sic] Lane…Presented

to the Museum in 1949, the Karoliks' paintings spurred a nationwide reassessment of nineteenth-century American art, and a number of the Karoliks' unknowns are today among the most sought-after American artists.[517]

Maxim Karolik, with his eager appetite for all things American and near limitless funds, must have seemed as if a gift from on high to the dodgy antiques dealers of Boston. For them the works of Fitz Henry Lane were unwanted cast-offs, low-end junk that they simply could not sell due to the public's fascination with all things European. To gain an appreciation of just how unknown and poorly represented Lane was at this time, we turn to the recollections of another great collector of early Americana, Nina Fletcher-Little:

> *One chilly evening in November 1939, I attended an obscure Boston auction and immediately spotted two attractive pictures, one of Boston Harbor and the other inscribed on the reverse: "Early morning, Pavilion Beach, Gloucester, F. H.Lane fecit." I had never heard the name Fitz Hugh* [sic] *Lane, nor had most other people at that time. However, I had summered near Gloucester since childhood, and being well acquainted with the locale of the scene, I purchased it out of nostalgia for less than twenty-five dollars.*[518]

Little did these dealers think of Lane's handiwork, and even less did they think of him as concerned scholarship. It is to these men that we can extend our thanks for creating the first of many myths to surround Lane, that being, of all things, his name. So long had it been since anyone had sung the praises of the great Gloucester artist, so quickly had his fame fled from the scene with his passing, that for those salesmen confronted with canvas after canvas bearing the enigmatic signatures *Fitz H. Lane*, *F. H.Lane* and *F.H.L.*, we find them simply conjuring the name Fitz *Hugh* Lane from out of thin air. Proof for this is to be found in the following advertisement, lifted from an anonymous (Boston?) newspaper from 1938:

> FOR SALE – *View of Gloucester. 1850. Drawn by Fitzhugh Lane. L.H. Bradford lithograph. Large and fine. Price low. Richard Nichols Col., 22 Bromfield St., up one flight. Boston, Mass.*[519]

With no scholarship yet in existence as concerned Lane, no one questioned whether or not this was in fact his full name. Indeed, no one had thought to question the veracity of the name or even cared to, and so was born the legend, one that would be perpetuated into the twenty-first century.

At the same time, as Maxim and Martha Karolik were beginning their collecting of Lane, so too was a small local institution thirty miles north of Boston amassing its own compilation of Lane works. Known then as the Cape Ann Scientific and Literary Association (today's Cape Ann Historical Association) this institution would in time

amass the world's largest and most pertinent collection of paintings, oil sketches and drawings by Fitz Henry Lane, though for far different reasons than the Karoliks had.

Located in the heart of downtown Gloucester, the Cape Ann Scientific and Literary Association (CAS&LA) was able to acquire so many pieces due once again to the phenomenon of Lane's work having not left the area, in this case his most productive of environments. Initially we find his creations to have been collected by the CAS&LA not for any artistic or aesthetic value, but rather due to their local associations, being superb depictions of Gloucester "as it appeared at that time."[520] In this regard they were valued as historic documents offering a window onto a world that was no more. As well, the paintings themselves were oftentimes donated by the descendants of those for whom Lane had created them...descendants who wished to enshrine the achievements of their storied ancestors, ensuring that future generations would be familiar with the names and accomplishments of Babson, Davis, Rogers and Mansfield. A stupendous debt to which we today owe the CAS&LA is that they not only focused upon the art of Lane, but also sought to accrue primary source material relevant to his life. Consequently, this small museum on Boston's North Shore would be so fortunate as to become *the* repository for the few scattered documents and artifacts still in existence pertaining to Lane's life, all while volunteers culled through old Gloucester city newspapers, clipping out stray articles that bore a relation to the life and times of Lane and pasting them in a scrapbook they would christen *Authors and Artists of Cape Ann*. Without these far-sighted efforts, this publication simply would not have been possible, leaving us with even more gray areas and unknowns.

With the Karoliks having sparked a renewed enthusiasm in the early American arts, it would not be long before the first scholarly interests fell upon Lane. In the late 1940s, John I.H. Baur would become the first academician to rise to the challenge of defining Lane and his work. Others were soon to come. By the 1960s Theodore Stebbins, Barbara Novak and, most celebrated of all, John Wilmerding would continue the work Baur had begun. Of their collective efforts, time would prove John Wilmerding's to enjoy the greatest commercial appeal and overall influence, his 1964 manuscript *Fitz Hugh Lane: 1804–1865, American Marine Painter* and 1971 book *Fitz Hugh Lane* serving to reintroduce the American public to the work and the story of Gloucester's first and greatest artist.

Public interest created a demand not only for further scholarship and books concerning Lane, but also for his paintings. Throughout the 1970s, '80s, and '90s the prices of Lane compositions for sale at auction would increase dramatically. A perfect example would be *Early Morning, Pavilion Beach, Gloucester*. As quoted above, Nina Fletcher-Little "purchased it out of nostalgia for less than twenty-five dollars," back in 1939. In 1997 that same painting, measuring no more than fourteen by twenty inches in size, was estimated to be worth $250–350,000 when the bidding began.[521] And as the works of Fitz Henry Lane grow scarcer on the open market, their prices will only continue to climb. On November 19, 2004, Lane's *Manchester Harbor* from 1853 claimed $5,506,000 at auction, and in so doing became at the time of this printing one of the top one hundred prices ever paid for a work of art at auction.[522]

Today we find ourselves looking back on more than half a century of research into the life and art of Fitz Henry Lane. On one hand, we have made immense strides in the scholarship of this man, uncovering new paintings and discovering previously unknown aspects concerning his life. On the other, we find ourselves virtually back at the beginning, endeavoring again to divine just *who* this man was, as we find that many of the stories that were presented to the public as fact are nothing more than legends, shoddy scholarship and yes, even outright fabrication. Until the year 2005 we did not even have his name right! In summary, we now know that several "factual" particulars in the story of Fitz H. Lane's life were in reality not:

* Lane's full name was Fitz Henry Lane, not Fitz Hugh Lane.
* Lane did not change his name in childhood, "as soon as he was able,"[523] but rather, petitioned the state of Massachusetts in 1831 as a grown man of twenty-seven years.
* Polio is a most remote and unlikely culprit behind his early loss of mobility, the probable cause being instead the accidental ingestion of *Datura stramonium* / Jimsonweed.
* There is no record in existence to substantiate the claim "Lane attended the Gloucester Common School."[524]
* The ancestors of Fitz Henry Lane were not "among the first settlers of Gloucester in 1623,"[525] this being an impossibility since the first Lane to settle on Cape Ann was "born about 1653,"[526] arriving "about the close of the seventeenth century."[527]
* "Clegg and Dodge"[528] was not a lithographic shop, being most likely instead a shoemaker's shop.
* Lane did not receive lithographic training in Gloucester. Such would have to wait until the year 1832, when he intentionally sought such training at the Pendleton brothers' lithographic workshop.
* It is impossible for the design of Lane's home at Duncan's Point, Gloucester, to have been derived "from the well-known House of Seven Gables made popular by Hawthorne's romantic tale,"[529] it being instead an original design created by the artist in line with the philosophy and aesthetics of Gothic revival.
* The image of him as a sad, lonely recluse simply does not hold up in light of contemporary testimony from friends and neighbors.

As well, we now are aware of the following, previously unknown information concerning the great Gloucester artist:

* Lane quite possibly had an older brother named Steven.
* Lane had more than one art student, having given detailed instruction to George Merchant Jr. and William Bradford, among several possible others.

Many notions concerning the life of Lane have now fallen under severe scrutiny and call for a reappraisal, as we now realize that his move to Boston in 1832, the return to Gloucester in the late 1840s and his voyages along the Maine coast of the 1850s and '60s were deliberate, pre-planned career moves, rather than being the product of dumb luck and serendipity. Comparing his creations to those of Robert Salmon has only strengthened the assumption that Salmon was Lane's teacher, while we must also re-think our idea that Lane was strictly a marine painter, as he also created works with strict pastoral and natural themes as well. And by all indications, from the organizations within which he was an active participant, to the house he built to the testimony of friends and even to his art, the long-held suspicions that Lane was a romantic, a transcendentalist and a mystic have been validated.

One other aspect of the story of Fitz Henry Lane's life that must be readdressed is the titles attached to many of his paintings. While some of his creations bear a name upon the back of the frame or stretcher bar, inscribed either by the individual who originally framed the canvas, or even by Lane himself, the vast majority of his works have no name or title directly ascribed to them. In a habit surely acquired at Pendleton's, Lane often did not sign and date his work, and during those rare moments when he did, he showed great inconsistency in the placement of his signature and date, several times choosing to cleverly incorporate them into the scenery itself. Whatever titles Lane coined for them were often lost over time as his fame faded and the original owners passed away. Ultimately, it was left up to descendants and antiques dealers to often invent titles by which to identify Lane's handiwork as they were again becoming collectible. As a consequence, many Lane paintings now sport names both erroneous and misleading.

Lane was not one to arbitrarily change local topography and geography in the name of making a picture more pleasing. Comparisons between his sketches and the paintings he created from them bear this out, revealing him to have "tweaked" the environment he was depicting very, very rarely, and even then only by the most minor of degrees. With this in mind, we turn to the findings of Erik A.R. Ronnberg Jr. As detailed in his essay *Imagery and Types of Vessels*, one of five dissertations created specifically for the National Gallery's 1988 Lane retrospective book *Paintings by Fitz Hugh Lane*, Ronnberg points out that *Gloucester Harbor at Sunrise*, ca. 1851 [plate 11], is actually Portsmouth Harbor, New Hampshire, as the landforms present do not correspond with Gloucester Harbor. As well, the sun, if this were indeed Gloucester Harbor, would be doing the impossible, rising in the south-southwest, and in addition, a clipper ship like that depicted on the left, could never have pulled so close into the inner harbor, given its shallow depth.[530] (See *Gloucester Inner Harbor*, ca. 1850 [plate 5], and *Gloucester Harbor*, 1847 [plate 4], for examples of Lane depicting what happens when vessels of much lesser tonnage pull in that close to shore in Gloucester Harbor.) It is Eric Ronnberg to whom we must also give credit for illustrating how *On the Wharves, Gloucester Harbor*, 1847 [figure 106], is probably Portsmouth again, as once more the landforms fail to correspond to those in Gloucester Harbor, being far too high and steep, and unlike any other depiction of Gloucester Lane ever painted.[531]

Similarly, Ronnberg has pointed out how Lane's *Gloucester Harbor*, 1859 [figure 107], could not be Gloucester either as, again, the vessel in the composition's center is of a tonnage Gloucester never accommodated, a mistake Lane simply would never have made. Further scrutiny proves the painting to be a vision of New York's Hudson River, the tugboat beside the packet ship being of a certain design identical to that featured in Lane's *New York Harbor*, 1850.[532] (In fact, this composition is but a mirror image of the central subject within *New York Harbor*, 1850.)

Good Harbor Beach, Cape Ann, dating from 1847 [figure 51], is another piece that in actuality depicts a locale miles away from that its present title claims it to portray. If this were indeed Good Harbor Beach, then aside from two small islands (Salt and Thacher's) we would see nothing but open ocean lying along the horizon. Instead, a close inspection reveals a large, long landform situated there instead, one that supports a sizeable township, as can be faintly discerned between the island with two lighthouses in the center-horizon and the large vessel also along the horizon to the island's right. This island with the unusual presence of two lighthouses upon it has long been believed to be Thacher's Island of Rockport, Massachusetts, which can definitely be seen from Good Harbor Beach. Yet in the late 1840s Baker's Island of Salem Harbor also possessed two lighthouses.[533] Rather than being Gloucester's Good Harbor Beach, Lane actually executed this painting from the vantage point of the shores of nearby Manchester, Massachusetts, looking toward Salem and Marblehead Harbors. This is the identity of that long, low landform along the horizon, with the sizeable township being Salem itself.

Contrary to the titles slapped onto some of Lane canvases, it would appear that the misnamed *Good Harbor Beach, Cape Ann* is the only Lane painting to ever actually feature the port city of Salem, Massachusetts, for once again, we find things to simply not be what they at first appear to. The painting *Salem Harbor*, 1853 [figure 108], has featured that name ever since Maxim Karolik first bought it from a Boston-area antiques dealer and brought it home. But yet again, the name does not hold up to historic reality. To begin, Salem Harbor, like Gloucester, could never have hosted a clipper ship like we see in this painting, for Salem was much akin to Gloucester in that its inner harbor was too shallow. Had a vessel of that draft ever entered Salem Harbor, it would still be there today, its keel wedged deep in the silty muck of a harbor floor that is as much as one-quarter exposed at low tide. As well, like in *Gloucester Harbor at Sunrise*, the landforms depicted do not correspond to those in the actual harbor; and neither does this painting match the testimony of the chief surveyor of the Salem Customs House from just a few years before, who informs us that mid-century Salem "exhibits few or no symptoms of commercial life; except, perhaps, a bark or brig…discharging hides; or, nearer at hand, a Nova Scotia schooner, pitching out her cargo of firewood."[534]

Nathaniel Hawthorne was not invoking poetic license when he penned these words. In fact, Salem was by all accounts a dead port at mid-century, with only the merest hint of coastal trade pulling in and out of her quays. Hawthorne speaks of barks, brigs and schooners, not clipper ships and United States Naval frigates, as Lane has depicted here.

Also, the clipper in this painting has deployed its "studding-sails," extensions of the vessel's normal sail plan employed only in still airs, when one is trying to move forward with only the merest whispers of wind to propel them. If this were in fact Salem Harbor, the deployment of studding-sails on a vessel that size would be a sure recipe for a crash, as Salem Harbor is narrow and confining, and a vessel moving under studding-sails tends to be unwieldy and poorly maneuverable.

While no particular port immediately comes to mind when viewing this piece, it could well enough be the outer reaches of Boston Harbor, a judgment call the antiques dealer who sold this to the Karoliks was ill-equipped to make, and one the Karoliks were ill-equipped to question. Yet of all the Lane paintings that have been misidentified, perhaps none is more troubling than another supposed Salem canvas, *"Unicorn" In Salem Harbor*, 1840. This painting first appeared on the market in the early 1970s, offered for sale by a gallery which presented it under the title *The Cunard Steamer "Unicorn" in Salem Harbor*, 1840. [See figure 109.] In an ad for this painting it is stated how "The painting has been described by an authority on Lane's work as 'one of his earliest dated oils and one of only three known, dated 1840.'" In the year 2000 this same painting would again come up for sale at auction, this time under the name *"Unicorn" In Salem Harbor*.[535] [See figure 110.]

Once more, we find a wide gulf between what we are being told, and what is being depicted. To begin, this painting could not be of Salem Harbor, due once again to the fact that the harbor was too shallow to accommodate a steamship of 648 tons.[536] The largest vessels ever to enter or leave Salem Harbor in the nineteenth century were East Indiamen averaging only 330 tons, the stated reason being that "the size of vessels intended for Salem merchants was limited by the shallowness of their own harbor."[537] Second, if the *Unicorn* had entered Salem in 1840, the inaugural year for the Cunard Line, it would have been an event that made a considerable stir in that town, and would have been logged in the records of the Salem Customs House. No record exists making mention of the Cunard liner *Unicorn* having ever visited Salem Harbor in 1840, or any other year. Third, and perhaps most telling, between the years 1840 to 1846 the *Unicorn* was chartered by the Cunard Line from the firm of G. & J. Burns, making regular runs between Halifax, Pictou and Quebec, Canada, a route hundreds of miles to the north that never brought it anywhere near Salem Massachusetts.[538]

Upon further scrutiny, we discover not only the identity of the port to be wrong in this painting, but also that of the steamship, for the *Unicorn* sports a color scheme contrary to that which Cunard liners were by regulation painted. In *The Britannia Entering Boston Harbor*, 1848 [plate 13], Lane portrays the *Britannia* in the correct color scheme: black hull with vermilion red smokestack, topped with a black band. Though shown here in black and white, the ship in the *Unicorn* painting bears a green/gray wash, a color scheme foreign to any Cunard liner.

One final aspect of this painting that must be addressed is the question of attribution. Did Lane actually paint this work? While it does bear the inscription *F. H.Lane, 1840*, in the lower-left corner, a close study of the two advertisements reveals something most

unsettling. Between the early 1970s and the year 2000, the painting has changed. In the 1970s advertisement, smoke can be discerned gently wafting up from the smokestack. By the year 2000, in the auction house's ad, the smoke has somehow disappeared. Also in this latter advertisement, the small vessel on the far left sports a leeboard, a device common to Dutch watercraft (and almost completely alien to American boats). Yet three decades before, in the 1970s ad, this device was *not* present on that very same boat.

The presence of a leeboard denotes this being a European painting of Dutch subject matter (if not Dutch origin), one that very well could have been "touched up" to hide its Dutch identity when it first went up for sale in the 1970s. Yet with the piece being cleaned years later, the leeboard re-emerged. This could also explain why the smoke disappeared: It must have been an addition that was removed during cleaning. As well, the simple, unimaginative treatment of sails and rigging appears out of synch with Lane's characteristic handiwork, as do the figures in the foreground; only in this case, they are too accomplished to be Lane's handiwork. These factors, coupled with its disproven title, make for a highly questionable piece, one that demands a firsthand study by accredited painting conservators before it is again considered to be a creation by Fitz Henry Lane.

In the end, we are left with the vexing question, How did highly trained, thoroughly educated, prominent curators, college professors and art historians ever come to make so many mistakes in regard to Fitz Henry Lane and his body of work? To begin, Lane is admittedly a "phantom," having left us little beyond his art by which to understand him. With little more than fragments of correspondences and newspaper clippings to go on, scholars, in their efforts to comprehend him, naturally enough turned to that one facet of his life that was conspicuous: his art. Yet as art can easily be subjected to interpretation, we find scholars in the past to have been prone to transfer their personal impressions—impressions heavily colored by their experiences of living in the twentieth century—onto Lane's work, rather than attempting to see it through the eyes of someone living in the nineteenth century. A prime example of this can be found in Lane's *Approaching Storm, Owl's Head*, 1860 (in a private collection). Because of its ominous, threatening storm clouds, and the fact that it was created in the year 1860, more than a few of the past generation of art historians have readily interpreted this painting as revealing Lane's personal reflections on the coming of the American Civil War—a claim that modern audiences today are most receptive to, given what we know of that horrible conflict. Yet when viewed through the eyes of someone alive in 1860, this interpretation simply does not hold up.

No one expected either the trauma or the blood, much less the battlefields, when it all started to unfold. After all, there had been decades of talk and more talk, with always some blustering, some posturing, some threatening, and then some compromising. It may never have left everyone satisfied entirely, but at least it left them with some alternative to violence in their minds and hearts. Even when 1860 brought the final collapse, when the election of Abraham Lincoln left the slave states feeling so threatened that secession and the resultant

challenge to the Constitution seemed to be the only recourse, most still hoped for a peaceful resolution…Southerners expected to be allowed to leave in peace.[539]

Thus, making the claim that Lane was commenting upon the coming of the Civil War is to convey onto him the gift of clairvoyance, as in 1860 he had no way of knowing for certain that a war would break out. As well, even if Lane had come to believe that conflict was imminent, he certainly had no way of knowing that it was to be as terrible and protracted a war as it would turn out to be. Indeed, the average American—Union and Confederate—believed the war would prove to be a brief affair, with neither side perceiving the other to have the stamina and determination to wage a major conflict. Enlistments reflected this trend in thought, with men at the war's beginning signing up to serve for only ninety days, believing the hostilities would be brief and over by the end of the summer.

When we view the remainder of Lane's work in the years leading up to as well as during the Civil War, we find few paintings akin to *Approaching Storm*, encountering instead glorious, halcyon sunsets, quiet bays, ship portraits and pastoral scenes aplenty. If indeed Lane had felt the Civil War weighing heavily on his thoughts, it stands to reason that *Approaching Storm* would not be the only painting of its kind, especially in the 1860s. But yet it is, and so reveals this once popular and accepted interpretation of the motive behind this work to be flawed and riddled with modern biases and expectations of what scholars and the public thought it *should* be.

In the telling of this tale, it has not been my intention to criticize those who came before me. In fact, I entered into this project believing that the story of Lane had pretty much been told. My initial goals were merely to offer some new interpretations on the themes present within his art by viewing it within a historic context, and perhaps to answer once and for all if Lane was indeed a student of Robert Salmon, and if he ever had made the acquaintance of Emerson or Thoreau, all with some basic biographical commentary included. Yet instead I encountered a historic personage whose life and art had been grossly misinterpreted.

The field of art history would do itself much good to remind itself that the key word in its designation is history, not art. At present, art history, as exemplified by the flaws found in past scholarship as concerns F.H. Lane, is in danger of becoming an oxymoron. The blithe ignorance exhibited by those who place past events within the wrong historic timeframes, vainly disregard data in the name of furthering their pet theories and declare events that never happened to be valid fact, is a threat to the future of this discipline. In the writing of this book, I conferred with several professionals from different fields of study—local and maritime historians, curators, archivists, librarians and painting and paper conservators were all consulted at various stages along the way. Aside from primary source materials, the publications to which I turned for information involved architecture, philosophy, social customs, popular literature contemporary from the time

of Lane and local, regional, national and maritime history. This holistic approach was essential to understanding the life and career of Lane. Had I centered my research solely on the works of art historians and had I employed their methods, this book would have been but the latest of several defective and slavishly repetitive studies on Lane, and would have done nothing more than continue to perpetuate a host of myths. If art history is to move beyond the danger of losing all credibility with the general public, it must embrace a holistic approach toward historic investigations, more stringent and critical evaluations of source materials and must periodically review the findings of others, lest it continue to perpetuate myths, shoddy scholarship and fraudulent claims.

At the beginning of this book, I stated that it was my intention that "indeed, a more thorough understanding of Lane shall be gained within these pages." Hopefully I have done my job. As well, I hope this work has given rise to new questions, and will stimulate a fresh reappraisal of Lane and other artists, and perhaps will prove a catalyst for change within the field of art history itself. I also hope I have answered those questions of why Lane's paintings are so valued (historically, not monetarily) and what it is about his work that makes it so quintessentially American.

As to the significance of his art, and what relevance it bears for people today, dwelling in the twenty-first century, I believe it to be found within how Lane's paintings offer a glimpse into the ideals, concerns and beliefs of the culture within which he lived. For me, this is the ultimate value Lane's paintings hold. No matter how much they may earn at auction or on a showroom floor, now matter how prestigious it may become to own one, such trivialities pale in comparison to the wealth of information held within a Lane canvas. Lane's paintings are a cultural transmission, a broadcast from a time long past and a culture long dead. Within his works we can behold photographically precise images of ports, ships and coastlines that have long since disappeared or been dramatically altered. In this regard his compositions are priceless historical documents. Yet he also offers us a window into the mid-nineteenth-century American mind. Not so much his, but that of his neighbors, his patrons and ultimately the nation itself. To gaze upon a Lane painting is to witness all that Americans of that time held dear, placed their faith in, loved, feared and aspired toward.

Winston Churchill once stated "The farther backward you can look, the farther forward you are likely to see." Looking into Lane's past thus becomes a way to divine our own collective future, as a nation. Great progress was made in the nineteenth century. Great, irrevocable losses were sustained as well. America as a nation appeared by all accounts to be a country guided by a common will as it pushed westward and across the world's oceans, yet underneath the surface partisan interests were slowly tearing her apart, culminating tragically in the American Civil War. Science and technology promised a perfect world free from fear and want, even as they ravaged and polluted a once-pristine wilderness. Lane's voyage through nineteenth-century America brought him into contact with many of the issues Americans face today: the advent of new technologies and their impact both upon society and the environment, the American preoccupation with commerce, religious

thought, tourism, urban growth, immigration and the longing for an ideal world—these are all to be found in his works. To learn from the example of those Americans for whom he crafted these pieces would go far in aiding today's citizen in deciding wherein our nation's destiny shall lay, especially as the challenges of globalization, environmental degradation, immigration, religious intolerance and the "culture wars" loom on our horizon.

From the anonymous toilers of the quay busily plying their trades atop teeming wharves, to empty shores bathed with peace and serenity, the creations of Fitz Henry Lane ultimately reveal their creator to be an ideal representative of the American nation one and a half centuries ago, a man charged with the optimism, hope and conviction that the American nation then held. Lane's paintings are more than just "beautiful pictures with pleasing associations." As well, they demand to be more than mere status symbols for those fortunate enough to afford them at auction. For the greatest value to be found in the works of Fitz H. Lane is their voice, communicating across the broad gulf of time to Americans today the ideals of a people and a society that is no more, whispering words of the world that once was *their* America. Within Lane's works we see the dream that was America. A dream to which we may yet aspire again.

Appendix
Last Will and Testament and
Probate Inventory for Fitz H. Lane

Know all men by these present, that I, Fitz H. Lane of Gloucester in the county of Essex and Commonwealth of Massachusetts, artist, being in good health and of sound and disposing mind and memory do make and publish this my last will and testament, hereby revoking all former wills by me at any time heretofore made.

First. I direct that my debts and funeral expenses and legacies herein after mentioned be paid out of my estate.

Second. I give to Dr. Herman E. Davidson of said Gloucester my gold watch and chain.

Third. I give to Horace R. Wilbur of Boston in the county of Suffolk my diamond breast pin.

Fourth. I give to the inhabitants of the town of Gloucester the picture of the old fort, to be kept as a memento of one of the localities of olden time the said picture now hanging in the reading room under the Gloucester bank, and said to be there kept until the town of Gloucester shall furnish a suitable and safe place to hang it.

Fifth. I give the beautiful wreath of wax flowers (wrought by Mrs. Mary B. Mellen) to Mrs. Caroline Stevens, wife of Joseph L. Stevens, jr. of said Gloucester.

Sixth. The picture of my mother, I give to my Brother.

Seventh. My own portrait, I give to Mrs. Mary B. Mellen of Taunton, state of Massachusetts.

Eighth. I give the sum of five hundred dollars to be equally divided between the herein named persons, each person so to dispose of his or her part as will give them some token of my remembrance and friendship. Dr, Herman E. Davidson, Mrs. Sarah C. Davidson, Mr. Joseph L. Stevens jr., Mrs. Caroline Stevens of Gloucester, Rev. Charles W. Mellen, Mrs. Mary B. Mellen, Mrs. Sarah Kendall, all of Taunton, Mass. Mr. Horace R. Wilbur of Boston, T. Sewall Lancaster and Mr. Eben Page of Gloucester.

Ninth. All the rest and residue of any property, real, personal, and mixed. I give, devise, and bequeath to said Joseph L. Stevens jr. and Mrs. Elizabeth A. Galacer, to be divided, two thirds to said Joseph L. Stevens jr. and the other third to Mrs. Elizabeth A. Galacer.

Tenth. I hereby constitute and appoint said Joseph L. Stevens jr. and T. Sewall Lancaster, of said Gloucester, to be the executors of this my last will and testament. In testimony whereof I have hereunto set my hand and seal and publish and declare this to be my last will and testament, in the presence of the witnesses named below, this seventeenth day of March in the year of our Lord, eighteen hundred and sixtyfive. [sic]

Fitz H. Lane (seal)
Signed

Signed, sealed, published and declared by the said Fitz H. Lane, as and for his last will and testament, in presence of us who, in his presence and in presence of each other and at his request, have subscribed our names as witnesses hereto.

Benjm. F. Somes
Chas. W. Davidson
Edward Perkins[540]

Household Furniture, Paintings, Books, Maps, Spy Glass and Barometer	*432.51*
Legacies Painting of Gloucester Harbor	*100.*
Family Portraits	*50.*
Wax Flower Wreath	*20.*
Watch and Chain	*100.*
Breast Pin	*25.*
Cash	*10.*
	737.51
Interest in Gas Stock	*70.*
Promissory Note	*4080.*

$4,887.50[541]

Notes

[1] Biographical information for Fitz Lane. AskArt.com. http://www.askart.com/AskART/artists/biography.aspx?artist=21328. 2005

[2] Auction results for Fitz Lane. AskArt.com. http://www.askart.com/AskART/artists/search/Search_Repeat.aspx?searchtype=AUCTION_RECORDS&&artist=21328. 2005.

[3] Book references for Fitz Lane. AskArt.com http://www.askart.com/AskART/artists/search/Search_Grid.aspx?searchtype=BOOKS&artist=21328.

[4] Thomas Dresser, *Dogtown: A Village Lost in Time* (Franconia, NH: Thorn Books, 1995), 6.

[5] Elizabeth Waugh, *The First People of Cape Ann: Native Americans on the North Coast of Massachusetts Bay* (Gloucester, MA: Dogtown Books, 2005), 1.

[6] Samuel de Champlain, *Voyages of Samuel de Champlain, Vol. 1*, translated by Charles P. Otis, 1840–1888 (The Project Gutenberg e-book, 2004), chapter 4.

[7] Ibid.

[8] John J. Babson, *History of the Town of Gloucester, Cape Ann* (Gloucester, MA: Procter Brothers, 1860; Reprint Gloucester, MA: Peter Smith Publishers, Inc., 1972), 21.

[9] James R. Pringle, *History of the Town and City of Gloucester, Cape Ann, Massachusetts* (Gloucester, MA: The City of Gloucester Archives Committee / Ten Pound Island Book Co., 1997), 24, 25.

[10] Babson, *History of the Town of Gloucester*, 52–53.

[11] Ibid., 111.

[12] Ibid.

[13] Ibid., 257–58.

[14] Ibid., 111.

[15] Vital Records of Gloucester, Massachusetts, Volume III, Deaths (Topsfield Historical Society, 1917), 195.

[16] Ibid., Volume I, Births, 418.

[17] "Babson's Church Records, 1703–1835," in Sarah Dunlap and Stephanie Buck, "Fitz Who? The Artist Latterly Known as Fitz Hugh Lane," *The Essex Genealogist* 25, no. 1 (February 2005), Gloucester Archives Committee.

[18] Susan Babson, "Fitz H. Lane," CAS&LA Weekly Column on Matters of Local History, Gloucester Daily Times, February 24, 1916 (in the collection of the Cape Ann Historical Association).

[19] Vital Records, Volume I, Births, 410, 420; Ibid., Volume III, Deaths, 195.

[20] The case for there being an older brother named Steven lies within the moldering pages of the ledger of "Master" Joseph Moore, (Ledger of Master Moore, unpublished document, collection of the Cape Ann Historical Association) an early nineteenth-century private school teacher in Gloucester who conducted evening classes for young men, particularly those who wished to learn navigation. Between the years 1810 and 1815, Jonathan Lane was charged $4.85 for the teaching

of a Steven Lane. (The debt seems to have largely been paid in firewood.) As well, he was charged $5.81 for services rendered in the teaching of someone identified as Edward Lane. According to the Gloucester Vital Records, between the years 1810 and 1815, the only Edward Lane living in Gloucester was the son of Jonathan Dennison Lane. (Vital Records, Volume I, Births, 410.) Consequently the assumption arises that if Jonathan Dennison Lane is paying for the private instruction of his known son Edward, then Steven Lane is more than likely a close relation as well. Furthermore, we find in *Babson's Church Records* the following passage: "child of Mr. Jon. Lane, buried April 28, 1815." And last but not least, page 10 of the 1810 Gloucester census records the household of Jonathan D. Lane having four males in residence: two inhabitants "under 10 yrs. of age" (Lane and his brother Edward), one inhabitant "of twentysix and under fortyfive including heads of families" (obviously Lane's father, Jonathan Dennison Lane) and a fourth individual "of ten years and under sixteen." As the existing Gloucester Vital Records make mention of there only being *three* males within Jonathan Dennison Lane's household, it is most probable that this fourth person is the Steven Lane mentioned in the ledger of Master Joseph Moore, the same "child of Mr. Jon. Lane" who was laid to rest in 1815. Unfortunately, any further evidence that would add to this find has yet to be unearthed. The Gloucester Vital Records make no mention of a Steven Lane contemporary to 1810–15 whatsoever. Furthermore, no reference to a Steven Lane is found in accounts and personal correspondences contemporary to Fitz H. Lane, his relatives or his friends, leaving this aspect of the artist's family an open mystery.

[21] Babson, *History of the Town of Gloucester*, 258.

[22] Edward Lane Jr., "Early Recollections of Artist Fitz H. Lane," undated newspaper article, in the collection of the Cape Ann Historical Association.

[23] *Wilson Museum Bulletin*, 2, no. 2 (Winter 1974–75); Barbara Erkilla, "Fitz Hugh Lane, Self taught Artist, Now Recognized Here and Nationally," *Gloucester Daily Times*, August 12, 1953.

[24] Michael Tierra, L.A.c., O.M.D., *The Way of Herbs* (New York: Simon & Schuster Inc., 1980, 1983, 1990), 35.

[25] John Wilmerding, *Fitz Hugh Lane* (Westport, CT: Praeger Publishers, Inc., 1971), 17.

[26] Edmund Sass, ed., *Polio's Legacy: An Oral History* (Lanham, MD: University Press of America, 1996), chapter 1.

[27] Ibid.

[28] Ibid.

[29] Ibid.

[30] Susan Babson, "Fitz H. Lane," CAS&LA Weekly Column on Matters of Local History, Gloucester Daily Times, February 24, 1916 (in the collection of the Cape Ann Historical Association).

[31] *Cape Ann Light*, August 19, 1865.

[32] The testimony of John Trask, found within the archives of the Cape Ann Historical Association, is admittedly problematic. On the one hand, Trask makes several statements concerning the intimate details of Lane with such an authoritative tongue, that it becomes readily obvious that he knew Lane, and knew him well. Yet some parts of his testimony fail to agree with the testimonies of others, while other parts are but quotes from the testimony of Gloucester historian (and known associate of Fitz H. Lane) John J. Babson. Ultimately, it is the opinion of this author that indeed, John Trask *was* a personal friend of Lane's, given that the vast majority of his testimony can easily be corroborated, as well as his having possessed and in-part commissioned a significant painting by Lane (*Three Master on the Gloucester Railway*, 1857) and, as he ran a paint shop, the probable connection of his having provided Lane with painting supplies.

As for the inconsistencies present within John Trask's testimony, this author is of a mind that Trask was perhaps employing Babson's published, widely circulated description of Lane's life and career either as a means to fill in gaps of a failing memory, or to embellish his recollections and thus appear more a part of Lane's life than he truly was. In all instances where the testimony of

John Trask is cited in this text, the reader can be assured that I have done so judiciously and with the support of corroborating data or plausible theory to guide my way.

[33] Wilmerding, *Fitz Hugh Lane* (1971), 18.

[34] Personal correspondence from Joseph L. Stevens to Samuel Mansfield, October 17, 1903, in the collection of the Cape Ann Historical Association.

[35] Myrtle L. Cameron, "Judy Millett," unpublished document, in the collection of the Cape Ann Historical Association.

[36] Ibid.

[37] John Wilmerding, *Fitz Hugh Lane: 1804–1865, American Marine Painter* (Salem, MA: The Essex Institute, 1964), 10.

[38] List of Persons whose Names Have Been Changed in Massachusetts, 1780-1892, Collated and Published by the Secretary of the Commonwealth, Under Authority of Chapter 191 of the Acts of the Year 1893, p. 66.

[39] Massachusetts Archives, Laws of the Commonwealth of Massachusetts, chapter CXXIV, March 13, 1832, as quoted in Dunlap and Buck, "Fitz Who?"

[40] As to how this error in scholarship occurred, or why subsequent generations of scholars have failed to take notice of it, the author cannot say. The earliest reference to this misidentification of the Gloucester artist that has been uncovered so far dates back to the 1930s, in a clipping from a Boston newspaper advertising Lane prints for sale (dated 1938, in the collection of the Cape Ann Historical Association). There, he is misidentified as Fitzhugh Lane, at a time when his work was both largely forgotten and yet being collected by the great Boston art connoisseur Maxim Karolik.

[41] John Trask, Notes on the life of Fitz Henry Lane as given by John Trask of Gloucester to Emma Todd (now Mrs. Howard P. Elwell), ca. 1885. Collection of the Cape Ann Historical Association.

[42] Ledger of Master Moore, unpublished document, in the collection of the Cape Ann Historical Association.

[43] Babson, *History of the Town of Gloucester*, 394.

[44] Ibid., 357.

[45] Jane Holtz Kay, *Lost Boston* (Boston: Houghton Mifflin Company, 1980), 128.

[46] Jack Larkin, *The Reshaping of Everyday Life. 1790–1840* (New York: Harper & Row, Publishers, Inc., 1988), 205.

[47] Gloucester seems to have been an exception to this trend, continuing a brisk and apparently legal trade with Bilbao, Spain, long after the passing of the English Navigation Act of 1651. In 1767 alone, 51,000 quintals of fish were shipped from the ports of Essex County, Massachusetts, to that Spanish market, the lion's share of which was surely supplied by Gloucester. (Babson, *History of the Town of Gloucester*, 566.) As well it should be noted that despite the crown's regulations, colonial mariners were often more than willing to engage in illicit trade outside the scope of the Navigation Acts. Particularly in New England, the epicenter of colonial maritime activity, do we find this to be so. In 1676 Edward Randolph, emissary of King Charles II, in a list of grievances condemning the Massachusetts Bay Colony sites among other things, wrote: "They have obstructed the execution of the Acts of Trade and Navigation, and refused to recognise [sic] many of them." (Edward Randolph, "Edward Randolph condemns the Massachussetts Bay Company before the Lords of Trade," Department of Alfa-informatica, University of Groningen, 1996-01-01 [update: 1995-05-20].) Randolph also claimed, "They have sent ships to 'Scanderoon' [Alexandretta]; to Guinea, the slave mart; and to Madagascar, the pirate rendezvous." (Samuel Eliot Morison, *The Maritime History of Massachusetts: 1783–1860* (London, William Heinemann, Ltd., 1923, p. 17.) Gloucester seems to have partaken of this trend, as John Price in 1680 would testify to witnessing contraband goods from Ireland being transferred from one vessel to another in Gloucester Harbor, from whence it was shipped to Boston on the pretense of having originated in Cape Ann. As well, the Earl of

Bellamont in correspondence to the Lords of Trade dated November 28, 1700, would state: "If the merchants of Boston be minded to run their goods, there is nothing to hinder them…'tis a common thing, as I have heard, to unload their ships at Cape Ann, and bring their goods to Boston in woodboats." (Babson, *History of the Town of Gloucester*, 379.)

[48] Oftentimes the first vessels ever to sport the American flag in these foreign ports hailed from Massachusetts. So often did they now voyage to these distant lands, so familiar did they become with these overseas metropolises, that Massachusetts seamen commonly knew the streets of Marseille, Zanzibar and Bombay better than those of Boston. Vessels hailing from Salem in particular grew to be so common a sight in Far Eastern waters that many an inhabitant of those countries, seeing the name Salem emblazoned upon their sterns, thought the city to be a nation unto itself.

[49] Captain Sylvanus Smith, *Fisheries of Cape Ann* (Gloucester, MA: Gloucester Times Co., 1913), 96–98; E. Hyde Cox, "Tour of Cape Ann Historical Association with Special Reference to A.M. Brooks," with J.E. Garland (unpublished document, February 23, 1976, in the collection of the Cape Ann Historical Association), 3, 5.

[50] Babson, *History of the Town of Gloucester*, 473.

[51] Ibid., 567.

[52] Ibid.

[53] Alfred Mansfield Brooks, *Gloucester Recollected: A Familiar History*, with contributions by Ruth Steele Brooks, edited by Joseph E. Garland (Gloucester, MA: Peter Smith Publishers, Inc., 1974), 52.

[54] Ibid., 54.

[55] Ibid., 52.

[56] "Wealth and Taste Came Out of the Sea," unpublished document, in the collection of the Cape Ann Historical Association.

[57] Rev. William Bentley, *The Diary of William Bentley, D.D., Vol. I.* (Gloucester, MA: Peter Smith Publishers, 1962), 359–60.

[58] Brooks, *Gloucester Recollected*, 55.

[59] *Cape Ann Light*, August 19, 1865.

[60] Erkilla, "Fitz Hugh Lane."

[61] *New York City Independent*, September 7, 1854, as quoted in W.H. Gerdts, "'The Sea is His Home': Clarence Cook Visits Fitz Hugh Lane," *American Art Journal* 17, no.3 (Summer 1985): 48–49.

[62] Trask, Notes on the life of Fitz Henry Lane.

[63] Nathaniel R. Lane et al. to Edward Lane, October 21, 1830, Archival Records, New Court House, Essex Probate Court, Book 257, p. 265. In this document, Edward Lane, brother of Fitz Henry Lane, is identified as being a sailmaker.

[64] Lane, "Early Recollections."

[65] Erik A.R. Ronnberg Jr., "Imagery and Types of Vessels," in John Wilmerding, *Paintings by Fitz Hugh Lane* (New York: Harry N. Abrams, Inc. / Washington D.C.: National Gallery of Art, 1988), 68.

[66] Ibid., "View Of Fort Point: Part Two: Fitz Hugh Lane's Images of a Gloucester Landmark," Cape Ann Historical Association Special Edition Newsletter, July 2004.

[67] Dennis Karl, *Glorious Defiance* (New York: Paragon House, 1990), 109.

[68] Unpublished eyewitness account of Gorham Parsons Low, in the collection of the Cape Ann Historical Association.

[69] Babson, *History of the Town of Gloucester*, 510.

[70] Massachusetts Volunteer Militia in the War of 1812 (Published by Brigadier General Gardner W. Pearson, the Adjutant General of Massachusetts, Boston, 1913), 9.

[71] Ibid., 13–14.

[72] "*Babson's Church Records, 1703–1835*," in Dunlap and Buck, "Fitz Who?"

[73] Vital Records, Volume III, Deaths, 193.

[74] 1820 Gloucester Town tax records, Gloucester City Archives; Interview with archivist Stephanie Buck.

[75] Lane, "Early Recollections."

[76] Wilmerding, *Fitz Hugh Lane* (1971), 18.

[77] Nathaniel R. Lane et al. to Edward Lane, October 21, 1830, Archival Records, New Court House, Essex Probate Court, Book 257, p. 265. [Brought to the author's attention by Eric A.R. Ronnberg, Jr.]

[78] Letter from Amanda Stanwood of Gloucester, to her brother Captain Richard Stanwood (unpublished document, in the collection of the Cape Ann Historical Association).

[79] Trask, Notes on the life of Fitz Henry Lane.

[80] Lane, "Early Recollections."

[81] Samuel Eliot Morison, *The Maritime History of Massachusetts: 1783–1860* (London: William Heinemann, Ltd., 1923), 214.

[82] E.D. Knight, first officer of the *Boston*, letter to Joseph Stevens, Jr., August 18, 1869. In the collection of the Cape Ann Historical Association.

[83] Wilmerding, *Fitz Hugh Lane* (1971), 19.

[84] Morison, *Maritime History*, 182–83.

[85] Brooks, *Gloucester Recollected*, 52.

[86] Elliot Bostwick Davis, *Training the Eye and the Hand: Fitz Hugh Lane and Nineteenth Century American Drawing Books* (Gloucester, MA: Cape Ann Historical Association, 1993), 10.

[87] Ibid., 14–18.

[88] For the complete argument, see Erik A.R. Ronnberg Jr., "William Bradford: Mastering Form and Developing a Style, 1852–1862," in Richard C. Kugler, *William Bradford: Sailing Ships & Arctic Seas* (New Bedford, MA: New Bedford Whaling Museum / Seattle: The University of Washington Press, 2003.

[89] A. Cobin, *Short and Plain Principles of Linear Perspective*, 4th ed., as quoted in Ronnberg, "William Bradford," in Kugler, *William Bradford*, 64.

[90] Ronnberg, "William Bradford," in Kugler, *William Bradford*, 58.

[91] Ibid., 50.

[92] Ibid.

[93] James F. O'Gorman, *This Other Gloucester* (Gloucester, MA: Ten Pound Island Book Co., 1990), 22–23.

[94] Wilmerding, *Fitz Hugh Lane* (1971), 19; Wilmerding, *Fitz Hugh Lane* (1964), 11.

[95] Trask, Notes on the life of Fitz Henry Lane.

[96] David Tatham, "The Lithographic Workshop, 1825–50," in Georgia B. Barnhill, Diana Korzenik, and Caroline F. Sloat, eds., *The Cultivation of Artists in Nineteenth-Century America* (Worchester, MA: American Antiquarian Society, 1997), 45.

[97] Ibid.

[98] Letter from Amanda Stanwood of Gloucester, to her brother Captain Richard Stanwood (unpublished document, in the collection of the Cape Ann Historical Association).

[99] Gloucester & Rockport Directory #3 (Boston: Sampson, Davenport & Co. / Gloucester: Procter Bros., 1873), 41.

[100] Morison, *Maritime History*, 225.

[101] F.E. Halliday, *England: A Concise History* (New York: Thames and Hudson Inc., 1995), 153–58.

[102] Workers of the Writers' Program of the Work Projects Administration in the state of Massachusetts, *Boston Looks Seaward: The Story of the Port, 1630–1940* (Reprint, Boston: Northeastern University Press, 1985), 93

[103] Jane Holtz Kay, *Lost Boston* (Boston: Houghton Mifflin Company, 1980), 128.

[104] Work Projects Administration, *Boston Looks Seaward*, 146.

[105] At 221 feet high and composed of 6,600 tons of granite quarried from nearby Quincy, Massachusetts, this memorial to American independence stood as the engineering marvel of its day. Having taken eighteen years to complete, the unique demands of its construction—particularly the transportation of 8-ton blocks of granite from quarry to construction site—gave birth to a number of new advancements in scientific design, including the aptly named Granite Railway. Complete with switch, cars and turntable, the only difference between the Granite Railway and those yet to come was the absence of a steam engine, the system relying instead upon gravity and a downward slope for propulsion. It would play a vital role in influencing the formation of the modern railroad, which would make its appearance nine years later. (Kay, *Lost Boston*, 129–32).

[106] Dorothy Schurman-Hawes, *To The Farthest Gulf: The Story of the American China Trade* (Ipswich, MA: The Ipswich Press, 1990), 73.

[107] Ezra S. Gannett, "Arrival of the Britannia, a Sermon…Federal Street Meeting-House…July 19th, 1840" (Boston, 1840), 16–17, as quoted in Oscar Handlin, *Boston's Immigrants: A Study in Acculturation* (New York: Atheneum, 1976), 23.

[108] Oliver Wendell Holmes, as quoted in: Kay, *Lost Boston*, 135–36.

[109] Babson, *History of the Town of Gloucester*, 258.

[110] William Winter (?), "Fitz H. Lane," *Cape Ann Light*, August 19, 1865. In the collection of the Cape Ann Historical Association.

[111] Trask, Notes on the life of Fitz Henry Lane.

[112] Nathaniel Hawthorne, as quoted in Larkin, *Reshaping of Everyday Life*, 209.

[113] Tatham, "The Lithographic Workshop," in Barnhill, Korzenik, and Sloat, *Cultivation of Artists*, 46, 47, 48.

[114] David Tatham, "The Pendleton-Moore Shop: Lithographic Artists in Boston, 1825–1840," *Old-time New England* 62, no. 2 (October–December 1971): 36.

[115] Tatham, "The Lithographic Workshop" in Barnhill, Korzenik, and Sloat, *Cultivation of Artists*, 45–46.

[116] Tatham, "The Pendleton-Moore Shop," 36.

[117] Charles Hart, quoted in Tatham, "The Lithographic Workshop," in Barnhill, Korzenik, and Sloat, *Cultivation of Artists*, 50.

[118] Ibid.

[119] Tatham, "The Pendleton-Moore Shop," 41.

[120] As *Gloucester from Governor's Hill*, 1830–31, prominently depicts "Gloucester's Universalist Church and Yard," one may speculate that this is the very Lane creation Trask speaks of as having been shown to Mr. Pendleton by W.E.P. Rogers in an endorsement of Lane's talents. (See Trask, Notes on the life of Fitz Henry Lane.)

[121] Hart, quoted in Tatham, "The Lithographic Workshop," Barnhill, Korzenik, and Sloat, *Cultivation of Artists*, 51.

[122] Tatham, "The Pendleton-Moore Shop," 30.

[123] Ibid., 32, 30.

[124] Trask, Notes on the life of Fitz Henry Lane.

[125] Ibid.

[126] Ibid.

[127] Helen Mansfield, "Fitz H. Lane," Cape Ann Scientific and Literary Association Weekly Column on Matters of Local History (CAS&LA), in the collection of the Cape Ann Historical Association.

[128] Benjamin Champney: *Sixty Years' Memories of Art and Artists* (Woburn, MA: Wallace and Andrews, 1900), 10.

[129] Stimpson's Boston Directory, July 1831, 1832, 1833. In the collection of the Massachusetts Historical Society. Most likely one of these two sources made a minor type-o when transcribing

the address of C. Bradlee's. Or perhaps the publisher's operation occupied both addresses, since they were adjoining.

[130] Tatham, "The Pendleton-Moore Shop," 37.

[131] F.H. Lane, Pendleton's Lithography, Boston, 1835.

[132] Kay, *Lost Boston*, 77.

[133] Nathaniel Hawthorne, *The House of the Seven Gables* (New York: Bantam Books, Inc., 1851; Bantam Classic edition, March 1981; fifth printing through July 1985).

[134] Wilmerding, *Fitz Hugh Lane* (1971), 22.

[135] F. H. Lane, del., *Horticultural Hall*, lithograph, Boston: Lane and Scott's Lithography, ca. 1845.

[136] Attributed to Fitz Henry Lane, Boston: Pendleton's Lithography, 1835.

[137] *Gloucester Telegraph*, August 15, 1835, in the collection of the Cape Ann Historical Association.

[138] Ibid., March 16, 1836, in the collection of the Cape Ann Historical Association.

[139] This is a compositional device Lane would constantly incorporate into his paintings, very often in the bottom-left corner of the canvas.

[140] Interview with Catharina Slautterback, Prints and Photographs Department, Boston Athenaeum.

[141] *The Maniac*, 1840. Words in part by Monk Lewis, music by Henry Russell (1812–1900). "Dedicated as a token of respect for Mrs. C.E. Habicht." Extract quoted in Lester S. Levy, *Grace Notes in American History: Popular Sheet Music from 1820 to 1900* (Baltimore: Johns Hopkins University Press, 1967).

[142] O. Downes, and E. Seigmeister, *A Treasury of American Song* (New York: Alfred A. Knopf, 1943).

[143] Ibid.

[144] *View of Norwich from the West Side of the River*, lithograph, 1839, "Sketched from nature by Lane, Sarony & Major, New York: 1839."

[145] Stimpson's Boston Directory, July 1841. In the collection of the Massachusetts Historical Society. This same address is also attested to as being the home address of Fitz Henry Lane in 1842, as found within the records of the Boston Artists Association (See Constitution of the Boston Artists Association, with a Catalogue of the First Public Exhibition of Paintings at Harding Gallery, No. 22 School Street, Boston. Prined by John H. Eastburn, 1842, in the collection of the Boston Athenaeum.)

[146] Curatorial file for Robert Salmon's *The British Fleet Forming a Line Off Algiers*, 1829, Museum of Fine Arts, Boston.

[147] National Maritime Museum, Greenwich, England.

[148] Curatorial file for Robert Salmon's *The British Fleet Forming a Line Off Algiers*, 1829, Museum of Fine Arts, Boston.

[149] National Maritime Museum, Greenwich, England.

[150] Champney, *Sixty Years' Memories*, 12.

[151] Ibid.

[152] Stimpson's Boston Directory, July 1834. In the collection of the Massachusetts Historical Society.

[153] Wilmerding, *Fitz Hugh Lane* (1971), 35.

[154] See Fitz Henry Lane, *Yacht "Northern Light" in Boston Harbor*, oil on canvas, 1845. Property of the Shelburne Museum, Shelburne, Vermont.

[155] Interview with Mary Warnement, Research Librarian, Boston Athenaeum.

[156] Unfortunately the Boston Athenaeum did not require visitors to these exhibitions to sign in, as the sheer volume of visitors precluded such a measure. Consequently, we do not definitively know whether or not Lane ever attended a Athenaeum show previous to 1841, when he himself began to exhibit there, though it would seem almost a given that he had attended these shows as so many of his fellow Pendleton's apprentices had.

[157] Trask, Notes on the life of Fitz Henry Lane.

[158] Stimpson's Boston Directory, July 1840. In the collection of the Massachusetts Historical Society.

[159] Ann Nichols, and Harriet Webster, eds, *Burnham Brothers Railway: Stories From The Neighborhood*, with contributions by Joseph Garland (Gloucester, MA: Gloucester Maritime Heritage Center, 2003), introduction.

[160] Morison, *Maritime History*, 66.

[161] Ibid., 241.

[162] Ibid., 242; Ronnberg, "Imagery and Types of Vessels," in Wilmerding, *Paintings by Fitz Hugh Lane*, 70.

[163] Boston Athenaeum exhibition records, 1834.

[164] Cam Cavanaugh, Barbara Haskins, and Frances D. Pingeon, *At Speedwell in the Nineteenth Century* (Morristown, NJ: The Speedwell Village, 1981).

[165] Ronnberg, "Imagery and Types of Vessels," in Wilmerding, *Paintings by Fitz Hugh Lane*, 70.

[166] Ibid.

[167] *Boston Daily Evening Transcript*, August 16, 1865.

[168] Several reasons have been given for Lane's creation of this painting, including to celebrate the voyage of Charles Dickens to Boston in 1842 on the *Britannia*; to advertise the Cunard Line, as commissioned by Cunard himself; and to craft this work for Cunard's own personal enjoyment, commissioned by Samuel Cunard personally. While any one of these claims may in fact be true, this author did not uncover any corroborating primary sources to legitimize them.

[169] *Boston Daily Evening Transcript*, quoted in the *Gloucester Telegraph*, November 5, 1851.

[170] *Telegraph and News*, April 26, 1856.

[171] Fitz Hugh Lane photographs, Frick Art Reference Library, New York City, January, 1961 (in the collection of the Cape Ann Historical Association).

[172] Richard C. Kugler, "William Bradford," in *William Bradford: Sailing Ships & Arctic Seas* (New Bedford, MA: New Bedford Whaling Museum / Seattle: The University of Washington Press, 2003), 8.

[173] Trask, Notes on the life of Fitz Henry Lane.

[174] Ibid.

[175] In Wilmerding, *Fitz Hugh Lane* (1971), 65, it is claimed (without a cited source) that Lane contributed paintings to the Massachusetts Charitable Mechanics Association, an organization headquartered in Worcester, Massachusetts, in 1841.

[176] Boston Athenaeum exhibition records, 1841.

[177] Boston Athenaeum exhibition records, 1841–1865.

[178] Proprietors of the Boston Athenaeum, "The Boston Athenaeum: Introduction and History." Library of the Boston Athenaeum, 2005. www.bostonathenaeum.org/general.html#intro.

[179] Anthony Albert Walsh, *Johann Christoph Spurzheim and the Rise and Fall of Scientific Phrenology in Boston, 1832–1842* (Ann Arbor, MI: University Microfilms, 1974), 305.

[180] Carlos Baker, *Emerson Among the Eccentrics: A Group Portrait* (New York: Penguin Books, USA, 1997), 154–55.

[181] Proprietors of the Boston Athenaeum, "Introduction and History."

[182] Boston Athenaeum visitor records (*Book of Strangers*), 1832–1865. .

[183] Sally Pierce and Catharina Slautterback, *Boston Lithography, 1825–1880: The Boston Athenæum Collection* (Boston: The Boston Athenaeum, 1991), 169.

[184] Ronnberg, "Imagery and Types of Vessels," in Wilmerding, *Paintings by Fitz Hugh Lane*, 68.

[185] Ibid.

[186] The two-volume *Glossaire Nautique* was received by the Boston Athenaeum on the fourth of August, 1851. (Source: Personal correspondence with Ms. Mary Warnement, Reference Librarian, Boston Athenaeum.)

[187] Boston Athenaeum exhibition records, 1832–1865.

[188] Champney, *Sixty Years' Memories*, 12.

[189] R.G. McIntyre, Exhibition Catalog, MacBeth Gallery, New York (Macbeth Gallery Records, 1838–1968. Archives of American Art, Smithsonian Institution).

[190] Boston Athenaeum exhibition records, 1836.

[191] Personal correspondence from Joseph L. Stevens to Samuel Mansfield, October 17, 1903, in the collection of the Cape Ann Historical Association.

[192] Curatorial file for Thomas Doughty's *Romantic Landscape with a Temple*, 1834, Museum of Fine Arts, Boston.

[193] *Casper Spurzheim M.D., 1832*, lithograph, printed by Pendleton's Lithography, Boston; published by William S. Pendleton.

[194] Boston Athenaeum exhibition records, 1830.

[195] Thomas S. Cummings, *Historic Annals of the National Academy of Design* (Philadelphia: George W. Childs, 1865), 12, quoted in Oswaldo Rodriguez Roque, "The Exhaltation of American Landscape Painting," in *American Paradise: The World of the Hudson River School* (New York: The Metropolitan Museum of Art, 1987), 22.

[196] Boston Athenaeum exhibition catalog, 1854, p. 5.

[197] Ibid.

[198] Ibid.

[199] Curatorial file for Thomas Doughty's *Romantic Landscape with a Temple*, 1834, Museum of Fine Arts, Boston.

[200] Boston Athenaeum exhibition records, 1827–1864.

[201] *American Paradise: The World of the Hudson River School* (New York: The Metropolitan Museum of Art, 1987), 49.

[202] Ibid., 54.

[203] American Art Union Records, 1849. In the collection of the Boston Athenaeum.

[204] *American Paradise*, 53.

[205] *The Knickerbocker*, November 1848, quoted in: *American Paradise*, 54.

[206] Wilmerding, *Fitz Hugh Lane* (1971), 33. (Note: Wilmerding does not cite the source from which he derived this information. The author has elected to include this information on the assumption of its veracity.)

[207] American Art Union Records. In the collection of the Boston Athenaeum.

[208] Wilmerding, *Fitz Hugh Lane* (1971), 65. (Note: Wilmerding does not cite the source from which he derived this information. The author has elected to include this information on the assumption of its veracity.)

[209] *Boston Daily Evening Transcript*, editorial correspondence, May 10, 1850.

[210] Constitution of the Boston Artists Association.

[211] For such purposes, the Boston Athenaeum would have served Lane far better than the Boston Artists Association, given the variety and sheer volume of works by the old world painters that were being shown year after year at the Athenaeum. (See Boston Athenaeum exhibition records, 1827–64.)

[212] *Boston Daily Evening Transcript*, February 4, 1851.

[213] George Saville, quoted in a newspaper clipping from 1892, in the collection of the Cape Ann Historical Association.

[214] Dunlap and Buck, "Fitz Who?"

[215] Larkin, *Reshaping of Everyday Life*, 74.

[216] Ibid.

[217] Lane, "Early Recollections."

[218] Babson, *History of the Town of Gloucester*, 258.

[219] Lane's determination to sell paintings and (by subscription) lithographs of Gloucester to its citizens, all the while residing in Boston, stands as a strong indication that he had always planned a return to Cape Ann. Remembering that Gloucester in the 1830s and early 1840s was a poor market for the arts, the question must be asked why Lane was going to all the trouble to court business in that town at a time when Boston and other locales held far greater promise. A perfect case in point is Lane's *View of the Town of Gloucester, Mass.*, 1836, a lithograph created over the passing of more than a year specifically for sale by subscription to the people of his homeport. From the *Gloucester Telegraph* we know that there was little business to be had ("The progress of the subscription has been slow," *Gloucester Telegraph*, August 15, 1835), something that is confirmed by the recollections of Alexander Pattillo: "Mr. Pattillo tells me that there was not very much of a demand for the originals [1836 lithographs]." ([no author], "Fitz H. Lane" Cape Ann Scientific and Literary Association Weekly Column on Matters of Local History, [no date], in the collection of the Cape Ann Historical Association.)

Since Lane would have known Gloucester to be a hard sell for such a piece, it is unlikely his reasons for crafting the litho would have been founded upon an unrealistic expectation of making money. Rather, it would seem that the 1836 lithograph was a tool designed to advertise his newfound talents and build a clientele among former neighbors. And when we consider his new name, it is most likely that Lane was also trying to re-introduce himself to a community that would not necessarily recognize him by his new moniker, a notion that is only strengthened when we consider the sanguine and all-too generous endorsements of the *Gloucester Telegraph*, a paper which until 1833 had been managed by Lane's apparent friend W.E.P. Rogers. (Source: American Antiquarian Society.)

[220] *Winnisimmet Pioneer*, January 1848.

[221] The first regular waterborne traffic between Gloucester and the state's capital would be established with the steamboat *Mystic* in the year 1859, thus precluding a consistent, reliable commute to Boston by water for Lane until the last years of his life. Babson, *History of the Town of Gloucester*, 553.

[222] Champney, *Sixty Years' Memories*, 99.

[223] Unpublished diary of Annette Babson, April 17, 1847 entry. In the collection of the Cape Ann Historical Association.

[224] Martha Oaks, *Gloucester at Mid-Century: The World of Fitz Hugh Lane, 1840–1865* (Gloucester, MA: Cape Ann Historical Association, 1988), 13.

[225] *Gloucester Telegraph*, Saturday morning, June 6, 1846, in the collection of the Cape Ann Historical Association.

[226] Untitled newspaper clipping dated 1850, in the collection of the Cape Ann Historical Association.

[227] Ibid.

[228] Susanna Paine, *Roses and Thorns or Recollections of an Artist* (Providence, RI: B.T. Albro, 1854).

[229] The *Bessie Neal* was built in Wells, Maine, in 1853, and registered in Gloucester on August 5 of that same year. (Source: Ship Registers of Gloucester, Massachusetts: 1789–1875. Compiled by the Essex Institute, Salem, MA, 1944.)

[230] Champney, *Sixty Years' Memories*, 10.

[231] The back of this painting bears the inscription: "Painted by Fitz H. Lane, 1856, for Sidney Mason of Gloucester and New York."

[232] In the past it has been claimed that this painting was employed specifically as an outdoor sign [see Wilmerding, *Fitz Hugh Lane* (1971), 69], the case being built upon the following notice, lifted from *The Cape Ann Advertiser*:

> *PRETTY SIGN—If our readers wish to see something pretty, let them take a walk down to Burnham Bros. Railway and take a peep at the new sign recently hung out over the paint shop of Mr.*

John Trask. It is a painting on canvas 4½ feet by 5 executed by Fitz H. Lane, Esq., representing a view of Burnham Bros. Railways, the wharf and stores adjoining. The front view represents the "ways" with a ship and schooner receiving a coat of paint. The workshop and counting room of Burnham Bros. And the building of Mr. Joseph Shepard, together with the old Parrott and Caswell houses are plainly visible. In the background, a partial view of the residence of Capt. Frederick Norwood on Spring street, the Universalist church on Elm street, Capt. Isaac Somes' residence on Pleasant street and several other buildings on Prospect St. The view is taken from Rocky Neck and makes a very pretty picture. [August 1, 1857 (reprint), in the collection of the Cape Ann Historical Association.]

It is known that the same John Trask mentioned in the article presented a painting of the Burnham Brothers Marine Railway to the City of Gloucester in 1876. This painting is presently on display within the Cape Ann Historical Association, and was claimed by local newspapers in 1876 to have been the very same painting "hung out over the paint shop of Mr. John Trask" nineteen years earlier. While it is not in dispute that Lane created a sign upon canvas for the purposes of advertising the Burnham Bros. Railway, the question does arise whether the painting presently on display with the Cape Ann Historical Association is the very same sign referred to in the article, or if it is a duplicate copy, created by Lane for some other purpose? The first challenge that arises in regard to this being the same painting mentioned in the *Advertiser* is that the measurements mentioned in the article do not match up with those of the painting in question. While the article gives the dimensions as "4½ feet [54 inches] by 5 [60 inches]," the measurements of the piece in question are 39¼ inches by 59¼ inches. While one side certainly corresponds, the other has a deficit of 14¾ inches, more than a foot difference. Another facet that throws doubt to this question of this painting being the one described is that if this painting were the one employed as an outdoor sign, then it hides well the scars from its outdoor ordeal. Having been hung outside from the year 1857 until (possibly) as late as 1876, one would expect to find it having accrued extensive damage from salt air deposits, rain, soot, coal dust and, most destructive of all, sun bleaching and paint loss from the canvas having constantly been loosened and tightened by the whims of shifting temperature and relative humidity beside the ocean. To be blunt, this painting, even if it were only hung outside for a short duration, should be in poor shape at best, having received irreparable damage from the elements. Perhaps most tellingly, the painting at the Cape Ann Historical Association has suffered from none of these environmental factors.

And lastly, while Lane rarely crafted canvases as large as *Three Master on the Gloucester Railway*, the fact remains that he *did* produce at least one other. *New York Harbor*, 1850 (in the collection of the Museum of Fine Arts, Boston), stands as a painting that is almost identical in size to *Three Master*, and has never been associated with having been displayed outdoors.

[233] Ronnberg, "Imagery and Types of Vessels," in Wilmerding, *Paintings by Fitz Hugh Lane*, 95.

[234] Ibid.

[235] See Fitz Henry Lane, *View at Bass Rocks Looking Eastward*, sketch, 1850s. Property of the Cape Ann Historical Association.

[236] Brooks, *Gloucester Recollected*, 62.

[237] *Boston Daily Evening Transcript*, editorial correspondence, May 10, 1850.

[238] Babson, *History of the Town of Gloucester*, 563.

[239] Herein could lie yet another motive for returning to Gloucester. While Lane's hometown may have been experiencing a taste of immigration, Boston was effectively drowning in a sea of dispossessed humanity (again, overwhelmingly Irish). Boston's citizenry, as part of their reaction to the introduction of this unsettling foreign element to their city, would turn to her suburbs for

escape. Jamaica Plain, Watertown, Milton, Brookline, Roxbury and Dorchester had been rural before the potato famine. With trolleys and trains to aid them in their daily commute, those with the means to now moved to these surrounding communities, enjoying a quiet, quasi-pastoral existence while reaping the benefits of working in Boston—a similar lifestyle to that which Lane enjoyed after coming back from the Hub.

[240] Brooks, *Gloucester Recollected*, 106–107.

[241] Untitled newspaper clipping dated October 23, 1850, in the collection of the Cape Ann Historical Association.

[242] *New York City Independent*, September 7, 1854, quoted in Gerdts, "'The Sea is His Home,'" 47.

[243] Brooks, *Gloucester Recollected*, 163–64.

[244] Ibid., 105–106.

[245] In fact, Norman's Woe was already quite famous with the majority of Americans, it having been immortalized as the setting for Henry Wadsworth Longfellow's popular poem *The Wreck of the Hesperus*, published in 1840.

[246] American Art Union exhibition records, 1848, in the collection of the Boston Athenaeum.

[247] Lane, "Early Recollections."

[248] Ibid.

[249] Ibid.

[250] Untitled newspaper clipping dated August 4, 1849, in the collection of the Cape Ann Historical Association.

[251] Ibid.

[252] Lane, "Early Recollections."

[253] Trask, Notes on the life of Fitz Henry Lane.

[254] While this narrow lane has been referred to as Ivy Court or Ivy Place in land deeds concerning Duncan's Point and the house F.H. Lane built, in an easement agreement between "Fitz H. Lane of Gloucester in the County of Essex and State of Massachusetts, In consideration of one dollar paid by Frederick G. Low and William Babson, both of said Gloucester," dated April 4, 1850, this avenue in question is referred to as "Iva Lane." In Frederick G. Low's acknowledgement of payment by Lane concerning the easement, we again find the right of way being referred to as "Iva Lane." [Source: Easement Agreement between Fitz H. Lane of Gloucester and Frederick G. Low and William Babson of Gloucester, April 4, 1850, Archival Records, New Court House, Essex Probate Court, Book 426, p. 109. Brought to the author's attention by Eric A.R. Ronnberg Jr.]

[255] Local legends make claim to the house also having once possessed a roof of glass and an underground tunnel leading down to the water from the house's basement, two assertions that seem to have little to no foundation in reality. The presence of a glass roof would be impossible due to the Gothic vaulting lining the inside of the ceiling (though it is both possible and most likely that Lane may have had a small skylight cut into the ceiling). And as Duncan's Point is a promontory composed of solid granite, the expense and time required to blast through so as to fashion a tunnel would have been an engineering feat by today's standards, let alone Lane's, not to mention an incredible expense with no obvious purpose to justify it.

[256] Susan Babson, "Fitz H. Lane," CAS&LA Weekly Column on Matters of Local History, Gloucester Daily Times, February 24, 1916 (in the collection of the Cape Ann Historical Association).

[257] Mansfield, "Fitz H. Lane," CAS&LA.

[258] Untitled newspaper clipping dated 1850, in the collection of the Cape Ann Historical Association.

[259] *Telegraph and News*, April 26, 1856.

[260] Fragment of a letter from Fitz Henry Lane to Joseph L. Stevens Jr., in the collection of the Cape Ann Historical Association.

[261] Babson, *History of the Town of Gloucester*, 569.

[262] *Telegraph and News*, April 26, 1856.

[263] Lane, "Early Recollections."

[264] Wilmerding, *Fitz Hugh Lane* (1971), 19.

[265] Edwin Haviland Miller, *Salem Is My Dwelling Place: A Life of Nathaniel Hawthorne* (Iowa City: University of Iowa Press, 1991), chapter 23.

[266] Hawthorne, *House of the Seven Gables*, 1. Recent study of the structure has raised certain doubts as to the house ever having had seven gables. Unfortunately, no definitive answer concerning this question has been reached as of the time of this book's printing.

[267] How Nathaniel Hawthorne came to know of the house having once possessed seven gables lies within popular lore surrounding his second cousin, Susannah Ingersol, who owned the house. Hawthorne, who was apparently close to his cousin, is claimed to have been a frequent visitor to her home. It was during one of these visits that Susannah informed Hawthorne of the legend that the house had once had seven gables, an architectural oddity he chose to incorporate into his fictional edifice. (Source: House of the Seven Gables Museum, Salem, Massachusetts.)

[268] Alfred Mansfield Brooks, Lane House (unpublished document, in the collection of the Cape Ann Historical Association).

[269] Andrew Jackson Downing, "The Architecture of Country Houses," as quoted in Carole Rifkind, *A Field Guide to American Architecture* (New York: Bonanza Books, 1984), 50.

[270] Susan Babson, "Fitz H. Lane," CAS&LA Weekly Column on Matters of Local History, Gloucester Daily Times, February 24, 1916 (in the collection of the Cape Ann Historical Association).

[271] Trask, Notes on the life of Fitz Henry Lane.

[272] Mansfield, "Fitz H. Lane," CAS& LA.

[273] Fragment of a letter from Fitz Henry Lane to Joseph L. Stevens, in the collection of the Cape Ann Historical Association.

[274] Interview with Catharina Slautterback, Boston Athenaeum.

[275] Even Alexander Jackson Davis would move to and fro between the two disciplines, devoting time to both his successful architectural career and the composing of drawings for various New York lithographic firms, becoming in time "one of the foremost draftsmen and watercolorists of his day." (Leland M. Roth, *A Concise History of American Architecture* (New York: Harper & Row, Publishers, Icon Editions, 1980), 95.)

[276] Interestingly, in a work commissioned (and later rejected) by the architect Ithiel Town, Cole would illustrate his envisioning of the creative, near-spiritual process of the architect in his *The Architects Dream*, 1840, a painting wherein among Greco-Roman and Egyptian architectural motifs we find the Gothic revival being referenced in the presence of a chapel with soaring spire, nestled amongst a dark copse of trees.

[277] Trask, Notes on the life of Fitz Henry Lane.

[278] Wilmerding, *Fitz Hugh Lane* (1971), 20.

[279] Ibid., 39.

[280] Babson, *History of the Town of Gloucester*, 258.

[281] Mansfield, "Fitz H. Lane," CAS& LA.

[282] Susan Babson, "Fitz H. Lane," CAS&LA Weekly Column on Matters of Local History, Gloucester Daily Times, February 24, 1916 (in the collection of the Cape Ann Historical Association).

[283] *Cape Ann Light*, August 19, 1865.

[284] *Boston Daily Evening Transcript*, August 19, 1865.

[285] Trask, Notes on the life of Fitz Henry Lane.

[286] *Boston Daily Evening Transcript*, August 16, 1865.

[287] See Fitz Henry Lane, *Folly Cove, Lanesville – Gloucester*, sketch, 1864. Property of the Cape Ann Historical Association.

[288] Diary of Samuel Sawyer, in the collection of the Cape Ann Historical Association.

289 Annette Babson, personal journal, Saturday, September 22, 1849 entry, as quoted in Oaks, *Gloucester at Mid-Century*, 21.

290 Lane, Early Recollections."

291 Mansfield, "Fitz H. Lane," CAS& LA.

292 *Winnisimmet Pioneer*, January 1848.

293 American Antiquarian Society, Worcester, Massachusetts.

294 Ibid.

295 Brooks, *Gloucester Recollected*, 22.

296 Ibid.

297 See Fitz Henry Lane, *Brace's Rock, Eastern Point*, sketch, 1863. Property of the Cape Ann Historical Association.

298 Records of the Gloucester Lyceum, March 1, 1831, in the collection of the Sawyer Free Library, Gloucester, Massachusetts.

299 Essex County Probate Records, Vol. 424, microfilm, Peabody Essex Museum Library. [Brought to the author's attention by Erik A.R. Ronnberg Jr.]

300 Ibid., Vols. 234, 237, microfilm, Peabody Essex Museum Library [Brought to the author's attention by Erik A.R. Ronnberg Jr.]

301 Charles C. Smith, "A Memoir [of John James Babson] by Charles C. Smith prepared for the Massachusetts Historical Society," 1886, in the collection of the Cape Ann Historical Association.

302 Records of the Gloucester Lyceum, 1849,in the collection of the Sawyer Free Library, Gloucester, Massachusetts.

303 Sharon Worley, "Fitz Hugh Lane and the Legacy of the Codfish Aristocracy," *Historical Journal of Massachusetts*, Winter 2004. In the collection of the Cape Ann Historical Association.

304 Mansfield, "Fitz H. Lane," CAS& LA.

305 Diary of Samuel Sawyer, in the collection of the Cape Ann Historical Association.

306 Ibid., August 8, 1864 entry.

307 Ledger of Samuel Sawyer, November 8, 1860, in the collection of the Cape Ann Historical Association.

308 Diary of Samuel Sawyer, November 4, 1864 entry, in the collection of the Cape Ann Historical Association.

309 "August 10. [1864] Called at Lane's studio." "November 17. [1864] Went to Gloucester. Called upon Mr. Lane artist." "August 4. [1865] Mr. & Mrs. Bartol came up via Rail Road. Went to the Country, thence to call upon Mr. Lane the artist. Afterwards went to sail. Got becalmed. Enjoyed the day." Diary of Samuel Sawyer, August 10, 1864; November 17, 1864; August 4, 1865 entries, in the collection of the Cape Ann Historical Association.

310 Trask, Notes on the life of Fitz Henry Lane; see chapter 10, "The Changing Canvas, Part One: Transitions in Color Palate and Technique" of this text for Trask's report on the color palette Lane employed.

311 Mansfield, "Fitz H. Lane," CAS& LA.

312 *Telegraph and News*, March 3, 1858.

313 Piper would serve as a director of the Lyceum in 1849.

314 Fragment of a letter from Fitz Henry Lane to Joseph L. Stevens Jr., in the collection of the Cape Ann Historical Association.

315 Records of the Gloucester Lyceum, 1849, in the collection of the Sawyer Free Library, Gloucester, Massachusetts.

316 Unattributed newspaper article, July 1849, in the collection of the Cape Ann Historical Association.

317 Ibid.

318 Personal correspondence from Joseph L. Stevens Jr. to Samuel Mansfield, October 17, 1903, in

the collection of the Cape Ann Historical Association.

[319] Unattributed newspaper article, Wednesday Morning, June 13, 1849, in the collection of the Cape Ann Historical Association.

[320] Personal correspondence from Joseph L. Stevens Jr. to Samuel Mansfield, October 17, 1903, in the collection of the Cape Ann Historical Association.

[321] Ibid.

[322] Personal correspondence from Joseph L. Stevens Jr. to Fitz Henry Lane, January 29, 1851, in the collection of the Cape Ann Historical Association.

[323] *Gloucester Daily Telegraph*, September 11, 1850.

[324] Personal correspondence from Joseph L. Stevens Jr. to Fitz Henry Lane, January 29, 1851, in the collection of the Cape Ann Historical Association.

[325] Personal correspondence from Fitz Henry Lane to Joseph L. Stevens, October 17, 1903, in the collection of the Cape Ann Historical Association.

[326] See Fitz Henry Lane, *Study of Ships*, 1857. Property of the Cape Ann Historical Association.

[327] See Fitz Henry Lane, *Seashore Sketch*, 1857. Property of the Cape Ann Historical Association.

[328] Personal correspondence from Caroline Stevens to Fitz Henry Lane, February 9, 1853, in the collection of the Cape Ann Historical Association.

[329] See Fitz Henry Lane, *Northeast View of Owl's Head*, sketch, August 1851. Property of the Cape Ann Historical Association.

[330] Personal correspondence from Joseph L. Stevens to Fitz Henry Lane, January 29, 1851, in the collection of the Cape Ann Historical Association.

[331] Constitution of the Gloucester Lyceum, 1830, Records of the Gloucester Lyceum. In the collection of the Sawyer Free Library, Gloucester, Massachusetts.

[332] In 1840 Horace Mann would report that Massachusetts alone contained 137 separate lyceums, each with an average attendance of more than 32,000. Ultimately lyceums would reach as far west as Detroit and as far south as Florida. (Source: Theodore Morrison, *Chautauqua* (Chicago: The University of Chicago Press, 1974.)

[333] Larkin, *Reshaping of Everyday Life*, xv.

[334] Ralph Waldo Emerson, "Self-Reliance," as published in *Self-Reliance and Other Essays* (New York: Dover Publications, Inc. 1841), 20.

[335] Ibid., 21.

[336] Ibid.

[337] Ibid., 20.

[338] Babson, *History of the Town of Gloucester*, 558.

[339] Ibid., 494.

[340] Unitarian Universalist Historical Society, "The Unitarian Controversy and Its Puritan Roots," in *Dictionary of Unitarian and Universalist Biography* (Boston: Unitarian Universalist Association, 1999–2004) www.uua.org/uuhs/duub/index.html.

[341] Babson, *History of the Town of Gloucester*, 495.

[342] Records of the Gloucester Lyceum, 1830–31. In the collection of the Sawyer Free Library, Gloucester, Massachusetts.

[343] Ibid.

[344] Babson, *History of the Town of Gloucester*, 495.

[345] Unitarian Universalist Historical Society, "Richard Hildreth," in *Dictionary of Unitarian and Universalist Biography*.

[346] Babson, *History of the Town of Gloucester*, 495.

[347] *Gloucester Daily Telegraph*, August 16, 1865.

[348] Record of the proceedings of the Religious Union of Associationists, Sunday, January 3, 1847, in the collection of the Massachusetts Historical Society.

349 Ibid.

350 Ibid.; Handbill for the Religious Union of Associationists, Boston, November 20, 1848, in the collection of the Massachusetts Historical Society.

351 Record of the proceedings of the Religious Union of Associationists, Sunday, January 3, 1847, in the collection of the Massachusetts Historical Society.

352 Baker, *Emerson Among the Eccentrics*, 154–55.

353 George Wilson Pierson, *Tocqueville and Beaumont in America* (New York: Oxford University Press, 1938), 421.

354 William Ellery Channing, "Spiritual Freedom" (speech delivered May 26, 1830).

355 Record of the proceedings of the Religious Union of Associationists, Sunday, January 3, 1847, in the collection of the Massachusetts Historical Society.

356 Amanda Kempa, "Fitz Hugh Lane and American Transcendentalism" (senior thesis, Columbia University, Fall, 1994). In the collection of the Cape Ann Historical Association.

357 Record of the proceedings of the Religious Union of Associationists, in the collection of the Massachusetts Historical Society.

358 Kempa, "Fitz Hugh Lane and American Transcendentalism."

359 Trask, Notes on the life of Fitz Henry Lane. It must be noted that this sentence was penned in as an afterthought, either by Emma Todd/Elwell or the person who transcribed the testimony.

360 Essex County Probate Records, Vol. 424, microfilm, Peabody Essex Museum Library. [Brought to the author's attention by Erik A.R. Ronnberg Jr.] In his will, Lane remembers Wilbur by declaring, "Third. I give to Horace R. Wilbur of Boston in the county of Suffolk my diamond breast pin." As well, Lane leaves Wilbur a portion of $500 to be divided amongst a select number of friends. Wilbur is the second person to be mentioned in Lane's will, being eclipsed only by Dr. Herman E. Davidson. Dr. Davidson would receive from Lane in the will a rather personal effect, the artist's "gold watch and chain." As we know Dr. Davidson to have been a close personal friend of Lane's, and as Lane remembered him in his will so prominently with such a personal effect, so can we surmise the depth of friendship enjoyed between Lane and Mr. Wilbur, given Wilbur's receiving an equally personal effect and *his* prominent place in Lane's will—a friendship that found common ground in their shared interest in Spiritualism.

361 Copy of a letter by Fitz Henry Lane, 1862. Written in the hand of Joseph L. Stevens Jr., in the collection of the Cape Ann Historical Association.

362 Personal correspondence from Thomas Cole to Asher B. Durand, March 20, 1838, as quoted in Randal C. Griffin, "The Untrammeled Vision: Thomas Cole and the Dream of the Artist – paintings entitled The Architect's Dream and Dream of Arcadia," *Art Journal*, Summer 1993.

363 Griffin, "Untrammeled Vision."

364 Nathaniel Hawthorne, *New England Magazine* 9 (1835), quoted in Griffin, "Untrammeled Vision."

365 Ralph Waldo Emerson, quoted in Griffin, "Untrammeled Vision."

366 Records of the Gloucester Lyceum, 1849, 1852, 1853, in the collection of the Sawyer Free Library, Gloucester, Massachusetts; *Gloucester Telegraph* 33, no. 38 (May 12, 1858), as cited in Mary Foley, "Discoveries In American Art: Fitz Hugh Lane, Ralph Waldo Emerson, and the Gloucester Lyceum," *The American Art Journal* 27, nos. 1 and 2 (1995–96): 100.

367 Records of the Gloucester Lyceum, 1849–53, in the collection of the Sawyer Free Library, Gloucester, Massachusetts.

368 Ibid., 1849.

369 Ibid., 1849–53.

370 Ibid.

371 Worley, "Legacy of the Codfish Aristocracy."

372 Boston Athenaeum exhibition records, 1841–48.

373 Baker, *Emerson Among the Eccentrics*, 251.

374 Ibid., 155.

375 Elizabeth Palmer Peabody, while not being a pledged member of the Union, is listed as having attended a festival held by the Union on April 7, 1848, in celebration of the French communitarian Charles Fourier. (Source: Record of the proceedings of the Religious Union of Associationists, in the collection of the Massachusetts Historical Society.)

376 Louise Hall Tharp, *The Peabody Sisters of Salem* (Boston: Little, Brown and Company, 1950), 46.

377 Ibid., 46–50, 57.

378 Boston Athenaeum exhibition records, 1834.

379 Louise Hall Tharp, *The Peabody Sisters of Salem* (Boston: Little, Brown and Company, 1950), 46.

378 Business correspondence from S.A. Clarke to William B. Fowle, Esq., June 1833, William B. Fowle Papers, 1753–1914 (box 4 of 5), in the collection of the Massachusetts Historical Society.

381 Catharina Slautterback, Sally Pierce, and Georgia Brady Barnhill, *Early American Lithography: Images to 1830* (Boston: The Boston Athenaeum, 1997), 17–33; Catherina Slaughterback, and Sally Pierce, *Boston Lithography: 1825–1880* (Boston: The Boston Athenaeum, 1991), 5–6.

382 Slautterback, Pierce, and Barnhill, *Early American Lithography*, 33.

383 Personal correspondence with Catharina Slautterback, Prints and Photographs Department, Boston Athenaeum.

384 Tharp, *Peabody Sisters*, 51.

385 Baker, *Emerson Among the Eccentrics*, 10, 404–407.

386 Reverend Hosea Hildreth, Address of the Gloucester Union, for the Promotion of Temperance and Economy; to Their Fellow Citizens, reported and accepted March 4, 1831. In the collection of the American Antiquarian Society.

387 Larkin, *Reshaping of Everyday Life*, 286.

388 Hildreth, Address of the Gloucester Union.

389 Ibid.

390 Records of the Massachusetts Society for the Suppression of Intemperance, 1833, in the collection of the Massachusetts Historical Society.

391 Ibid., May 22, 1830.

392 Ibid., May 20, 1829.

393 Ibid., 1833.

394 Ibid., June 27, 1833–March 31, 1848.

395 William Ellery Channing, *An Address on Temperance* (Boston: Weeks, Jordan, & Company, 1837), in the collection of the Massachusetts Historical Society.

396 Ibid.

397 Babson, *History of the Town of Gloucester*, 258.

398 Unattributed newspaper article, July 1849, in the collection of the Cape Ann Historical Association.

399 Ibid.

400 Josiah Holbrook, "Associations of Adults for Mutual Education," 594–597, quoted in Foley, "Discoveries In American Art," 101.

401 *The Telegraph*, July 7, 1849. The four temperance organizations from Gloucester that were present in the parade were: Sons of Temperance, Washington Section of Cadets of Temperance, Granite Section Cadets of Temperance and the Excelsior Section Cadets of Temperance.

402 Advertisements for Thomson Mountain House, Gloucester, and D.D. Driscoll's "Temperance House," *The Telegraph*, Saturday Morning, June 6, 1846, in the collection of the Cape Ann Historical Association.

403 See Fitz Henry Lane, *John H. Hawkins*, lithograph, 1842. Property of the Library of Congress.

404 Pringle, *Town and City of Gloucester*, 109–10.

[405] See Edward Pessen, *Jacksonian America: Society, Personality, and Politics*, Rev. ed. (Champaign: University of Illinois Press, 1985); Ronald P. Formisano, *The Transformation of American Political Culture: Massachusetts Parties, 1790s–1840s* (New York: Oxford University Press, 1983); Daniel Walker Howe, *The Political Culture of the American Whigs* (Chicago, University of Chicago Press: 1979).

[406] Diary of Samuel Sawyer, in the collection of the Cape Ann Historical Association.

[407] Records of the Gloucester Lyceum, February 23, 1849, in the collection of the Sawyer Free Library, Gloucester, Massachusetts.

[408] Ibid.

[409] *Telegraph and News*, March 3, 1858.

[410] Pheobe A. Hanaford, *Daughters of America* (Augusta, ME: True and Company, 1882), 289–90.

[411] Ibid.

[412] Ibid.

[413] Ibid.

[414] Skinner, Inc., Catalog for Sale 2194, American and European Paintings, May 16, 2003. Lot # 114, Mary Blood Mellen, *Three Master in Rough Seas* (descriptive text).

[415] Christie's, Important American Paintings , Drawings and Sculpture, Thursday 19 May 2005. Lot # 101. Fitz Hugh Lane, *A Storm, Breaking Away, Vessel Slipping Her Cable*.

[416] Skinner, Inc., Catalog for Sale 2194, American and European Paintings, May 16, 2003. Lot # 114, Mary Blood Mellen, *Three Master in Rough Seas*.

[417] Ronnberg, "Imagery and Types of Vessels," in Wilmerding, *Paintings by Fitz Hugh Lane*, 64, 67–68.

[418] Ibid., 103.

[419] See, Mary Blood Mellen, *Two Ships in Rough Waters*, oil on canvas painting, 1865. Property of the Cape Ann Historical Association.

[420] One interesting example that is contrary to this prevailing trend is Mary Mellen's *Taking in Sails at Sunset*, where (with probable assistance by Lane) she has created a fairly competent portrayal of a vessel's sails.

[421] Skinner, Inc., Catalog for Sale 2194, American and European Paintings, May 16, 2003. Lot # 114, Mary Blood Mellen, *Three Master in Rough Seas* (descriptive text).

[422] Wilmerding, *Fitz Hugh Lane* (1971), 42.

[423] *Gloucester Daily Times*, obituary of George Merchant Jr., May 5, 1906.

[424] Wilmerding, *Fitz Hugh Lane* (1971), 78.

[425] This particular painting was created by Merchant as a background for a diorama depicting a whaling ship anchored off Pico. Merchant apparently created the diorama as part of his lobbying efforts to encourage Gloucester to reenter the whaling industry.

[426] Trask, Notes on the life of Fitz Henry Lane.

[427] Ronnberg, "William Bradford," in Kugler, *William Bradford*, 55.

[428] Ibid., 62.

[429] Ibid., 64.

[430] Ibid., 58.

[431] Ibid., 63.

[432] Kugler, "William Bradford," in *William Bradford*, 10.

[433] Helen Mansfield, Daniel Jerome Elwell (unpublished document, in the collection of the Cape Ann Historical Association).

[434] See Fitz Henry Lane, *Island with Beacon*, oil on panel painting, 1851. Property of the Cape Ann Historical Association.

[435] Wilmerding, *Fitz Hugh Lane* (1971), 78.

[436] Ibid.

[437] Ibid.

[438] From the June 1887 obituary for John Trask, we find the following: "He [Trask] was by trade a ship painter…His business sign, painted by Fitz H. Lane, showing a ship upon the railway and the buildings in the vicinity as they then appeared, is now a valued ornament of the aldermen's room in the city hall, having been retouched by Capt. Center and presented to the city by Mr. Trask."

[439] Fitz Henry Lane, *Owl's Head from the South*, sketch, August 1851. Property of the Cape Ann Historical Association.

[440] This should not be taken to mean that Lane was unimaginative or non-innovative in his cloud treatments. In fact, his clouds are quite often very useful if not essential for adding drama to the scene, being at times even crucial, as in *Gloucester Harbor*, 1852.

[441] The clouds featured in this painting are very interesting, as they are massed to form a "cloud deck," which creates a second plane, parallel to the water. This is done even more successfully in *Approaching Storm, Owls Head*, 1860.

[442] See chapter 6: First Exhibitions, First Clients.

[443] Both of these works appear to have been mistakenly dated in the 1850s due once again to a newspaper article, when all evidence upon the canvases points to their having been crafted in the decade previous, particularly the lithographic depiction of clouds and the lack of development along the Fort Point area.

[444] Franklin Kelly, "Lane and Church in Maine," in Wilmerding, *Paintings by Fitz Hugh Lane*, 132.

[445] The date of 1850–51 is derived from the fact that the wharf under construction in the foreground was built during these years.

[446] See Ronnberg, "Imagery and Types of Vessels," in Wilmerding, *Paintings by Fitz Hugh Lane*, 74.

[447] Dr. Robert Legatt, *A History of Photography from its beginnings till the 1920's* (Bath, England: The Royal Photographic Society, 1995).

[448] Ibid.

[449] Ibid.

[450] Daniel Finamore, *Capturing Poseidon: Photographic Encounters with the Sea* (Salem, MA: Peabody Essex Museum, 1998), 3.

[451] W. Parry, "Some Experiences in Photographing Steamships," in *American Annual of Photography and Photographic Times Almanac*, (New York: Scovill and Adams, 1890), 105, quoted in Finamore, *Capturing Poseidon*, 3.

[452] Finamore, *Capturing Poseidon*, 17.

[453] Fitz Henry Lane, *Steamer "Harvest Moon" Lying at Wharf in Portland*, photograph, 1863. Property of the Cape Ann Historical Association. The full name of the steamship company that contracted Lane to make a portrait of the *Harvest Moon* was "Spear, Lang, and Delano of Boston." That Lane was hired for the express purpose of fashioning a portrait of the *Harvest Moon* is verified by the inscription attached to his sketch *Looking up Portland Harbor*, 1863 (property of the Cape Ann Historical Association), wherein it is stated: "Sketch made for a painting for J.H.B. Lang in which to introduce steamer *Harvest Moon*."

Built at Portland, Maine, in 1862 for commercial use, *Harvest Moon* was sold to the United States Navy on November 16, 1863, for use in the then-ongoing Civil War. *Harvest Moon* would ultimately serve as flagship of Admiral John A. Dahlgren, only to be sunk by a Confederate torpedo in Winyah Bay, five miles south-southeast of the city of Georgetown, South Carolina. (Sources: Department of the Navy, Naval Historical Center and *Harvest Moon* Historical Society.)

[454] No other example of this procedure having been done by Lane has ever come to light.

[455] Trask, Notes on the life of Fitz Henry Lane.

[456] Admittedly, it has been postulated that the pink tone could be partly due to fading of the blue pigment Salmon employed. If indeed this is fading, then it is the only known example of this kind of pigment degradation occurring in a Salmon painting.

[457] These works by Hodges, having been converted into engravings, are the same works the Reverend

William Bentley commented upon having viewed in the mansion of Captain Beach in Gloucester.
[458] Personal correspondence from Joseph L. Stevens Jr. to Samuel Mansfield, October 17, 1903, in the collection of the Cape Ann Historical Association.
[459] Even in *Gloucester Harbor from Rocky Neck*, 1844, we find this to be the case. The two seated figures in the center foreground are shepherds at work, Rocky Neck at this time being pasturage for goats, and the man at left with musket in hand is off to shoot seabirds, not for sport but rather as pest control, to reduce the thefts of and defecation upon fish drying on racks by scavenging herring gulls.
[460] Henry David Thoreau, *Walking: A Journal* (Bedford, MA: Applewood Books, 1989; originally published in the *Atlantic Monthly*, June, 1862), 29–30.
[461] While some may object to this interpretation, citing that, as it is obviously daybreak, of course the harbor is to be found tranquil in the painting, it must be remembered that Lane specifically *chose* to depict the harbor in a state of repose, rather than during a more wakeful hour. As well, even a Lane painting depicting the early morning need not be sleepy, as his *Good Harbor Beach, Cape Ann*, 1847, is of the dawn breaking across the water, and that image is full of activity and action.
[462] See Kelly, "Lane and Church in Maine," in Wilmerding, *Paintings by Fitz Hugh Lane*, 132. Kelly takes poetic license in laying claim to the vessel in the foreground being either abandoned or awaiting repair, with "no further clues to its fate." Indeed, the very clue alluding to the reason for its presence lies right beside it—a log raft. The log raft, complete with a full load of freshly milled lumber, has been towed down river to the landing in the foreground, where its cargo has already been loaded aboard the lumber brig, which had been beached along the riverbank expressly for the taking on of this cargo. (In Lane's *Entrance of Somes Sound from Southwest Harbor*, 1852, we actually witness a similar scene where cut lumber is being loaded from a raft into a vessel midstream via a hatch at the vessels bow.) As well, its "sails and rigging hang loosely" for a definite reason, that being the heavy dews that are characteristic to Maine evenings. If the crew of this lumber brig were to furl their sails tight, not only would they become soaked with dew, they would take a good amount of time to dry, and would be more susceptible to mildew. By keeping them unfurled, it will be easier for them to dry in the morning while lessening the chances of mildew. Kelly also claims in his essay that the schooner or brig's bowsprit is broken. Simply put, it is not, being instead both intact and operable. (Technical assistance in the interpretation of activities illustrated in this painting provided by Erik A.R. Ronnberg Jr.)
[463] Ronnberg, "Imagery and Types of Vessels," in Wilmerding, *Paintings by Fitz Hugh Lane*, 102. Ronnberg points out that, despite the (highly exaggerated) effects of Confederate commerce raiders on Northern shipping during the Civil War, Gloucester's fisheries would hardly suffer, especially as the wartime demands to feed the Union army created a need that Gloucester's fisheries eagerly stepped up to fill, a phenomena that would repeat itself during the two world wars.
[464] Henry David Thoreau, *The Maine Woods* (New York: Apollo Editions, 1961), 108, quoted in John Wilmerding, "The Lure of Mount Desert and the Maine Coast," in *Paintings by Fitz Hugh Lane*, 115.
[465] American Art Union exhibition records, 1849, in the collection of the Boston Athenaeum.
[466] *Wilson Museum Bulletin*. 2, no 2 (Winter 1974–75).
[467] Ibid.
[468] Ibid.
[469] Susan Babson, "Fitz H. Lane," CAS&LA Weekly Column on Matters of Local History, Gloucester Daily Times, February 24, 1916 (in the collection of the Cape Ann Historical Association).
[470] See Kelly, "Lane and Church in Maine," in Wilmerding, *Paintings by Fitz Hugh Lane*; Wilmerding, "Lure of Mount Desert" in *Paintings by Fitz Hugh Lane*; and Wilmerding, *Fitz Hugh Lane* (1971), chapter 5, "The Meaning of Maine."
[471] Kelly, "Lane and Church in Maine," in Wilmerding, *Paintings by Fitz Hugh Lane*, 154.

[472] Morison, *Maritime History*, 216.

[473] Ibid., 236.

[474] Pamela J. Belanger, curator of nineteenth-century American art, Farnsworth Art Museum, Rockland, Maine, *Inventing Acadia: Artists and Tourists at Mount Desert*, exhibition text, June 13–October 2, 1999.

[475] Thomas Cole, Cole Papers: Cole to Reed (Albany, New York: New York State Library, March 2, 1836), quoted in *American Paradise*, 126.

[476] *American Paradise*, 130–33.

[477] Griffin, "Untrammeled Vision."

[478] Wilmerding, *Fitz Hugh Lane* (1971), 50.

[479] Kelly, "Lane and Church in Maine," in Wilmerding, *Paintings by Fitz Hugh Lane*, 132.

[480] John I.H. Baur, "American Luminism, A Neglected Aspect of the Realist Movement in Nineteenth-Century American Paintings," *Perspectives USA* 9 (Autumn 1954).

[481] It must be noted that Luminism, as both a school of artistic thought and as a unified aesthetic principle, has never been decisively proven to have ever existed, and remains at the time of this writing merely a theory, complete with tenets that have often been questioned and sometimes refuted. (A prime flaw in the theory of Luminism is that its historic lineage has never been credibly established.) Today, supporters and detractors of the theory alike concede that its importance as a movement has been exaggerated and overstated at the expense of a better comprehension of nineteenth-century artistic trends.

[482] Barbara Novak, *American Painting of the Nineteenth Century: Realism, Idealism and the American Experience* (New York: Praeger Publishers, 1969).

[483] Malcolm Cowley, ed., *The Portable Hawthorne* (New York: Penguin Books, 1976), editor's introduction, section 2, p. 8.

[484] Ibid.

[485] Novak, *American Painting of the Nineteenth Century*.

[486] Ralph Waldo Emerson, "Transcendentalism," Uncollected Prose, Dial Essays, 1842.

[487] This hypothesis was presented by Ronnberg in conversations with the author and the associate curator for exhibitions at the Cape Ann Historical Association, Susan Erony, in spring 2004. Ronnberg was particularly interested in the possibility that Lane used these boats as symbols of the fleeting presence of man's works in contrast to the permanence of the natural world.

[488] This particular vessel was a descendant of the colonial shallop used by early settlers for fishing and coastwise transportation. New England boats evolved into several distinct regional types in the early nineteenth century, but Cape Ann versions had seen only modest changes. They ranged from twenty to thirty feet in length, and could be "square-sterned" or "double-ended." Lane depicted mostly the double-enders. Howard I. Chapelle, *American Small Sailing Craft* (New York: W.W. Norton & Co., Inc., 1951), 20–22, 136, 137, 141–145; William A. Baker, *Sloops & Shallops* (Barre, MA: Barre Publishers, 1966), 20–33, 153–157.

[489] As stated by Pamela J. Belanger, curator of nineteenth-century American art at the Farnsworth Art Museum in Rockland, Maine, "A new tourist culture stimulated by beliefs in the *transcendent value of the wilderness experience* [emphasis added] and an appreciation of landscape emerged." *Inventing Acadia: Artists and Tourists at Mount Desert*, exhibition text, June 13–October 24, 1999.

[490] Assorted drawings by Fitz Henry Lane, in the collection of the Cape Ann Historical Association.

[491] See Fitz Henry Lane, *Somes Sound, Looking Southerly*, sketch. August 1850. Property of the Cape Ann Historical Association.

[492] "The Lyceum," *Gloucester Telegraph*, November 24, 1849, quoted in Sharon Worley, "Transcendentalism on Cape Ann: Rev. Amory Dwight Mayo and Fitz Hugh Lane," in the collection of the Cape Ann Historical Association.

[493] See Fitz Henry Lane, *Brace's Rock, Eastern Point*, sketch, August 1863. Property of the Cape Ann Historical Association.

[494] Worley, "Legacy of the Codfish Aristocracy."

[495] Ibid.

[496] Annette Babson, personal journal, Saturday, September 22, 1849 entry, quoted in Oaks, *Gloucester at Mid-Century*, 21.

[497] Worley, "Transcendentalism on Cape Ann."

[498] Ibid.

[499] Babson, Annette, personal journal, Sunday, September 23, 1849, as quoted in Worley, "Transcendentalism on Cape Ann."

[500] Worley, "Transcendentalism on Cape Ann."

[501] Hannah Stanwood Babson, personal journal, February 24, 1850 entry, in the collection of the Cape Ann Historical Association, quoted in Worley, "Transcendentalism on Cape Ann."

[502] Boston Athenaeum exhibition records, 1860–1865.

[503] See Fitz Henry Lane, *Steamer "Harvest Moon" Lying at Wharf in Portland*, photograph, 1863. Property of the Cape Ann Historical Association.

[504] See Fitz Henry Lane, *Eagle Cliff at Old Neck Beach*, sketches, 1863. Property of the Cape Ann Historical Association.

[505] See Mary Blood Mellen, *Two Ships in Rough Waters*, oil on canvas painting, 1865. Property of the Cape Ann Historical Association.

[506] "And from this [sketch] was taken one of the unfinished pictures for Mrs. S.G. Rogers of Roxbury standing on Lane's easel when he died." See Fitz Henry Lane, *Ten Pound Island in Gloucester Harbor*, sketch, 1864. Property of the Cape Ann Historical Association.

[507] "Painting ordered from the entire sketch by Mrs. S.G. Rogers of Roxbury. Shortly before his death Lane prepared a canvas 22 x 36 for it, and that was all." See Fitz Henry Lane, *Brace's Cove, Eastern Point*, sketch, 1863. Property of the Cape Ann Historical Association.

[508] *Gloucester Telegraph* article dated August 1865, in the collection of the Cape Ann Historical Association.

[509] *Cape Ann Light*, August 19, 1865. It must be noted that Lane's having worked on three paintings simultaneously at the time of his death offers us an interesting window into his work habits. The ability to divide his attention among several works in progress is not a habit one acquires in old age. Thus, we can reasonably assume it was an approach to producing art that he had developed when working at Pendleton's, where this situation would have been a normal aspect of his everyday work, and that he had maintained this habit to his advantage after having graduated to being a professional marine painter.

[510] *Boston Daily Evening Transcript*, August 19, 1865.

[511] Discharge: William P. Dolliver to Fitz H. Lane, July 25, 1856, Archival Records, New Court House, Essex Probate Court, Book 870, p. 221. [Brought to the author's attention by Eric A.R. Ronnberg Jr.]

[512] Discharge: Cape Ann Savings Bank to Fitz H. Lane, July 22, 1859, Archival Records, New Court House, Essex Probate Court, Book 257, p. 265. [Brought to the author's attention by Eric A.R. Ronnberg Jr.]

[513] Deed of sale between Joseph L. Stevens Jr. of Gloucester, Massachusetts, and Frederick G. Low, also of Gloucester, November 15, 1866, in the collection of the Cape Ann Historical Association.

[514] Personal correspondence between Florence Lamb and Alfred M. Brooks, president, Cape Ann Historical Association, January 30, 1961, in the collection of the Cape Ann Historical Association.

[515] Maxim Karolik, quoted in "The Karoliks: Larger than Life," in Dunlap and Buck, "Fitz Who?"

[516] Ibid.

[517] Ibid.

[518] Nina Fletcher-Little, *Little By Little*, (Boston: Society for the Preservation of New England Antiquities, 1998), 53, 60, quoted in Northeast Auctions, November 1 and 2, 1997. Lot# 545, Fitz Hugh Lane, Early Morning, Pavilion Beach, Gloucester (descriptive text).

[519] Newspaper advertisement dated 1938, collection of the Cape Ann Historical Association.

[520] "Painting by Lane of Town in 1852 Presented by Washington Lady as Memento of Her Grandfather, Mason," undated newspaper clipping in the collection of the Cape Ann Historical Association.

[521] Northeast Auctions, November 1 and 2, 1997. Lot# 545, Fitz Hugh Lane, *Early Morning, Pavilion Beach, Gloucester*.

[522] Auction results for Fitz Lane. AskArt.com. http://www.askart.com/AskART/artists/search/Search_Repeat.aspx?searchtype=AUCTION_RECORDS&&artist=21328.

[523] Wilmerding, *Fitz Hugh Lane*, 10.

[524] Ibid., 18.

[525] Ibid., 17.

[526] Babson, History of the Town of Gloucester, 111.

[527] Ibid.

[528] Wilmerding, Fitz Hugh Lane, 19.

[529] Ibid., 39.

[530] See Ronnberg, "Imagery and Types of Vessels," in Wilmerding, *Paintings by Fitz Hugh Lane*, 64.

[531] Interview with Erik A.R. Ronnberg Jr., summer 2005.

[532] Ibid. Author's note: The source for this misidentification lies within an inscription upon the back of the piece. Inscribed "F.H. Lane/Gloucester/1859," it becomes obvious that the dealers of this painting (Vose Galleries of Boston) misinterpreted the presence of the place name "Gloucester" to be the name of the composition, rather than seeing it as the artist stating his city of residence, something he would be inclined to do when trying to build a name in a distant market like New York.

[533] Baker's Island sported two lighthouses, affectionately nicknamed "Mr. and Mrs." and "Ma and Pa" from 1820 until 1926, when the smaller of the two was deactivated and dismantled. [Source: United States Coast Guard, Historic Light Station Information and Photography, www.uscg.mil/hq/g-cp/history/WEBLIGHTHOUSES/LHMA.html.]

[534] Nathaniel Hawthorne, *The Scarlet Letter*: "The Custom House," as reprinted in Cowley, *The Portable Hawthorne*, 294.

[535] "According to John Wilmerding, *Unicorn in Salem Harbor* is one of Fitz Hugh [*sic*] Lane's earliest known oil paintings, and one of only three known from 1840. It shows the arrival of the Cunard Line's steam packet *Unicorn* on its maiden voyage from England. In a letter of June 25, 1971, Wilmerding writes: 'Lane's painting of the Cunard steamer, *Unicorn* is…closely related in subject and composition to one of the others from this year, *S.S. Britannia in Boston Harbor* which is in a private collection.'" [Sotheby's, Catalog for Sale 7480, American Paintings, Drawings and Sculpture. Lot # 132, Fitz Hugh Lane, Unicorn in Salem Harbor (descriptive text).]

[536] Cunard Line, The British and North American Royal Mail Steam-Packet Company, Cunard Steamship Company, Limited. The Ships List, www.theshipslist.com/ships/lines/cunard.html.

[537] National Park Service, Division of Publications (in cooperation with the Peabody Museum and the Essex Institute), *Salem: Maritime Salem in the Age of Sail* U.S. Washington, D.C.: Department of the Interior, 1987), 106.

[538] Cunard Line, The British and North American Royal Mail Steam-Packet Company, Cunard Steamship Company, Limited. The Ships List, www.theshipslist.com/ships/lines/cunard.html.

[539] William C. Davis, *Rebels and Yankees: The Battlefields of the Civil War*, with Russ A. Pritchard, technical advisor (New York: Smithmark Publishers, Inc., 1991), 8.

540 Essex County Probate Records, Vol. 424, microfilm, Peabody Essex Museum Library. [Brought to the author's attention by Eric A.R. Ronnberg Jr.]

541 Massachusetts Supreme Judicial Court, Archives and Records. [Brought to the author's attention by Eric A.R. Ronnberg Jr.]

Bibliography

Albion, Robert Greenhalgh. *The Rise of New York Port, 1815–1860*. New York: Charles Scribner's Sons, Ltd. London, 1939.

American Paradise: The World of the Hudson River School. New York: The Metropolitan Museum of Art, 1987.

AskArt.com

Babson, John J. *History of the Town of Gloucester, Cape Ann*. Gloucester, MA: Procter Brothers, 1860. Reprint, Gloucester, MA: Peter Smith Publishers, Inc., 1972.

Babson, Susan. "Fitz H. Lane." CAS&LA Weekly Column on Matters of Local History, Gloucester Daily Times, February 24, 1916. In the collection of the Cape Ann Historical Association.

Baker, Carlos. *Emerson Among the Eccentrics: A Group Portrait*. New York: Penguin Books, USA, 1997.

Baker, William A. *Sloops & Shallops*. Barre, MA: Barre Publishers, 1966.

Baur, John I.H. "American Luminism, A Neglected Aspect of the Realist Movement in Nineteenth-Century American Paintings," *Perspectives USA* 9 (Autumn 1954): 90–98.

Belanger, Pamela J. *Inventing Acadia: Artists and Tourists at Mount Desert*. Farnsworth Art Museum, Rockland, Maine, exhibition text, June 13–October 2, 1999.

Bentley, Rev. William. *The Diary of William Bentley, D.D., Vol. I*. Gloucester, MA: Peter Smith Publishers, Inc., 1962.

Boston Daily Evening Transcript.

Brooks, Alfred Mansfield. *Gloucester Recollected: A Familiar History*. With contributions by Ruth Steele Brooks, edited by Joseph E. Garland. Gloucester, MA: Peter Smith Publishers, Inc., 1974.

———. Lane House. Unpublished document. In the collection of the Cape Ann Historical Association.

Brooks, Van Wyck. *The Flowering of New England: 1815–1865*. New York: E.P Dutton & Co., Inc., 1936.

Cavanaugh, Cam, Barbara Haskins, and Frances D. Pingeon. *At Speedwell in the Nineteenth Century*. Morristown, NJ: The Speedwell Village, 1981.

Champlain, Samuel de. *Voyages of Samuel de Champlain, Vol. 1*. Translated by Charles P. Otis. (1840–1888). The Project Gutenberg e-book, 2004.

Champney, Benjamin. *Sixty Year's Memories of Art and Artists*. Woburn, MA: Wallace and Andrews, 1900.

Channing, William Ellery. *An Address on Temperance*. Boston: Weeks, Jordan, & Company, 1837.

————. "Spiritual Freedom" (speech delivered May 26, 1830).

Chapelle, Howard I. *American Small Sailing Craft*. New York: W.W. Norton & Co., Inc., 1951.

Connolly, James B. *The Port of Gloucester*. New York: Doubleday, Doran & Company, Inc., 1940.

Constitution of the Boston Artists Association, with a Catalogue of the First Public Exhibition of Paintings at Harding Gallery, No. 22 School Street, Boston. Printed by John H. Eastburn, 1842. In the collection of the Boston Athenaeum.

Cowley, Malcolm, ed. *The Portable Hawthorne*. New York: Penguin Books, 1976.

Cox, E. Hyde. "Tour of Cape Ann Historical Association with Special Reference to A.M. Brooks," with J.E. Garland. Unpublished document, February 23, 1976, In the collection of the Cape Ann Historical Association.

Cummings, Thomas S. *Historic Annals of the National Academy of Design*. Philadelphia: George W. Childs, 1865, quoted in Oswaldo Rodriguez Roque, "The Exhaltation of American Landscape Painting," in *American Paradise: The World of the Hudson River School*, p. 12. New York: The Metropolitan Museum of Art, 1987.

Cutler, Carl C: *Greyhounds of the Sea*. New York: Halcyon House, 1930.

Davis, Elliot Bostwick. *Training the Eye and the Hand: Fitz Hugh Lane and Nineteenth Century American Drawing Books*. Gloucester, MA: Cape Ann Historical Association, 1993.

Davis, William C. *Rebels and Yankees: The Battlefields of the Civil War*, with Russ A. Pritchard, technical advisor. New York: Smithmark Publishers, Inc., 1991.

Downes, O. and E. Seigmeister. *A Treasury of American Song*. New York: Alfred A. Knopf, 1943.

Dresser, Thomas. *Dogtown: A Village lost in Time*. Franconia, NH: Thorn Books, 1995.

Dunlap, Sarah and Stephanie Buck. "Fitz Who? The Artist Latterly Known as Fitz Hugh Lane," *The Essex Genealogist* 25, no. 1 (February 2005), Gloucester Archives Committee.

Emerson, Ralph Waldo. "Nature," in *The Essential Writings of Ralph Waldo Emerson*, edited by Brooks Atkinson, with an introduction by Mary Oliver. New York: Modern Library, 2000.

———. "Self-Reliance" (from *Essays*, 1841), in *Self-Reliance and Other Essays*, New York: Dover Publications, Inc.

———. "Transcendentalism," Uncollected Prose, Dial Essays, 1842.

Erkilla, Barbara. "Fitz Hugh Lane, Self taught Artist, Now Recognized Here and Nationally," *Gloucester Daily Times*, August 12, 1953.

Essex Institute, comp. *Ship Registers of Gloucester, Massachusetts: 1789–1875*. Salem, MA: Essex Institute, 1944.

Finamore, Daniel. *Capturing Poseidon: Photographic Encounters with the Sea*. Salem, MA: Peabody Essex Museum, 1998.

Fitz Hugh Lane photographs, Frick Art Reference Library, New York City, January 1961.

Foley, Mary. "Discoveries in American Art: Fitz Hugh Lane, Ralph Waldo Emerson, and the Gloucester Lyceum," *The American Art Journal* 27, nos. 1 and 2 (1995–96).

Formisano, Ronald P. The Transformation of Political Culture: Massachusetts Parties, 1790s–1840s. New York: Oxford University Press, 1983.

Garland, Joseph E. *Guns Off Gloucester*. Gloucester, MA: Essex County Newspapers, Inc., 1975.

Gerdts, W.H. "'The Sea is His Home': Clarence Cook Visits Fitz Hugh Lane," *American Art Journal* 17, no.3 (Summer 1985).

Gloucester & Rockport Directory #3. Boston: Sampson, Davenport & Co. / Gloucester: Procter Bros., 1873

Griffin, Randal C. "The Untrammeled Vision: Thomas Cole and the Dream of the Artist," specifically paintings entitled *The Architect's Dream* and *Dream of Arcadia*, *Art Journal* 52, no. 2 (Summer 1993).

Halliday, F.E. *England: A Concise History*. New York: Thames and Hudson Inc., 1995.

Hanaford, Pheobe A. *Daughters of America*. Augusta, ME: True and Company, 1882.

Handlin, Oscar. *Boston's Immigrants: A Study in Acculturation*. New York: Athenaeum, 1976.

Hawthorne, Nathaniel. *The House of the Seven Gables*. New York: Bantam Books, Inc., 1851; Bantam Classic edition, March 1981; fifth printing through July 1985.

Hildreth, Reverend Hosea. "Address of the Gloucester Union, for the Promotion of Temperance and Economy; to Their Fellow Citizens," reported and accepted March 4, 1831.

Howe, Daniel Walker. The Political Culture of the American Whigs. Chicago: University of Chicago Press, 1979.

Karl, Dennis. Glorious Defiance. New York: Paragon House, 1990.

Kay, Jane Holtz. Lost Boston. Boston: Houghton Mifflin Company, 1980.

Kelly, Franklin. "Lane and Church in Maine," in John Wilmerding, Paintings by Fitz Hugh Lane. New York: Harry N. Abrams, Inc., 1988. Originally published as exhibition catalogue by National Gallery of Art, Washington, D.C., 1988.

Kempa, Amanda. "Fitz Hugh Lane and American Transcendentalism." Senior thesis, Columbia University, 1994.

Kugler, Richard C. "William Bradford," in William Bradford: Sailing Ships & Arctic Seas. New Bedford, MA: New Bedford Whaling Museum / Seattle: University of Washington Press, 2003.

Lane, Edward Jr. "Early Recollections of Artist Fitz H. Lane." Undated newspaper article. In the collection of the Cape Ann Historical Association.

Larkin, Jack. The Reshaping of Everyday Life. 1790–1840. New York: Harper & Row Publishers, Inc., 1988.

Legatt, Dr. Robert. A History of Photography from its Beginnings till the 1920's. Bath, England: The Royal Photographic Society, 1995.

List of Persons whose Names Have Been Changed in Massachusetts, 1780–1892, Collated and Published by the Secretary of the Commonwealth, Under Authority of Chapter 191 of the Acts of the Year 1893.

Longfellow, Henry Wadsworth. "The Building of the Ship," in The Poetical Works of Henry Wadsworth Longfellow, with Bibliographical and Critical Notes, Riverside Edition, Boston: Houghton, Mifflin, 1890.

Maddocks, Melvin, and the editors of Time-Life Books. The Great Liners. Alexandria, VA: Time-Life Books, 1982.

Mansfield, Helen. "Fitz H. Lane." Cape Ann Scientific and Literary Association Weekly Column on Matters of Local History. In the collection of the Cape Ann Historical Association.

Massachusetts Volunteer Militia in the War of 1812. Published by Brigadier General Gardner W. Pearson, adjutant general of Massachusetts, Boston, 1913.

McCulloh-Lemmon, Sarah. North Carolina and the War of 1812. Raleigh: Division of Archives and History, North Carolina Department of Cultural Resources, 1971.

Miller, Edwin Haviland. *Salem Is My Dwelling Place: A Life of Nathaniel Hawthorne*. Iowa City: University of Iowa Press, 1991.

Morison, Samuel Eliot. *The Maritime History of Massachusetts: 1783–1860*. London: William Heinemann, Ltd., 1923.

Morrison, Theodore. *Chautauqua*. Chicago: The University of Chicago Press, 1974.

National Park Service, Division of Publications (in cooperation with the Peabody Museum and the Essex Institute). *Salem: Maritime Salem in the Age of Sail*. Washington, D.C.: U.S. Department of the Interior, 1987.

Nichols, Ann, and Harriet Webster, eds. *Burnham Brothers Railway: Stories From the Neighborhood*. With contributions by Joseph E. Garland. Gloucester, MA: Gloucester Maritime Heritage Center, 2003.

Novak, Barbara. *American Painting of the Nineteenth Century: Realism, Idealism and the American Experience*. New York: Praeger Publishers, 1969.

Oaks, Martha. *Gloucester at Mid-Century: The World of Fitz Hugh Lane, 1840–1865*.Gloucester, MA: Cape Ann Historical Association, 1988.

O'Gorman, James F. *This Other Gloucester*. Gloucester, MA: Ten Pound Island Book Co., 1990.

Paine, Susanna. *Roses and Thorns, or Recollections of an Artist*. Providence, RI: B.T. Albro, 1854.

Paintings and Drawings by Fitz Hugh Lane. Gloucester, MA: Cape Ann Historical Association, 1974.

Parry, J.H. *Romance of the Sea*. Washington, D.C.: The National Geographic Society, 1981.

Pessen, Edward. Jacksonian America: Society, Personality, and Politics. Rev. ed. Champaign: University of Illinois Press, 1985.

Pierce, Sally, and Catharina Slautterback. *Boston Lithography, 1825–1880: The Boston Athenæum Collection*. Boston: The Boston Athenaeum, 1991.

Pierson, George Wilson. *Tocqueville and Beaumont in America*. New York: Oxford University Press, Inc, 1938.

Pringle, James R. *History of the Town and City of Gloucester, Cape Ann, Massachusetts*. Gloucester, MA: The City of Gloucester Archives Committee / Ten Pound Island Book Co., 1997.

Rifkind, Carole. *A Field Guide to American Architecture*. New York: Bonanza Books, 1984.

Ronnberg, Erik A.R., Jr. "A Few Words about this Picture: an 1852 artist's view of New York Harbor reveals itself to be an invaluable document of the wood-and-canvas technology of another era," *American Heritage of Invention & Technology* 4, no. 2 (Fall 1988).

———. "Imagery and Types of Vessels," in John Wilmerding, *Paintings by Fitz Hugh Lane*. New York: Harry N. Abrams, Inc., 1988. Originally published as exhibition catalogue by National Gallery of Art, Washington, D.C., 1988.

———. "View Of Fort Point: Part Two: Fitz Hugh Lane's Images of a Gloucester Landmark." Cape Ann Historical Association Special Edition Newsletter, July 2004.

———. "William Bradford: Mastering Form and Developing a Style, 1852–1862," in Richard C. Kugler, *William Bradford: Sailing Ships & Arctic Seas*. New Bedford, MA: New Bedford Whaling Museum / Seattle: University of Washington Press, 2003.

Roth, Leland M. *A Concise History of American Architecture*. New York: Harper & Row, Publishers, Icon Editions, 1980.

Rowe, William Hutchinson. *The Maritime History of Maine: Three Centuries of Shipbuilding and Seafaring*. New York: W.W. Norton & Company, Inc., 1948.

Sass, Edmund, ed. *Polio's Legacy: An Oral History*. With Goerge Gottfried and Anthony Sorem. Foreword by Richard Owen. Lanham, MD: University Press of America, 1996.

Schurman-Hawes, Dorothy. *To The Farthest Gulf: The Story of the American China Trade*. Ipswich, MA: The Ipswich Press, 1990.

Slautterback, Catharina, Sally Pierce, and Georgia Brady Barnhill. *Early American Lithography: Images to 1830*. Boston: The Boston Athenaeum, 1997.

Smith, Captain Sylvanus. *Fisheries of Cape Ann*. Gloucester, MA: Gloucester Times Co., 1913.

Smith, Charles C. "A Memoir [of John James Babson] by Charles C. Smith prepared for the Massachusetts Historical Society," 1886. In the collection of the Cape Ann Historical Association.

Snell, Tee Loftin. *The Wild Shores: America's Beginnings*. Washington, D.C.: The National Geographic Society, 1974.

Stimpson's Boston Directory, July 1831–1849.

Tatham, David. "The Lithographic Workshop, 1825–1850," in Georgia B. Barnhill, Diana Korzenik, and Caroline F. Sloat, eds., *The Cultivation of Artists in Nineteenth-Century America*. Worchester, MA: American Antiquarian Society, 1997.

———. "The Pendleton-Moore Shop: Lithographic Artists in Boston, 1825–1840." *Old-time New England* 62, no. 2 (October–December 1971).

Tharp, Louise Hall. *The Peabody Sisters of Salem*. Boston: Little, Brown and Company, 1950.

Thoreau, Henry David. *Walking: A Journal*. Bedford, MA: Applewood Books, 1989. Originally published within the *Atlantic Monthly*, June 1862.

Tibbets, Frederick W. *Story of Gloucester, Massachusetts*. Gloucester, MA: Clark the Printer, 1923.

Tierra, Michael, L.Ac., O.M.D. *The Way of Herbs*. New York: Simon & Schuster, Inc., 1980, 1983, 1990.

Tocqueville, Alexis de. *Democracy in America*, volume 1. 1835. Made available electronically through the American Studies programs at the University of Virginia, June 1, 1997.

Trask, John. Notes on the life of Fitz Henry Lane as given by John Trask of Gloucester to Emma Todd (now Mrs. Howard P. Elwell), ca. 1885. In the collection of the Cape Ann Historical Association.

Unitarian Universalist Historical Society. *Dictionary of Unitarian and Universalist Biography*. Boston: Unitarian Universalist Association, 1999–2004.

Vital Records of Gloucester, Massachusetts, Volume I, Births. Topsfield Historical Society, 1917.

Vital Records of Gloucester, Massachusetts, Volume III, Deaths. Topsfield Historical Society, 1917.

Walsh, Anthony Albert. *Johann Christoph Spurzheim and the Rise and Fall of Scientific Phrenology in Boston, 1832–1842*. Ann Arbor, MI: University Microfilms, 1974.

Waugh, Elizabeth. *The First People of Cape Ann: Native Americans on the North Coast of Massachusetts Bay*. Gloucester, MA: Dogtown Books, 2005.

Wilmerding, John. *Fitz Hugh Lane*. Westport, CT: Praeger Publishers, Inc., 1971.

———. *Fitz Hugh Lane: 1804–1865, American Marine Painter*. Salem, MA: The Essex Institute, 1964.

Wilson Museum Bulletin 2, no. 2 (Winter 1974–75).

Workers of the Writers' Program of the Work Projects Administration in the state of Massachusetts. *Boston Looks Seaward: The Story of the Port, 1630–1940*. Reprint, Boston: Northeastern University Press, 1985.

Worley, Sharon. "Fitz Hugh Lane and the Legacy of the Codfish Aristocracy," *Historical Journal of Massachusetts*, Winter 2004.

———. "Mapping the metaphysical landscape off Cape Ann: The receptions of Ralph Waldo Emerson's transcendentalism among the Gloucester audience of Reverend Amory Dwight Mayo and Fitz Hugh Lane," *Historical Journal of Massachusetts*, Summer 2001.

Index